MAGNUM ATLAS

AROUND THE WORLD IN 365 PHOTOS
FROM THE MAGNUM ARCHIVE

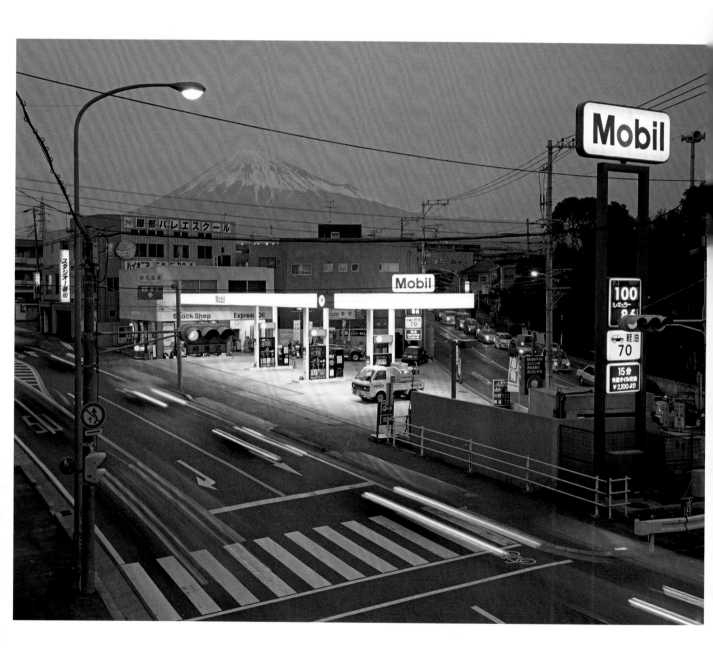

MAGNUM ATLAS

AROUND THE WORLD IN 365 PHOTOS
FROM THE MAGNUM ARCHIVE

PRESTEL

MUNICH | LONDON | NEW YORK

MAGNUM PHOTOS

NEW YORK | PARIS | LONDON | TOKYO

The Archive of Magnum Photos is its DNA. It represents the photographers who have been a part of this prestigious agency, now in its seventieth year, and it is a record of the intricate and textured world in which those photographers have lived and worked. It has a global reach and intersects great moments in history with quieter, more subtle observations: a hairdresser in Senegal, or a wedding in Santiago Atitlán, and on through hundreds of thousands of other distinctive moments – moments of joy, sorrow, humour, war, peace, turmoil, surprise, anger, love and awe.

The Magnum Archive can be viewed from diverse perspectives and can be "sampled" by curators with differing degrees of astuteness and imagination. At the time of writing I am aware of a number of projects drawn from it: an exhibition on youth culture; a book on Magnum's co-founder George Rodger's lost colour photographs from the Sudan; an exhibition of screen idols; a presentation of Henri Cartier-Bresson's first photographs; and naturally this collection, *Magnum Atlas*, which follows Magnum photographers on their extensive wanderings around the globe.

The reason it is possible to work with these images in so many different ways, and for the outcome to remain so interesting, is because of the quality and depth of the photographs created by individuals with unique visions and distinctive points of view. If you are seeking a clichéd vision of the world, Magnum Photos is not the place to go. Not because Magnum photographers have a dark and dystopian

vision of the world (although they sometimes do), but because they have sought out truth in a hard-lived life, and have looked into the dark corners of the world (as well as the bright), and have found beauty and understanding beyond the pretty and superficial.

Millions of photographs are made daily. "Everybody is a photographer now", goes the popular saying. However, people need quality and conviction in a world in which everything is disposable and in which Snapchat is the natural evolution of the disposable image. There is a similarity to be drawn between photography and poetry in that anybody can make a rhyme but that does not make them a poet, and so it is with this special craft. Magnum photographers strive for an authorship and poetry in their work, which separates them from the masses.

This collection of photographs, curated by Elisa Mazza along with Hamish Crooks, who probably know the Magnum Archive better than anyone, can be seen as a poetic anthology on the theme of travel. Travelling around the whole world, you are offered glimpses from places near and far filtered through the eyes and lenses of Magnum photographers. A collection of well-known images, yes, but also a fascinating treasury of lesser-known images that deserve attention and that promise an undeniable reward.

Chris Steele-Perkins
London, 2017

Nothing is more characteristic of photography than a journey. Seeing and accepting other ways of being in this world is the key to understanding our own lives and to setting our priorities in the right place.

The powerful images in this book by eighty-four esteemed Magnum photographers allow us to travel around the world and see the way people live. Through the visions of these exceptional photographers we acknowledge being a part of humanity.

Elisa Mazza

"Culture shock is often felt sharply at the borders between countries, but sometimes it doesn't hit fully until you've been in a place for a long time."

Henri Cartier-Bresson
The Mind's Eye

LA PAMPA, ARGENTINA
South of Buenos Aires. 1958

René Burri

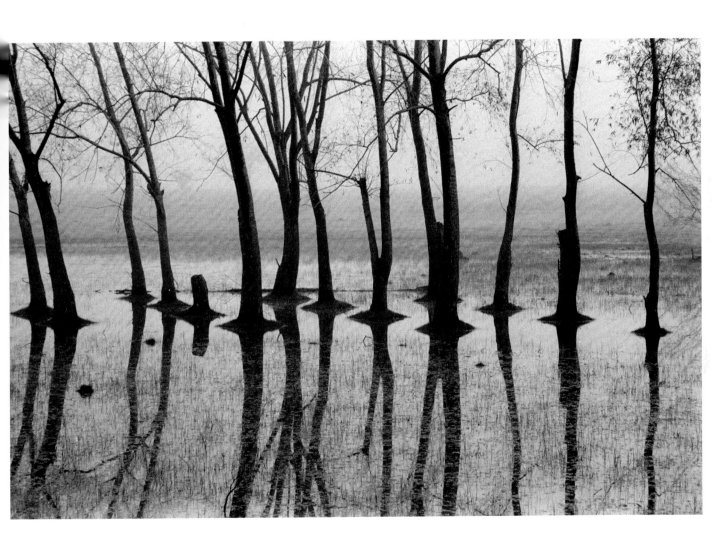

ARGENTINA
On the Estancia Marianita, a herd of wild horses is
brought out to the pampas to be trained for work
with herds of cattle. 1958

René Burri

JANUARY 1 **2** 3 4 5 6 7 8 9 10 11 12 13 14 15 16 17 18 19 20 21 22 23 24 25 26 27 28 29 30 31

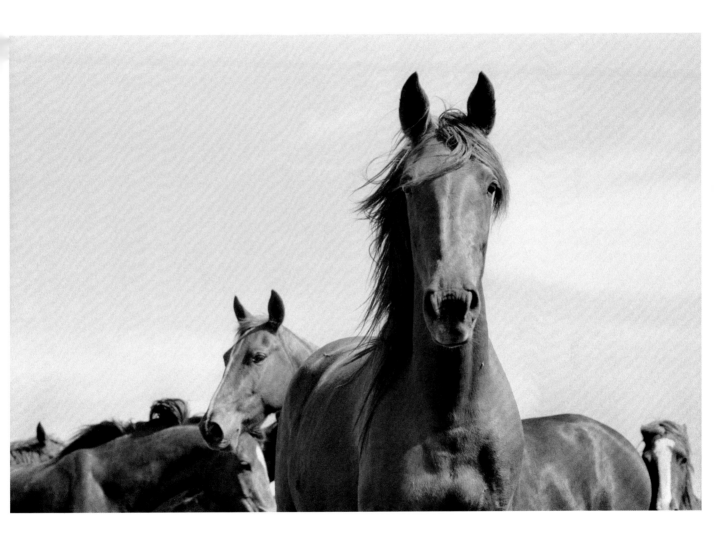

BUENOS AIRES, ARGENTINA

The Estancia Rincón de López is run by
the *mayordomo* (administrator). Here two
peones (farmers) simulate a knife fight;
this was a game, although such conflicts
still exist among the gauchos. 1958

René Burri

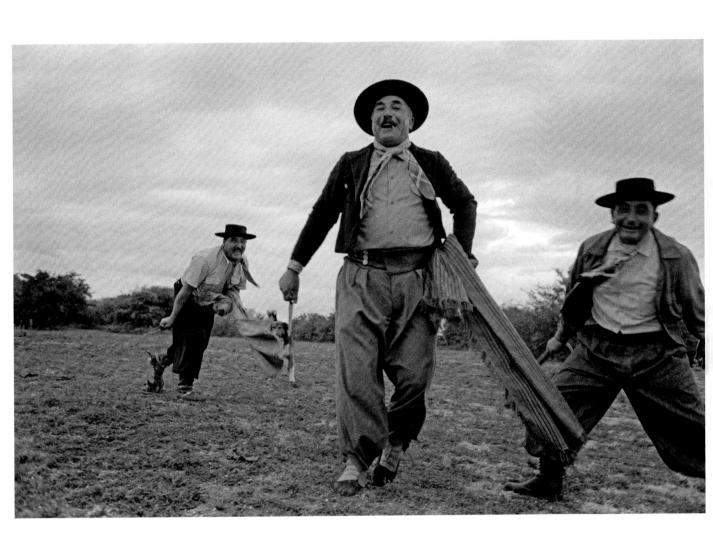

ARGENTINA
1958

René Burri

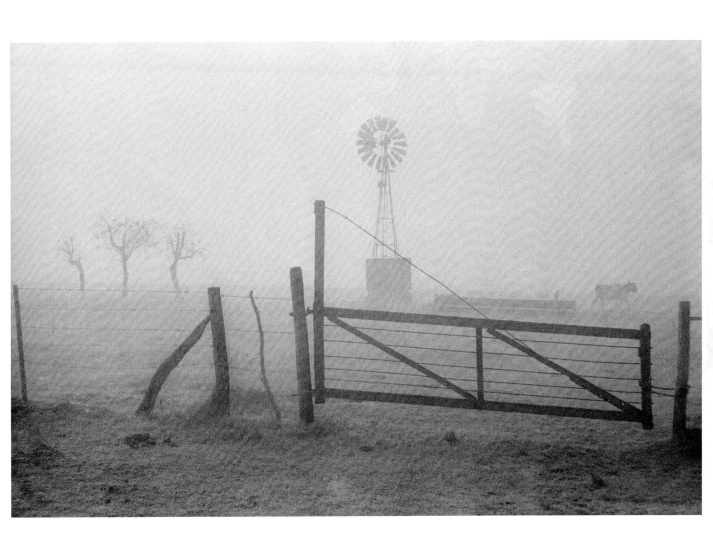

VALPARAÍSO, CHILE
1963

Sergio Larraín

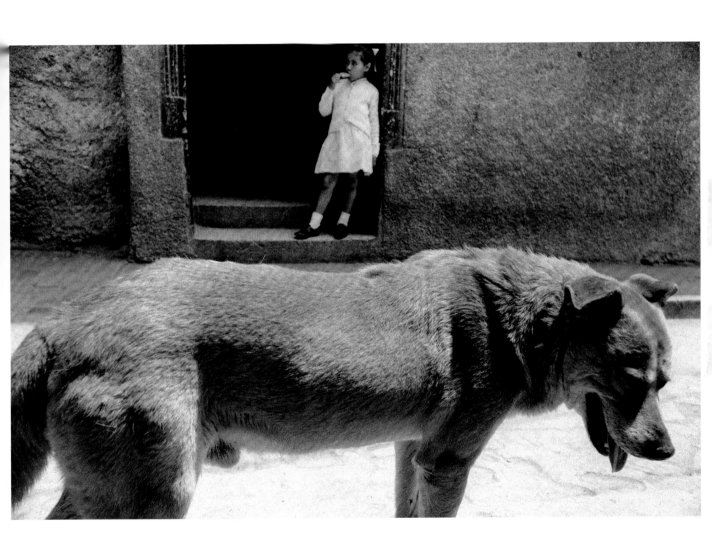

CHILOÉ ISLAND, CHILE
1957

Sergio Larraín

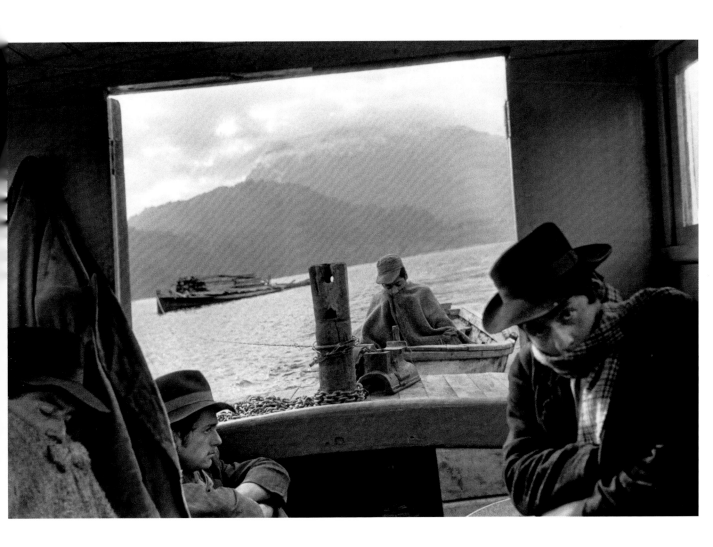

SANTIAGO, CHILE
1963

Sergio Larraín

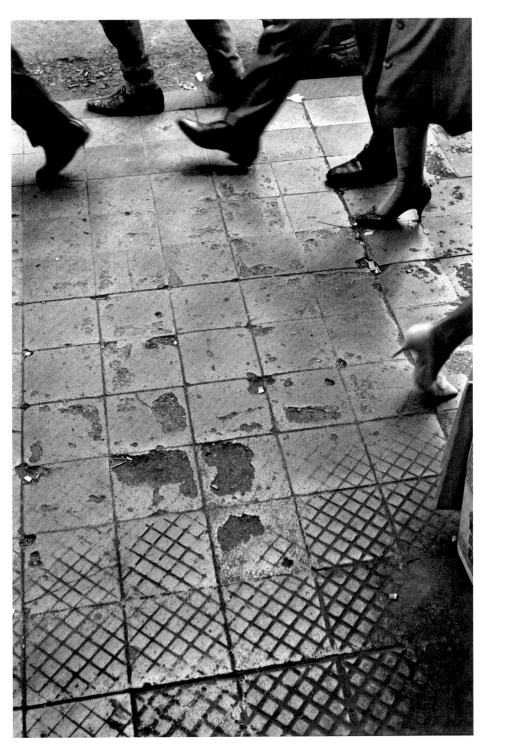

SANTIAGO, CHILE
1963

Sergio Larraín

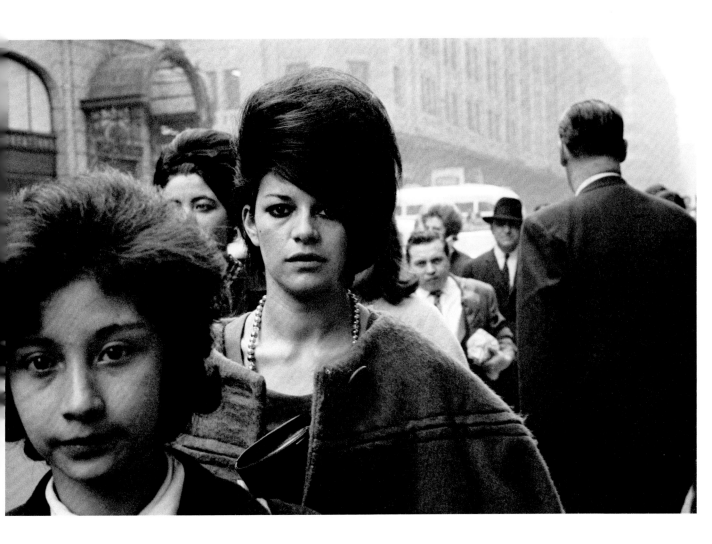

RIO DE JANEIRO, BRAZIL
2011

David Alan Harvey

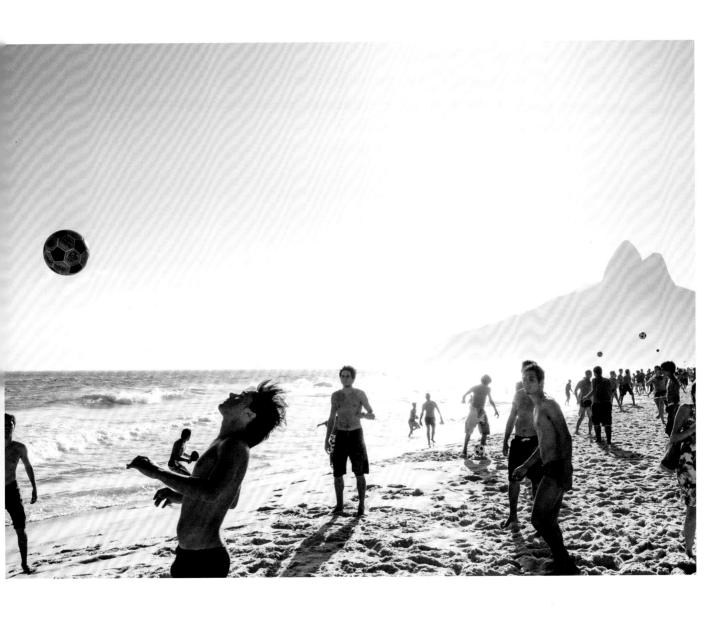

RIO DE JANEIRO, BRAZIL
A boy walks the rainy streets of Zona Norte. 2010

David Alan Harvey

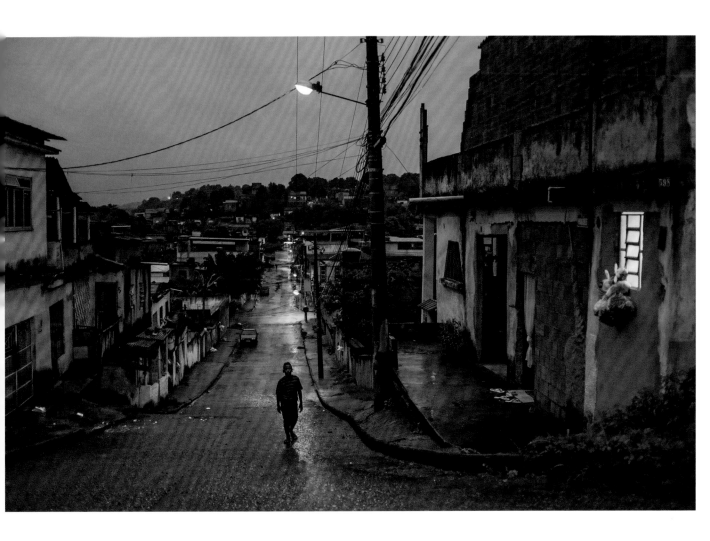

RIO DE JANEIRO, BRAZIL
Schoolchildren dance in Rocinha, the largest
favela in Rio de Janeiro, as their classmates
and teacher look on. 2011

David Alan Harvey

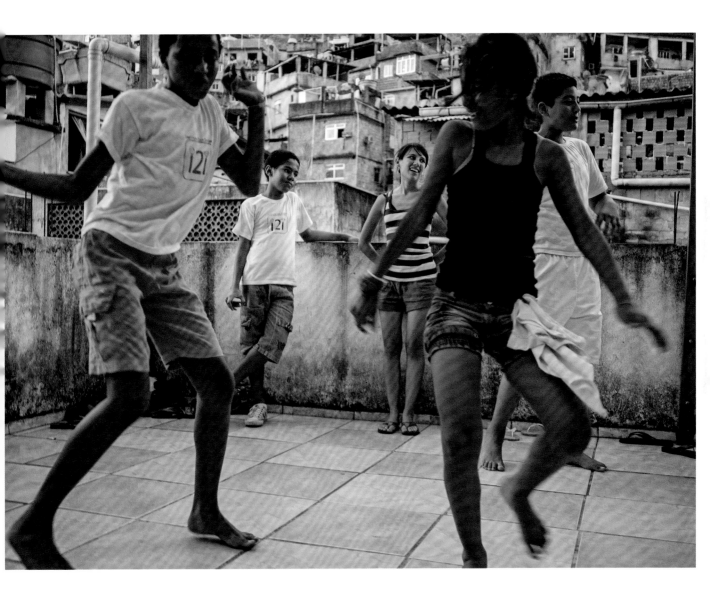

RIO DE JANEIRO, BRAZIL
Copacabana street and beach scene at dusk. 2011

David Alan Harvey

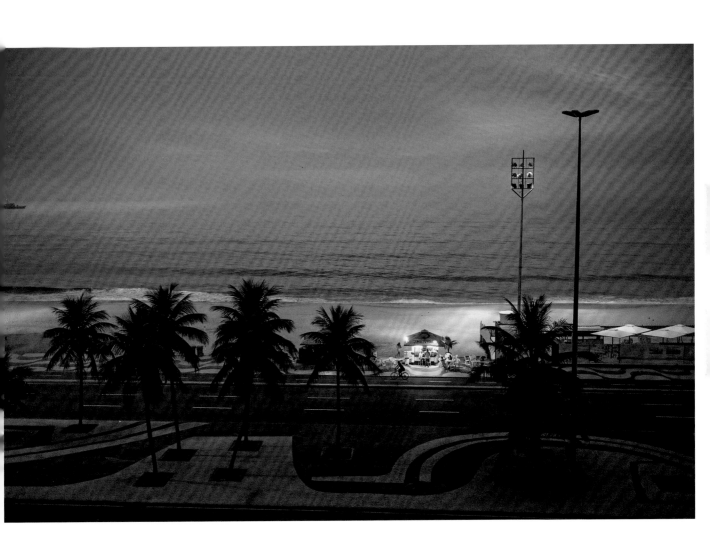

CARACAS, VENEZUELA
Police patrol in Petare. 2013

Jérôme Sessini

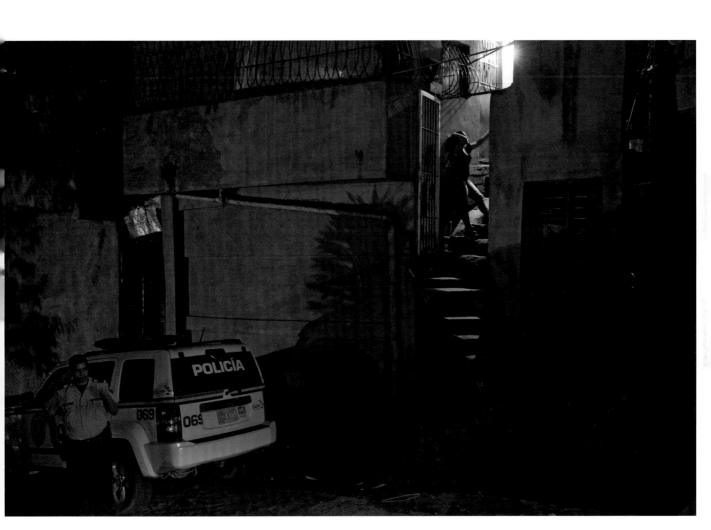

CARACAS, VENEZUELA
Tower of David, probably the world's tallest slum
squatted by eight hundred families. 2013

Jérôme Sessini

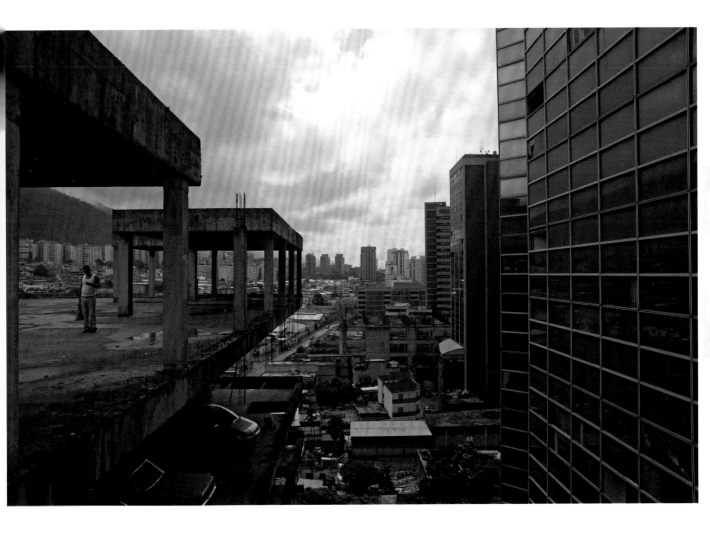

CARACAS, VENEZUELA
Tower of David, probably the world's tallest slum
squatted by eight hundred families. 2013

Jérôme Sessini

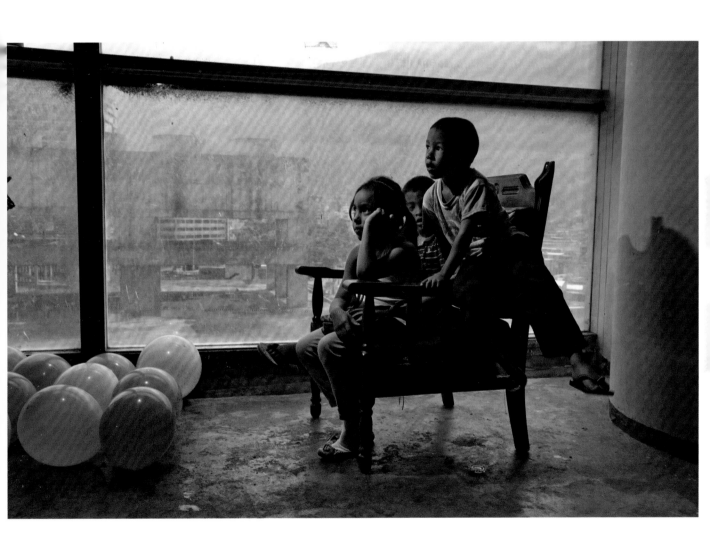

CARACAS, VENEZUELA
23 de Enero parish. Venezuelan and pro-Chavez
flag on a rooftop. 2013

Jérôme Sessini

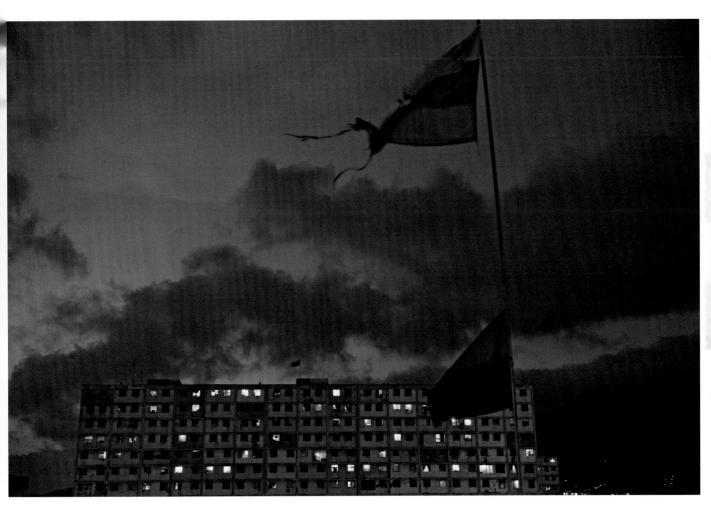

CARACAS, VENEZUELA
View of Caracas. 2013

Jérôme Sessini

JANUARY 1 2 3 4 5 6 7 8 9 10 11 12 13 14 15 16 **17** 18 19 20 21 22 23 24 25 26 27 28 29 30 31

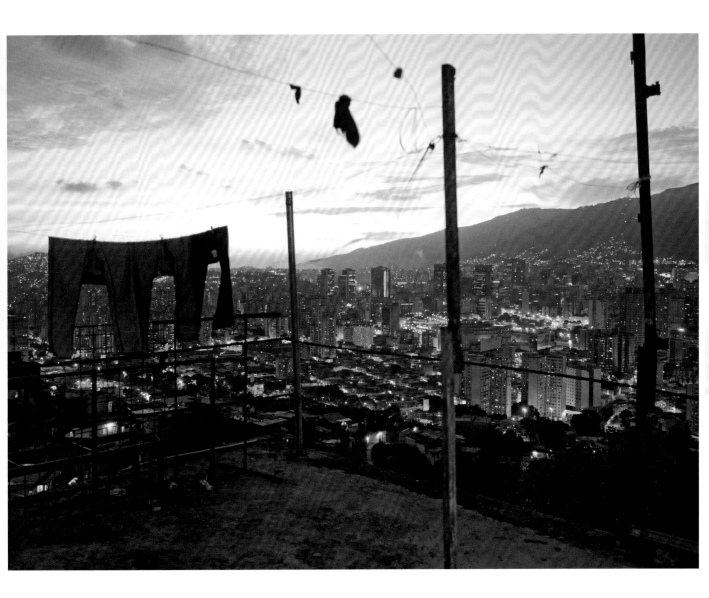

CARTAGENA, COLOMBIA
2015

Raymond Depardon

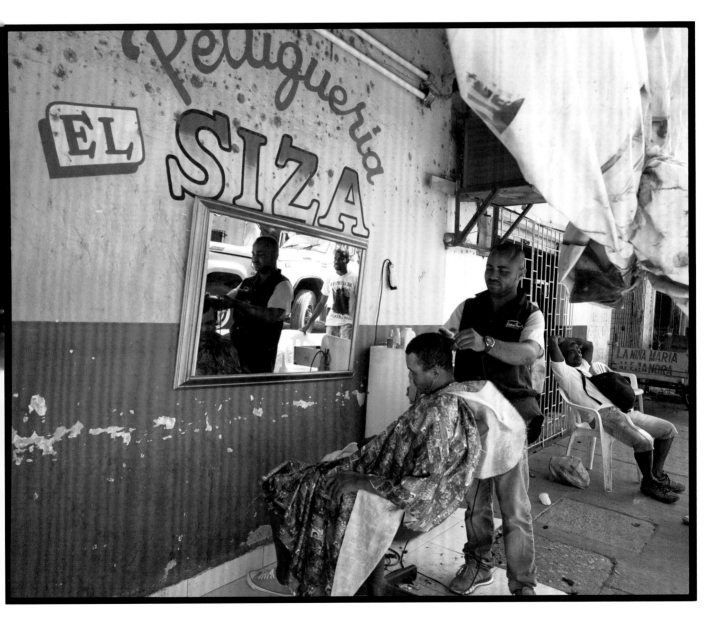

CARTAGENA, COLOMBIA
2015

Raymond Depardon

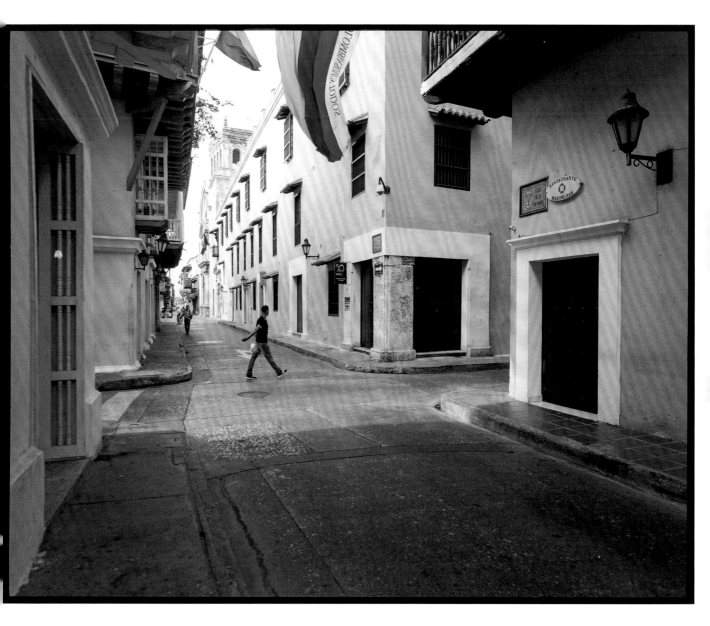

CARTAGENA, COLOMBIA
2015

Raymond Depardon

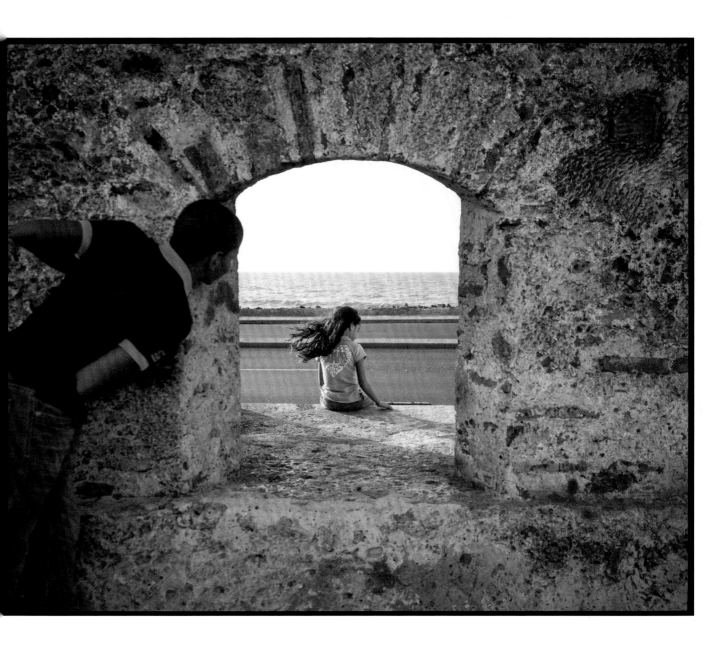

TORTOLA, BRITISH VIRGIN ISLANDS
Street scene on the island of Tortola. 1966

Dennis Stock

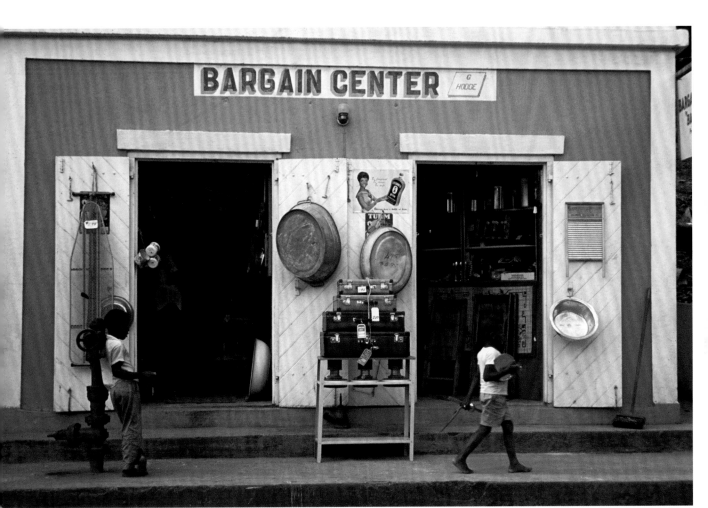

VIRGIN ISLANDS
1966

Dennis Stock

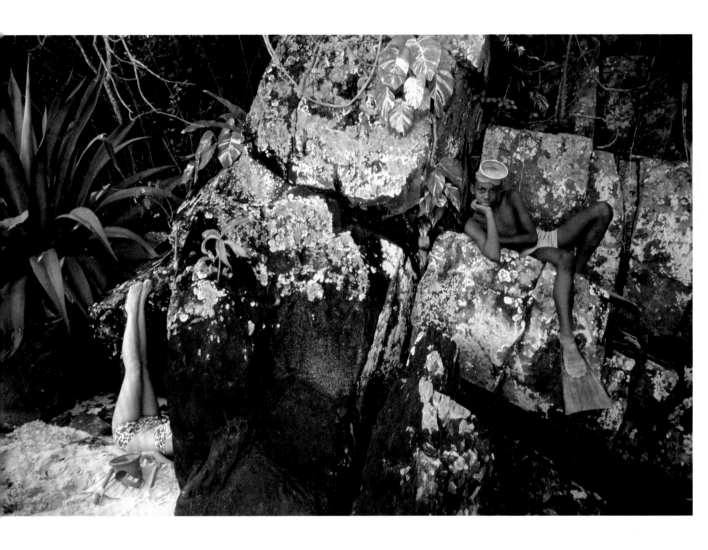

VIRGIN ISLANDS
1966

Dennis Stock

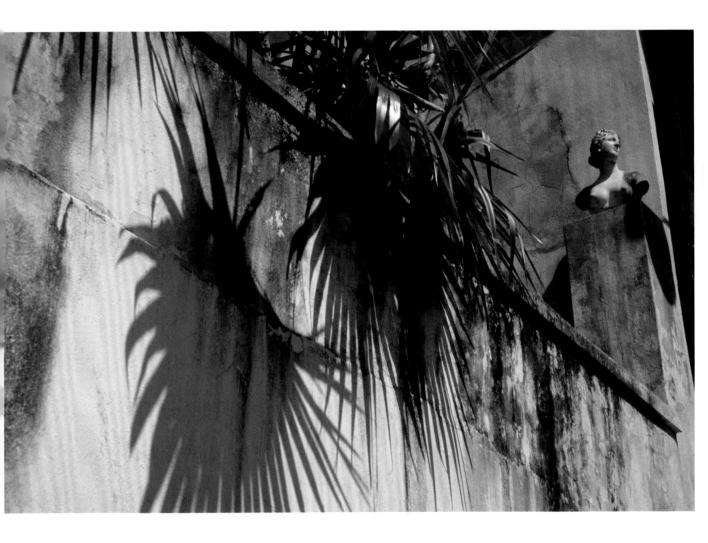

PORT-AU-PRINCE, HAITI
Earthquake aftermath. 2010

Bruce Gilden

JANUARY 1 2 3 4 5 6 7 8 9 10 11 12 13 14 15 16 17 18 19 20 21 22 23 **24** 25 26 27 28 29 30 31

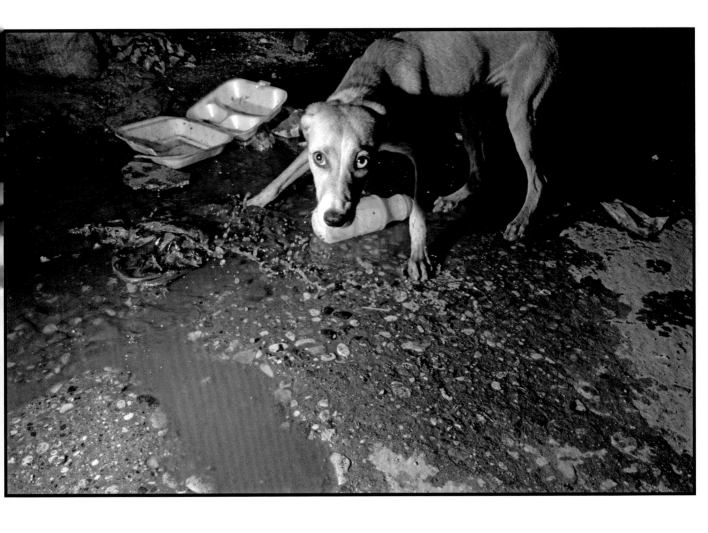

PORT-AU-PRINCE, HAITI
After a funeral. 2011

Bruce Gilden

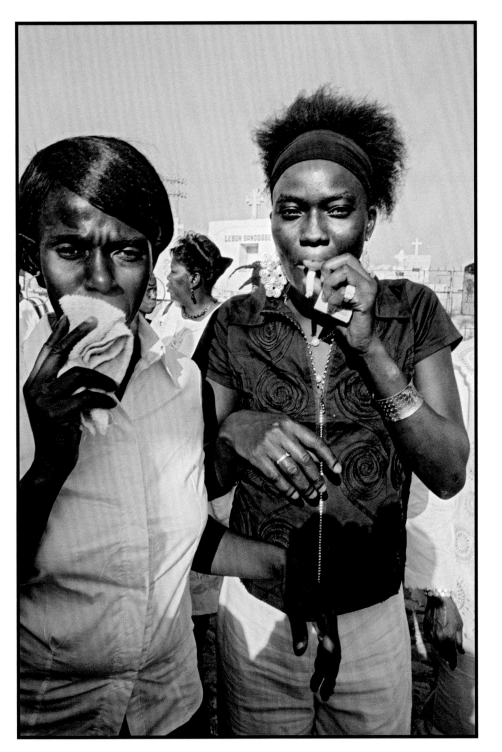

PORT-AU-PRINCE, HAITI
Abattoir outside Port-au-Prince. 1992

Bruce Gilden

JANUARY 1 2 3 4 5 6 7 8 9 10 11 12 13 14 15 16 17 18 19 20 21 22 23 24 25 **26** 27 28 29 30 31

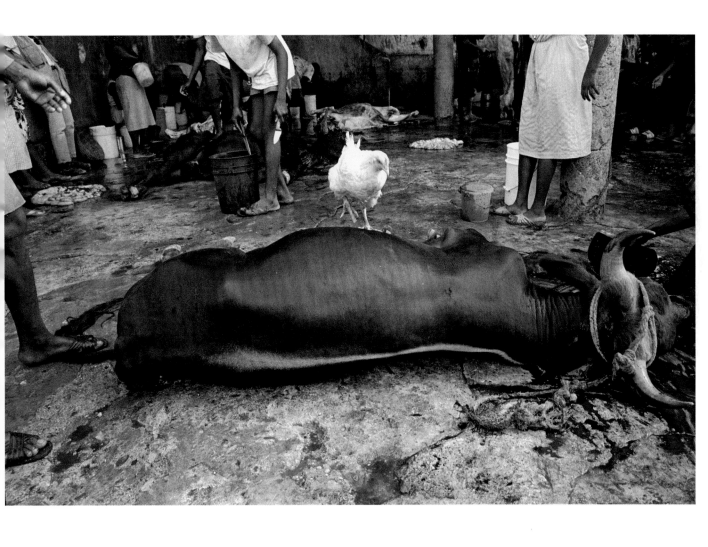

PORT-AU-PRINCE, HAITI
At a bus station on "La Grande Rue"
(Rue Dessalines). 2011

Bruce Gilden

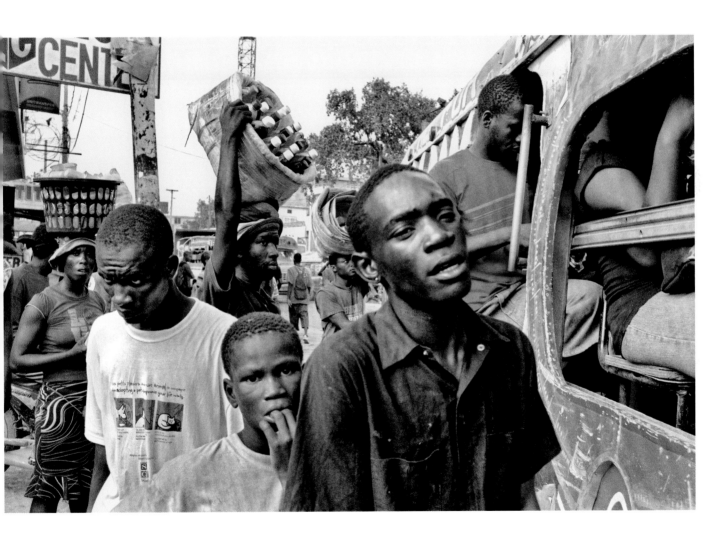

HAVANA, CUBA
Regla. Inside a store. 2003

Alex Webb

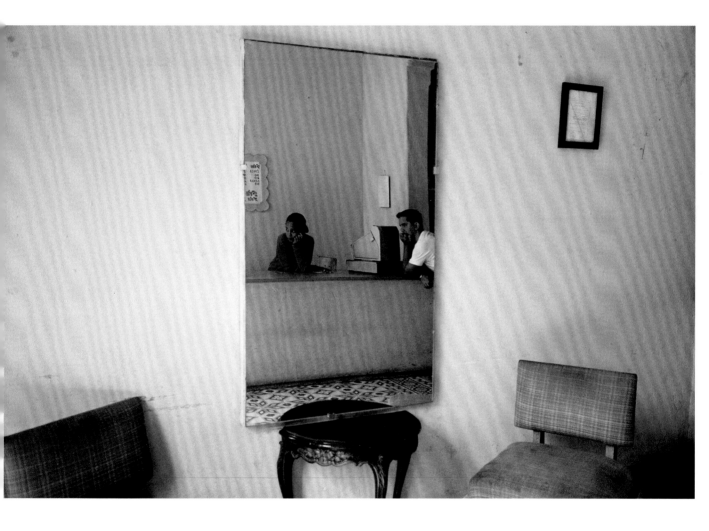

HAVANA, CUBA
Painting along the Malecón. 2004

Alex Webb

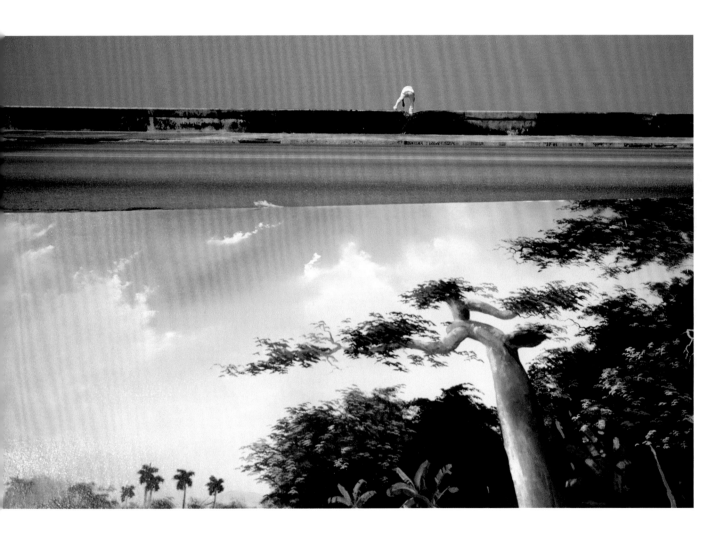

HAVANA, CUBA
Vedado. Children play around stadium area. 2012

Alex Webb

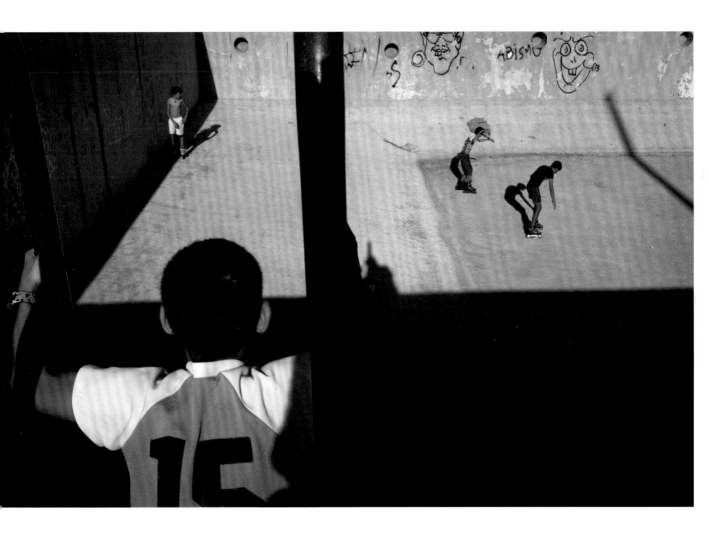

PLAYA GIRÓN, CUBA
1993

Alex Webb

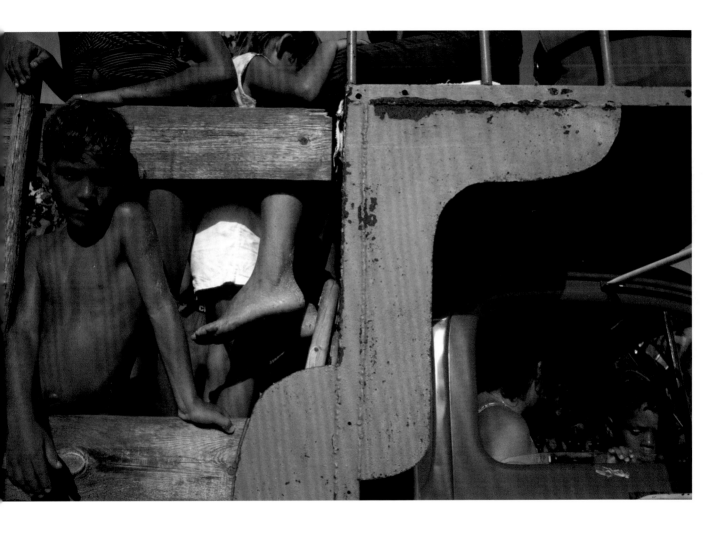

SANCTI SPÍRITUS, CUBA
Baseball fans. 1993

Alex Webb

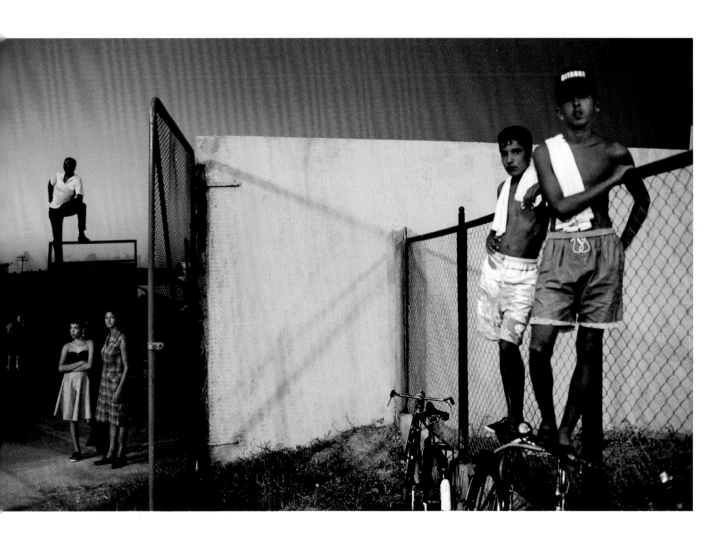

KINGSTON, JAMAICA
At the Kingston Dub Club, a weekly Monday night
house party overlooking the city of Kingston. 2015

Michael Christopher Brown

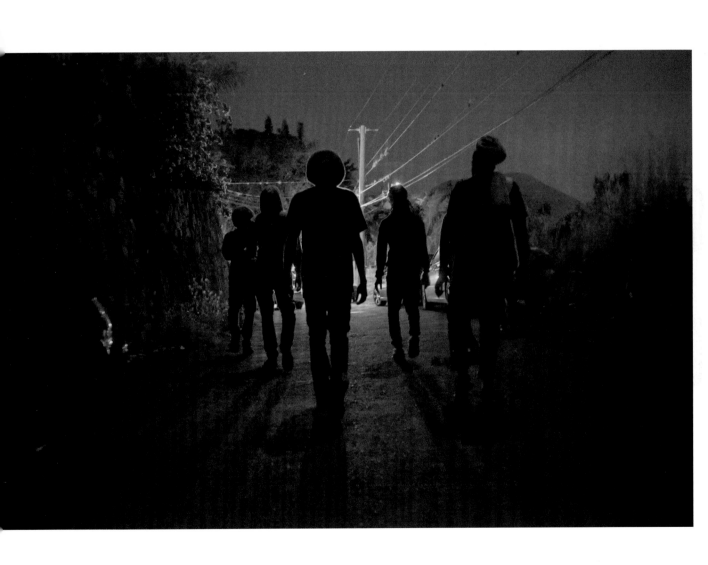

KINGSTON, JAMAICA
The Jamaica Reggae artist Protoje, in beige hat and suit, at his album release party at Pegasus Gardens. 2015

Michael Christopher Brown

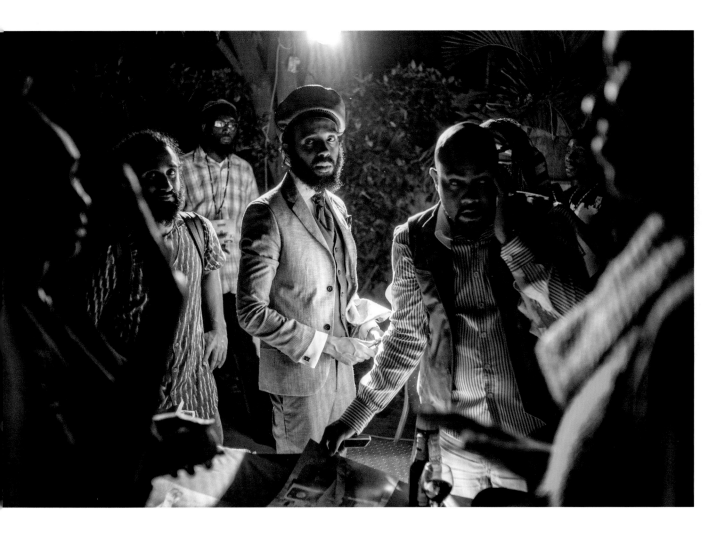

KINGSTON, JAMAICA
The Jamaica Reggae artist Jessie Royal, at a
playing field near his home. 2015

Michael Christopher Brown

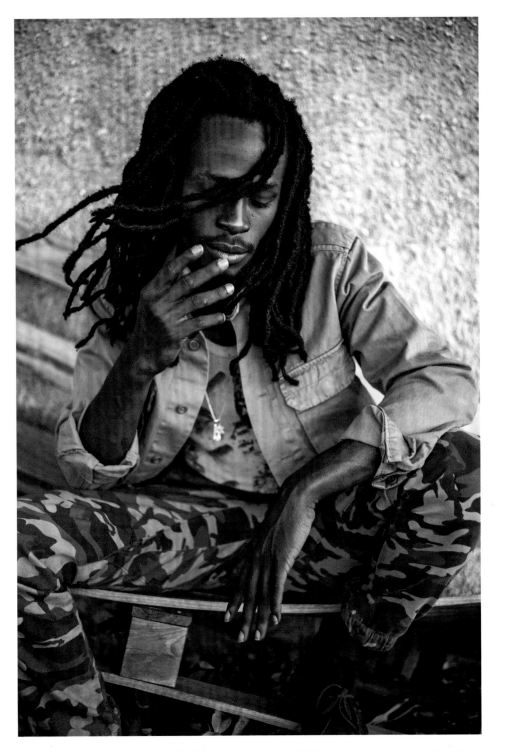

EIGHT MILES BULL BAY, KINGSTON, JAMAICA
Jamnesia Surf Camp director and surf coach
Billy Wilmot, aka Billy Mystic or Uncle Bill,
is a surf legend in Jamaica. 2015

Michael Christopher Brown

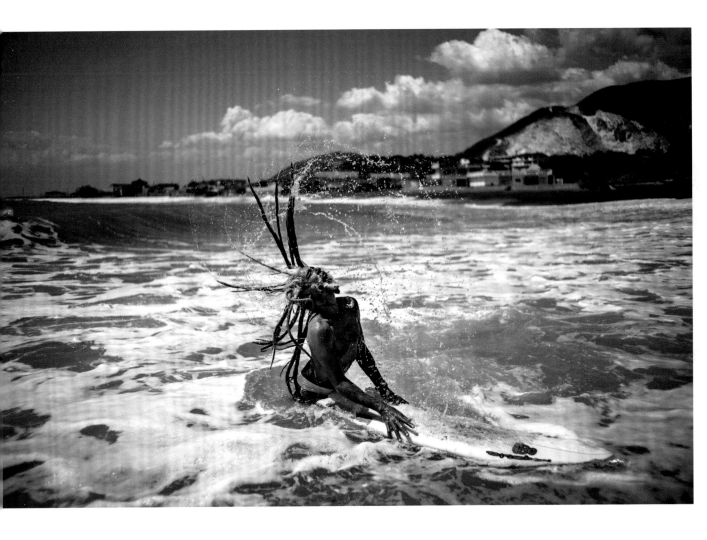

NEAR COBÁN, GUATEMALA
Maya ceremony in Chicoy Cave. Maestro Cirilo and
disciples lighting candles in observance of the
Maya New Year. 1997

Thomas Hoepker

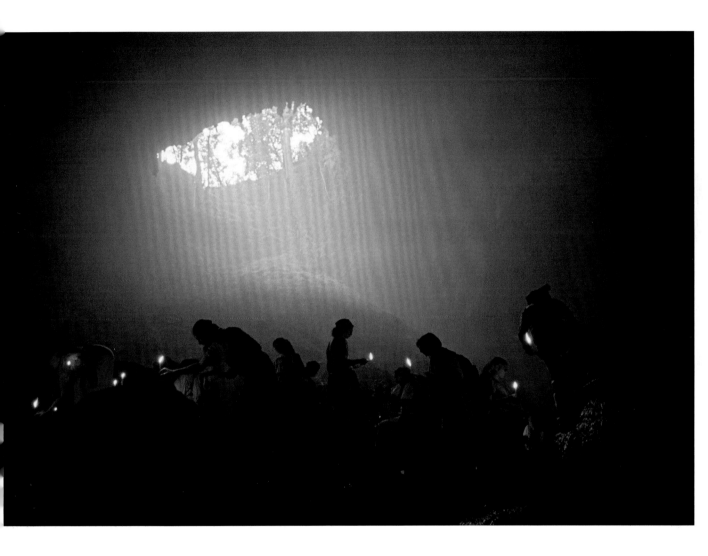

SANTA MARÍA NEBAJ, EL QUICHÉ, GUATEMALA
Plaza and church in early morning. 1997

Thomas Hoepker

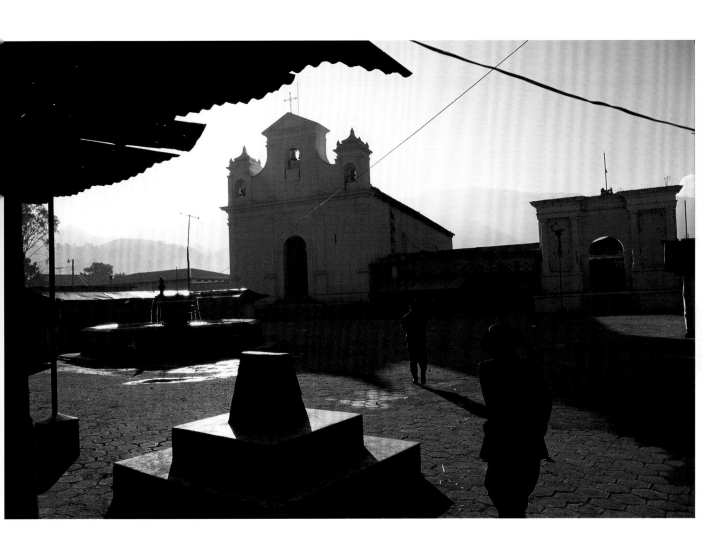

TODOS SANTOS CUCHUMATÁN, GUATEMALA
Men and a woman in local garb. The men
with guns belong to a civil patrol. 1991

Thomas Hoepker

FEBRUARY 1 2 3 4 5 6 7 **8** 9 10 11 12 13 14 15 16 17 18 19 20 21 22 23 24 25 26 27 28/29

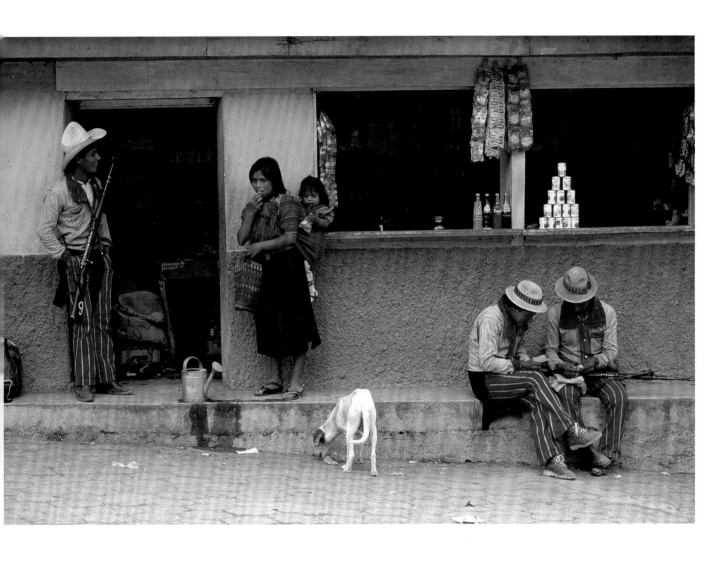

SANTIAGO ATITLÁN, GUATEMALA
Bride and groom at church. 1992

Thomas Hoepker

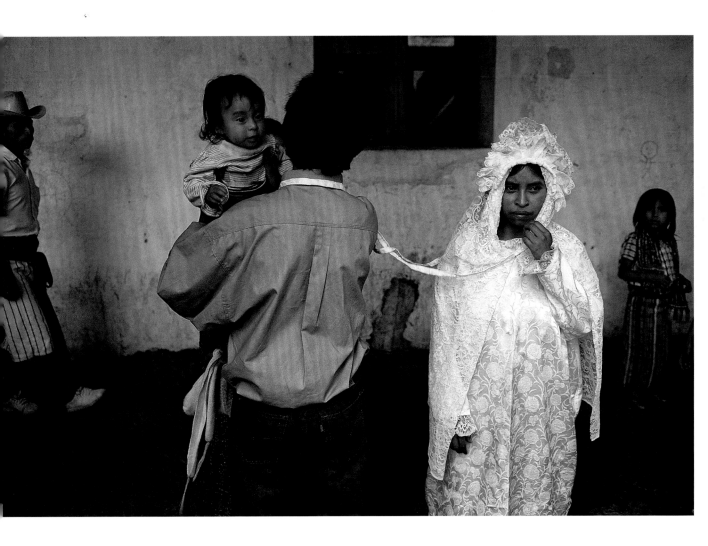

TOLUCA, MEXICO
1958

Herbert List

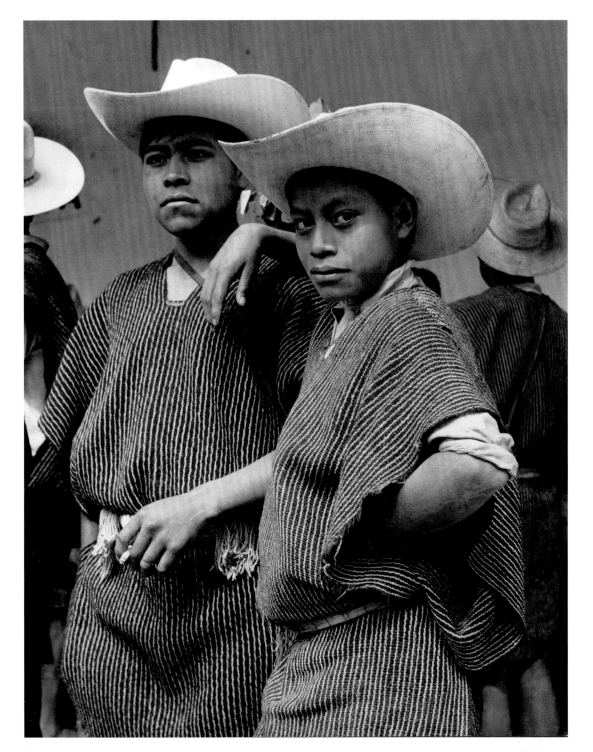

MEXICO
Mexican prison. 1958

Herbert List

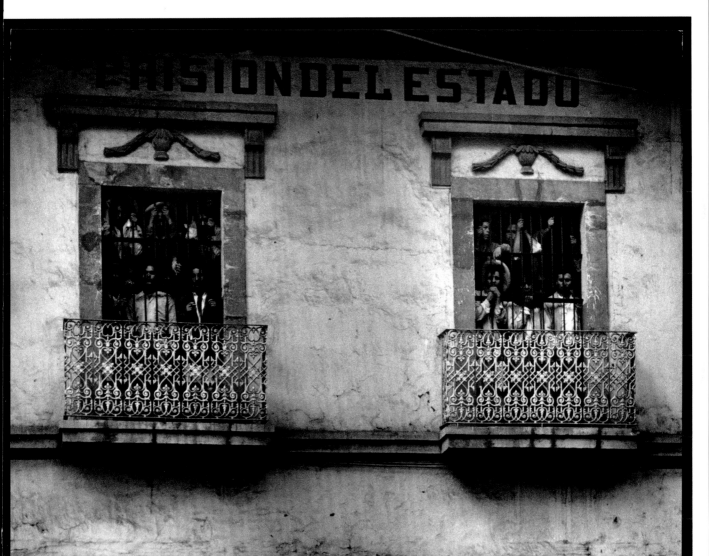

CHICHEN ITZA, YUCATÁN, MEXICO
1958

Herbert List

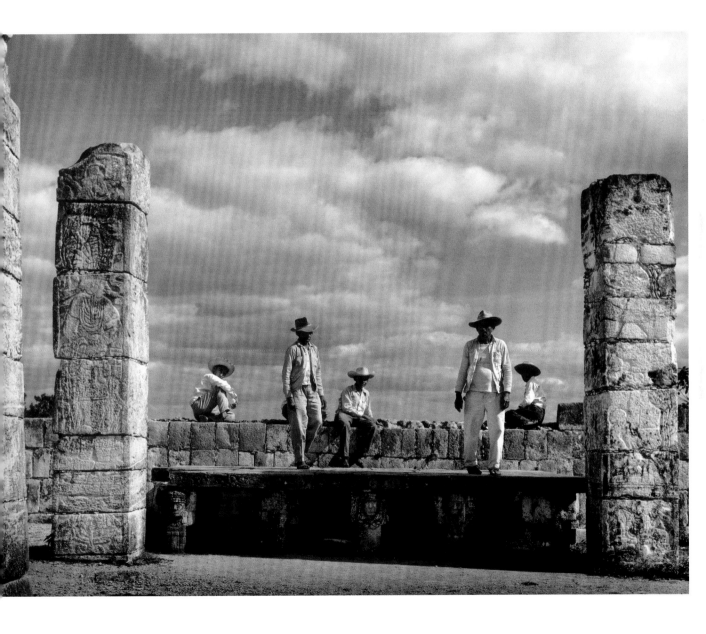

PUEBLA, MEXICO
1958

Herbert List

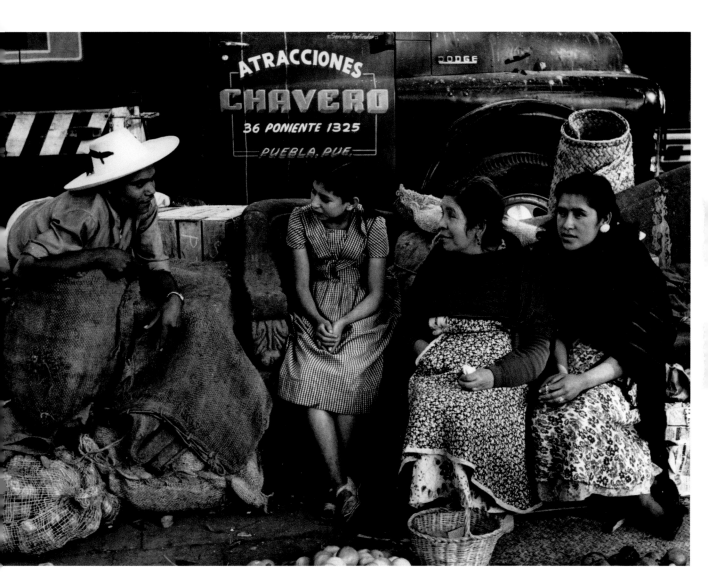

NAVAJO RESERVATION, ARIZONA, USA
Painted Desert. 2015

Larry Towell

FEBRUARY 1 2 3 4 5 6 7 8 9 10 11 12 13 **14** 15 16 17 18 19 20 21 22 23 24 25 26 27 28/29

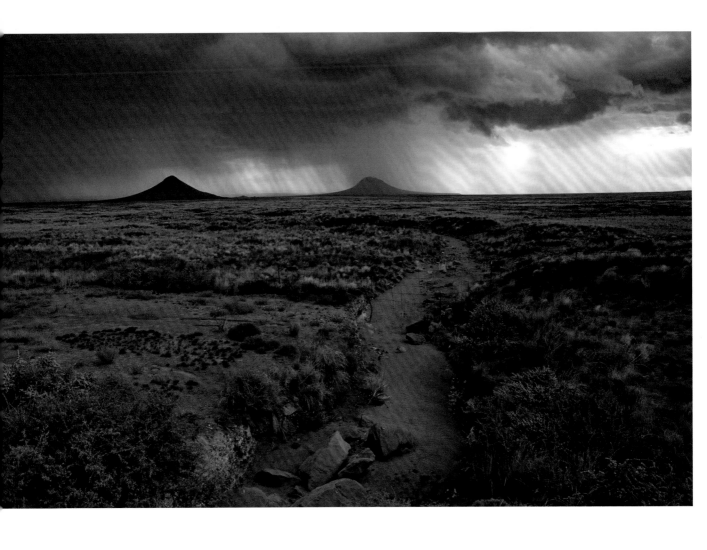

NAVAJO RESERVATION, ARIZONA, USA
American flag with "End of the Trail" iconography
based on a 1915 sculpture by American artist
James Earl Frazer who sympathized with
American native people. Highway 89. 2015

Larry Towell

FEBRUARY 1 2 3 4 5 6 7 8 9 10 11 12 13 14 **15** 16 17 18 19 20 21 22 23 24 25 26 27 28/29

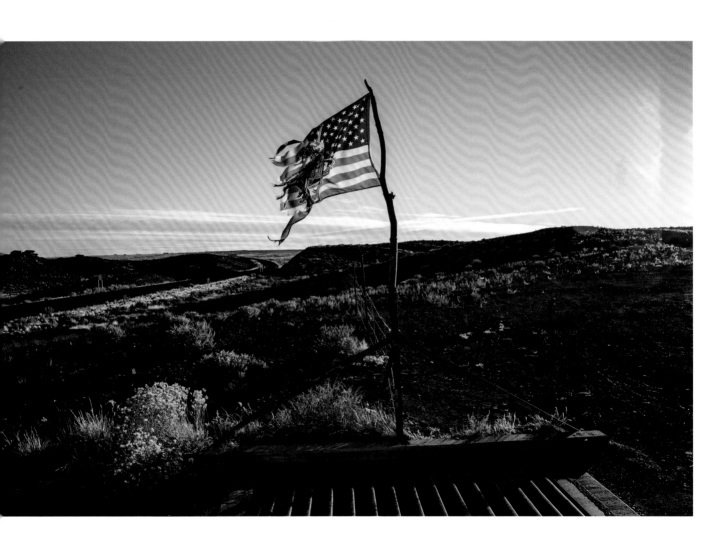

NAVAJO NATION, ARIZONA, USA
On Highway 89. 2015

Larry Towell

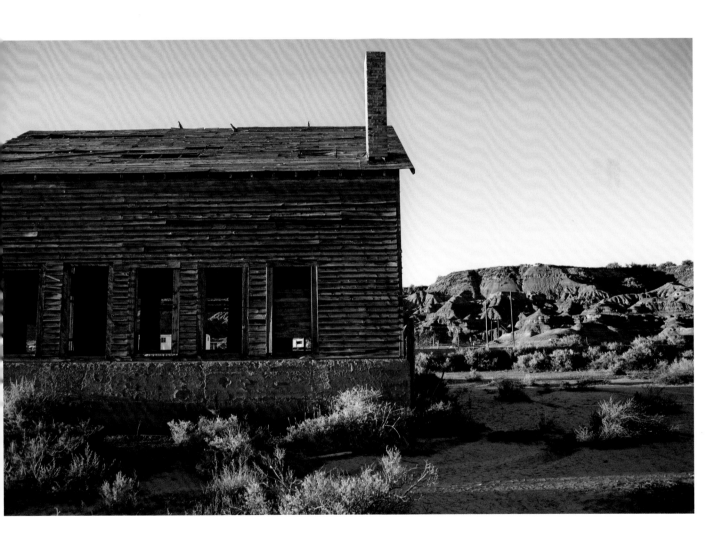

FORT APACHE INDIAN RESERVATION, ARIZONA, USA
Eleven year-old Serenity Sinquah (right) during the
sunrise dance of a four-day puberty ceremony.
The morning ritual is accompanied by thirty-two
chants sung by a medicine man and his singers. 2015

Larry Towell

FEBRUARY 1 2 3 4 5 6 7 8 9 10 11 12 13 14 15 16 **17** 18 19 20 21 22 23 24 25 26 27 28/29

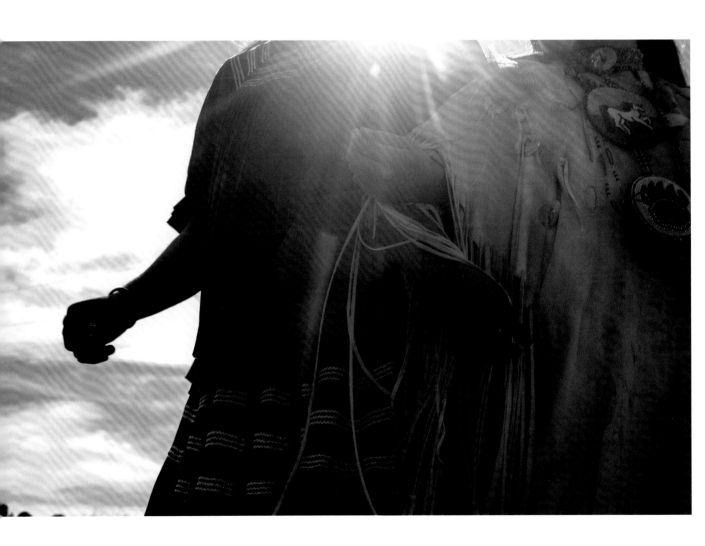

SOUTHWEST USA
15 May (From the series
"Postcards from America"). 2011

Mikhael Subotzky

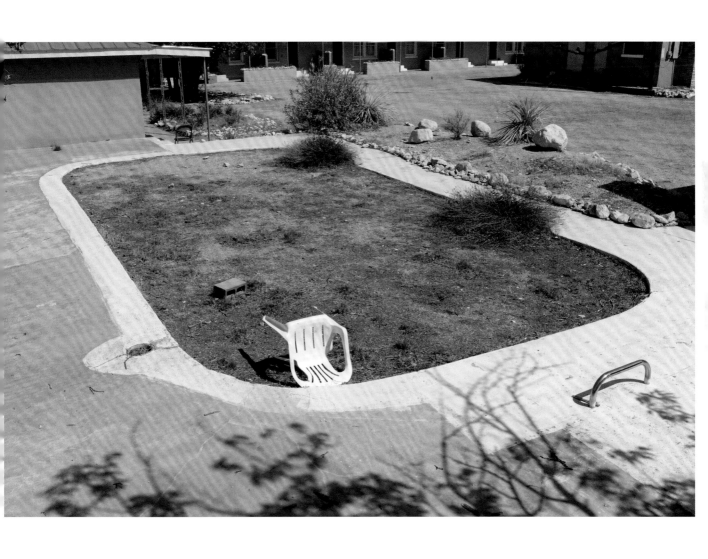

SOUTHWEST USA
16 May (From the series
"Postcards from America"). 2011

Mikhael Subotzky

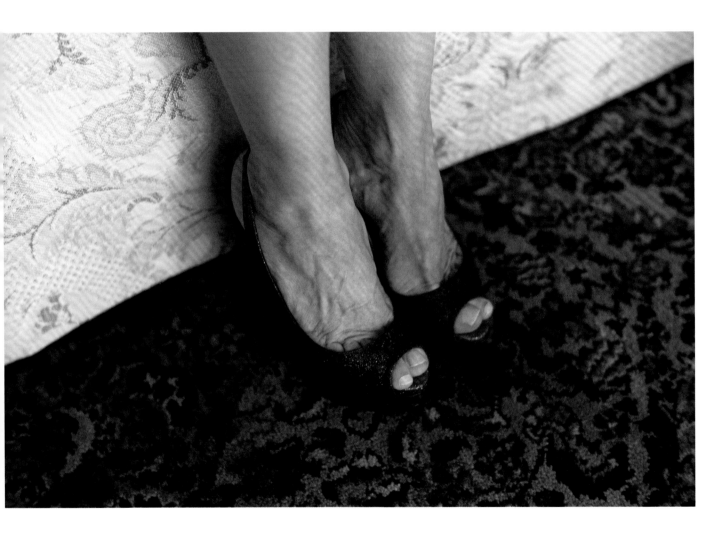

LAS VEGAS, NEVADA, USA
21 May (From the series
"Postcards from America"). 2011

Mikhael Subotzky

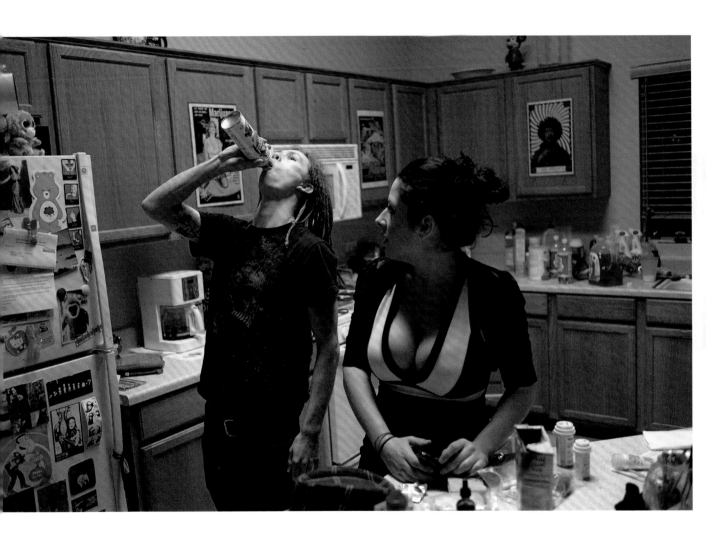

LAS VEGAS, NEVADA, USA
21 May 2011

Mikhael Subotzky

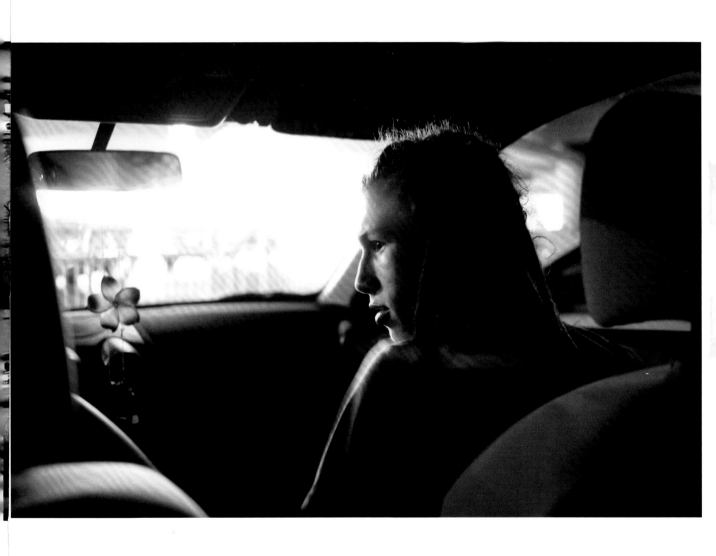

HARLEM, NEW YORK, USA
Savoy Ballroom. 1939

Cornell Capa

FEBRUARY 1 2 3 4 5 6 7 8 9 10 11 12 13 14 15 16 17 18 19 20 21 22 **23** 24 25 26 27 28/29

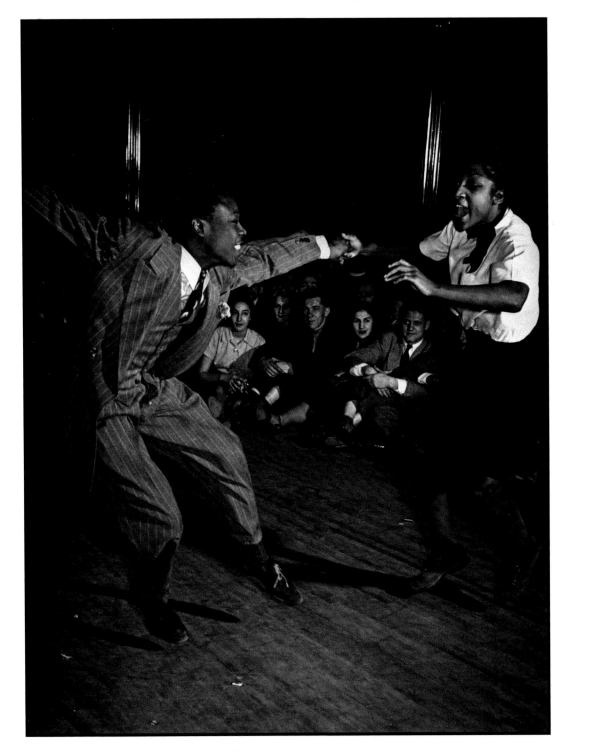

NEW YORK CITY, NEW YORK, USA
Literary cocktail party at George Plimpton's
Upper East Side apartment. 1963

Cornell Capa

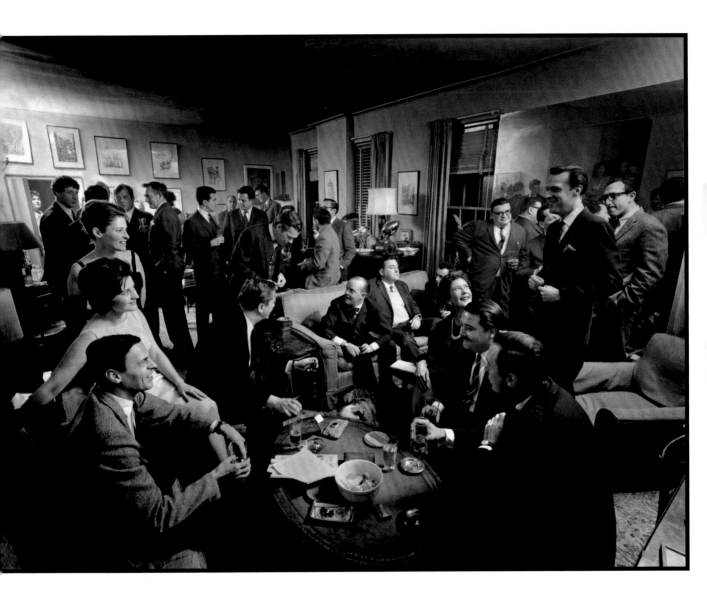

NEW YORK CITY, NEW YORK, USA
Central Park. 1992

Bruce Davidson

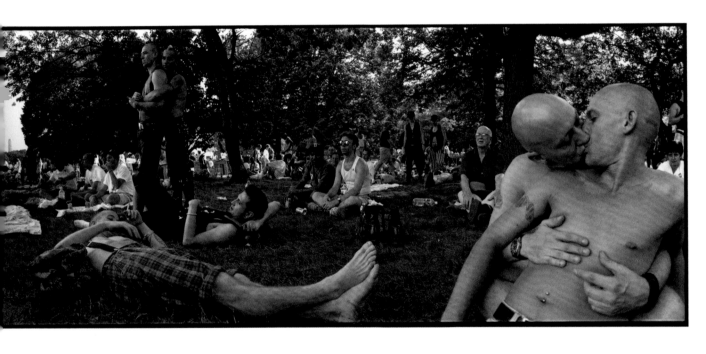

NEW YORK CITY, NEW YORK, USA
Cat on terrace overlooking lake and park,
Central Park. 1992

Bruce Davidson

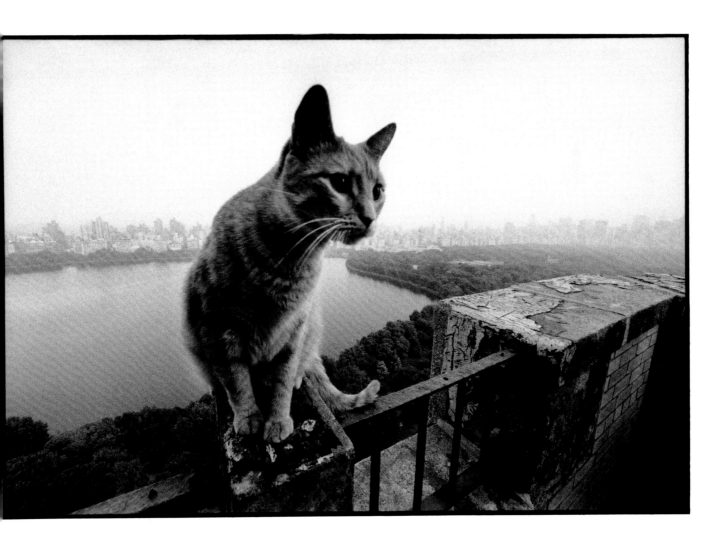

NEW YORK CITY, NEW YORK, USA
Central Park. 1992

Bruce Davidson

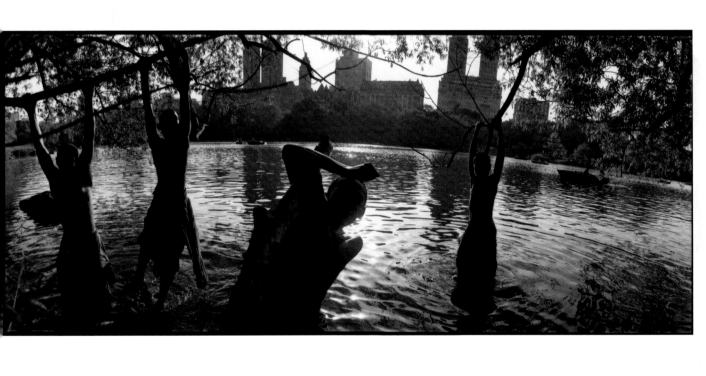

NEW YORK CITY, NEW YORK, USA
Belvedere Castle looking towards 5th Avenue,
Central Park. 1991

Bruce Davidson

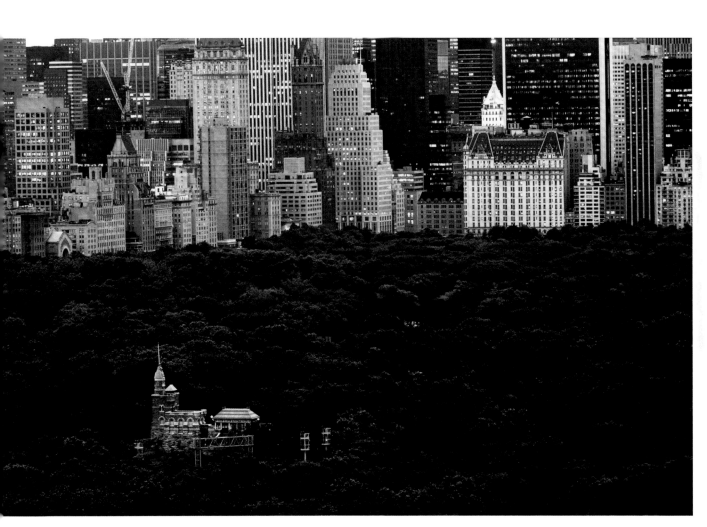

ROCHESTER, NEW YORK, USA
2012

Donovan Wylie

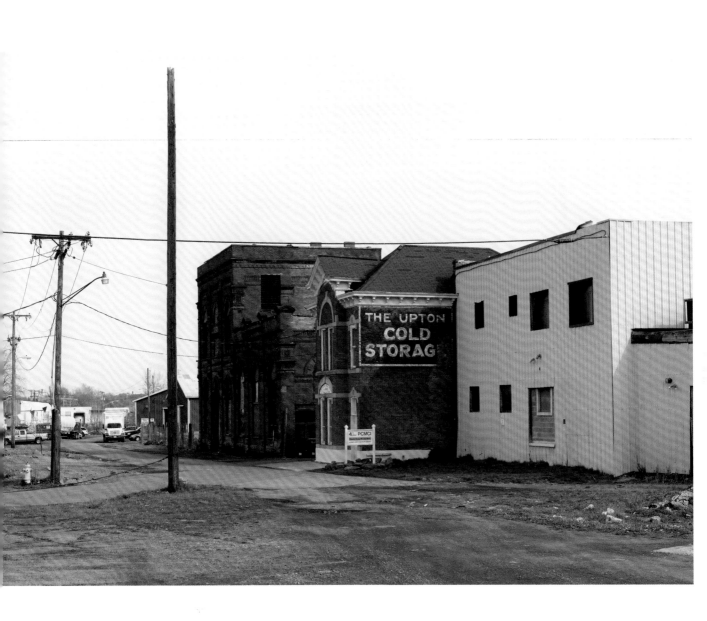

ROCHESTER, NEW YORK, USA
2012

Donovan Wylie

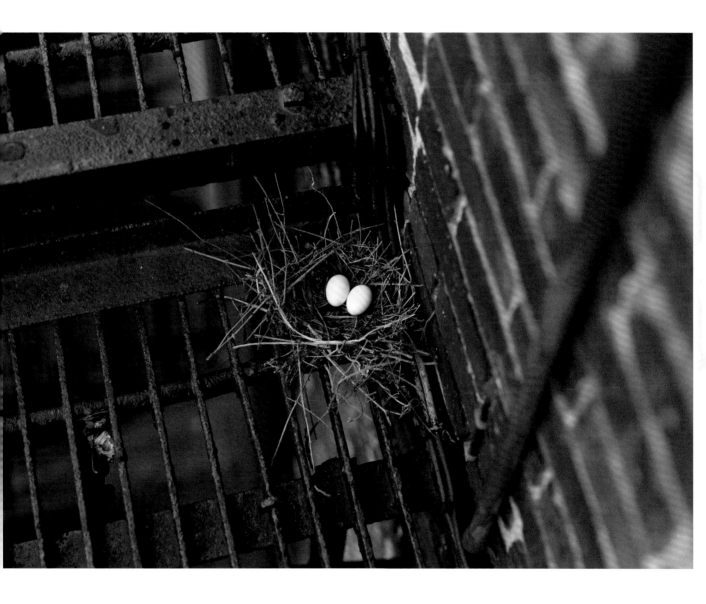

ROCHESTER, NEW YORK, USA
2012

Donovan Wylie

MARCH 1 2 **3** 4 5 6 7 8 9 10 11 12 13 14 15 16 17 18 19 20 21 22 23 24 25 26 27 28 29 30 31

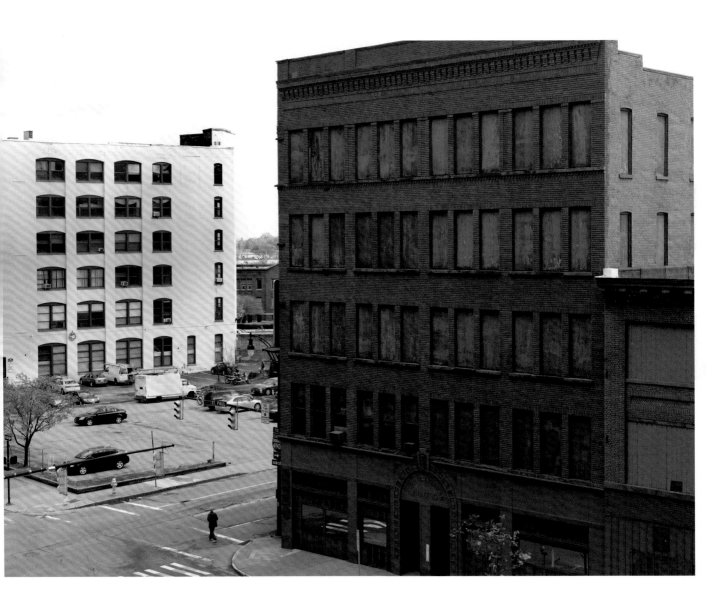

ROCHESTER, NEW YORK, USA
2012

Donovan Wylie

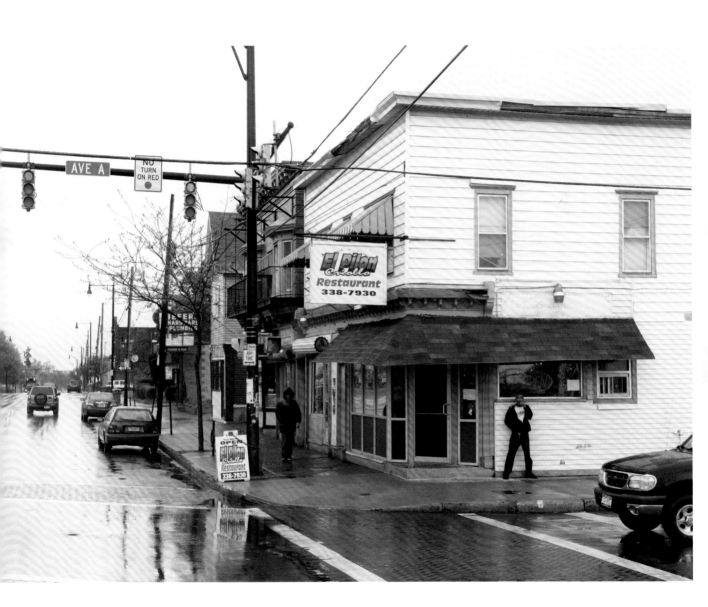

CAPE BRETON ISLAND, NOVA SCOTIA, CANADA
Cabot Trail. 2016

Thomas Dworzak

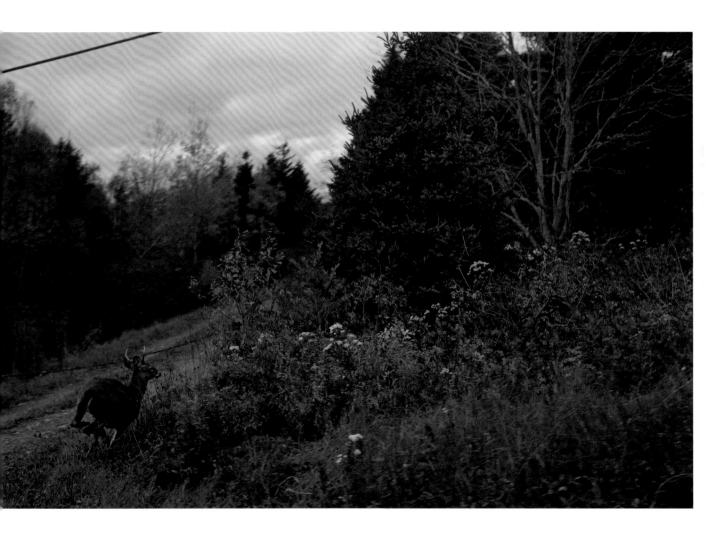

CAPE BRETON ISLAND, NOVA SCOTIA, CANADA
United States citizens who came in the 1970s as part of
the counterculture hippie "back-to-the-land" movement.
Instrument maker, Cabot Trail. 2016

Thomas Dworzak

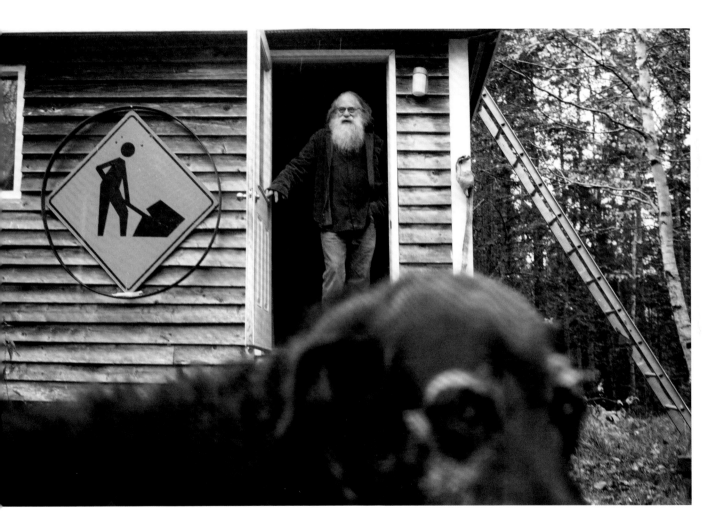

CAPE BRETON ISLAND, NOVA SCOTIA, CANADA
A&K Lick-A-Chick fast-food joint. 2016

Thomas Dworzak

MARCH 1 2 3 4 5 6 **7** 8 9 10 11 12 13 14 15 16 17 18 19 20 21 22 23 24 25 26 27 28 29 30 31

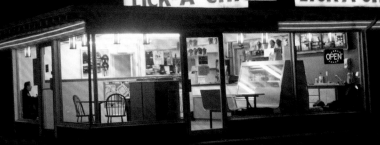

CAPE BRETON ISLAND, NOVA SCOTIA, CANADA
Young couple dressing up as Hillary Clinton
and Donald Trump and watching the comedy
programme *Saturday Night Live*. 2016

Thomas Dworzak

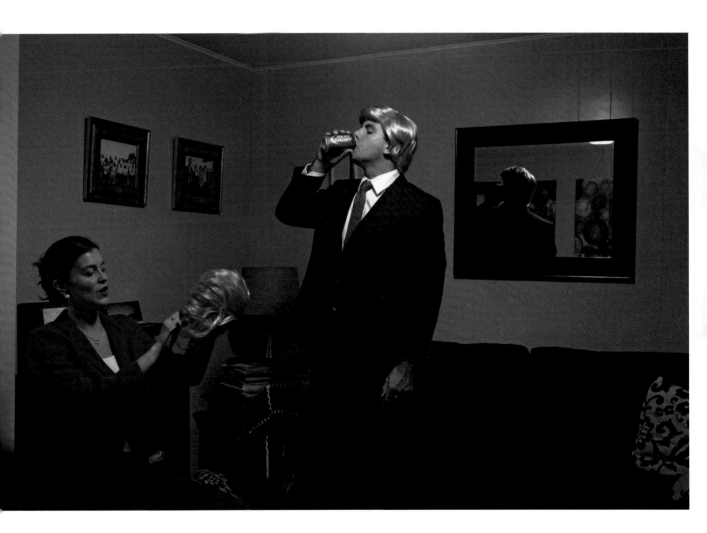

NIAGARA FALLS, ONTARIO, CANADA
The Seneca. 2004

Alec Soth

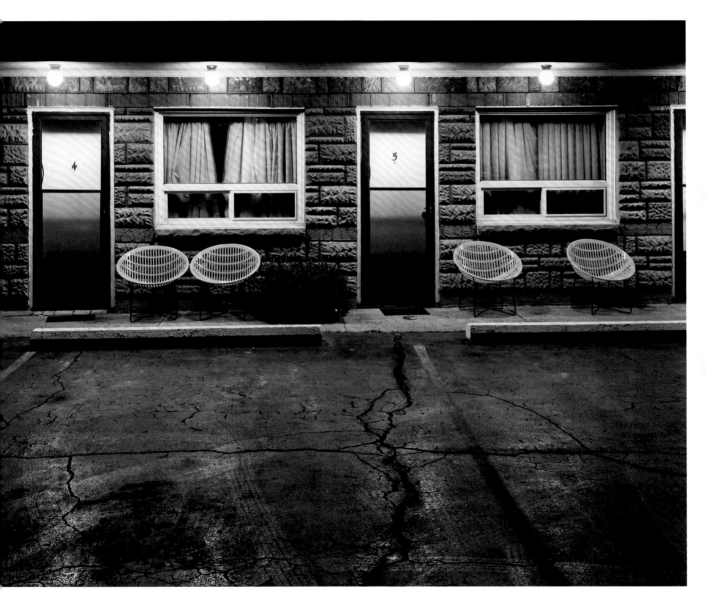

NIAGARA FALLS, ONTARIO, CANADA
Impala. 2005

Alec Soth

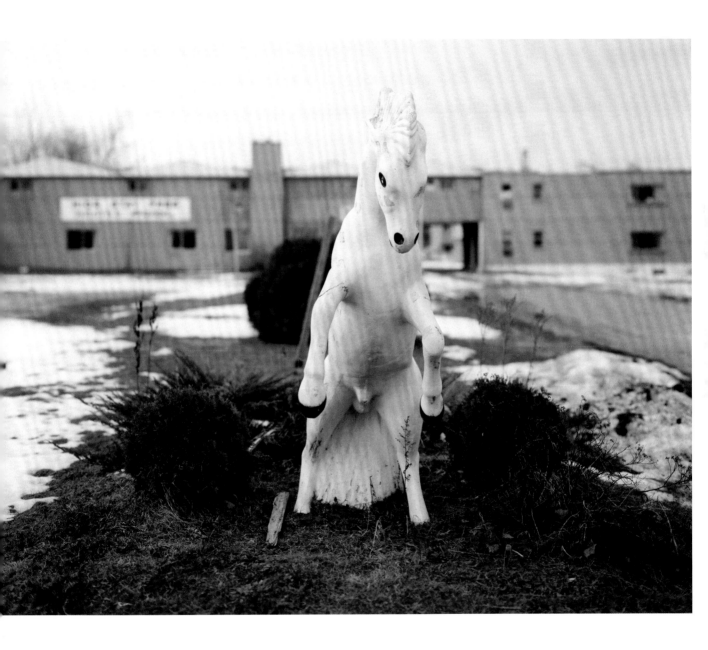

NIAGARA FALLS, ONTARIO, CANADA
Tricia and Curtis. 2005

Alec Soth

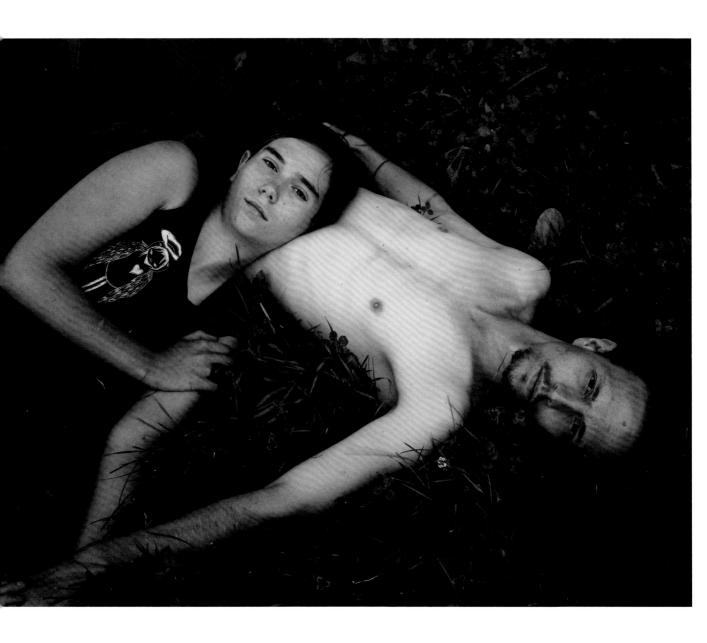

NIAGARA FALLS, ONTARIO, CANADA
"Cry Baby". 2005

Alec Soth

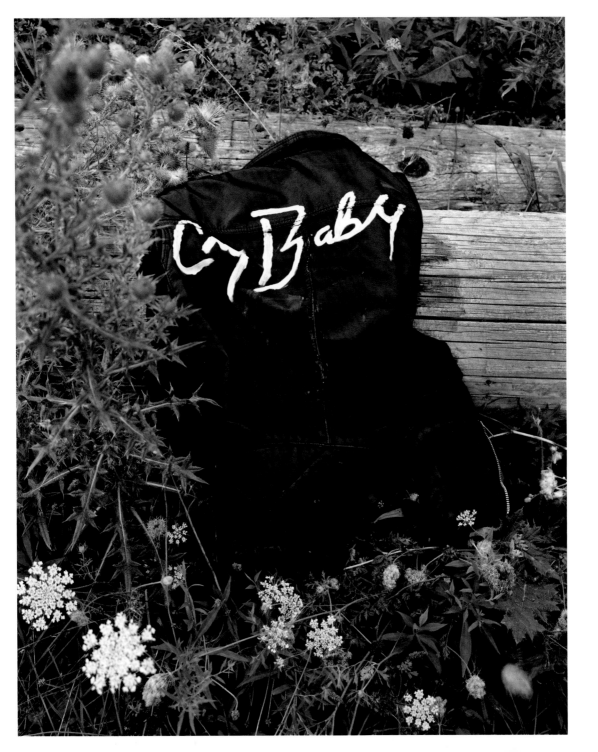

PALMER, ALASKA, USA
A rodeo clown, right, steps in to save a cowboy
from the horns and feet of the bull he has been
trying to ride, Alaska State Fair rodeo. 2001

Ian Berry

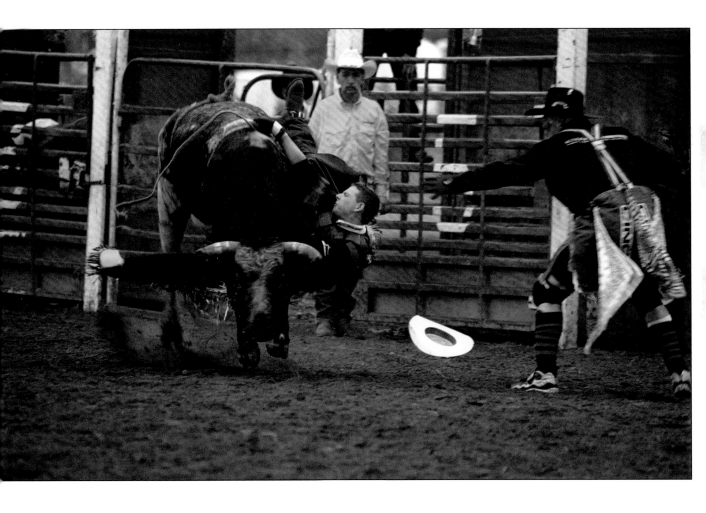

PALMER, ALASKA, USA
Competitors at the rodeo, Alaska State Fair. 2001

Ian Berry

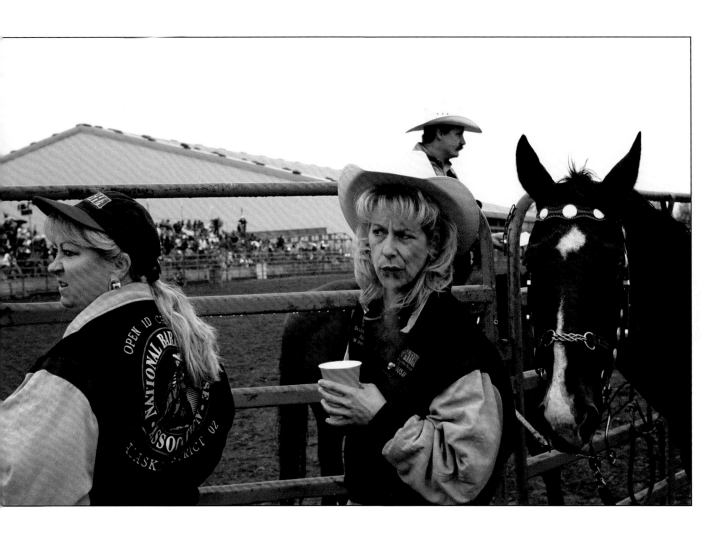

JUNEAU, ALASKA, USA
2001

Ian Berry

MARCH 1 2 3 4 5 6 7 8 9 10 11 12 13 14 **15** 16 17 18 19 20 21 22 23 24 25 26 27 28 29 30 31

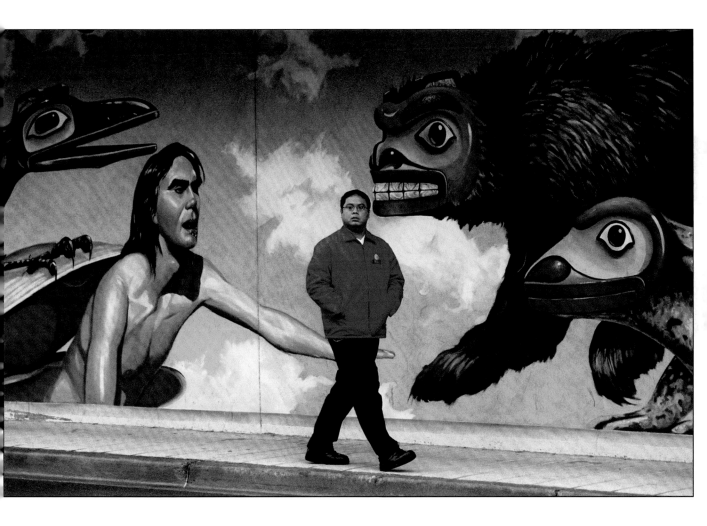

SKAGWAY, ALASKA, USA
A fire fighter couples his hose to a fire hydrant
during an emergency while a youngster with his
bike ignores the excitement and continues
eating his smoothie snack. 2001

Ian Berry

MARCH 1 2 3 4 5 6 7 8 9 10 11 12 13 14 15 **16** 17 18 19 20 21 22 23 24 25 26 27 28 29 30 31

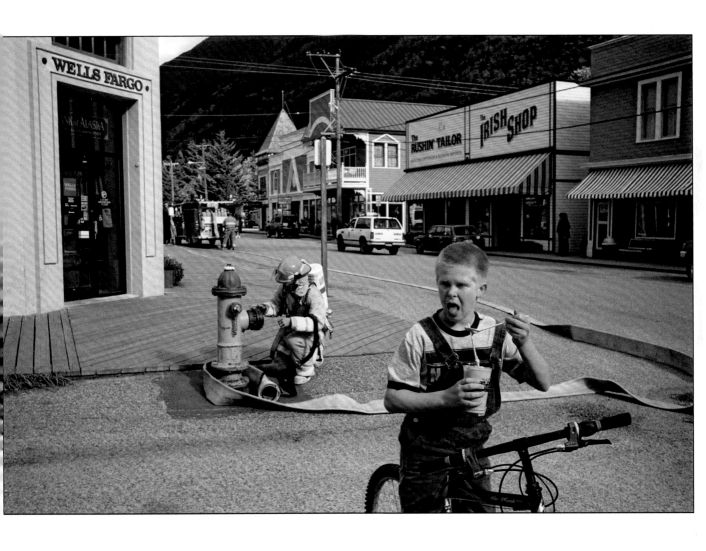

KOSHIMIZU, HOKKAIDO PREFECTURE, JAPAN
2003

Hiroji Kubota

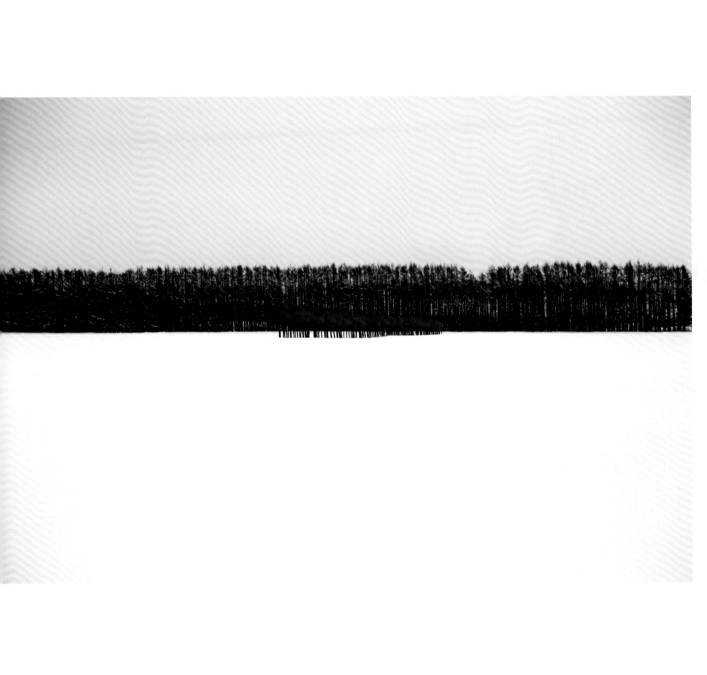

GIFU, GIFU PREFECTURE, JAPAN
Beneath a lantern of flaming pine, the fisherman
puts twelve fully trained sea cormorants into the river
and uses them to catch *ayu*, or sweetfish. 2003

Hiroji Kubota

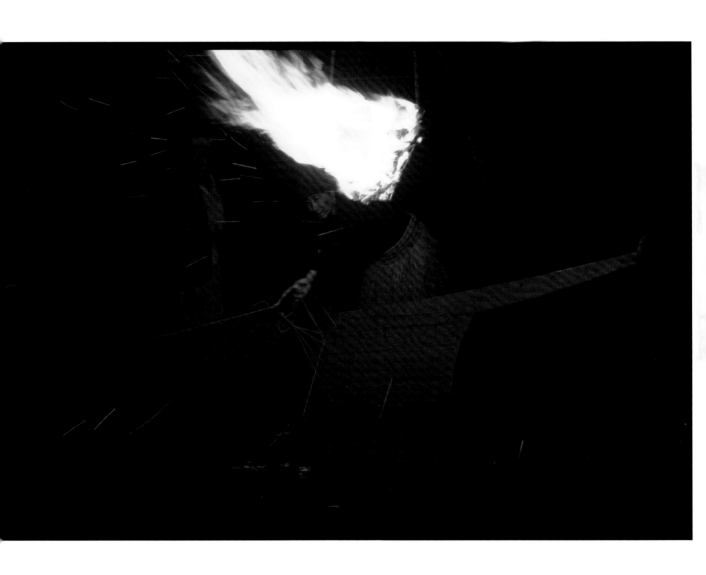

YUZAWA, NIIGATA PREFECTURE, JAPAN
Naeba is a ski resort, which is
easily accessible from Tokyo. 2003

Hiroji Kubota

MARCH 1 2 3 4 5 6 7 8 9 10 11 12 13 14 15 16 17 18 **19** 20 21 22 23 24 25 26 27 28 29 30 31

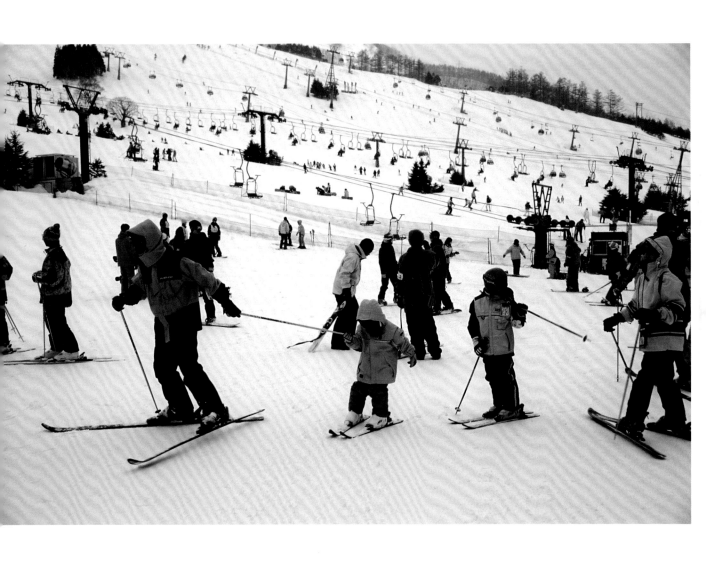

TSUWANO, SHIMANE PREFECTURE, JAPAN
Steps to Taikodani Inari Shrine. 2003

Hiroji Kubota

MARCH 1 2 3 4 5 6 7 8 9 10 11 12 13 14 15 16 17 18 19 **20** 21 22 23 24 25 26 27 28 29 30 31

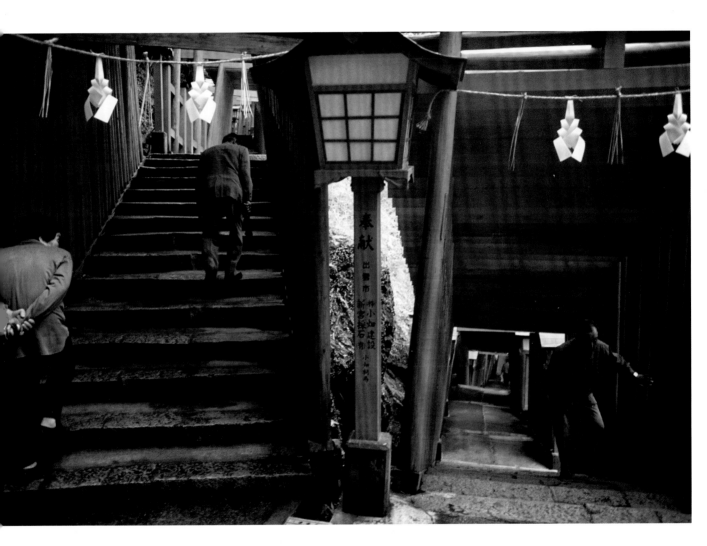

TONAMI, TOYAMA PREFECTURE, JAPAN
The Sankyo village on this plain is unique,
with farmhouses surrounded by tall trees
located approximately every two hundred
metres in the rice paddies. 2003

Hiroji Kubota

MARCH 1 2 3 4 5 6 7 8 9 10 11 12 13 14 15 16 17 18 19 20 **21** 22 23 24 25 26 27 28 29 30 31

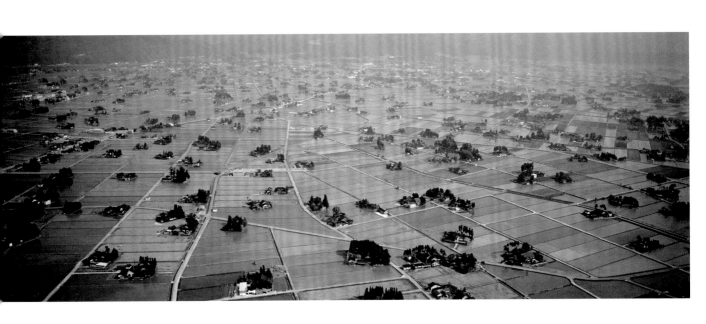

TOKYO, JAPAN
From *Babel.* 2005

Miguel Rio Branco

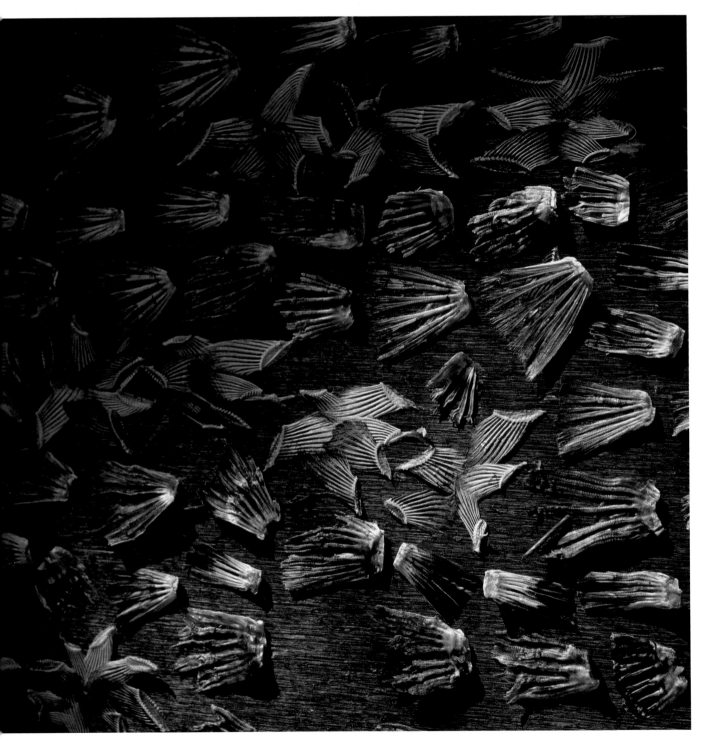

TOKYO, JAPAN
From *Babel*. 2005

Miguel Rio Branco

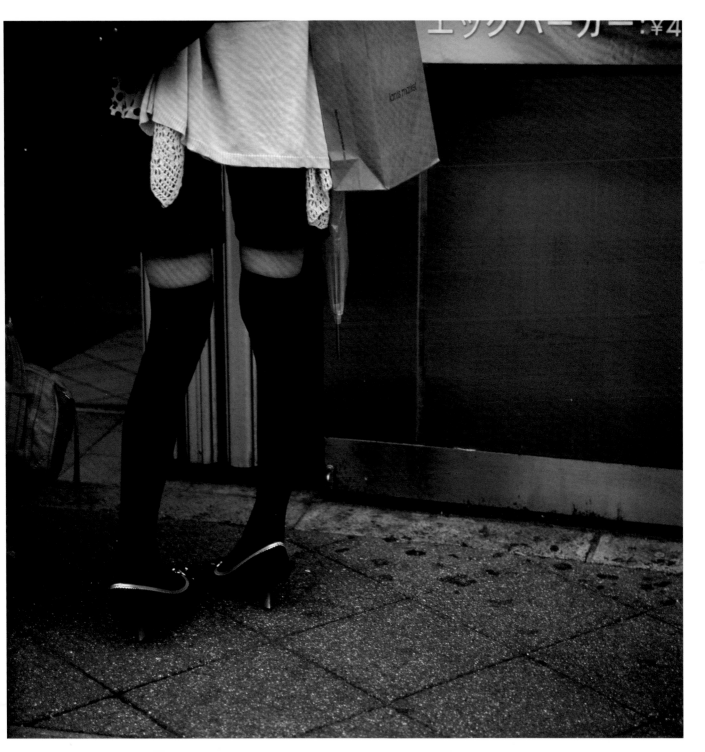

TOKYO, JAPAN
From *Babel*. 2005

Miguel Rio Branco

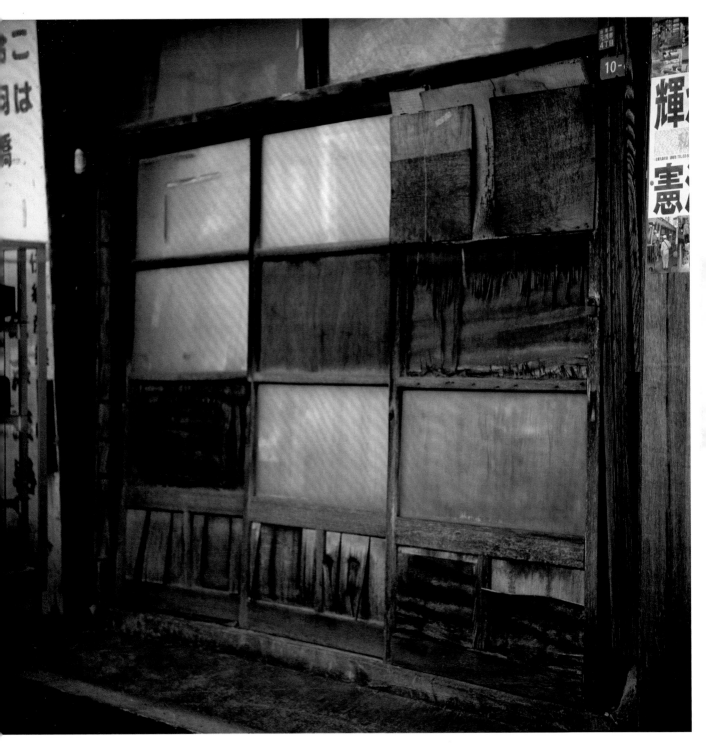

SOUTH KOREA
2002

Gueorgui Pinkhassov

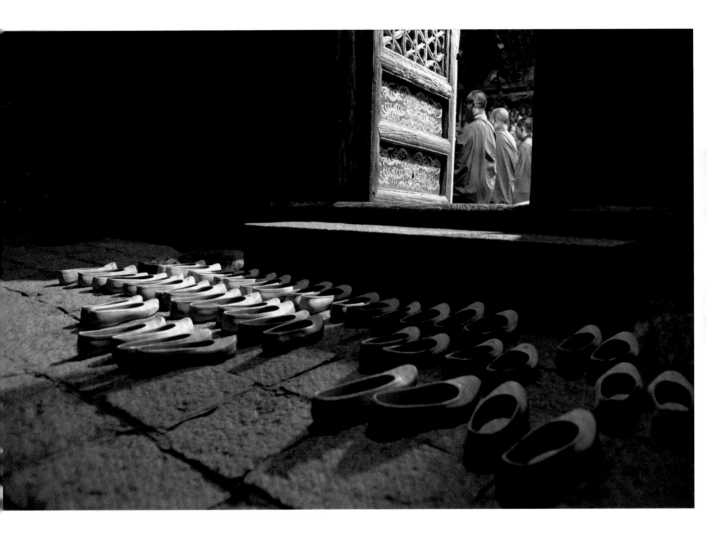

SACHEON, GYEONGSANGNAMDO, SOUTH KOREA
Samcheonpo Fish Market. 2007

Gueorgui Pinkhassov

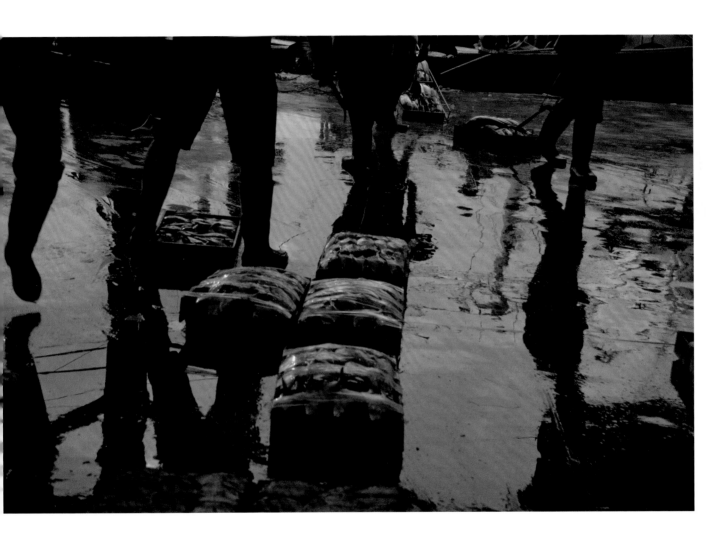

SOUTH KOREA
2007

Gueorgui Pinkhassov

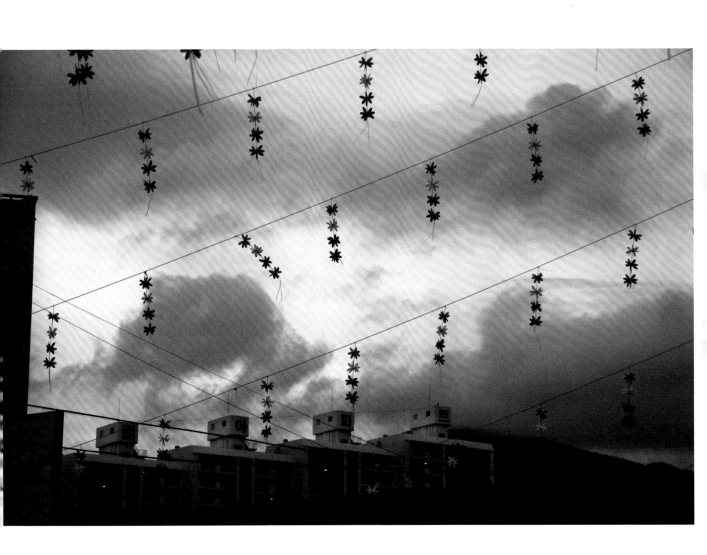

SEOUL, SOUTH KOREA
Highway. 2013

Gueorgui Pinkhassov

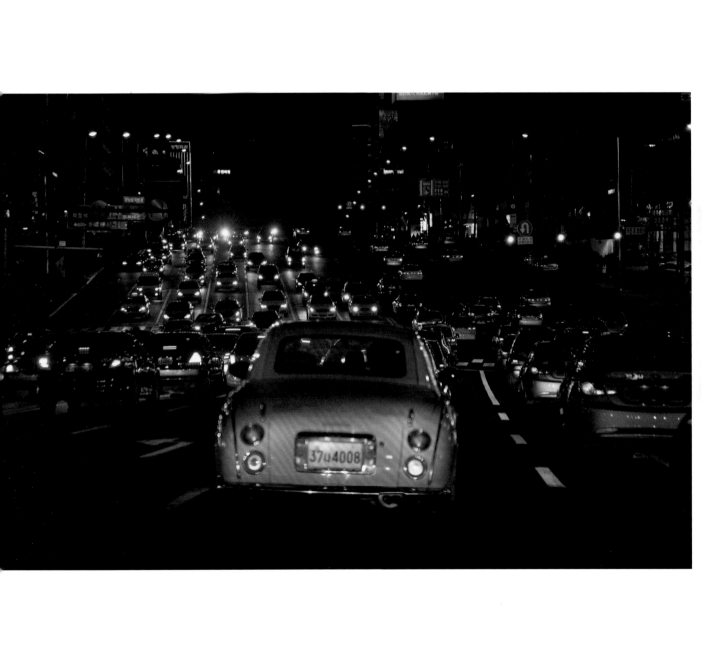

SEOUL, SOUTH KOREA
37 Grill & Bar in the Conrad Hotel, Yeouido. 2013

Gueorgui Pinkhassov

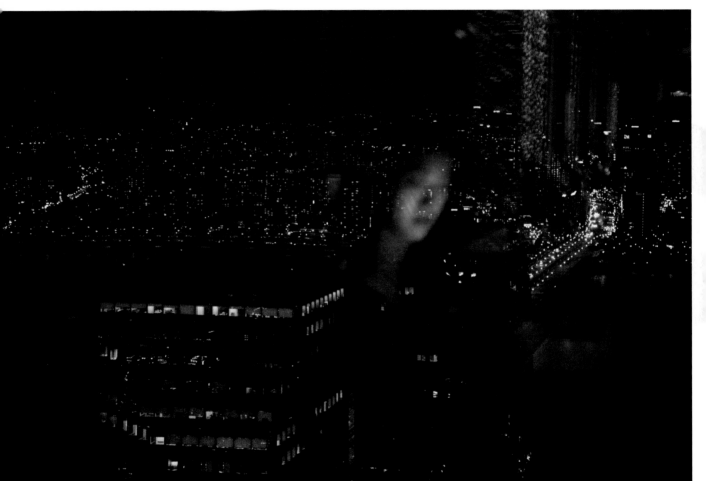

TAIPEI COUNTY, TAIWAN
Sanzhi District. 2012

Chien-Chi Chang

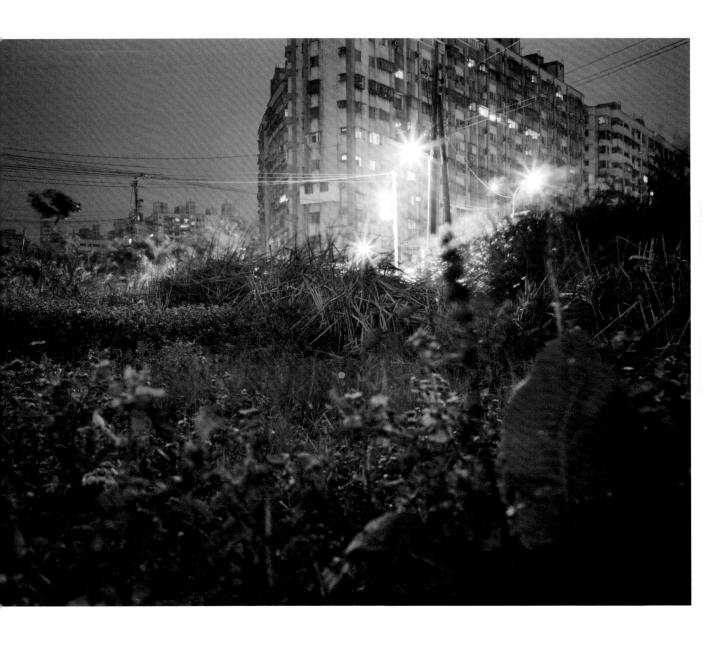

TAIPEI, TAIWAN
A Japanese visitor. 2011

Chien-Chi Chang

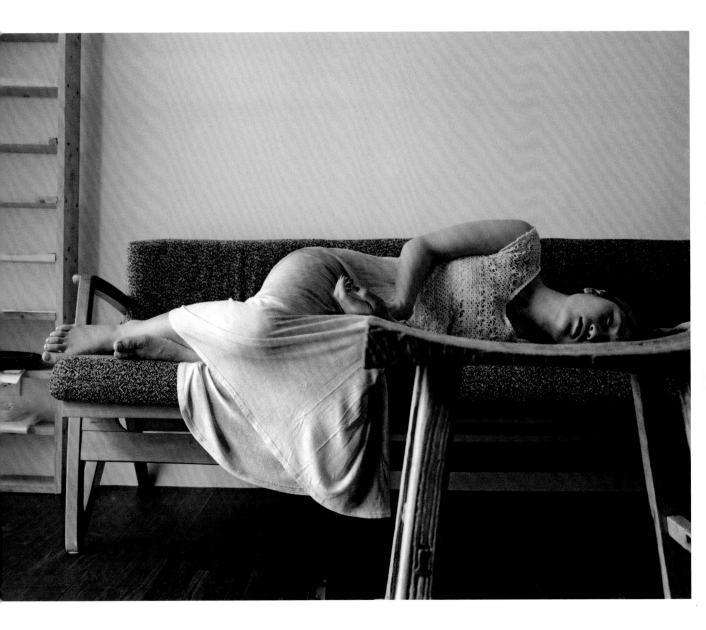

TAIPEI, TAIWAN
Downtown Taipei. 2012

Chien-Chi Chang

APRIL **1** 2 3 4 5 6 7 8 9 10 11 12 13 14 15 16 17 18 19 20 21 22 23 24 25 26 27 28 29 30

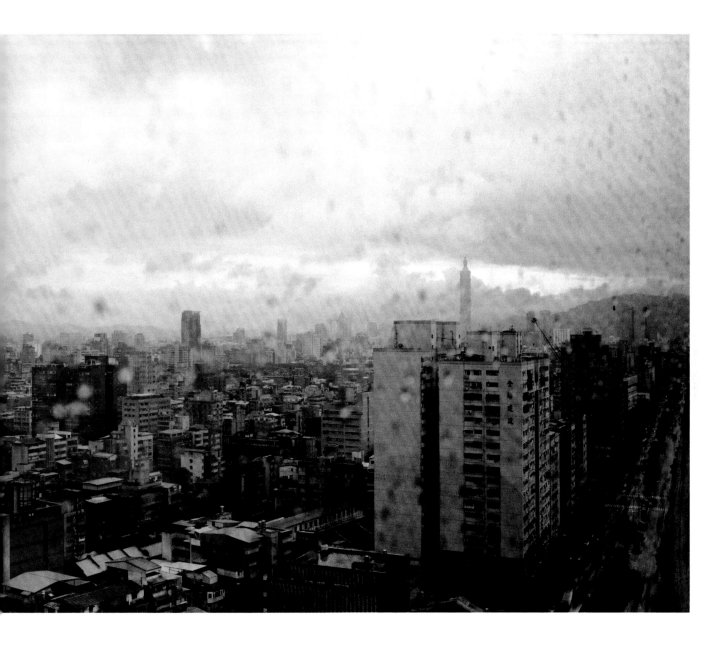

TAIPEI, TAIWAN
Evening snack after work. 2012

Chien-Chi Chang

APRIL 1 **2** 3 4 5 6 7 8 9 10 11 12 13 14 15 16 17 18 19 20 21 22 23 24 25 26 27 28 29 30

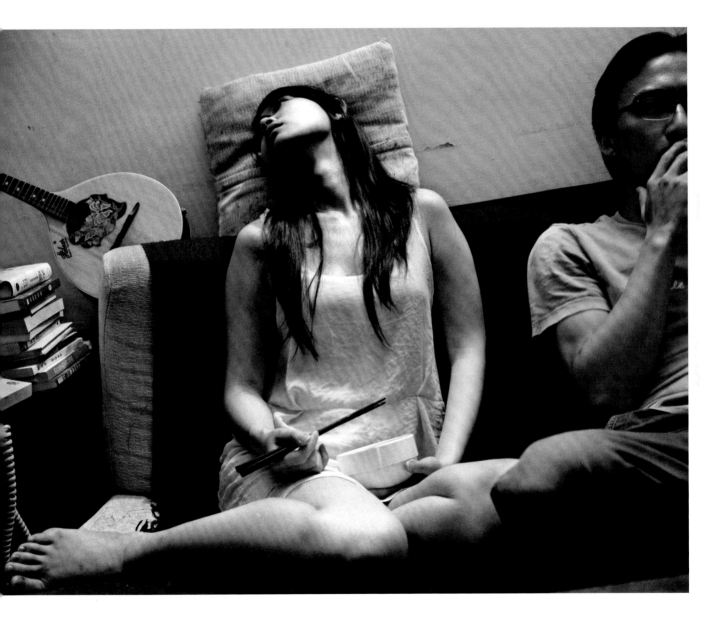

INDONESIA
A squadron of PNI guerrilla fighters coming in
from the mountains for a day in town. 1949

Henri Cartier-Bresson

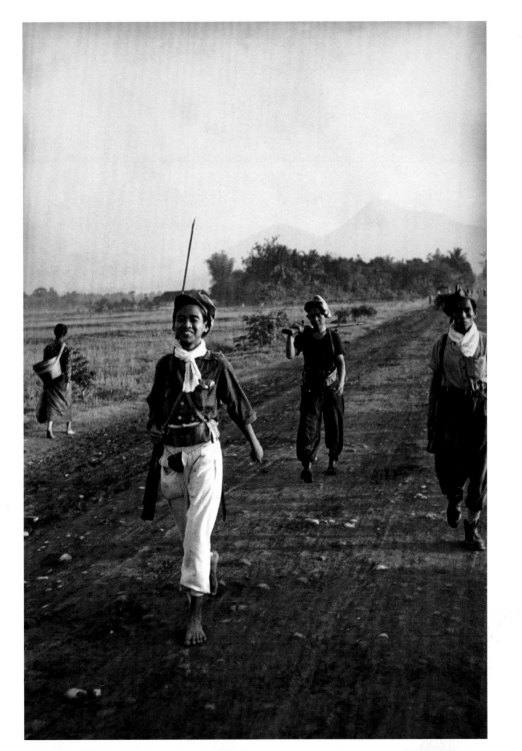

JAVA, INDONESIA
Borobudur Temple. 1949

Henri Cartier-Bresson

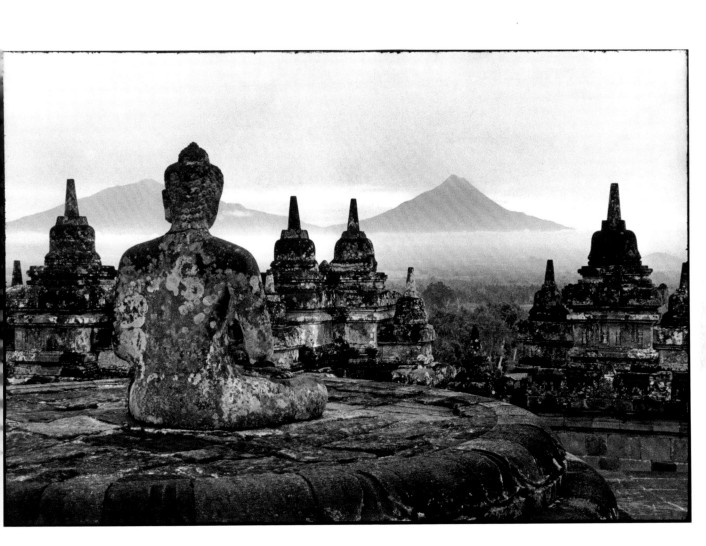

BALI, INDONESIA
In a little village five kilometres away from
Ubud lives the guru of the dancers of Ubud.
The guru is also a farmer like everyone else.
This picture shows him giving a dance lesson
to his little daughter Ikakol in his yard. 1949

Henri Cartier-Bresson

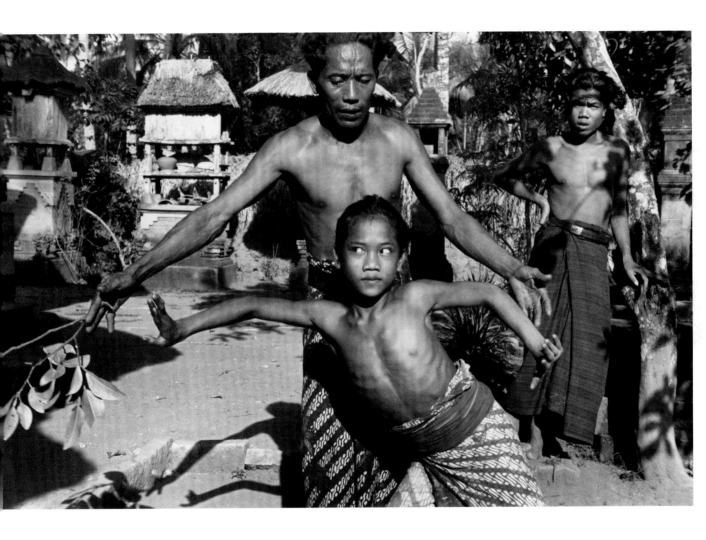

BALI, INDONESIA
A village market. 1949

Henri Cartier-Bresson

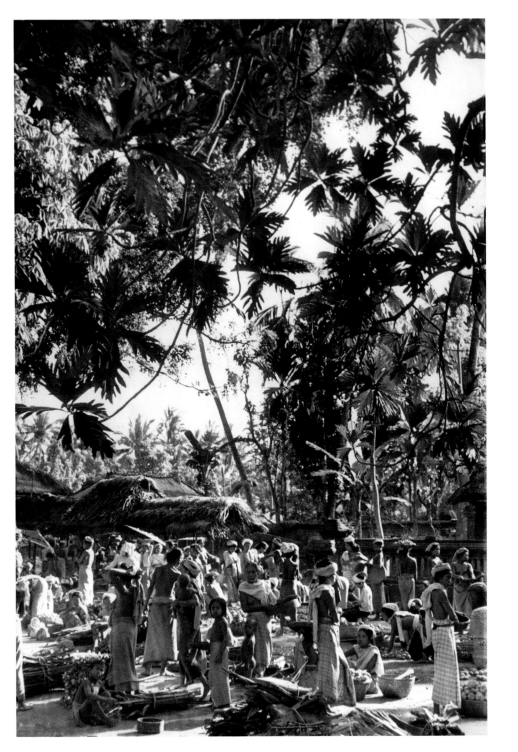

BATUBULAN, BALI, INDONESIA
Barong dance. So-called "Kris dancers" in
a trance, they are doing the self-stabbing
(ngurek) with *kris*. 1949

Henri Cartier-Bresson

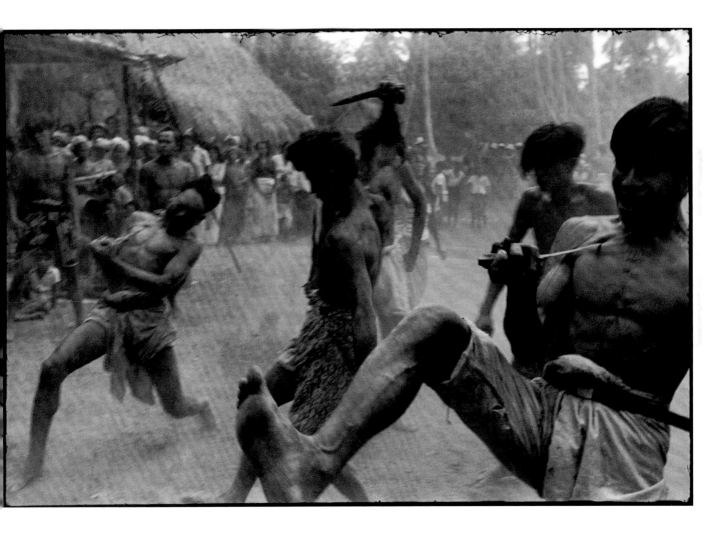

MELBOURNE, AUSTRALIA
2012

Ferdinando Scianna

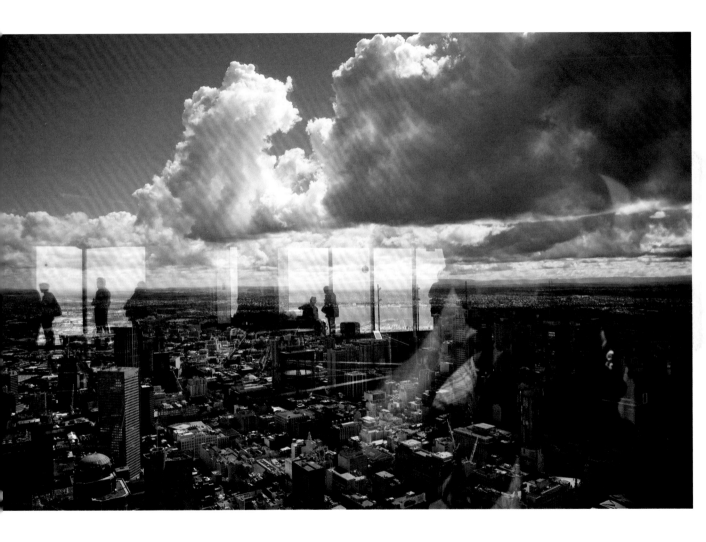

AUSTRALIA
2012

Ferdinando Scianna

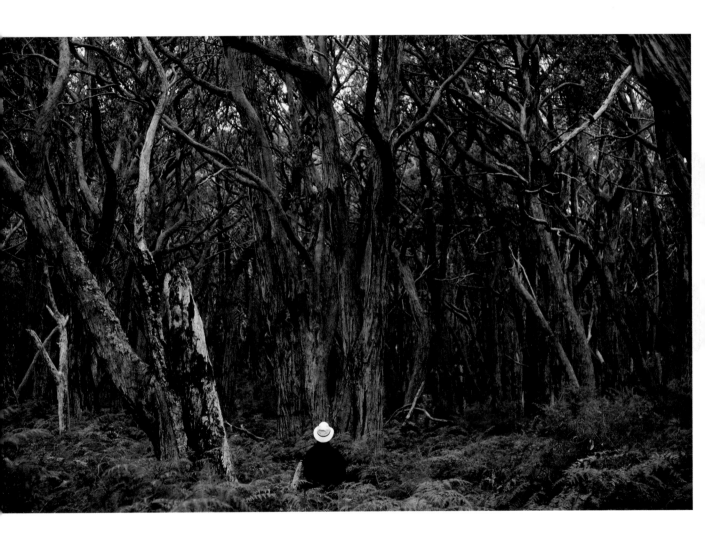

AUSTRALIA
2012

Ferdinando Scianna

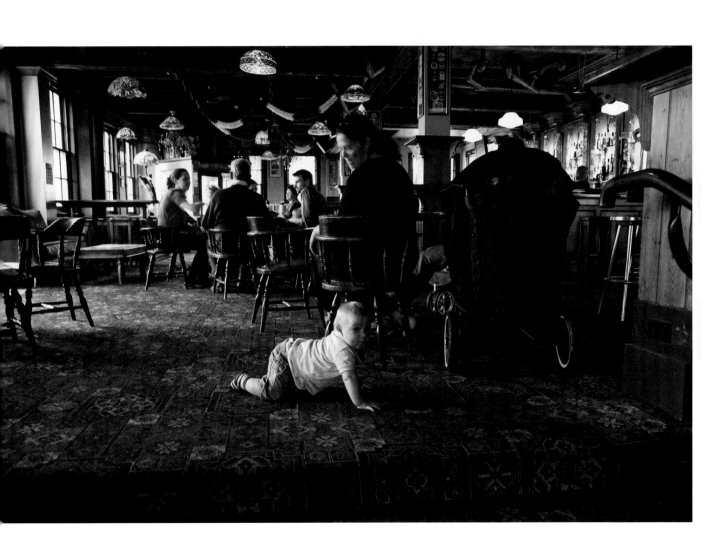

AUSTRALIA
2012

Ferdinando Scianna

APRIL 1 2 3 4 5 6 7 8 9 10 **11** 12 13 14 15 16 17 18 19 20 21 22 23 24 25 26 27 28 29 30

SYDNEY, AUSTRALIA
Opera singer, Sydney Opera House. 2008

Trent Parke

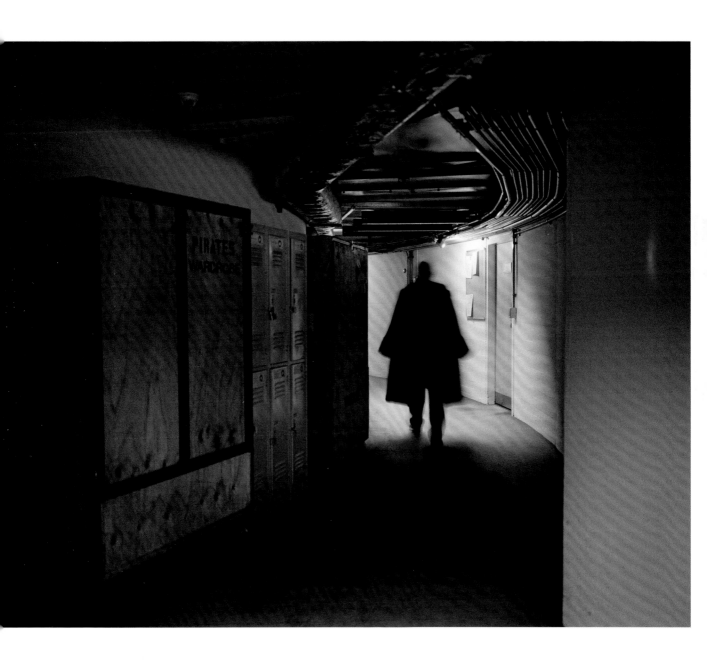

SYDNEY, AUSTRALIA
Concert Hall, Sydney Opera House. 2008

Trent Parke

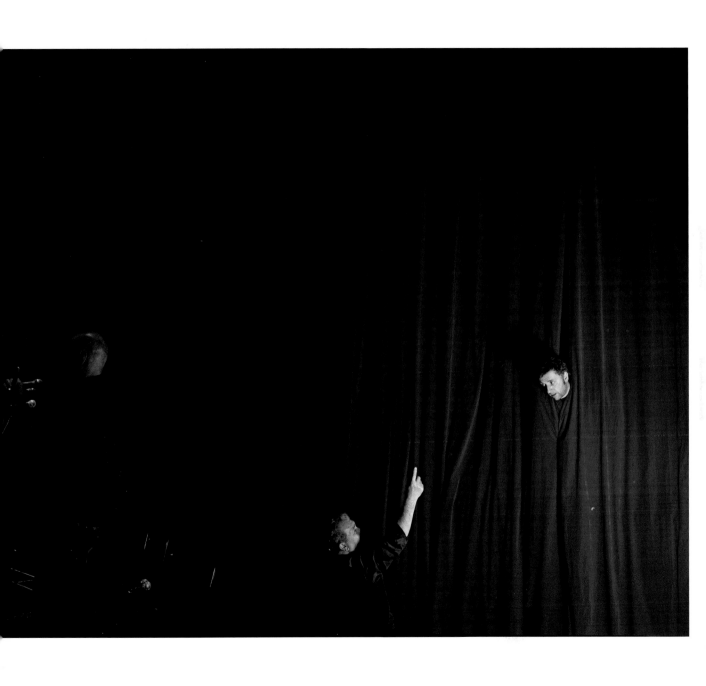

SYDNEY, AUSTRALIA
Opera Theatre during performance,
Sydney Opera House. 2008

Trent Parke

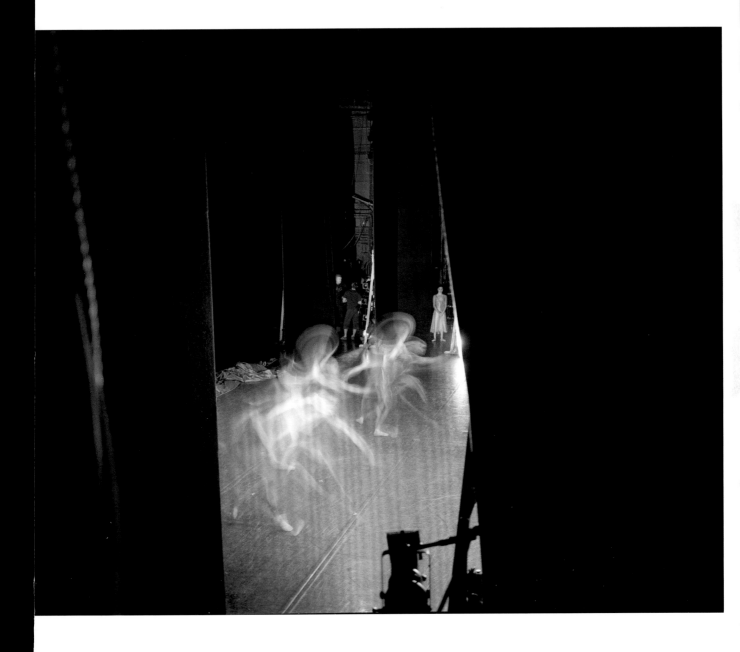

APRIL 1 2 3 4 5 6 7 8 9 10 11 12 13 14 **15** 16 17 18 19 20 21 22 23 24 25 26 27 28 29 30

SYDNEY, AUSTRALIA
Opera Theatre Workshop recreation room,
Sydney Opera House. 2009

Trent Parke

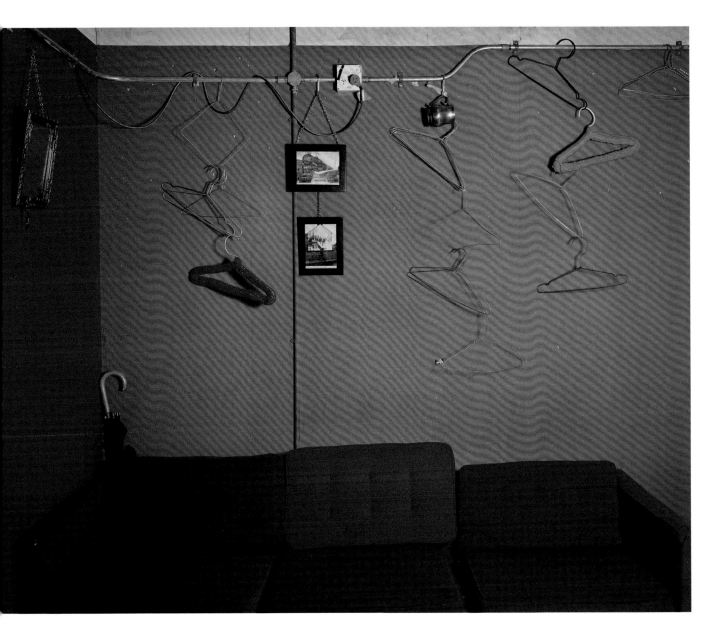

FRENCH POLYNESIA
A sea plane, currently the only transportation
between islands in French Polynesia. 1960

Burt Glinn

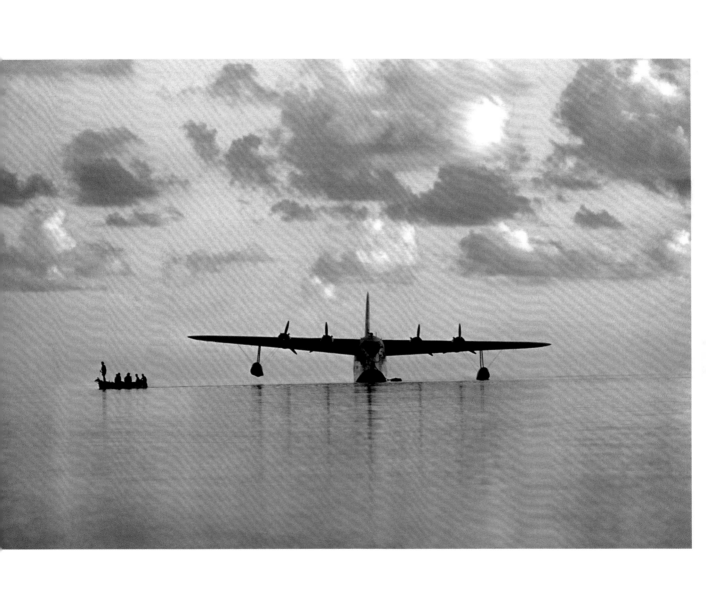

TAHITI, FRENCH POLYNESIA
A man climbing up a coconut tree to gather copra,
a mainstay of Pacific island commerce. The metal
bands on the trees fend off rats and crabs. 1960

Burt Glinn

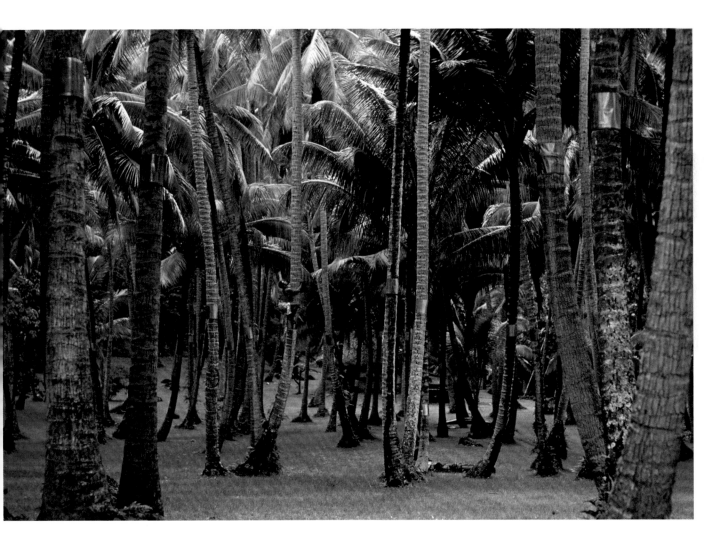

TAHITI, FRENCH POLYNESIA
Trading post. 1960

Burt Glinn

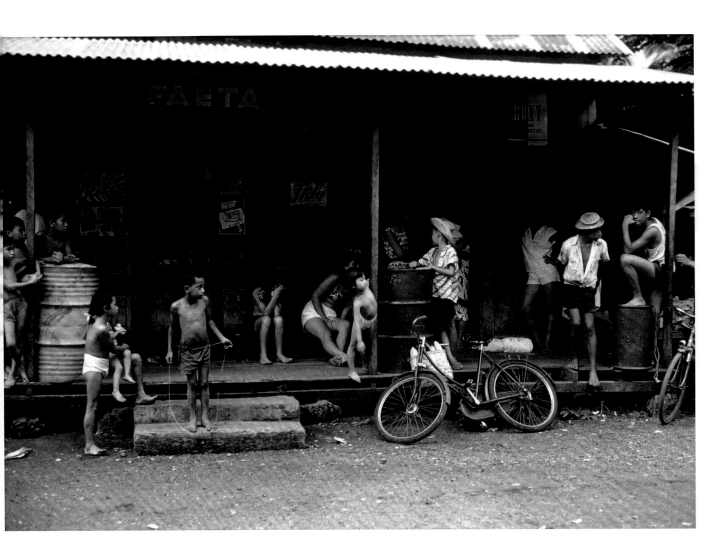

SOUTH PACIFIC
Aircraft carrier USS *Saratoga*. 1943

Wayne Miller

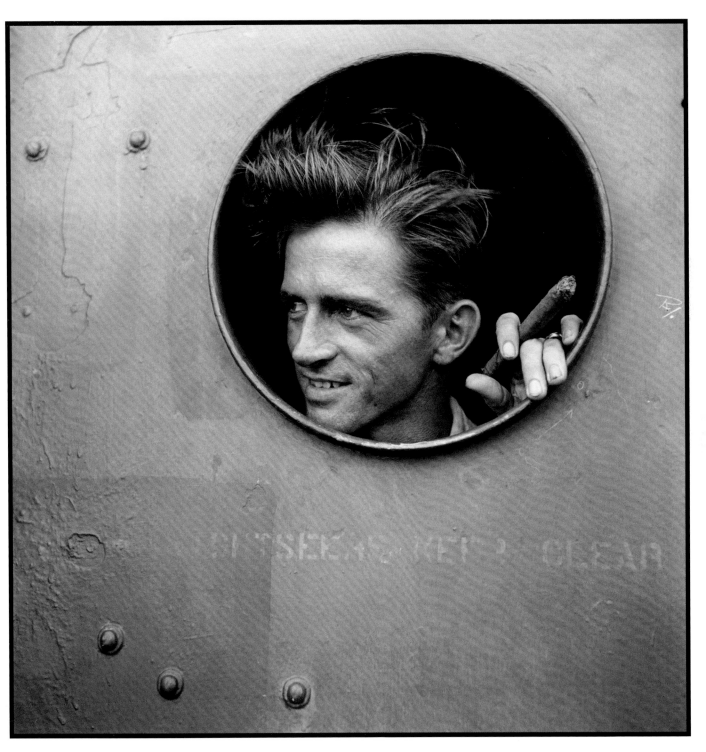

SOUTH PACIFIC
Aircraft carrier USS *Saratoga*. 1943

Wayne Miller

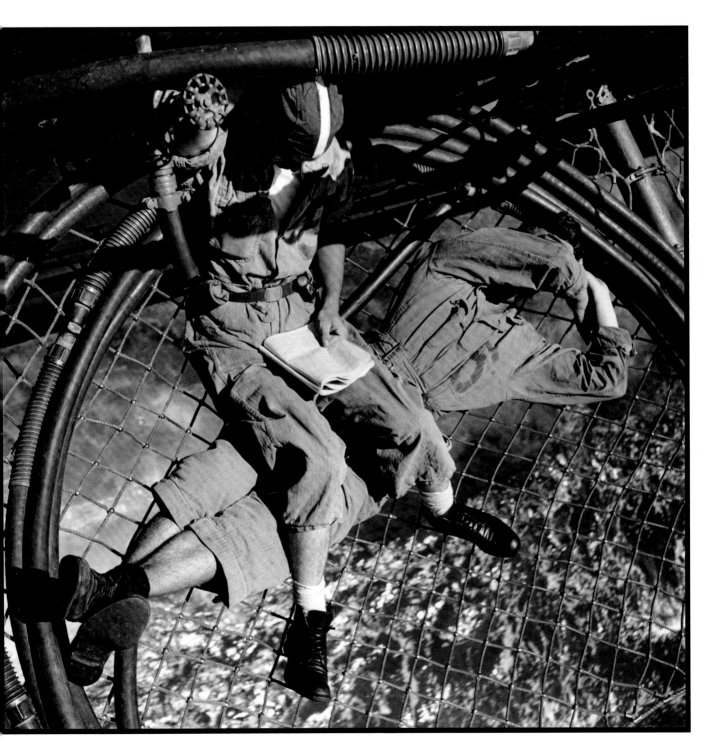

SOUTH PACIFIC
Aircraft carrier USS *Saratoga*. 1943

Wayne Miller

APRIL 1 2 3 4 5 6 7 8 9 10 11 12 13 14 15 16 17 18 19 20 21 **22** 23 24 25 26 27 28 29 30

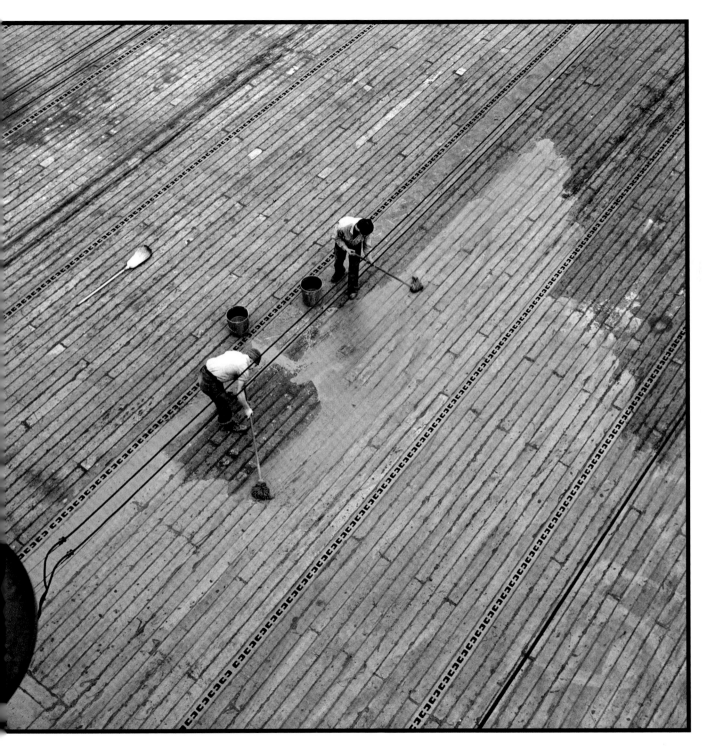

TRINCOMALEE, SRI LANKA
Admiral Lord Louis Mountbatten addresses
personnel aboard the USS *Saratoga*. 1943

Wayne Miller

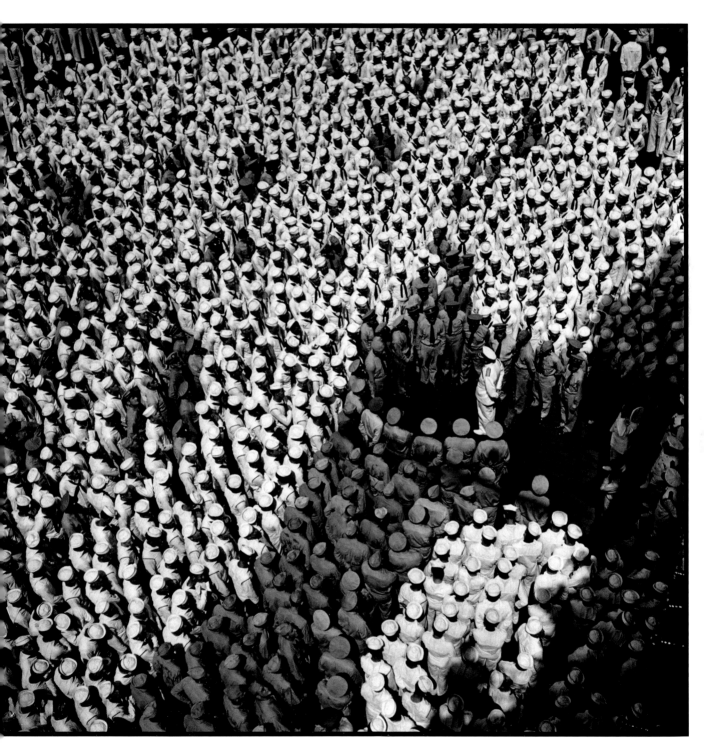

URIPIV ISLAND, VANUATU
A schoolboy who just returned from
the main island of Malekula. 2014

Alessandra Sanguinetti

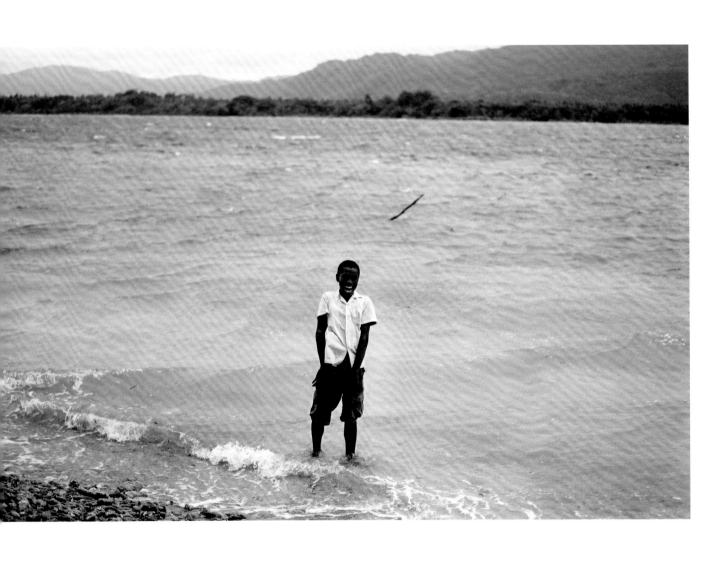

MALEKULA, VANUATU
Uripiv Island, off Malekula. 2014

Alessandra Sanguinetti

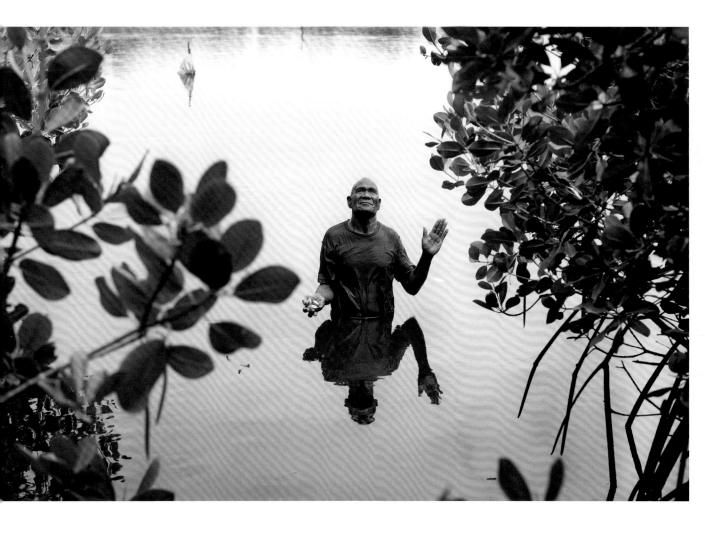

TANNA ISLAND, VANUATU
2014

Alessandra Sanguinetti

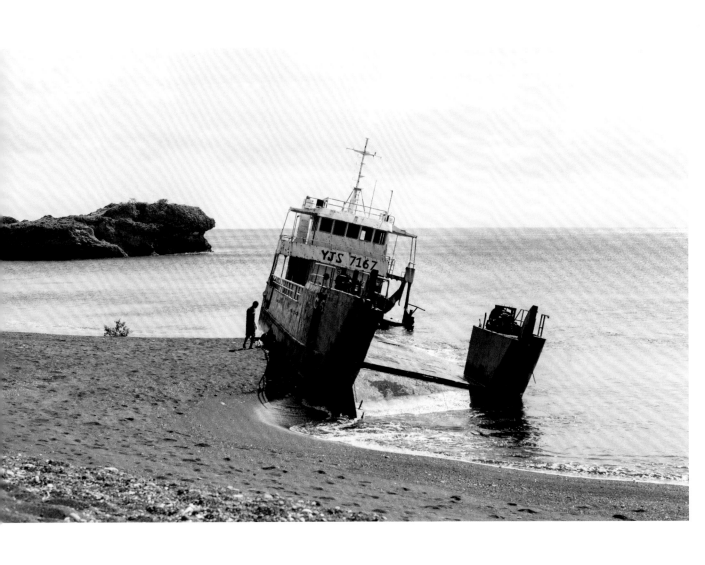

TANNA ISLAND, VANUATU
2014

Alessandra Sanguinetti

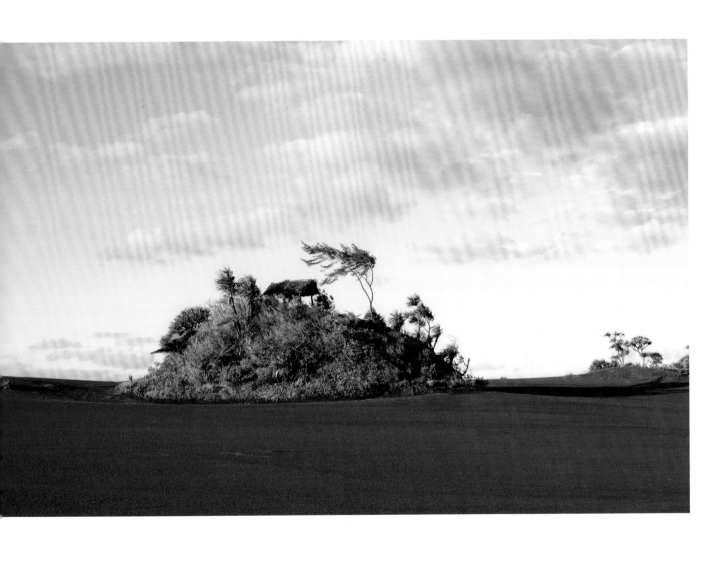

TANNA ISLAND, VANUATU
2014

Alessandra Sanguinetti

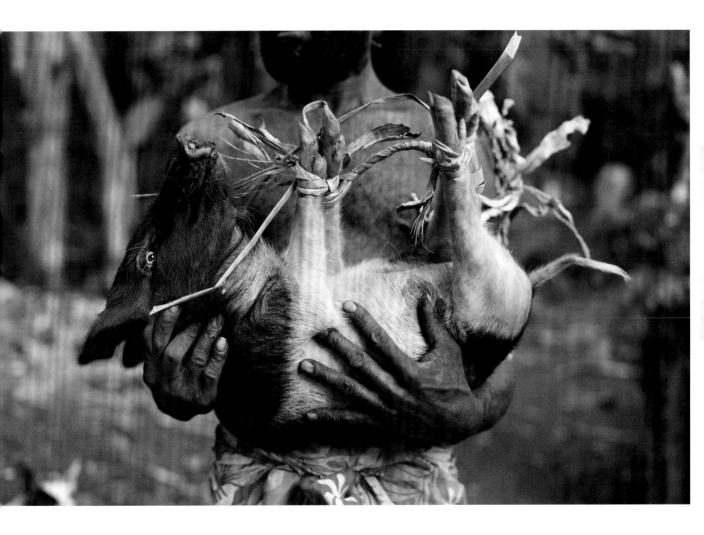

BANGKOK, THAILAND
Night shot of Bangkok taken from
the Banyan Tree Hotel. 2002

Stuart Franklin

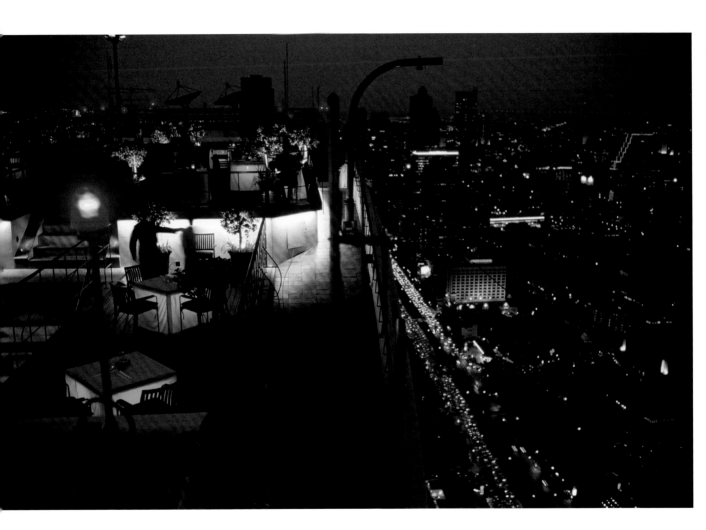

BANGKOK, THAILAND
Old Chinese men playing Chinese
chess in Lumphini Park. 2002

Stuart Franklin

APRIL 1 2 3 4 5 6 7 8 9 10 11 12 13 14 15 16 17 18 19 20 21 22 23 24 25 26 27 28 29 **30**

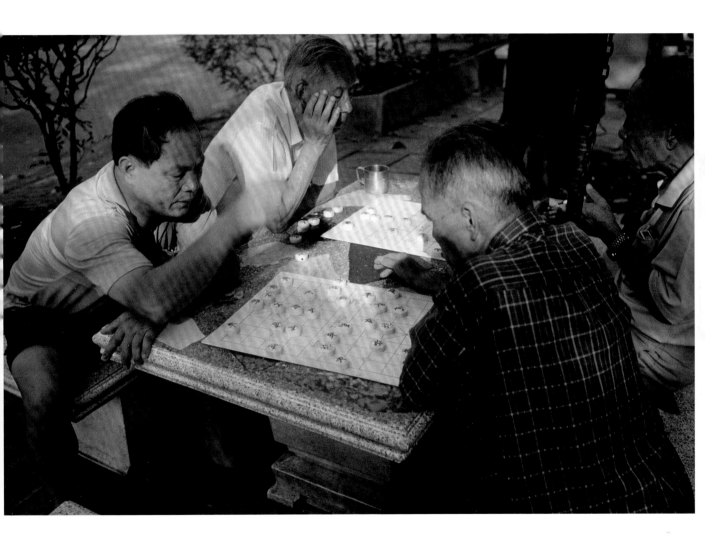

BANGKOK, THAILAND
Royal Guard outside the Grand Palace. 2002

Stuart Franklin

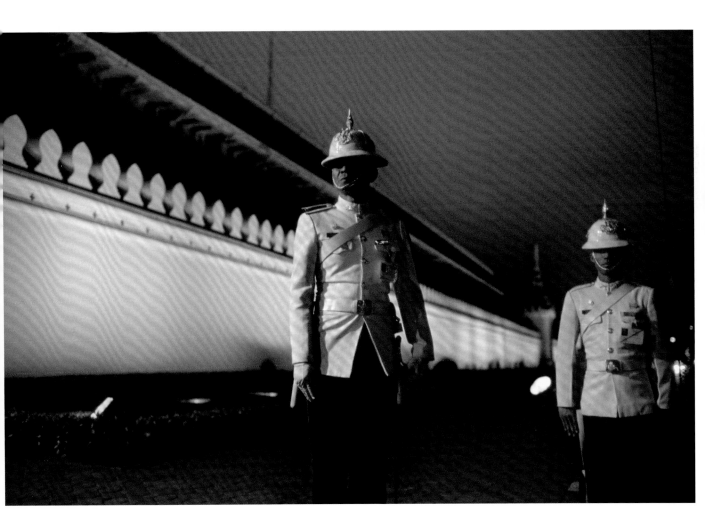

BANGKOK, THAILAND
Klong Toey children's playground. 2002

Stuart Franklin

MAY 1 **2** 3 4 5 6 7 8 9 10 11 12 13 14 15 16 17 18 19 20 21 22 23 24 25 26 27 28 29 30 31

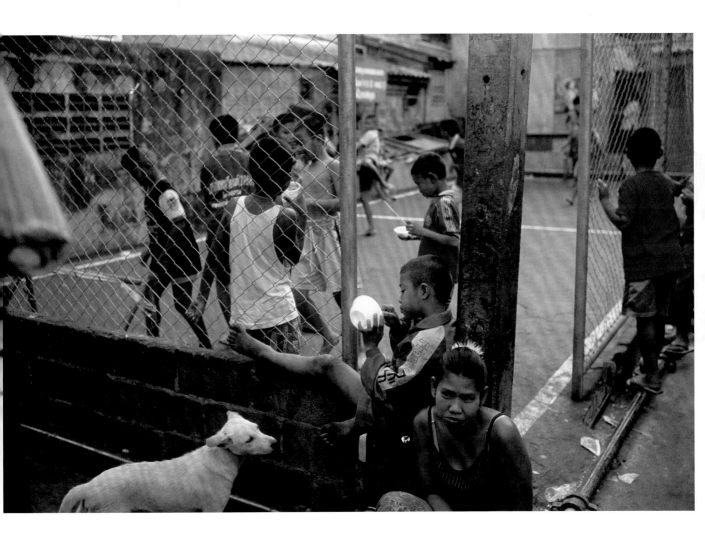

BANGKOK, THAILAND
View of the Skytrain from the
roof of Police Hospital. 2002

Stuart Franklin

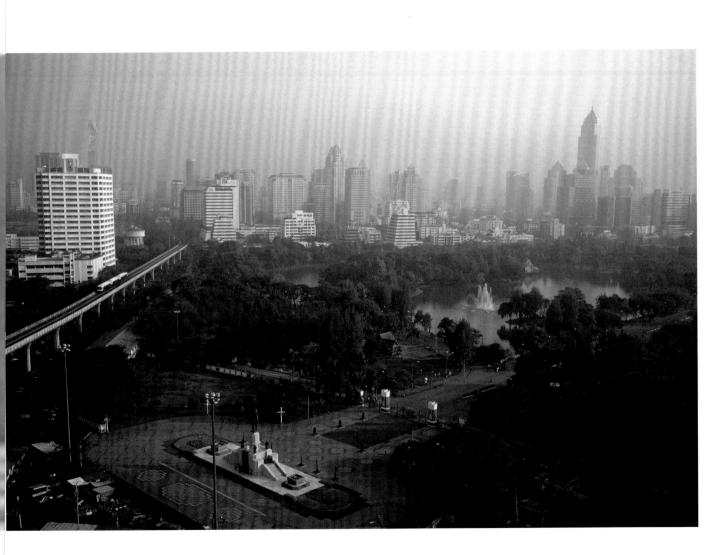

PHNOM PENH, CAMBODIA
A man takes a nap in the alleys around
the Central Market. 2016

John Vink

MAY 1 2 3 4 **5** 6 7 8 9 10 11 12 13 14 15 16 17 18 19 20 21 22 23 24 25 26 27 28 29 30 31

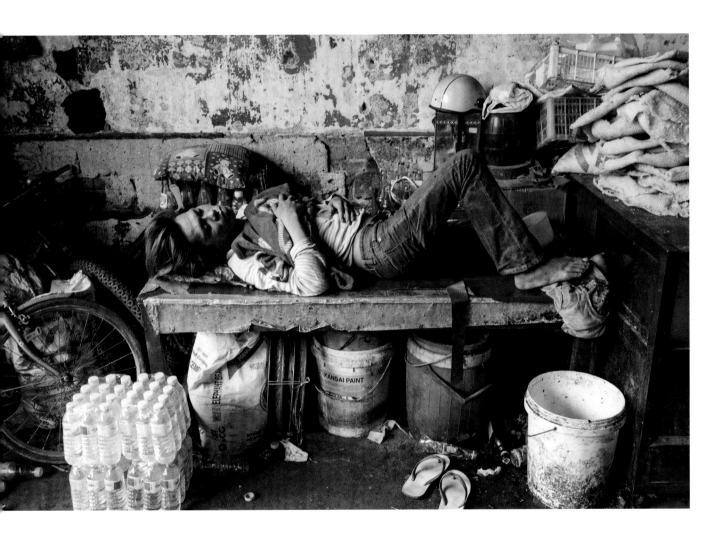

TREANG DISTRICT, TAKÉO PROVINCE, CAMBODIA
A woman throws the straw remaining
after she shredded the rice from her
"heavy rice" harvest. 2016

John Vink

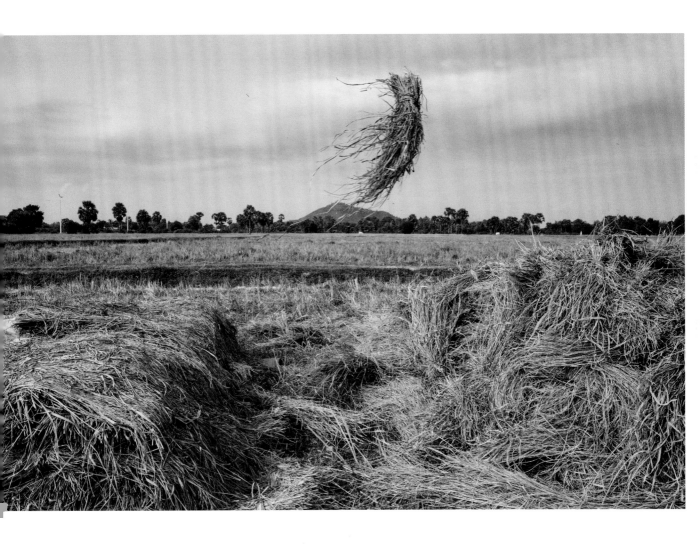

TEUK CHHOU DISTRICT, KAMPOT PROVINCE, CAMBODIA
A farmer started ploughing with a tractor after
the first heavy downpour from the rainy season
flooded his rice field. 2016

John Vink

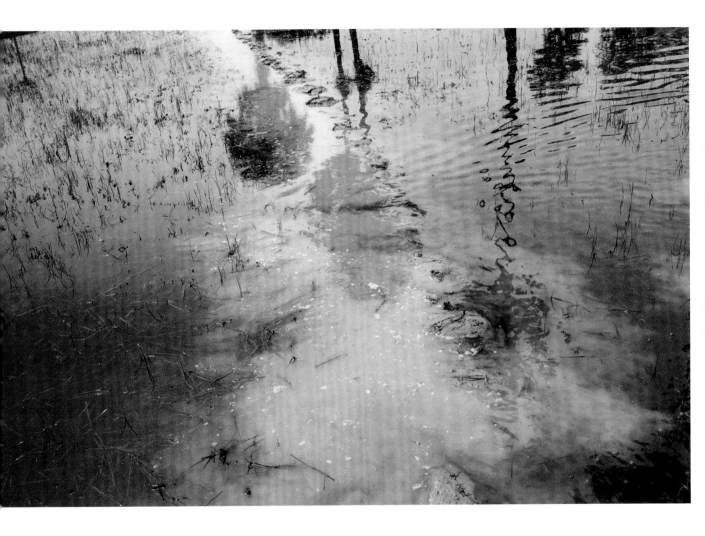

DAMNAK CHANG'AEUR DISTRICT, KEP PROVINCE, CAMBODIA
Farmers, very few of them from the younger
generation, transplant rice seedlings in a
recently ploughed and harrowed field. 2016

John Vink

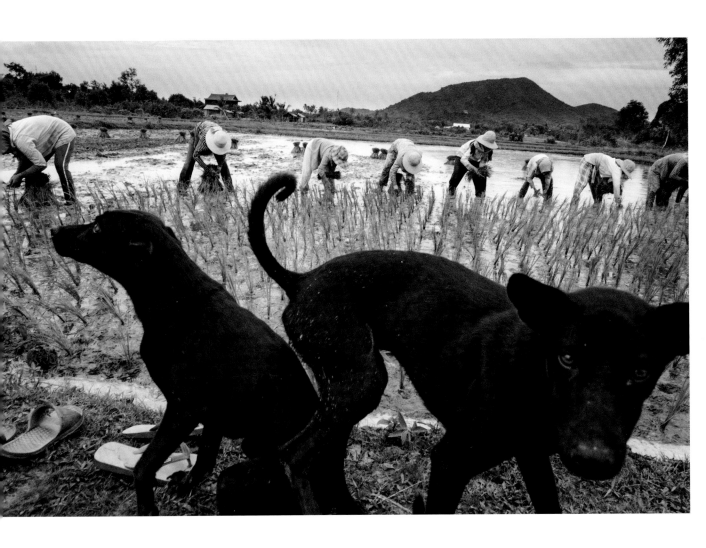

HANOI, INDOCHINA (VIETNAM)
1954

Robert Capa

MAY 1 2 3 4 5 6 7 8 **9** 10 11 12 13 14 15 16 17 18 19 20 21 22 23 24 25 26 27 28 29 30 31

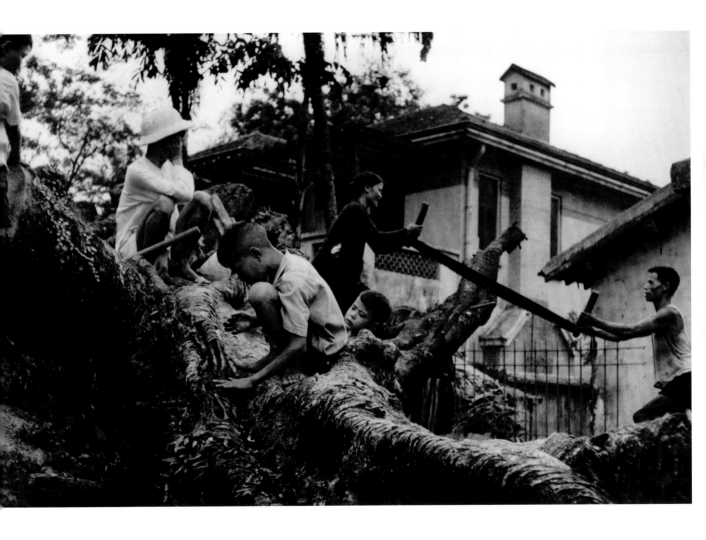

HANOI, INDOCHINA (VIETNAM)
1954

Robert Capa

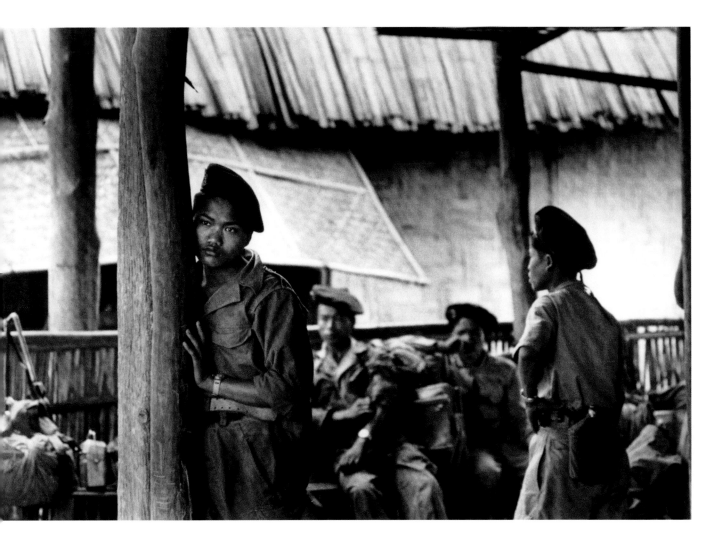

NEAR NAM DINH, INDOCHINA (VIETNAM)
1954

Robert Capa

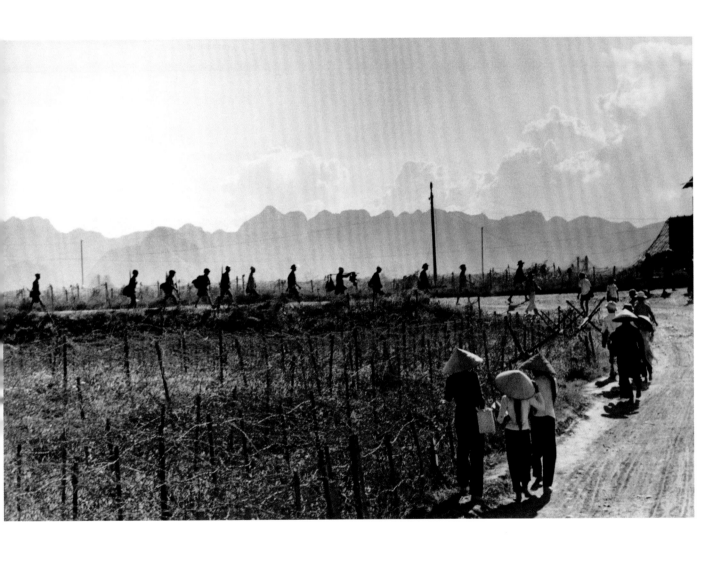

NEAR NAM DINH, INDOCHINA (VIETNAM)
1954

Robert Capa

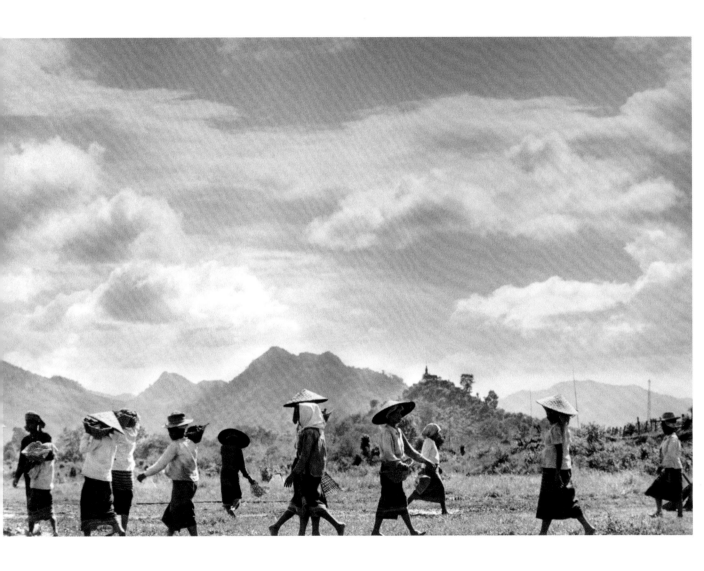

LUANG PRABANG, LAOS
Young Laotian soldier playing with a baby boy. 1961

Nicolas Tikhomiroff

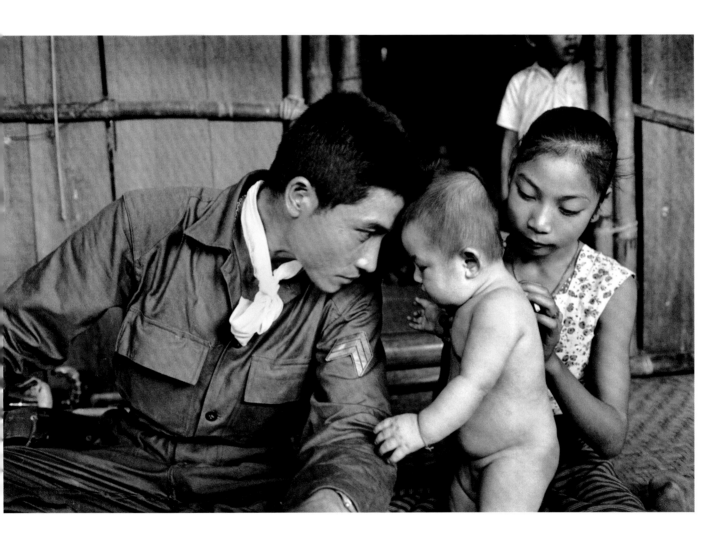

LUANG PRABANG, LAOS
1961

Nicolas Tikhomiroff

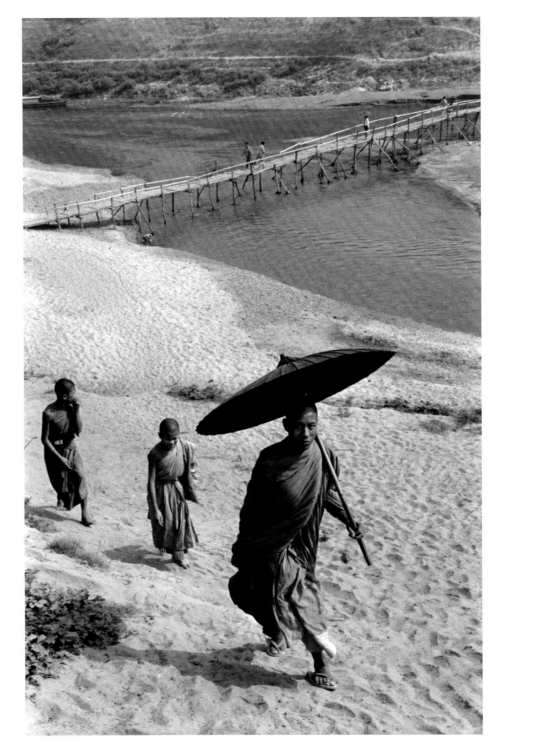

MEKONG DELTA REGION, SOUTH VIETNAM
A bus takes villagers to the nearest market town,
Ba Tri. Villagers are tense during such trips, for
often they are suddenly attacked by guerrillas
on the road. 1961

Nicolas Tikhomiroff

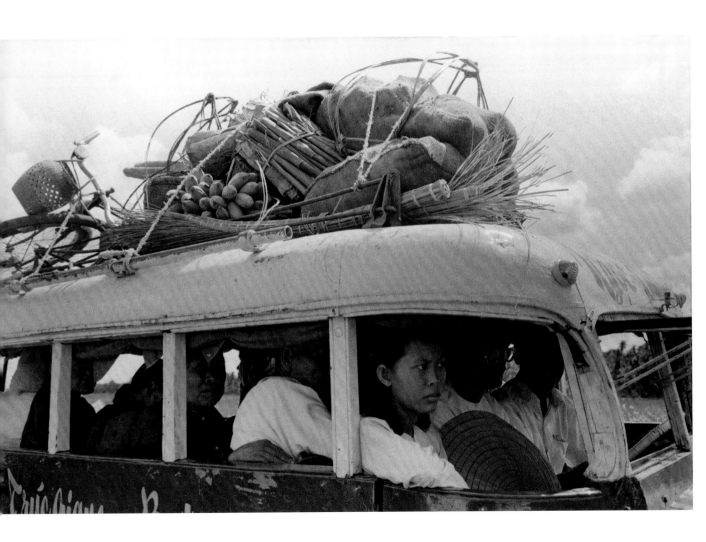

YANGON, MYANMAR
Colonial building in Muslim area. 2014

Chris Steele-Perkins

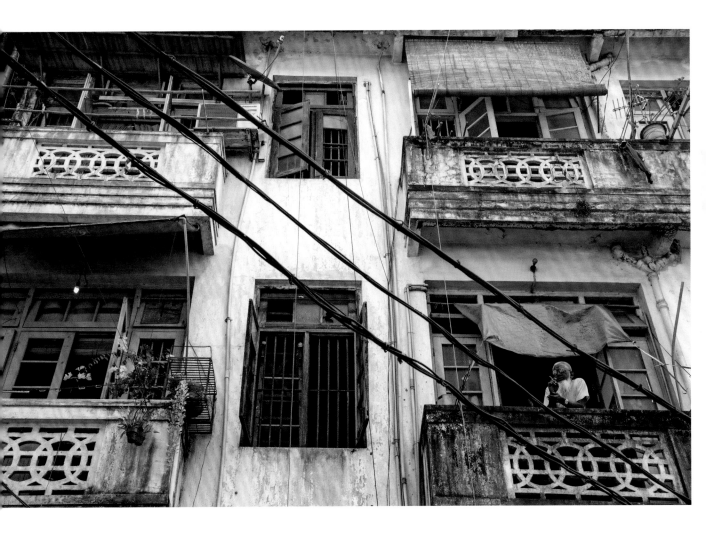

SITTWE, RAKHINE STATE, MYANMAR
Local area where a number of camps have been set
up for the internally displaced people, all Muslim,
who were attacked by the local Arakan people who
do not want them living in Myanmar. 2014

Chris Steele-Perkins

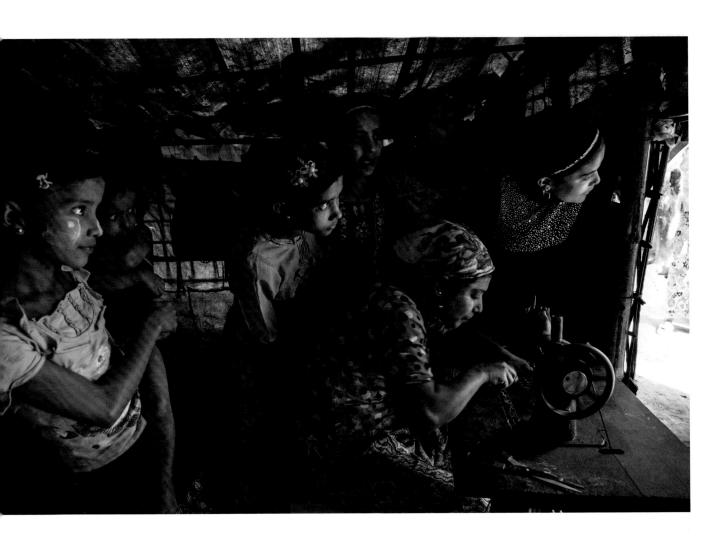

HAKHA, CHIN STATE, MYANMAR
Early morning. 2014

Chris Steele-Perkins

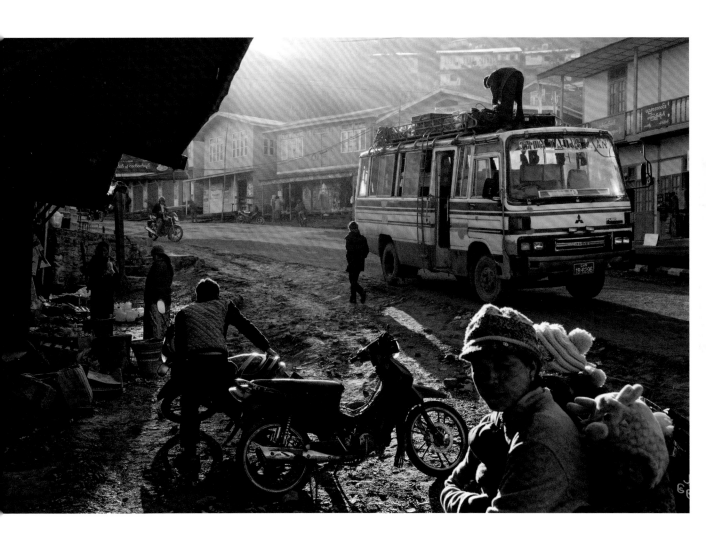

BAGAN, MYANMAR
Early morning balloon flights are
popular with tourists. 2015

Chris Steele-Perkins

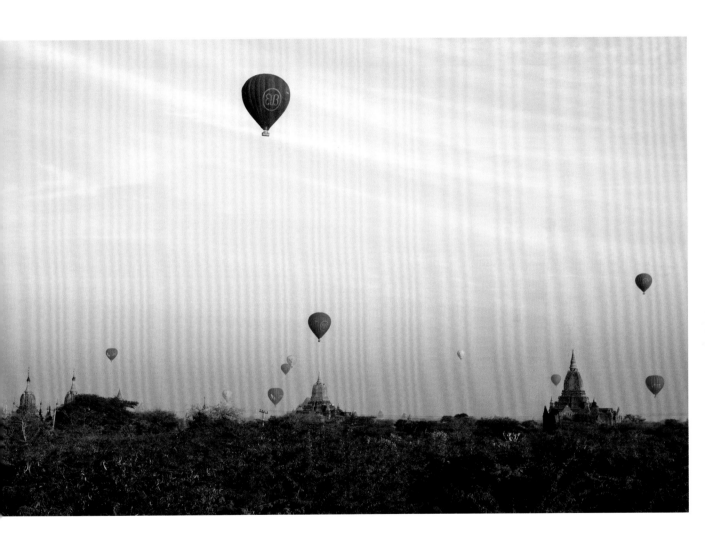

KENGTUNG, SHAN STATE, MYANMAR
A fairground at night before Myanmar
National Day celebrations. 2015

Chris Steele-Perkins

MAY 1 2 3 4 5 6 7 8 9 10 11 12 13 14 15 16 17 18 19 **20** 21 22 23 24 25 26 27 28 29 30 31

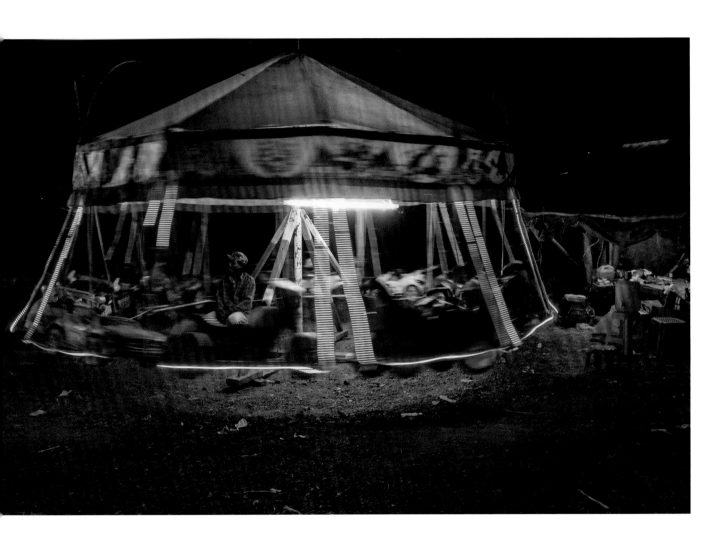

CHITTAGONG, BANGLADESH
1987

Ara Güler

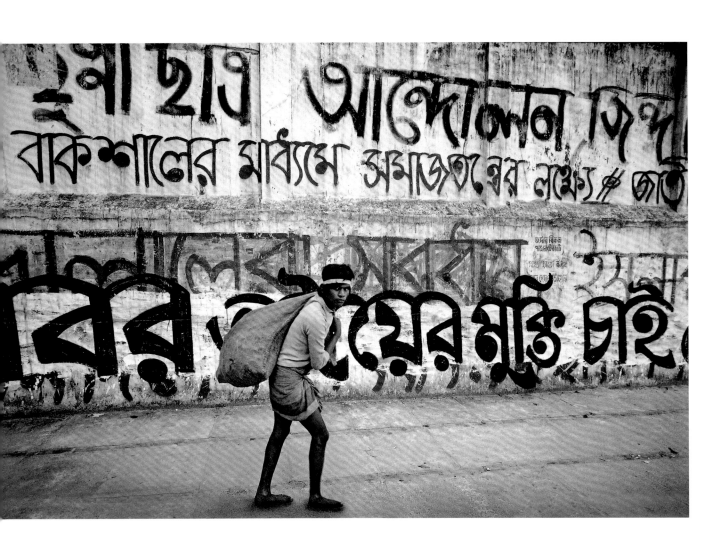

INDIA
1988

Ara Güler

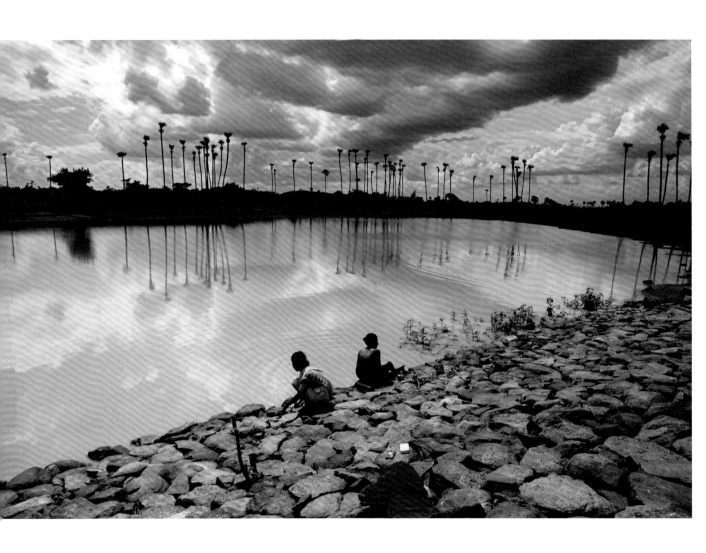

RAJASTHAN, INDIA
A temple on the shore of the
sacred Pushkar Lake. 1988

Ara Güler

MAY 1 2 3 4 5 6 7 8 9 10 11 12 13 14 15 16 17 18 19 20 21 22 **23** 24 25 26 27 28 29 30 31

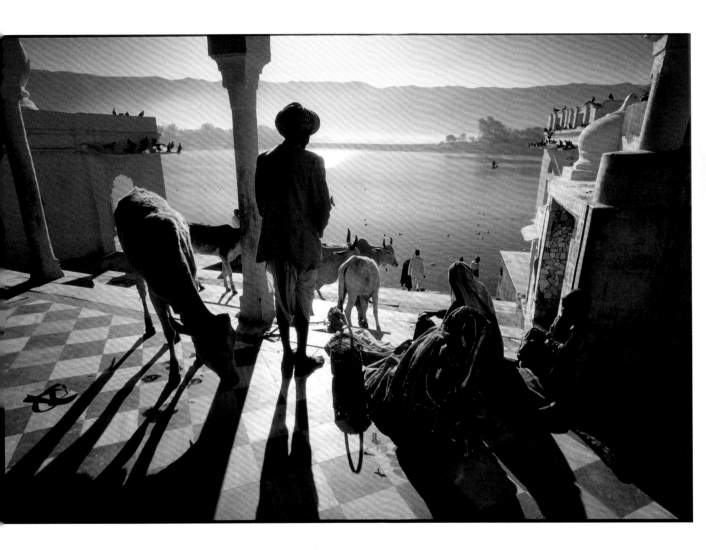

INDIA
2015

Raghu Rai

MAY 1 2 3 4 5 6 7 8 9 10 11 12 13 14 15 16 17 18 19 20 21 22 23 **24** 25 26 27 28 29 30 31

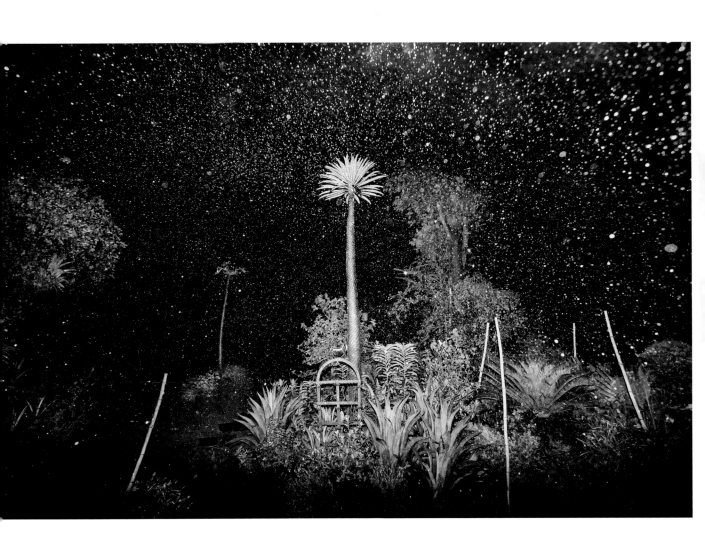

INDIA
2015

Raghu Rai

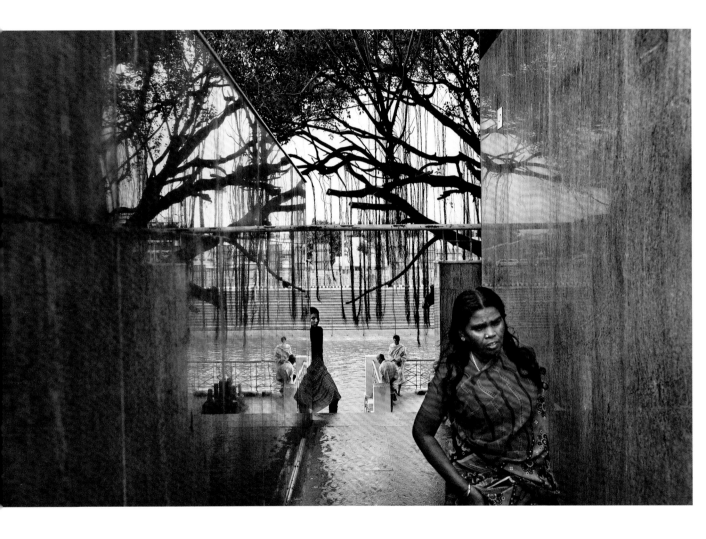

INDIA
2015

Raghu Rai

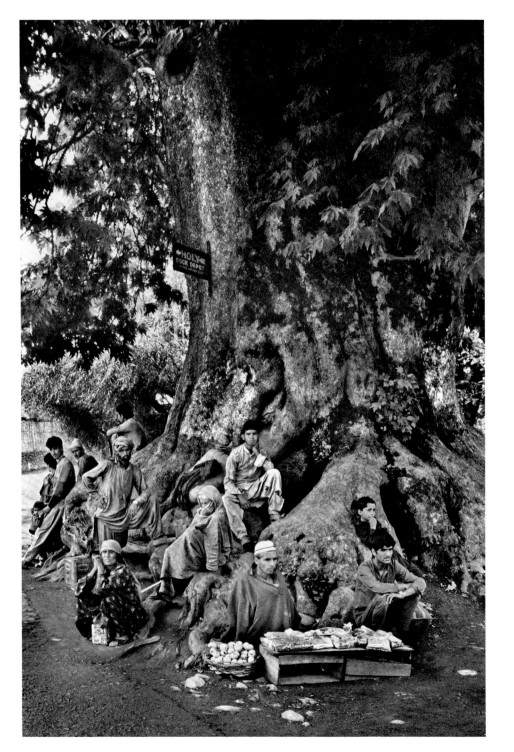

GHUM, WEST BENGAL, INDIA
2015

Raghu Rai

MAY 1 2 3 4 5 6 7 8 9 10 11 12 13 14 15 16 17 18 19 20 21 22 23 24 25 26 **27** 28 29 30 31

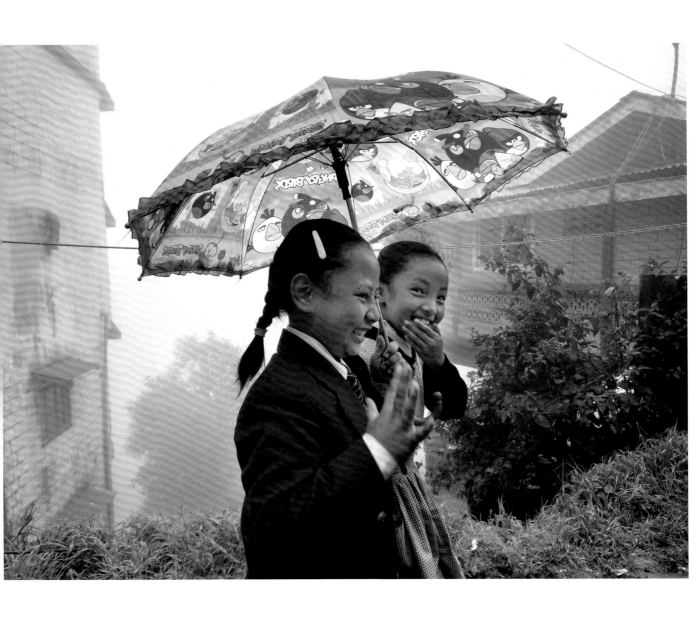

POKHARA VALLEY, NEPAL
Chandra Sing is a farmer; he is holding his baby
in a pixie-like grey-hooded woollen cloak.
It provides a tent-like shelter for when he
squats or stoops at work in the fields. 1961

Marilyn Silverstone

MAY 1 2 3 4 5 6 7 8 9 10 11 12 13 14 15 16 17 18 19 20 21 22 23 24 25 26 27 **28** 29 30 31

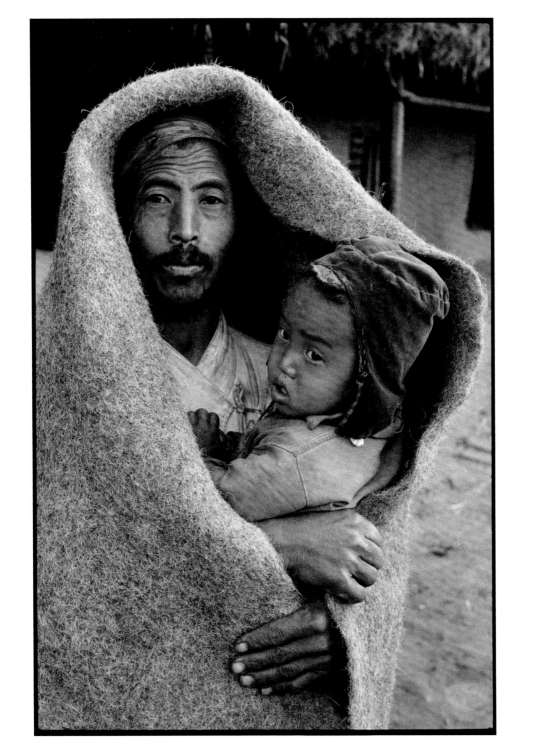

NEAR KATHMANDU, NEPAL
Tibetan refugees in a classroom,
refugee self-help centre. 1962

Marilyn Silverstone

MAY 1 2 3 4 5 6 7 8 9 10 11 12 13 14 15 16 17 18 19 20 21 22 23 24 25 26 27 28 **29** 30 31

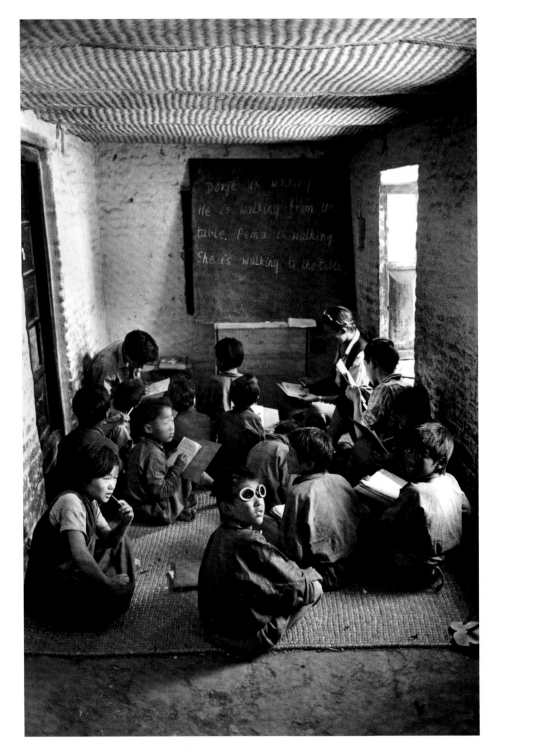

POKHARA VALLEY, NEPAL
Purna and Masina sleeping near a kerosene
lantern, nightfall in Pokhara. 1962

Marilyn Silverstone

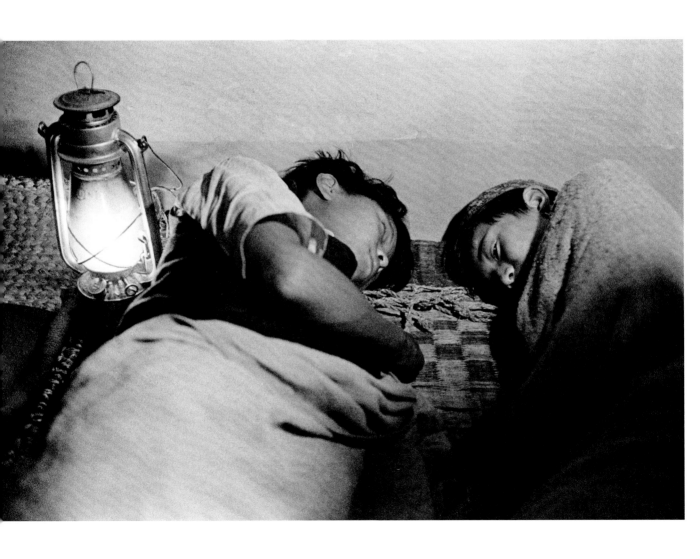

ISLAND OF CHEUNG CHAU, HONG KONG
Cheung Chau Bun Festival. 2015

Bruno Barbey

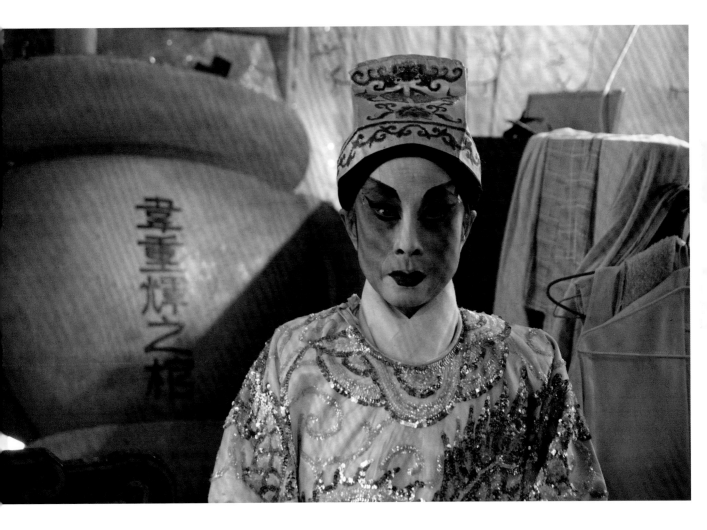

QINGDAO, SHANDONG PROVINCE, CHINA
2015

Bruno Barbey

JUNE **1** 2 3 4 5 6 7 8 9 10 11 12 13 14 15 16 17 18 19 20 21 22 23 24 25 26 27 28 29 30

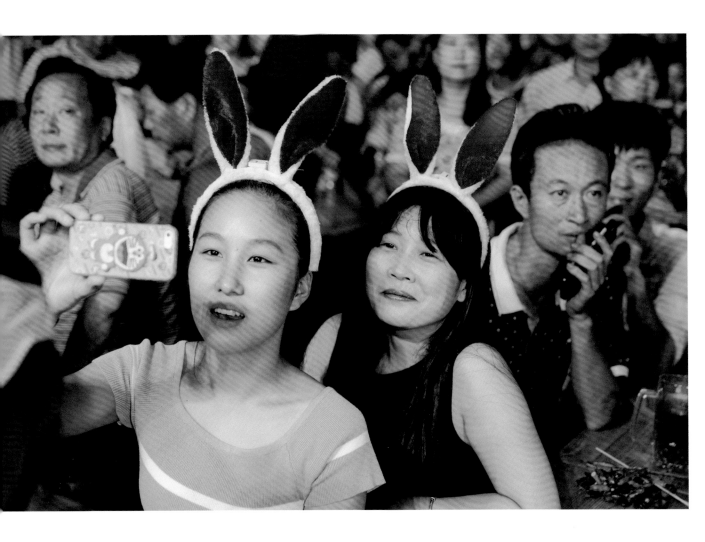

QINGDAO, SHANDONG PROVINCE, CHINA
2015

Bruno Barbey

JUNE 1 **2** 3 4 5 6 / 8 9 10 11 12 13 14 15 16 17 18 19 20 21 22 23 24 25 26 27 28 29 30

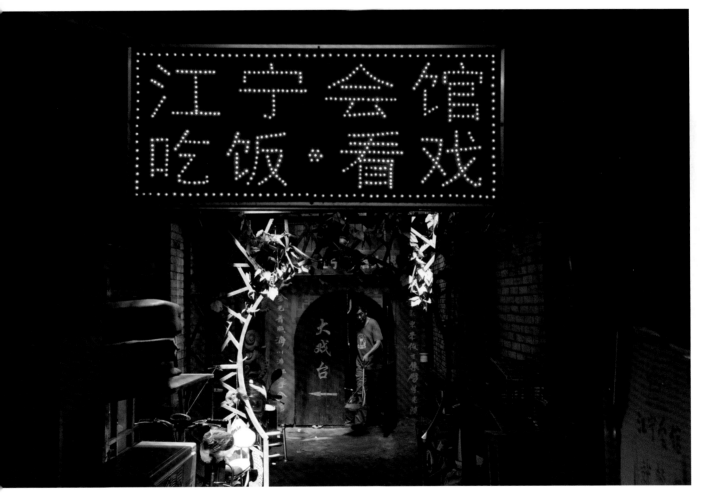

SHANGHAI, CHINA
2016

Bruno Barbey

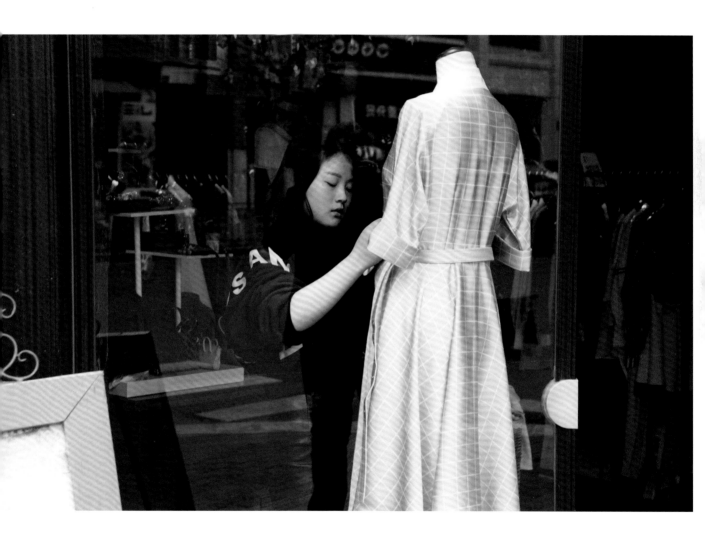

PINGYAO, CHINA
2016

Bruno Barbey

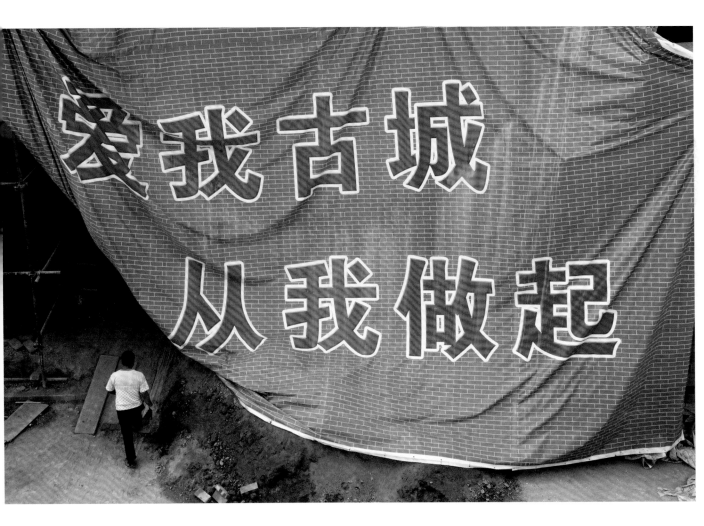

ULAANBAATAR, MONGOLIA
2012

Jacob Aue Sobol

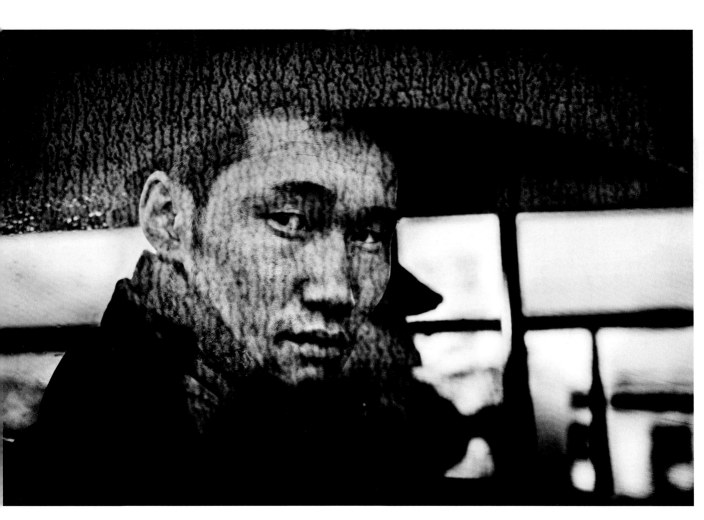

ULAANBAATAR, MONGOLIA
2012

Jacob Aue Sobol

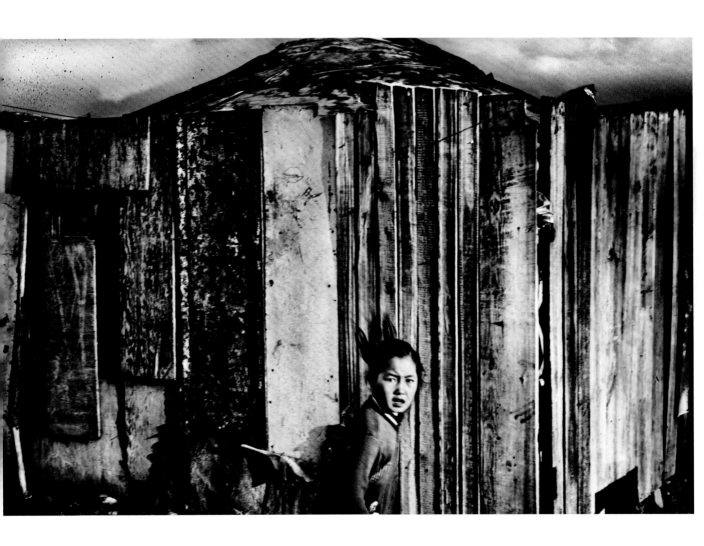

ULAANBAATAR, MONGOLIA
2012

Jacob Aue Sobol

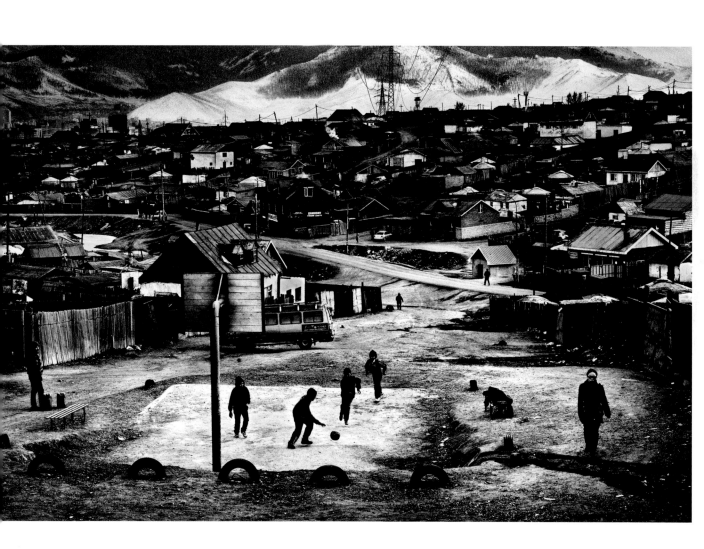

ULAANBAATAR, MONGOLIA
2012

Jacob Aue Sobol

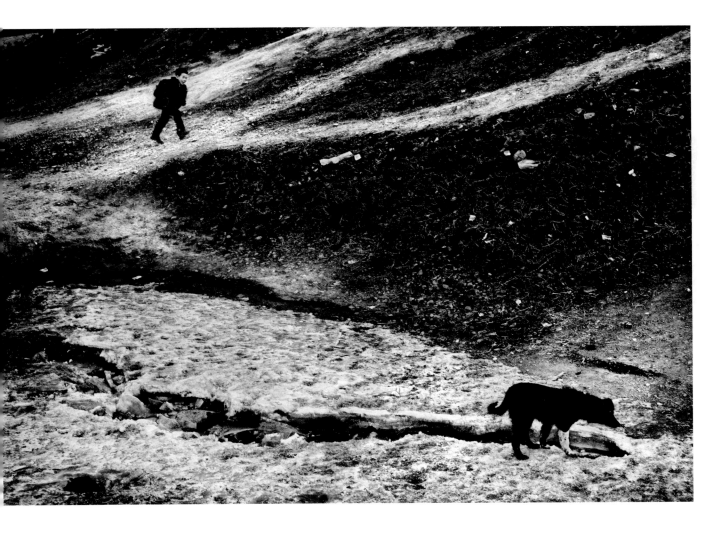

ULAANBAATAR, MONGOLIA
2012

Jacob Aue Sobol

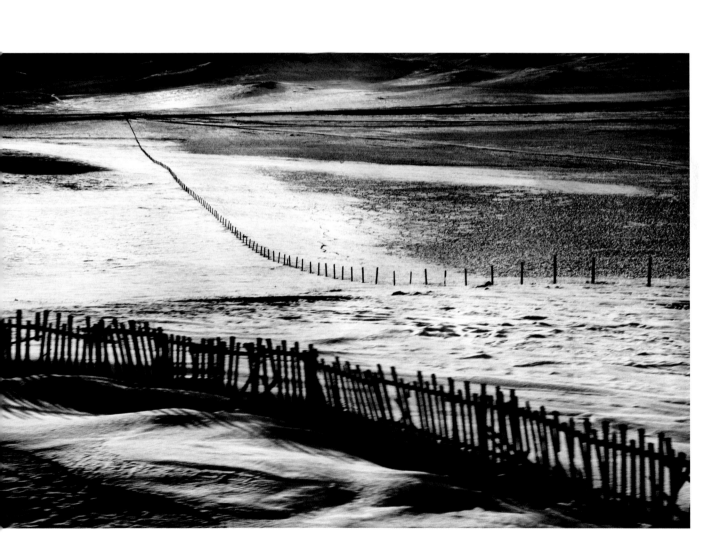

CHELEKOV, SIBERIA, RUSSIA
The main square. 1972

Martine Franck

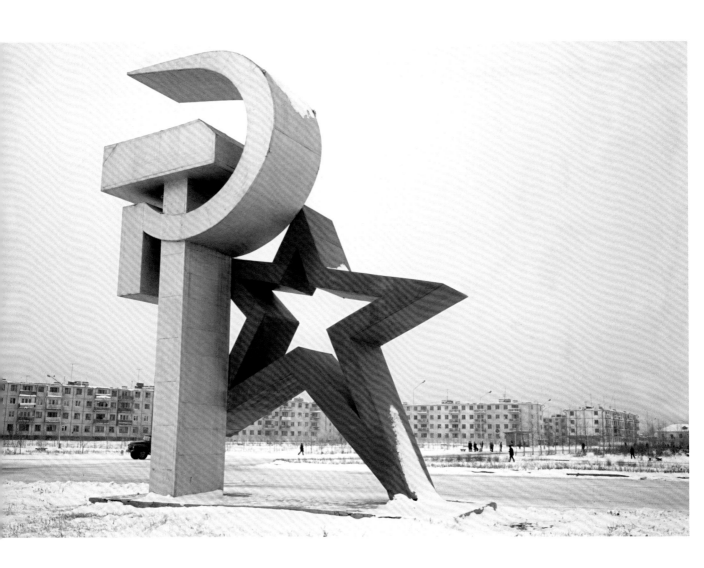

KYRGYZSTAN
Seventeenth-century Muslim cemetery. 1972

Martine Franck

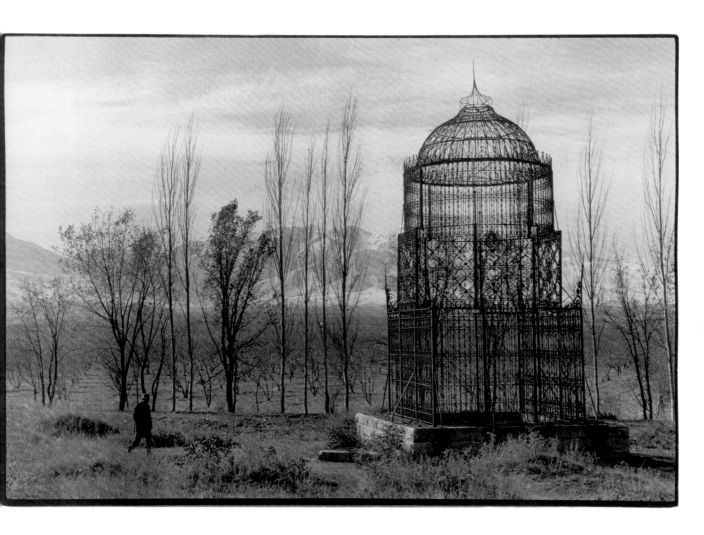

TASHKENT, UZBEKISTAN
1972

Martine Franck

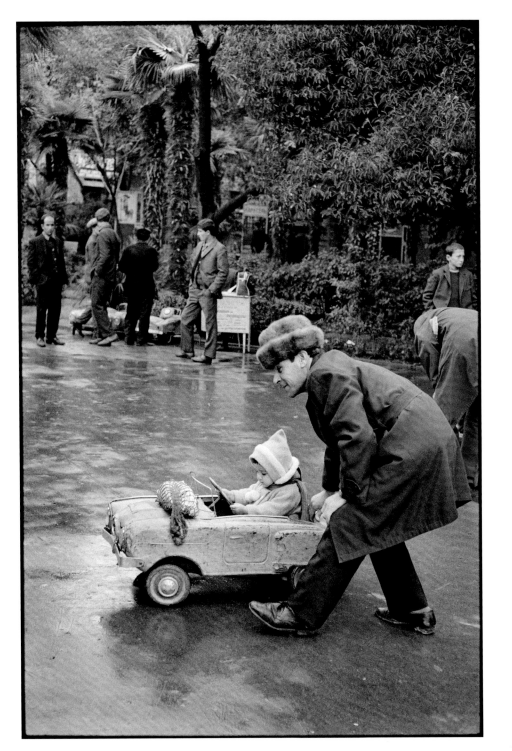

MOSCOW, RUSSIA
A group of Muscovites looking at space models in
the "Hall of Cosmos" of the Exhibitions Park. 1972

Martine Franck

JUNE 1 2 3 4 5 6 7 8 9 10 11 12 **13** 14 15 16 17 18 19 20 21 22 23 24 25 26 27 28 29 30

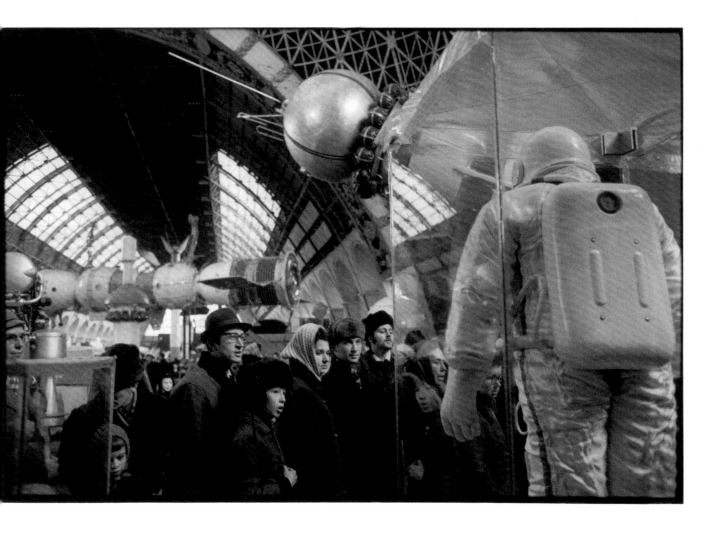

BELARUS
Brothers Sasha and Valera Zhuk approach the
radiation-polluted Pripyat River, which runs
near Chernobyl, to frolic in the water at the end
of a summer day. 2000

Paul Fusco

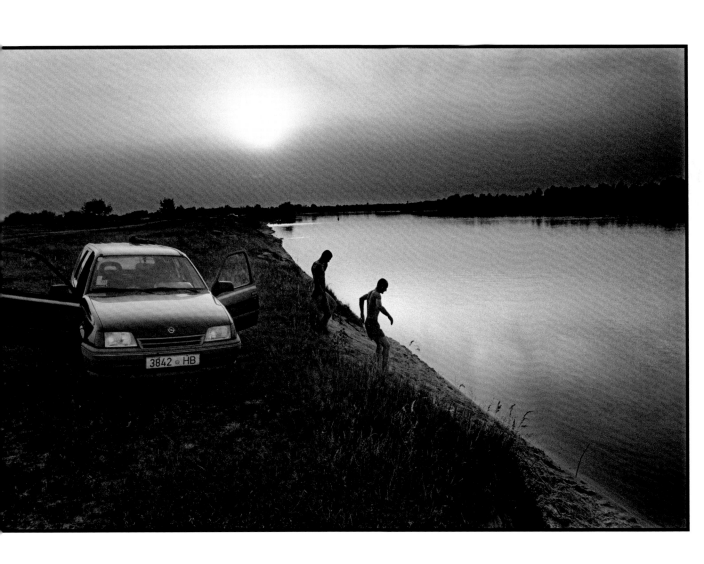

MAISKY VILLAGE, BELARUS
Potato field near the Hot Zone, a thirty kilometre zone
around Chernobyl which was horrifically radiated.
These women and this young girl are harvesting the
potato crop which are all contaminated from growing
in the tainted soil. 2000

Paul Fusco

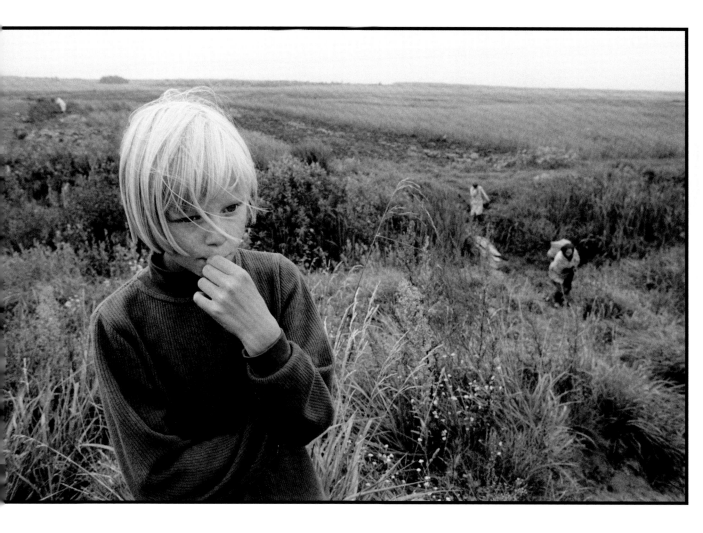

MINSK, BELARUS
An inmate during free time in a fenced-in
area, Novinki Asylum. 1997

Paul Fusco

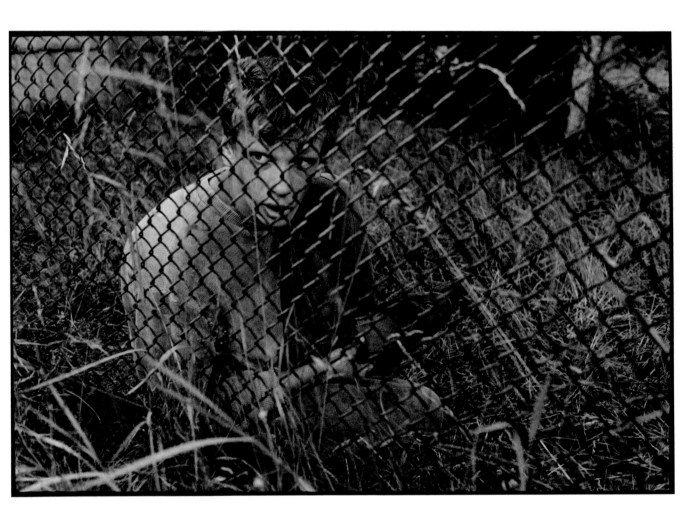

NAROVLYA AREA (NAROULIA), BELARUS
Heavy contamination, considered dangerous, but
being resettled by former evacuees. 1999

Paul Fusco

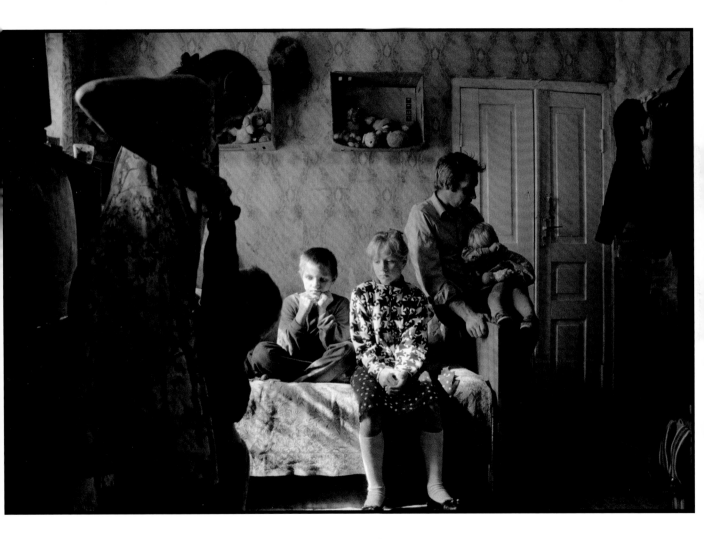

UKRAINE
2006

Jim Goldberg

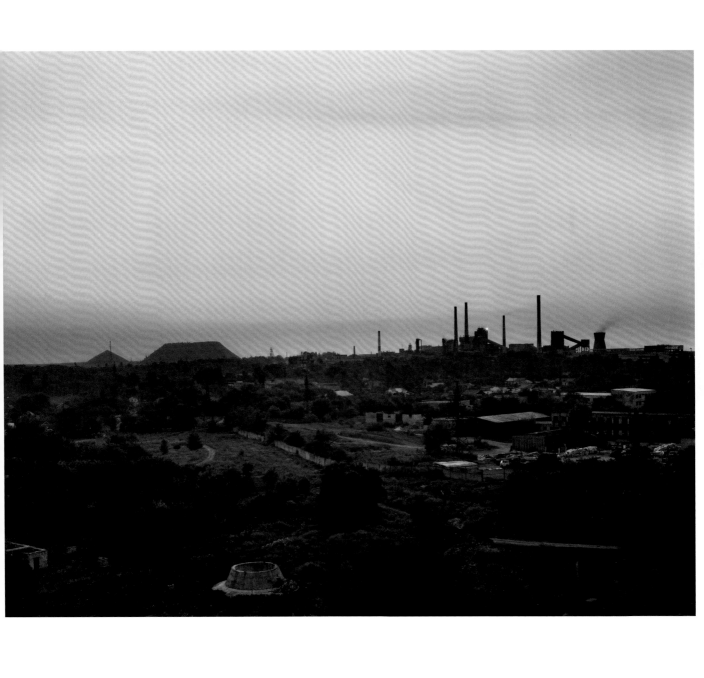

UKRAINE
2006

Jim Goldberg

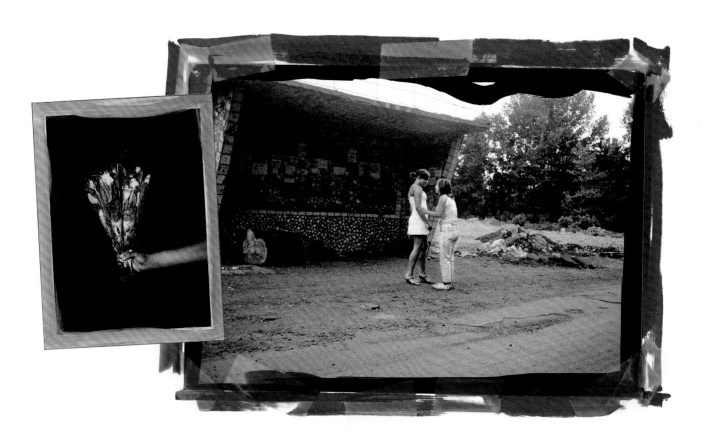

KIEV, UKRAINE
2006

Jim Goldberg

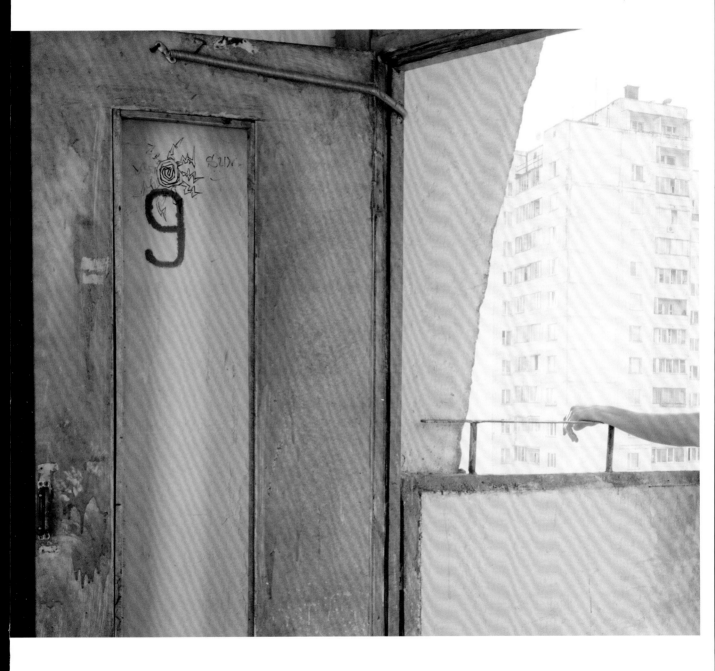

KIEV, UKRAINE
On the outskirts of Kiev street kids
teaching a young boy to smoke. 2006

Jim Goldberg

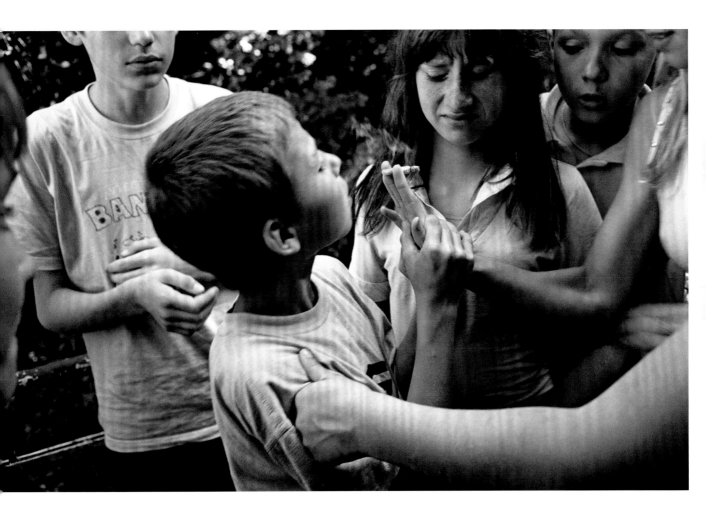

KIEV, UKRAINE
On the outskirts of Kiev homeless boys
use an old grain silo for shelter. 2006

Jim Goldberg

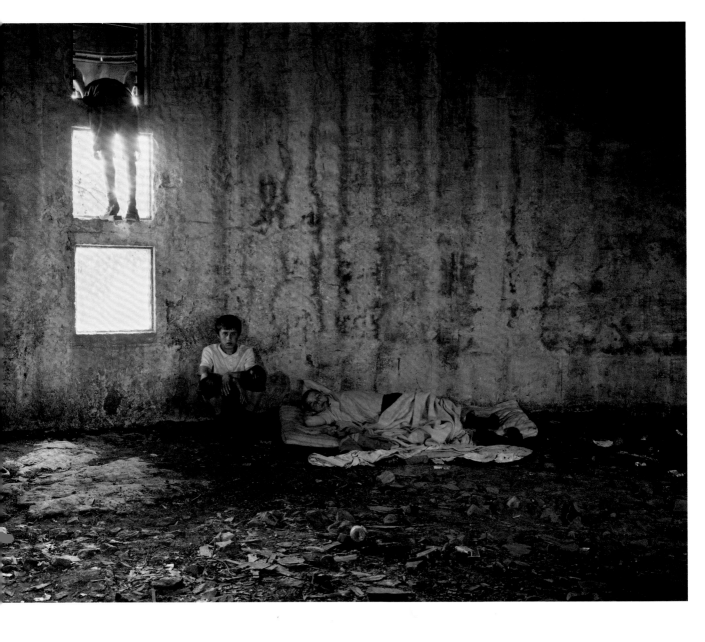

SOPOT, POLAND
First election of a beauty queen in communist
Poland. The contest for the title of "Miss Sopot"
drew such huge crowds that it had to be moved
to the roof of the casino of that once elegant
seaside resort. 1956

Erich Lessing

JUNE 1 2 3 4 5 6 7 8 9 10 11 12 13 14 15 16 17 18 19 20 21 22 **23** 24 25 26 27 28 29 30

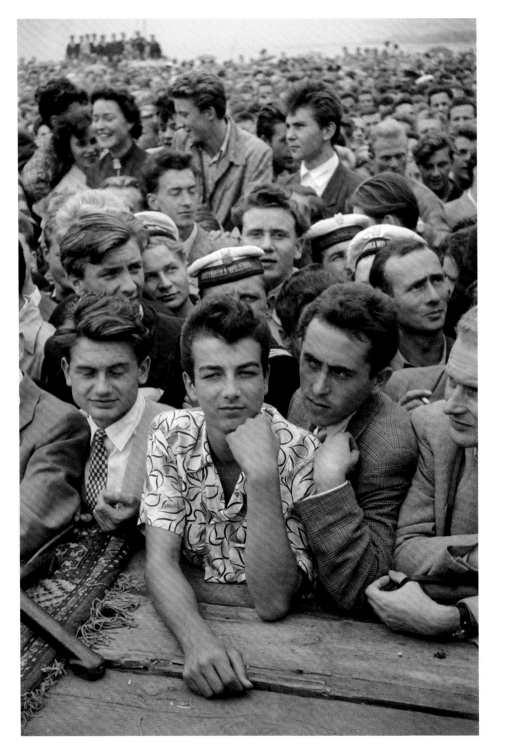

NOWA HUTA, POLAND
Nowa Huta, an unfinished town with vacant lots.
Mothers and children take the air on a shabby
lawn. A Ferris wheel and new, cheap housing in
the background. 1956

Erich Lessing

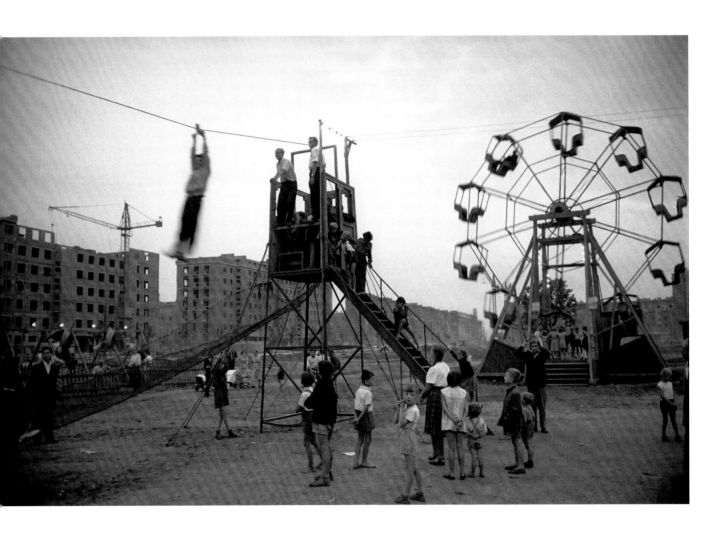

NOWA HUTA, POLAND
A Saturday afternoon in unfinished Nowa Huta.
Young people, mothers and children sit under the
swings of a fairground. 1956

Erich Lessing

JUNE 1 2 3 4 5 6 7 8 9 10 11 12 13 14 15 16 17 18 19 20 21 22 23 24 **25** 26 27 28 29 30

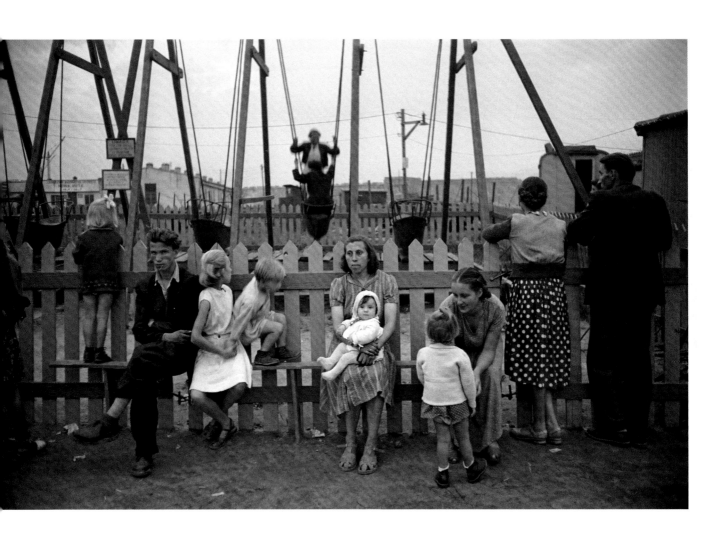

HAJDÚHADHÁZ, HUNGARY
The children's town at Hajdúhadház, a large
orphanage for children rendered parentless
and homeless by the war. 1948

David Seymour

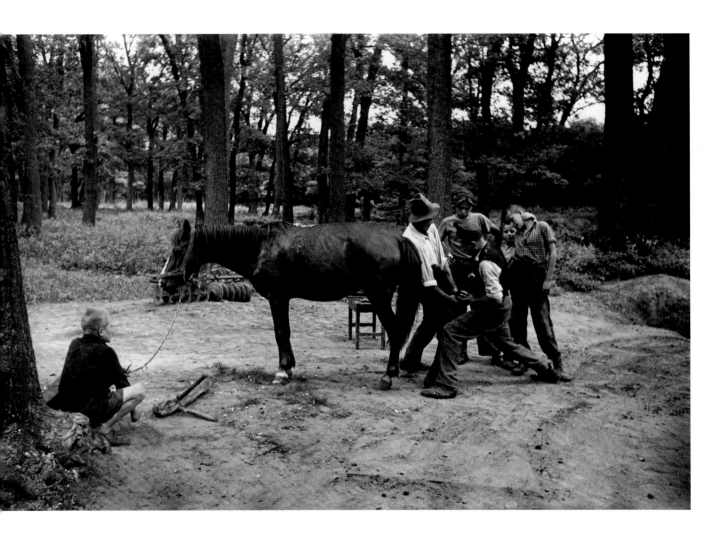

NEAR BUDAPEST, HUNGARY
In the kindergarten for children of
factory workers. 1948

David Seymour

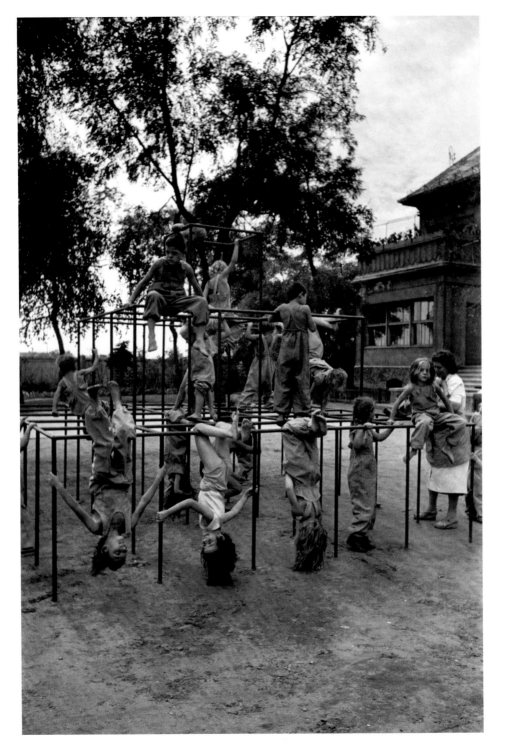

NEAR BUDAPEST, HUNGARY
Children's printing plant at the "Children's
Republic". During summer about 2,000 children
were camping there and a special camp
newspaper was printed in this plant. 1948

David Seymour

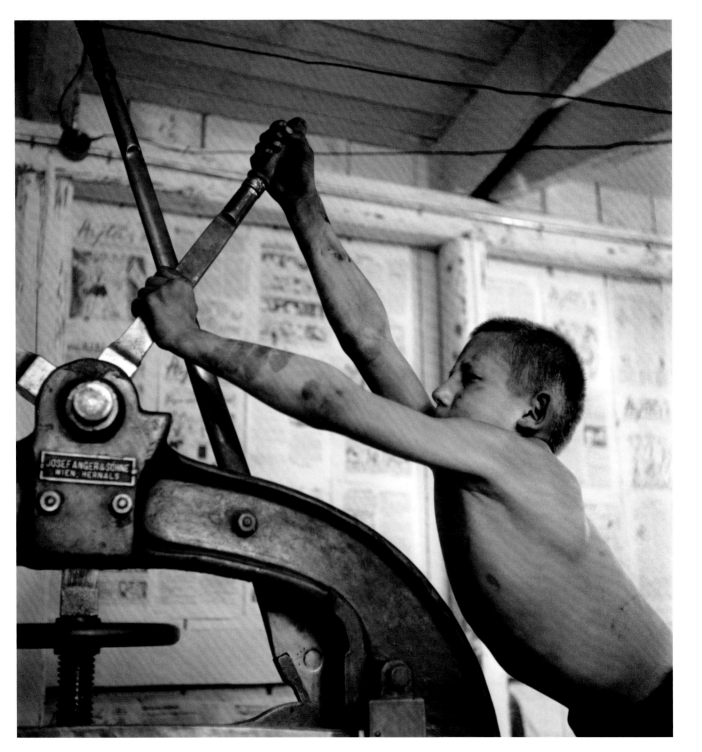

SARAJEVO, BOSNIA AND HERZEGOVINA
Orphans. 1993

Gilles Peress

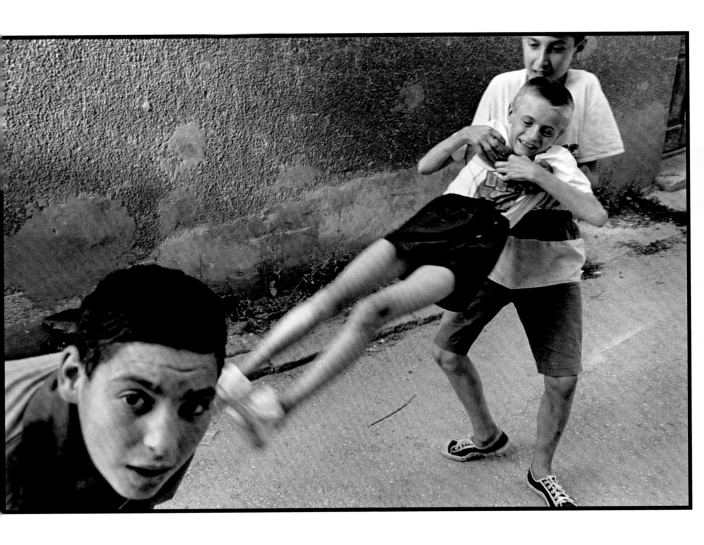

SARAJEVO, BOSNIA AND HERZEGOVINA
Summer in Obala Vojvode Stepe Stepanovića. 1993

Gilles Peress

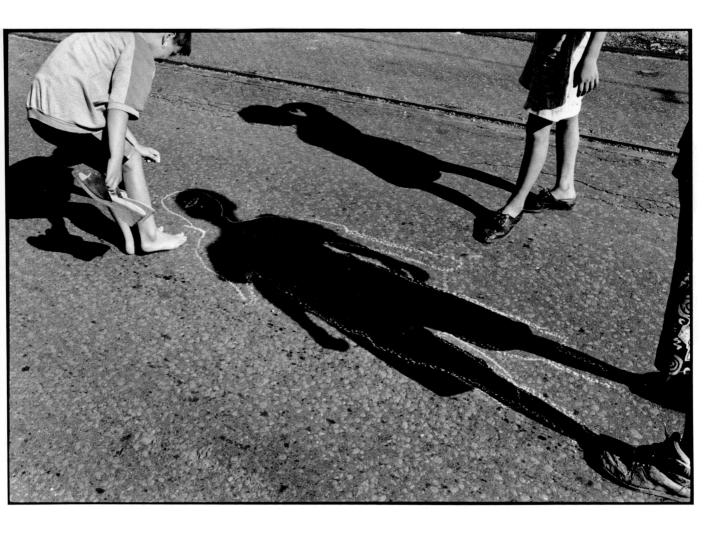

BOSNIA AND HERZEGOVINA
Refugees from Doboj on the road to Travnik. 1993

Gilles Peress

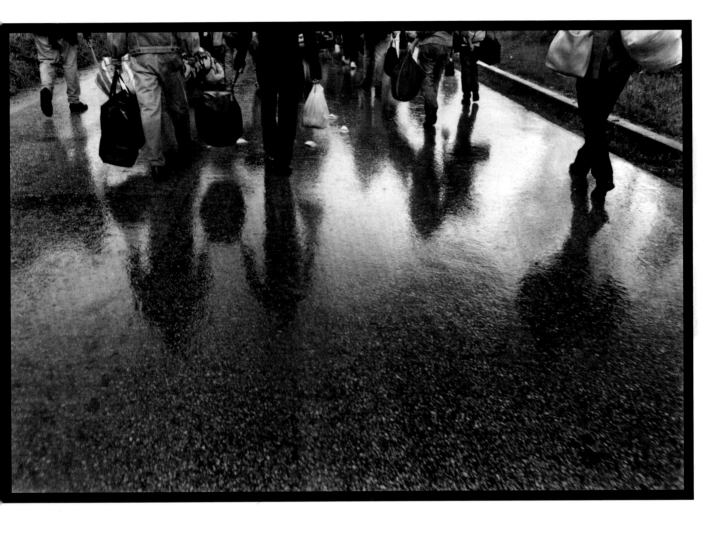

SARAJEVO, BOSNIA AND HERZEGOVINA
Summer in Obala Vojvode Stepe Stepanovića. 1993

Gilles Peress

JULY 1 **2** 3 4 5 6 **7** 8 9 10 11 12 13 14 15 16 17 18 19 20 21 22 23 24 25 26 27 28 29 30 31

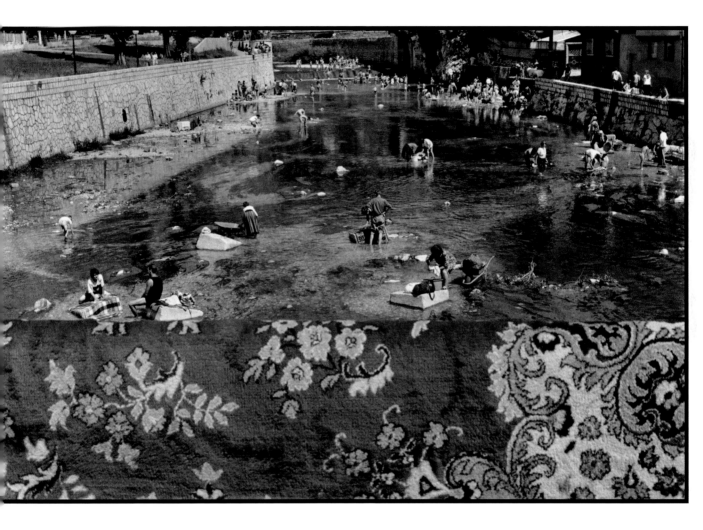

ROMANIA
2012

Nikos Economopoulos

JULY 1 2 **3** 4 5 6 **7** 8 9 10 11 12 13 14 15 16 17 18 19 20 21 22 23 24 25 26 27 28 29 30 31

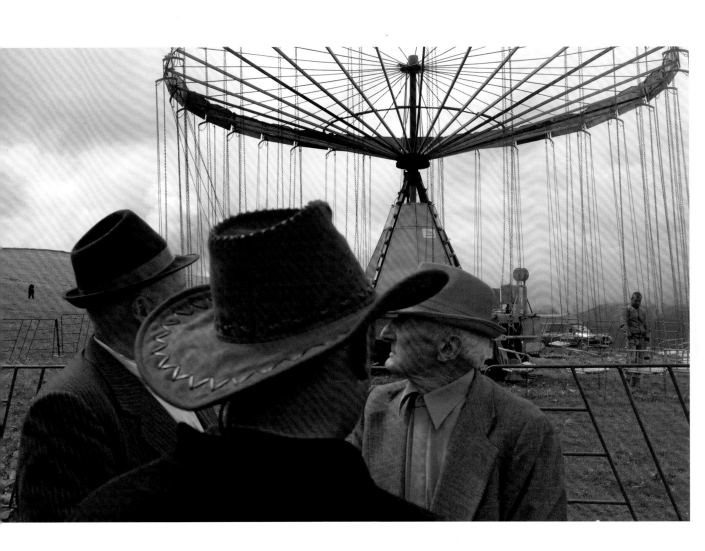

ROMANIA
2012

Nikos Economopoulos

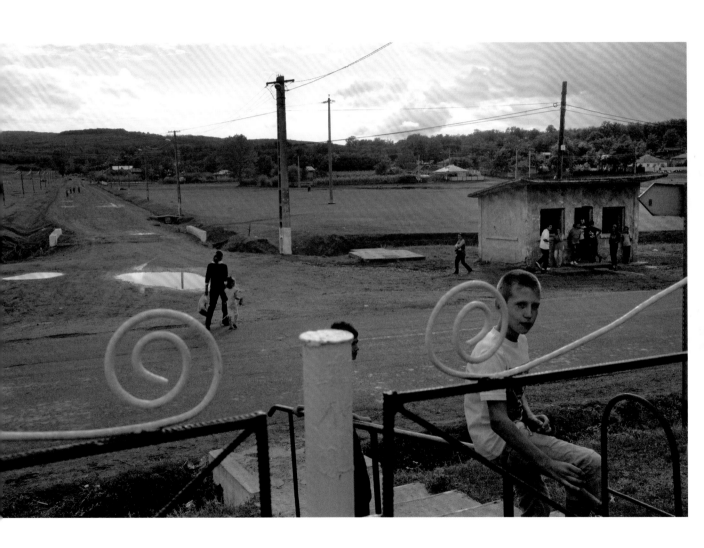

ROMANIA
2012

Nikos Economopoulos

ROMANIA
2012

Nikos Economopoulos

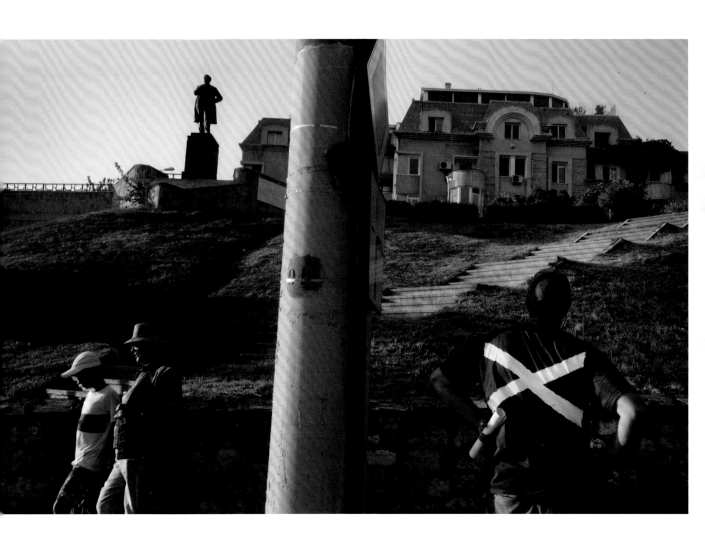

CHANIA, CRETE, GREECE
Man reading newspaper. 1967

Constantine Manos

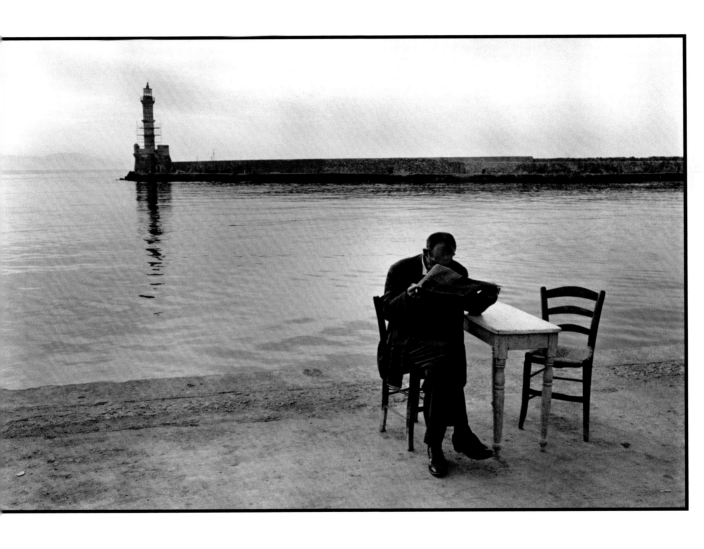

OLYMPOS, KARPATHOS, GREECE
Watching the dance. 1964

Constantine Manos

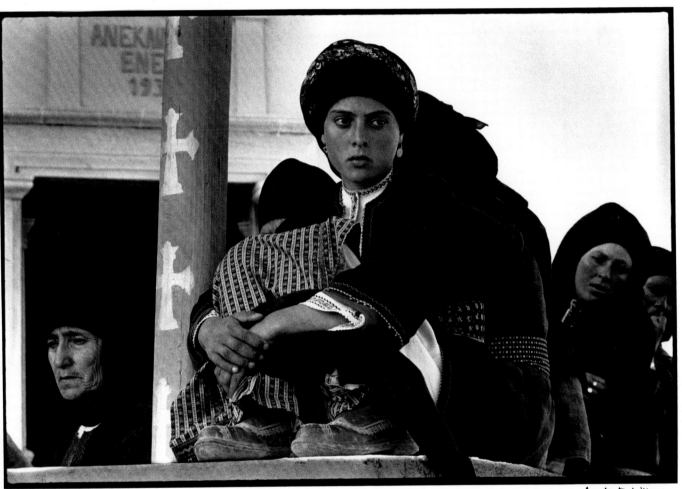

Constantine Manos

CRETE, GREECE
Priest tending his vineyard. 1964

Constantine Manos

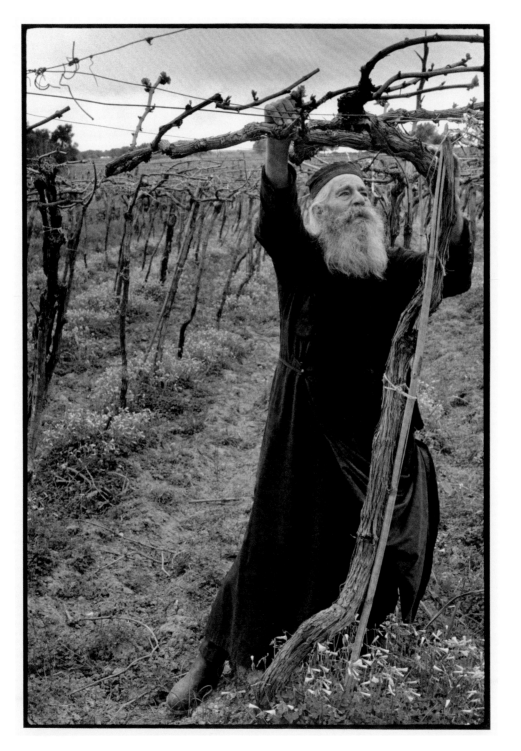

NEA MOUDANIA, CHALKIDIKI, GREECE
By the sea. 1964

Constantine Manos

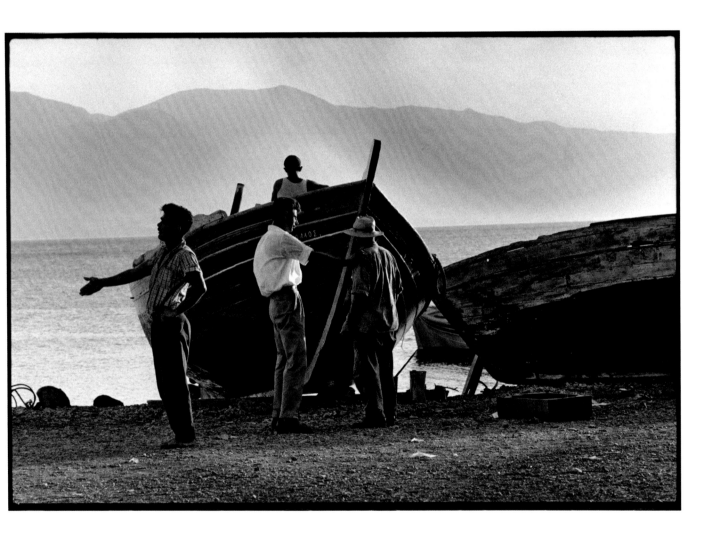

ISTANBUL, TURKEY
Rollerbladers in a park in the
Asian-side suburbs. 2013

Jonas Bendiksen

JULY 1 2 3 4 5 6 7 8 9 10 **11** 12 13 14 15 16 17 18 19 20 21 22 23 24 25 26 27 28 29 30 31

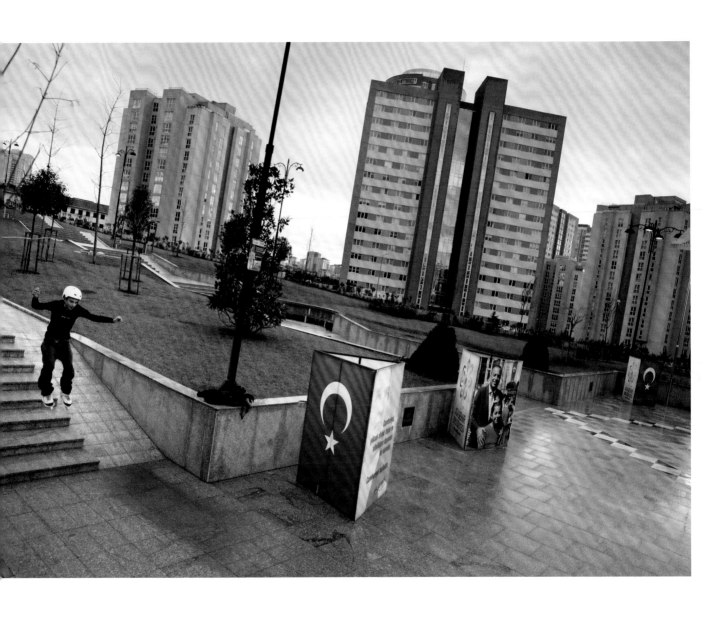

ISTANBUL, TURKEY
Fashion posters in the market area
near the Grand Bazaar. 2013

Jonas Bendiksen

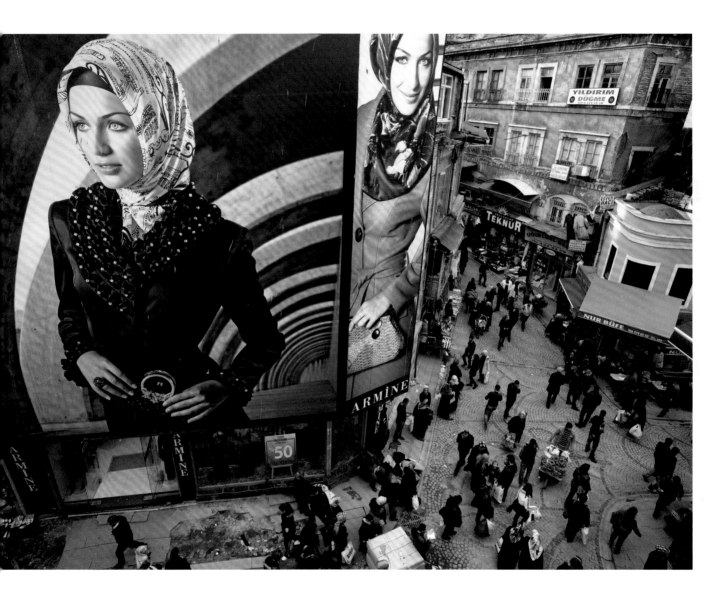

ISTANBUL, TURKEY
Overview of the city from the Sapphire Tower,
Istanbul's tallest building. 2013

Jonas Bendiksen

JULY 1 2 3 4 5 6 7 8 9 10 11 12 **13** 14 15 16 17 18 19 20 21 22 23 24 25 26 27 28 29 30 31

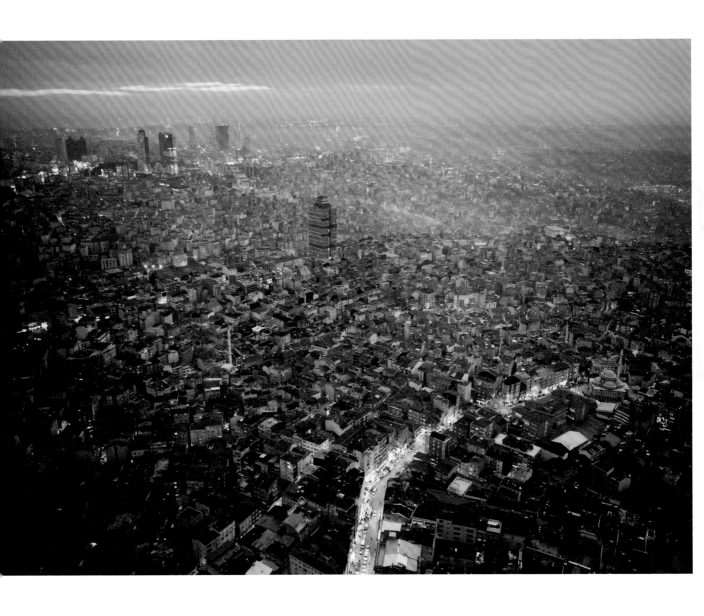

ISTANBUL, TURKEY
Seagulls in the sky, with financial
districts in the background. 2013

Jonas Bendiksen

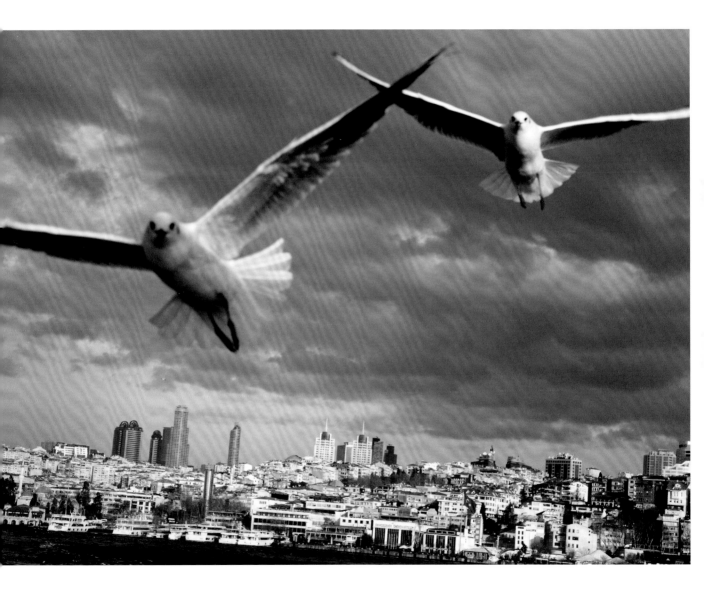

ISTANBUL, TURKEY
Woman in the high-end restaurant Club 29. 2013

Jonas Bendiksen

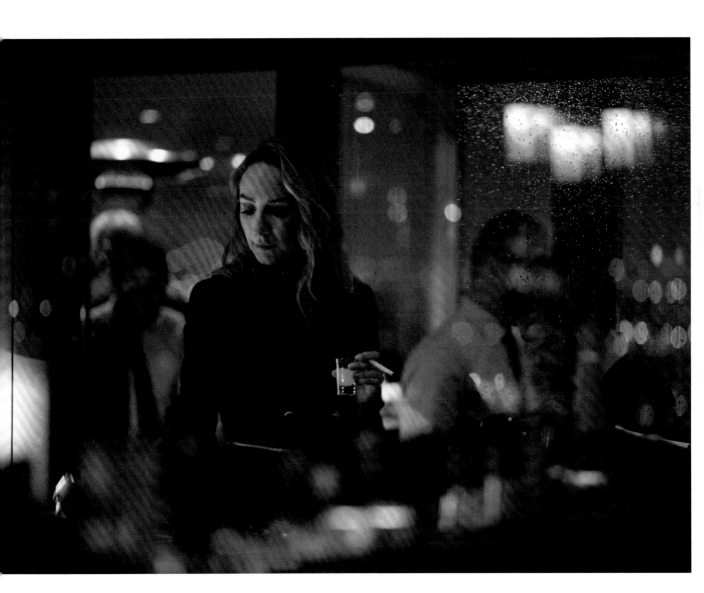

GEORGIA
2016

Antoine d'Agata

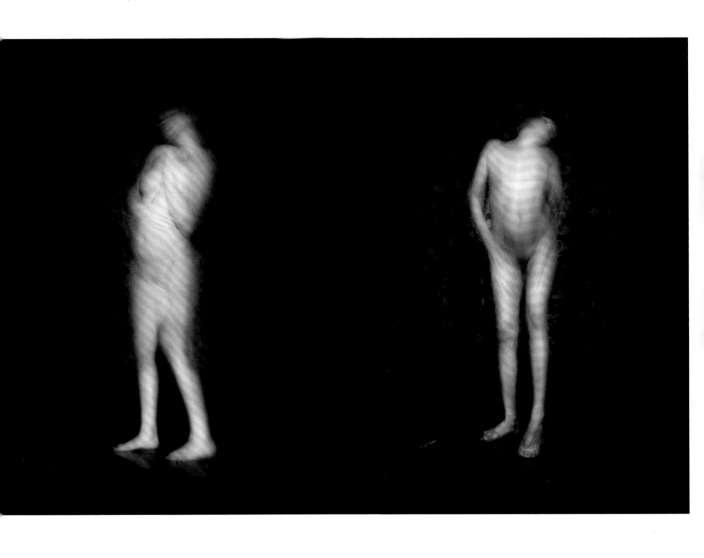

GEORGIA
2016

Antoine d'Agata

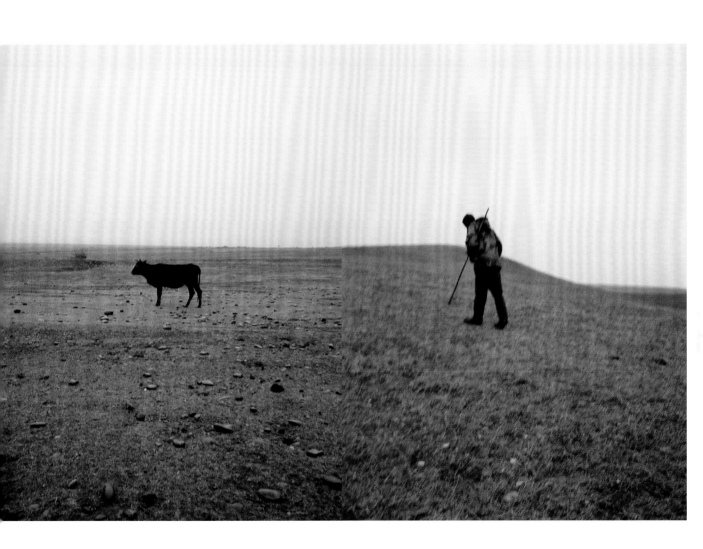

GEORGIA
2016

Antoine d'Agata

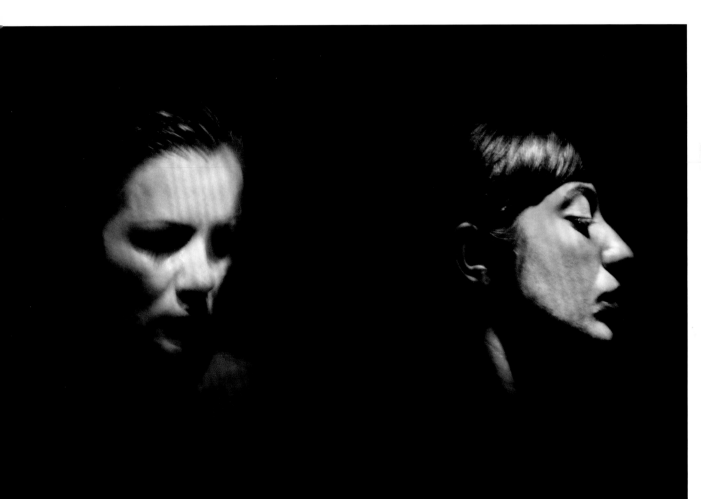

GEORGIA
2016

Antoine d'Agata

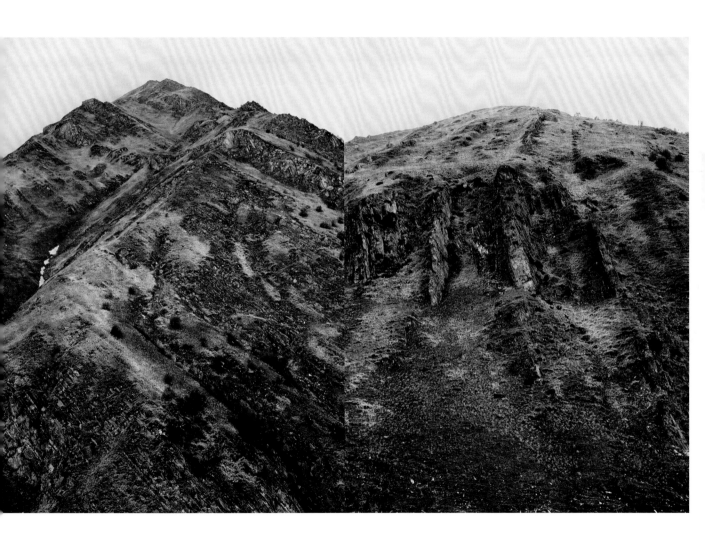

GEORGIA
2016

Antoine d'Agata

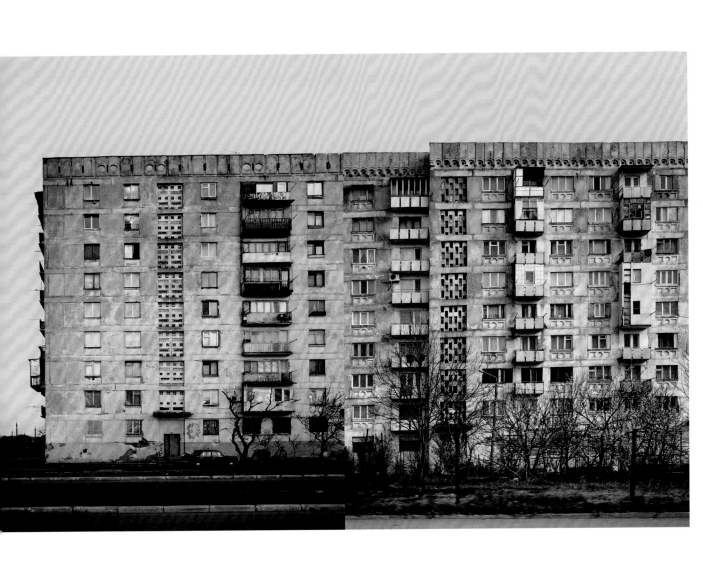

TAVUSH, ARMENIA
2013

Cristina García Rodero

JULY 1 2 3 4 5 6 7 8 9 10 11 12 13 14 15 16 17 18 19 20 **21** 22 23 24 25 26 27 28 29 30 31

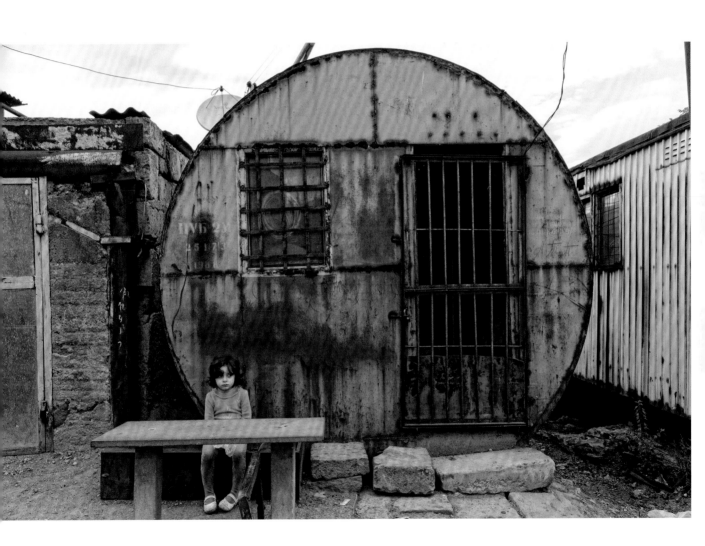

TAVUSH, ARMENIA
Fresh homegrown figs and grapes grace the
table in Anush and Ararat's living room. 2013

Cristina García Rodero

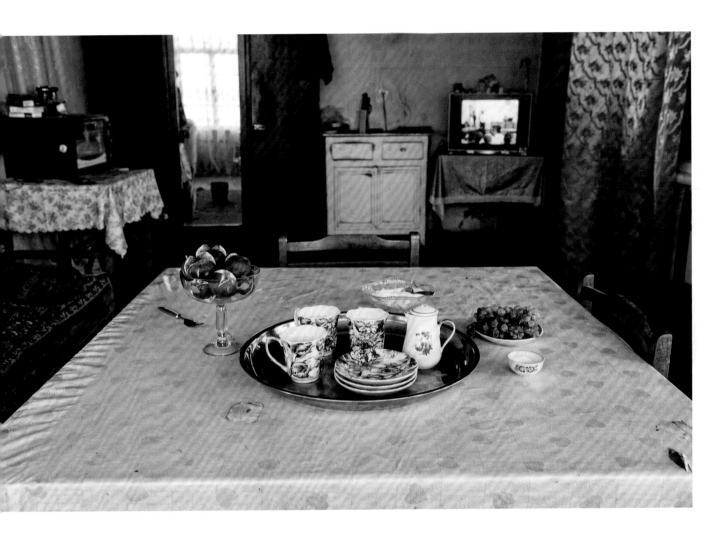

TAVUSH, ARMENIA
Kristine, her husband and their children all sleep
in one room. She is playing with her youngest son,
Grikor, while her daughter Inga, aged 10, sleeps. 2013

Cristina García Rodero

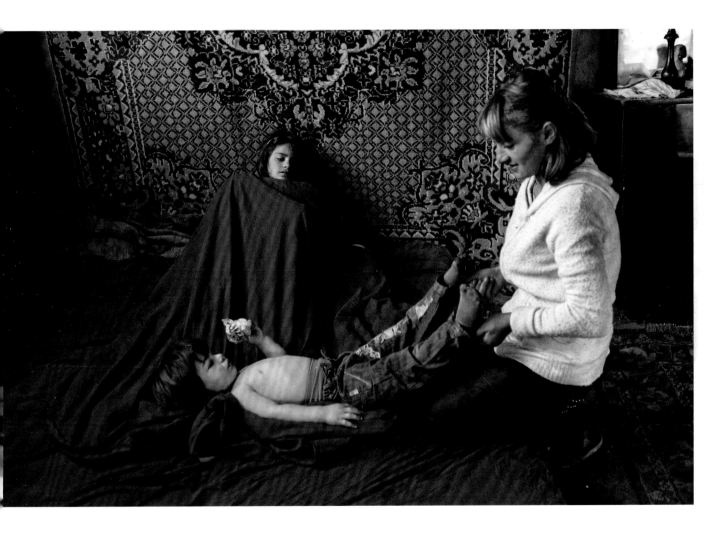

TAVUSH, ARMENIA
Eleven-year-old twins Tigran and Narek
attend the local school in Ayrum. 2013

Cristina García Rodero

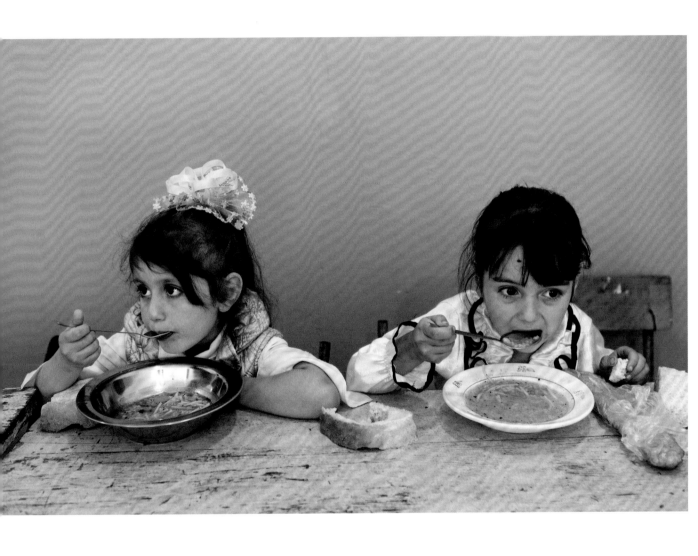

JULY 1 2 3 4 5 6 7 8 9 10 11 12 13 14 15 16 17 18 19 20 21 22 23 24 **25** 26 27 28 29 30 31

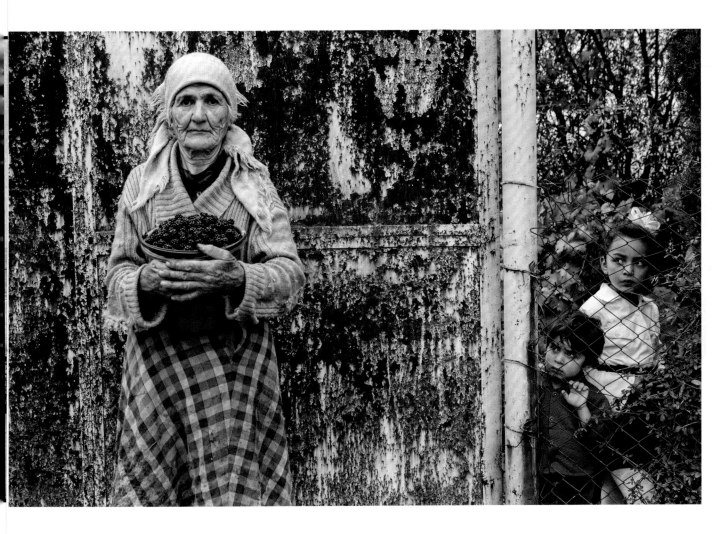

PERSEPOLIS, IRAN
Ruins. 1956

Inge Morath

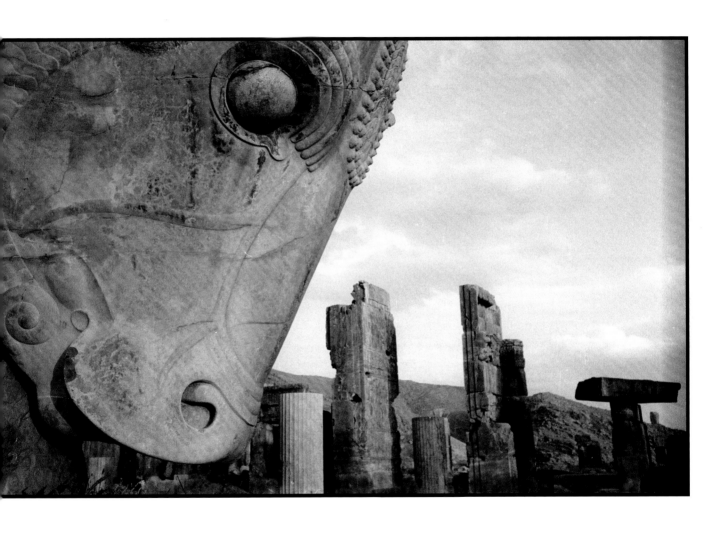

IRAN
Persian Gulf. 1956

Inge Morath

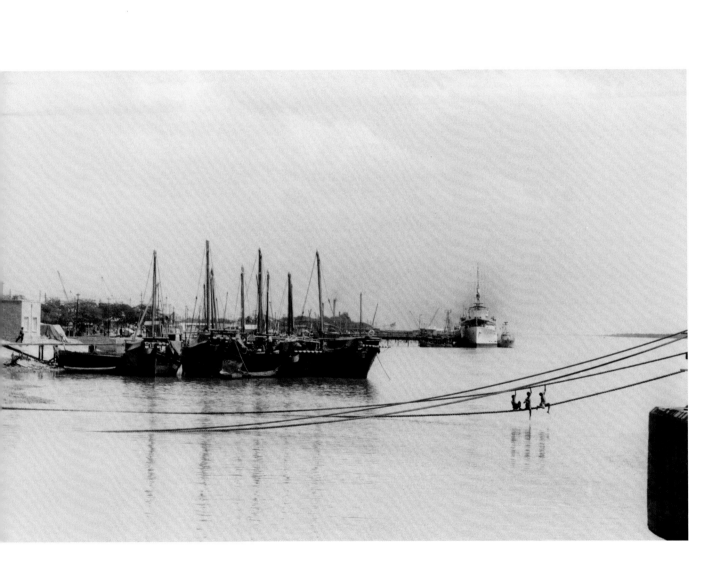

PUL-I-KHUMRI, AFGHANISTAN
Coal miner smoking a cigarette. 2002

Steve McCurry

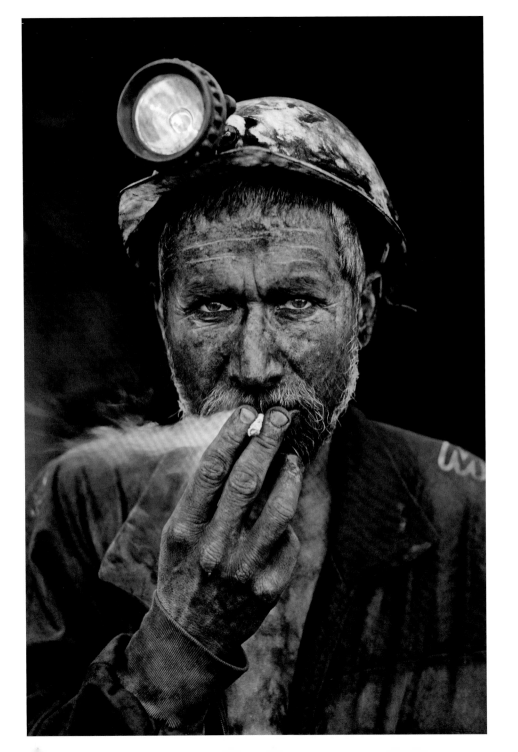

KABUL, AFGHANISTAN
2007

Steve McCurry

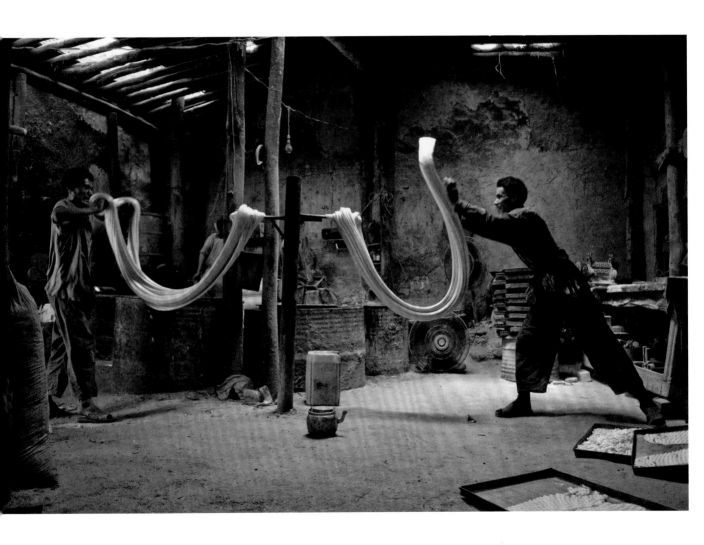

KABUL, AFGHANISTAN
Boy selling oranges. 2003

Steve McCurry

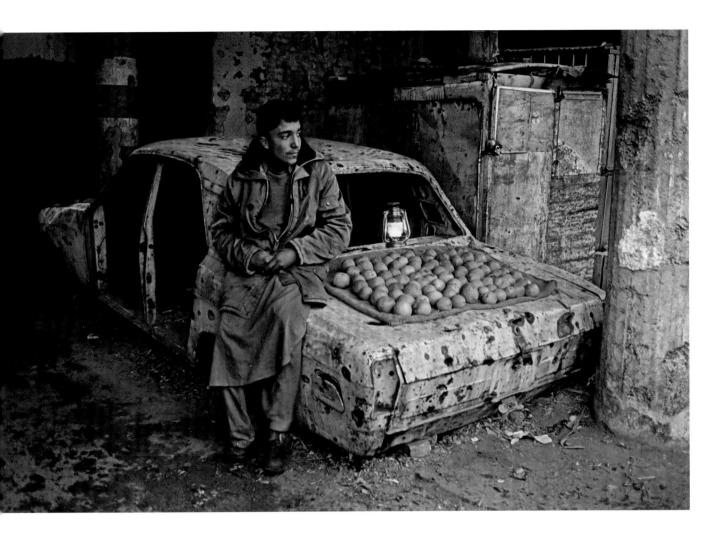

AFGHANISTAN
Two young Hazara girls read at school. 2007

Steve McCurry

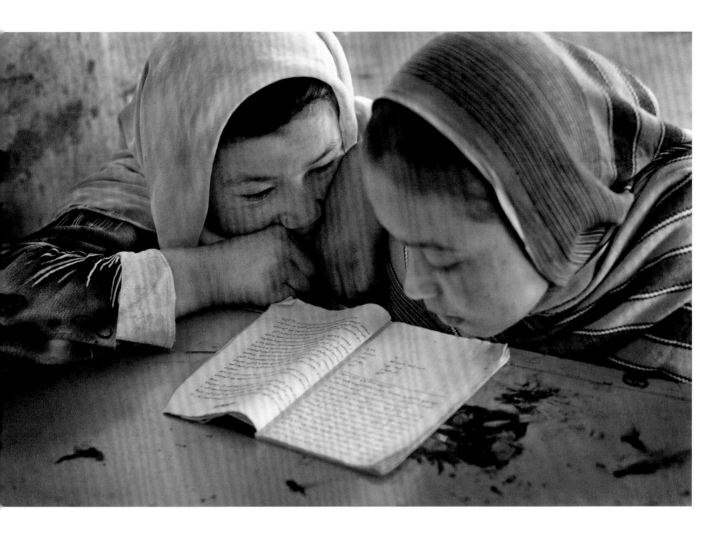

AFGHANISTAN
2016

Steve McCurry

AUGUST 1 2 **3** 4 5 6 7 8 9 10 11 12 13 14 15 16 17 18 19 20 21 22 23 24 25 26 27 28 29 30 31

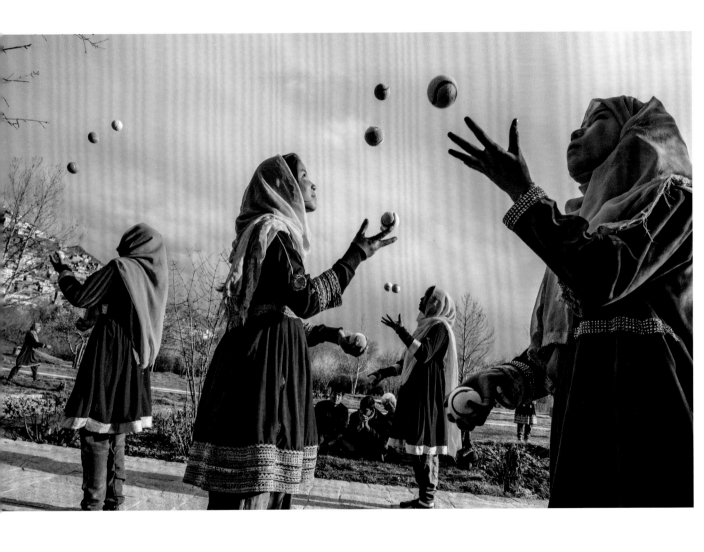

LAHORE, PAKISTAN
1954

Elliott Erwitt

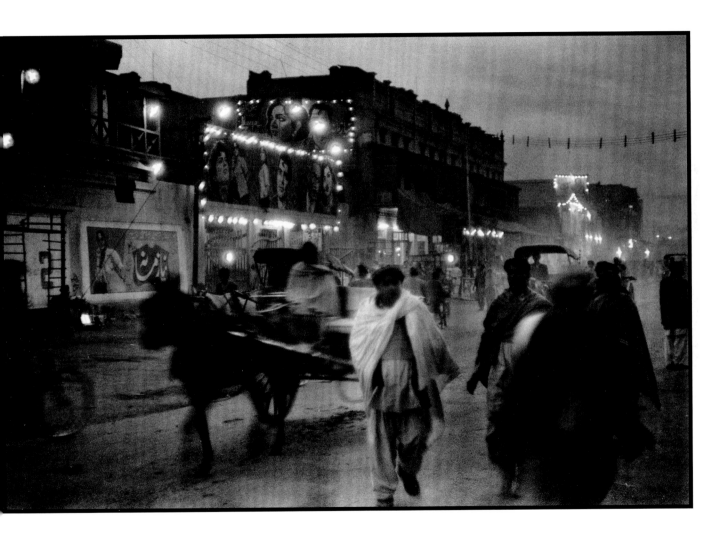

LAHORE, PAKISTAN
1960

Elliott Erwitt

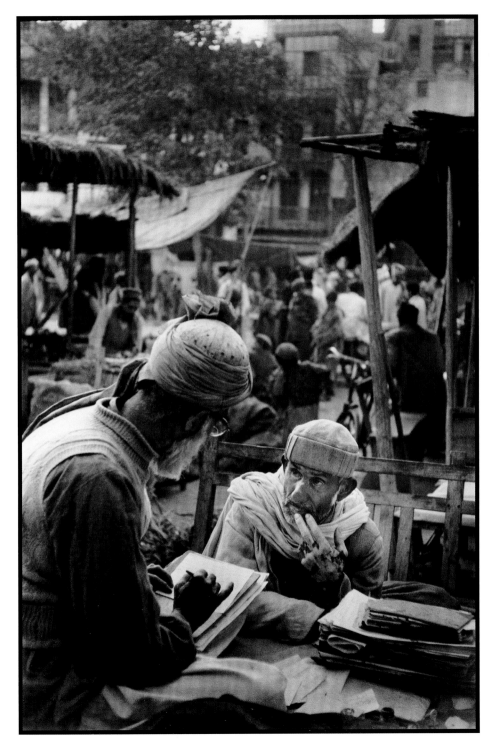

LAHORE, PAKISTAN
Arms factory. 1980

Elliott Erwitt

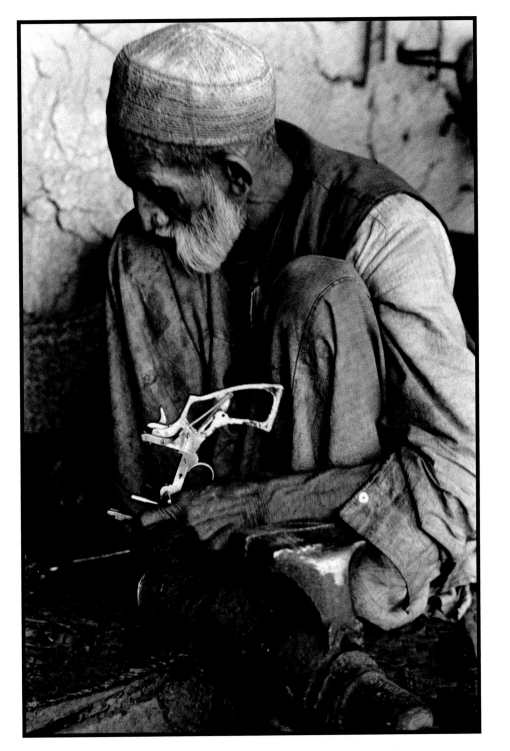

LAHORE, PAKISTAN
1980

Elliott Erwitt

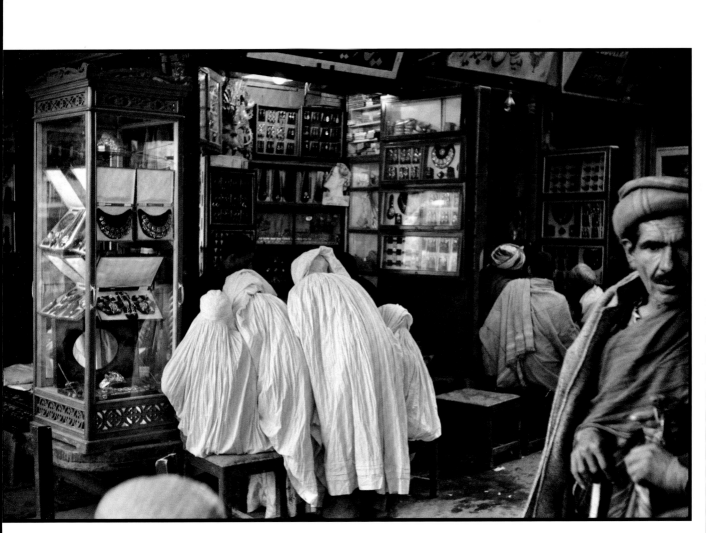

JEDDAH, SAUDI ARABIA
Saudi girls at a women-only Iftar party. 2010

Olivia Arthur

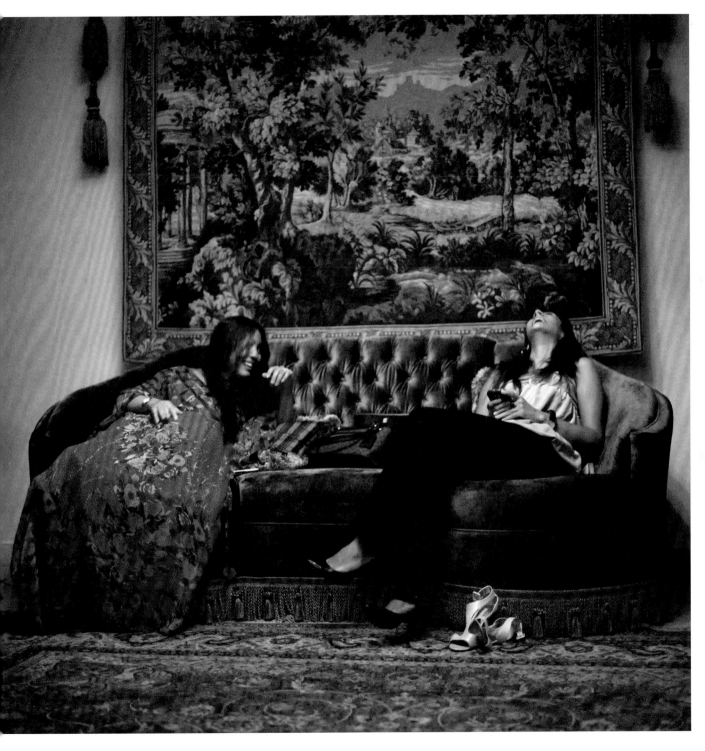

JEDDAH, SAUDI ARABIA
2009

Olivia Arthur

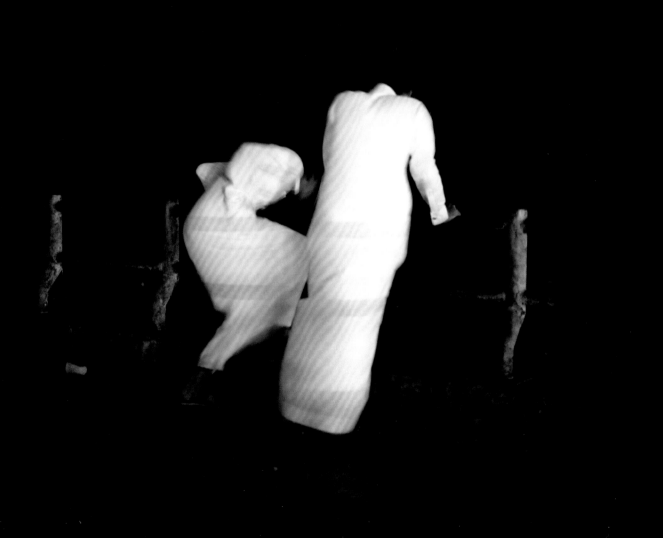

RIYADH, SAUDI ARABIA
2009

Olivia Arthur

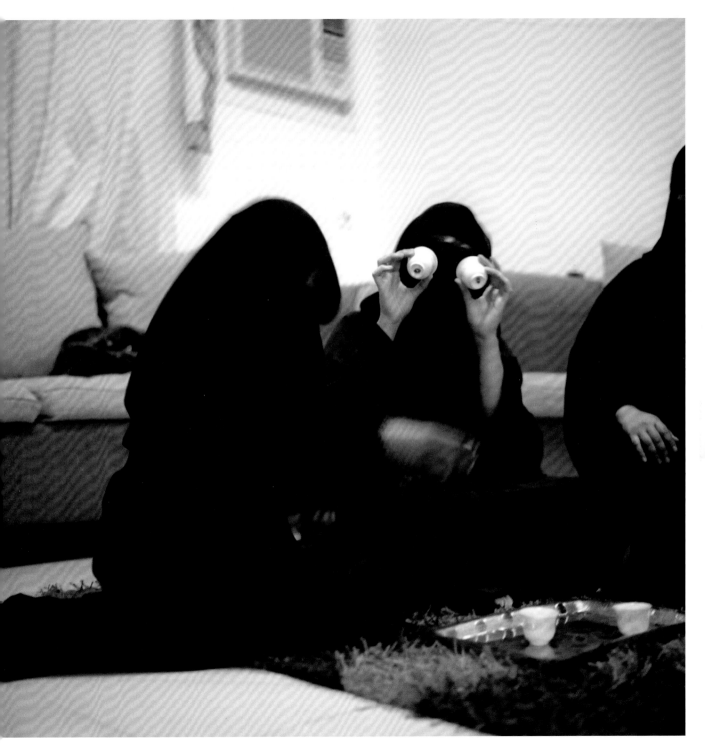

DUBAI, UAE
Billboard advert for a water park. 2013

Olivia Arthur

DUBAI, UAE
Dubailand entertainment complex under
construction. 2013

Olivia Arthur

DUBAI, UAE
Trees at night in Sonapur. 2014

Olivia Arthur

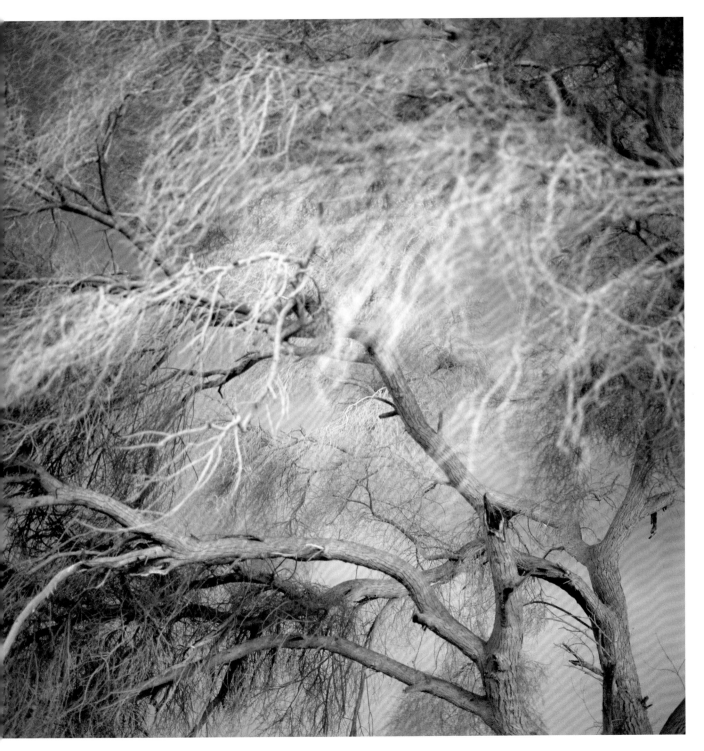

KUWAIT
Veiled Arab women at the
wedding of a sheikh. 1952

George Rodger

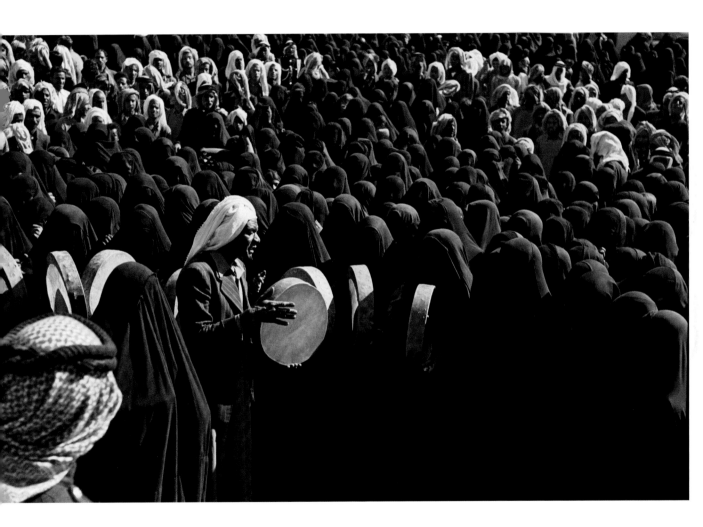

KUWAIT
Oil tank being painted. 1952

George Rodger

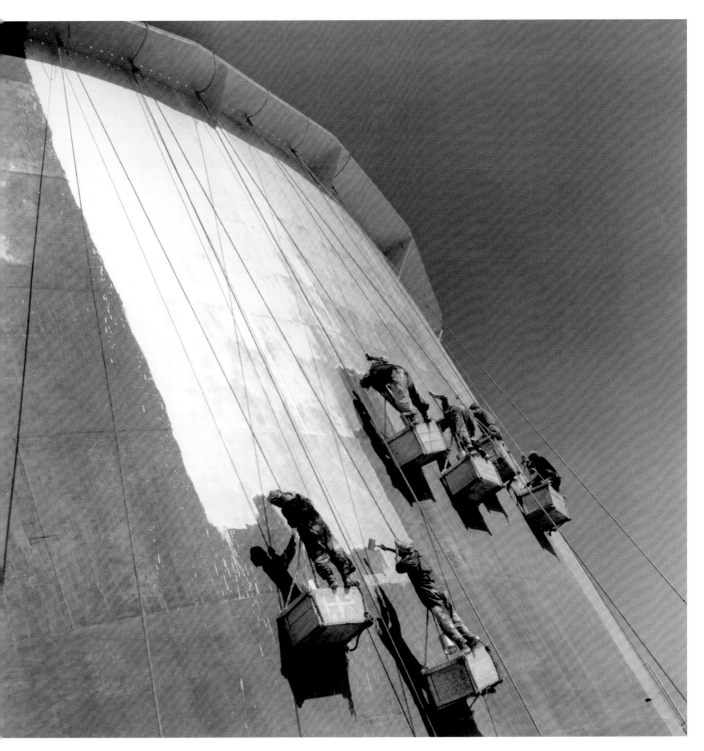

KUWAIT
New houses being constructed near the seafront
to house foreign workers and oil men. 1952

George Rodger

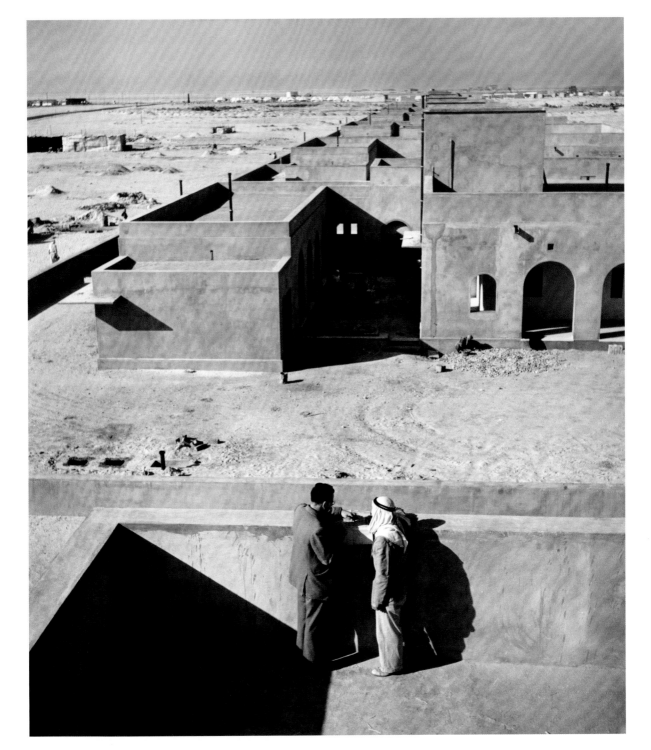

KUWAIT
Young Kuwaiti boys being taught new skills. 1952

George Rodger

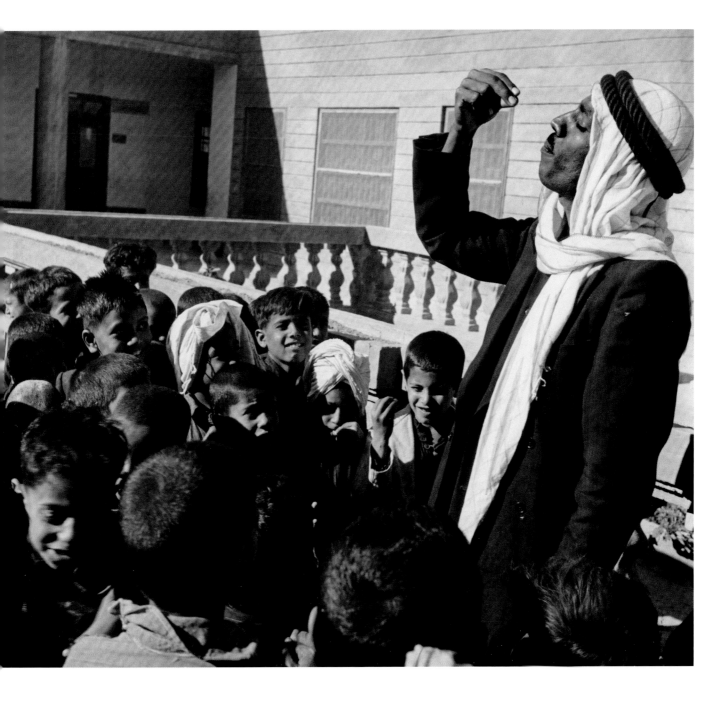

QAYYARAH, IRAQ
People flee Islamic State-controlled areas carrying
with them their possessions, and in the case of
farmers their sheep. 2016

Paolo Pellegrin

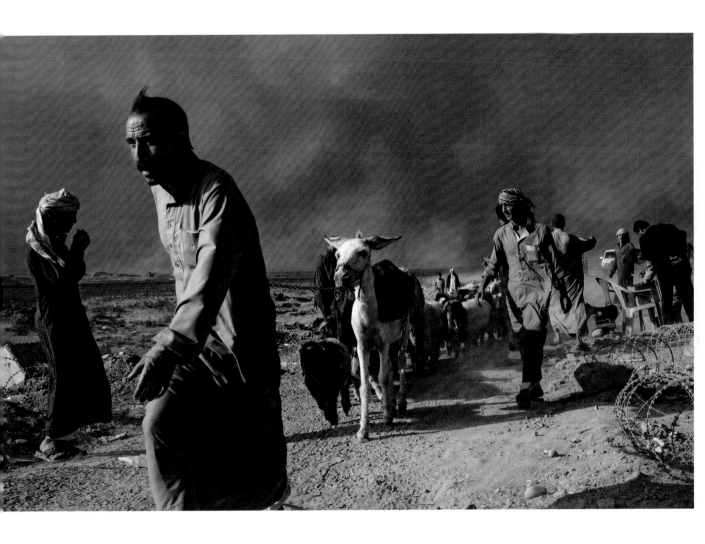

TIKRIT, IRAQ
Girl running in the IIDP Al-Qadisiya
apartment complex in Tikrit. 2016

Paolo Pellegrin

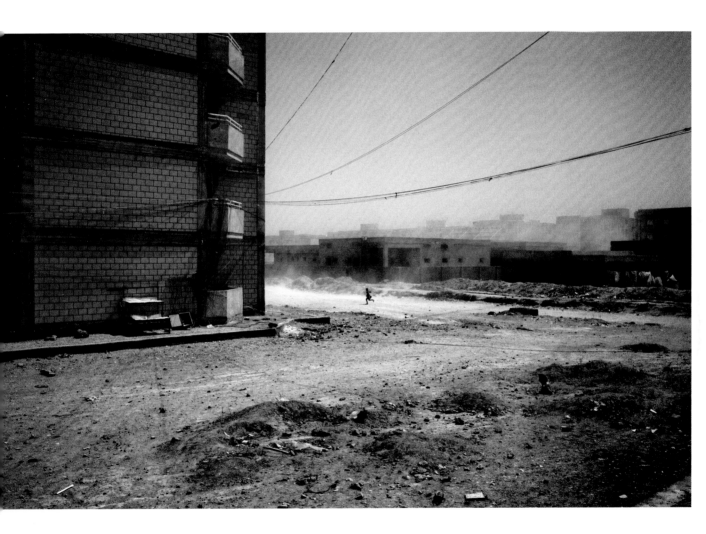

BALAD, IRAQ
Fifty people were killed and nearly a hundred injured
in an Islamic State suicide attack on the Sayyid
Mohammed Shia shrine in Balad north of Baghdad in
the early hours of Friday, 8 July 2016

Paolo Pellegrin

AUGUST 1 2 3 4 5 6 7 8 9 10 11 12 13 14 15 16 17 18 19 **20** 21 22 23 24 25 26 27 28 29 30 31

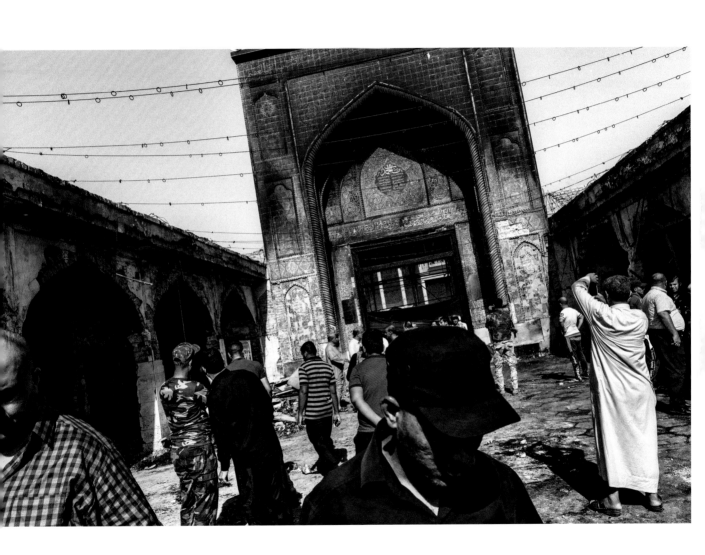

BALAD, IRAQ
Fifty people were killed and nearly a hundred injured
in an IS suicide attack on the Sayyid Mohammed
Shia shrine in Balad north of Baghdad in the early
hours of Friday, 8 July 2016

Paolo Pellegrin

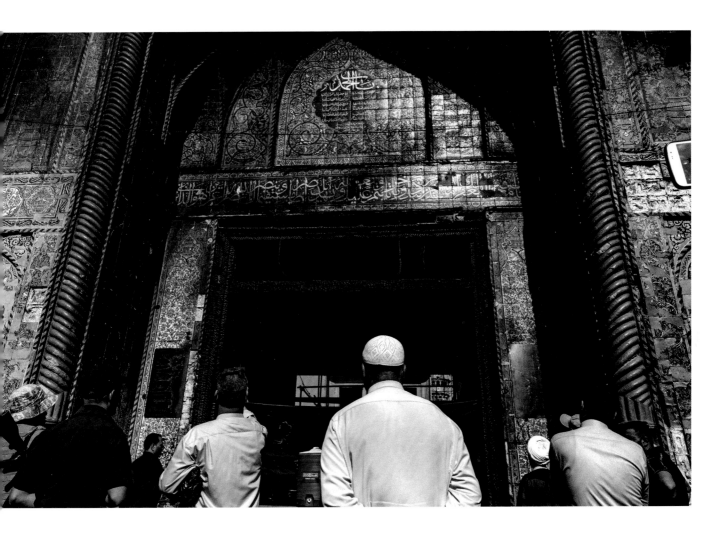

BAGHDAD, IRAQ
The aftermath of the bombing in the predominantly
Shia neighbourhood of Karrada in central Baghdad
on 3 July 2016

Paolo Pellegrin

AUGUST 1 2 3 4 5 6 7 8 9 10 11 12 13 14 15 16 17 18 19 20 21 **22** 23 24 25 26 27 28 29 30 31

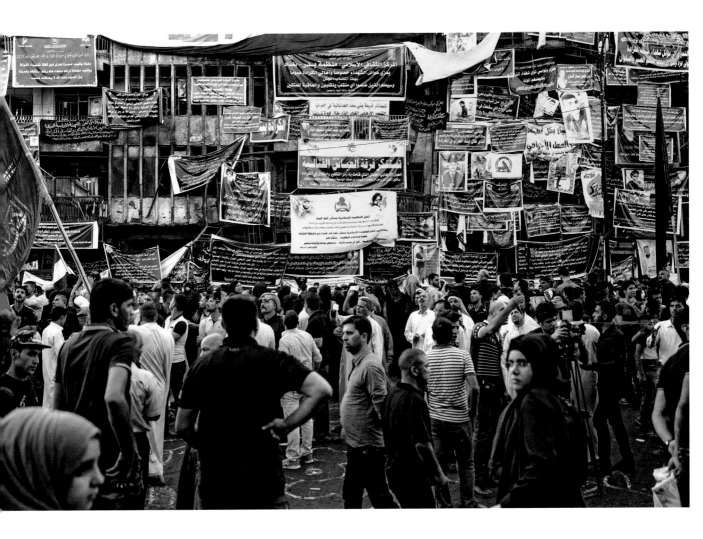

TEL AVIV, ISRAEL
The "old" Central Bus Station. 1966

Micha Bar Am

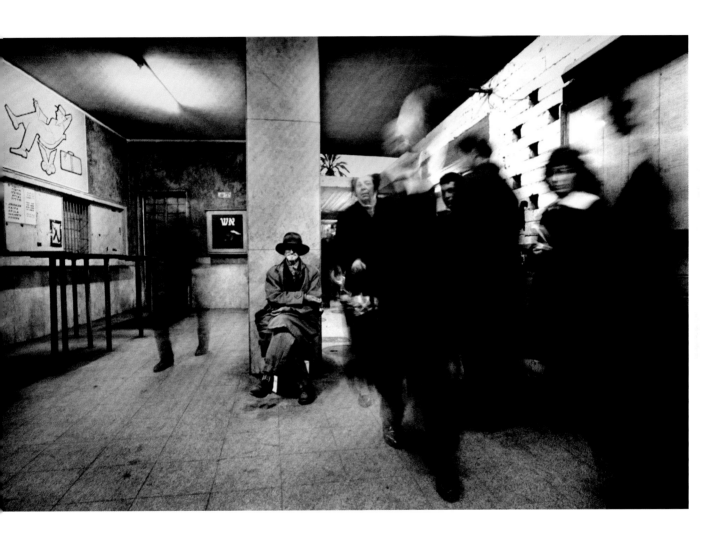

TEL AVIV, ISRAEL
A "hostess" in HaYarkon Street. 1969

Micha Bar Am

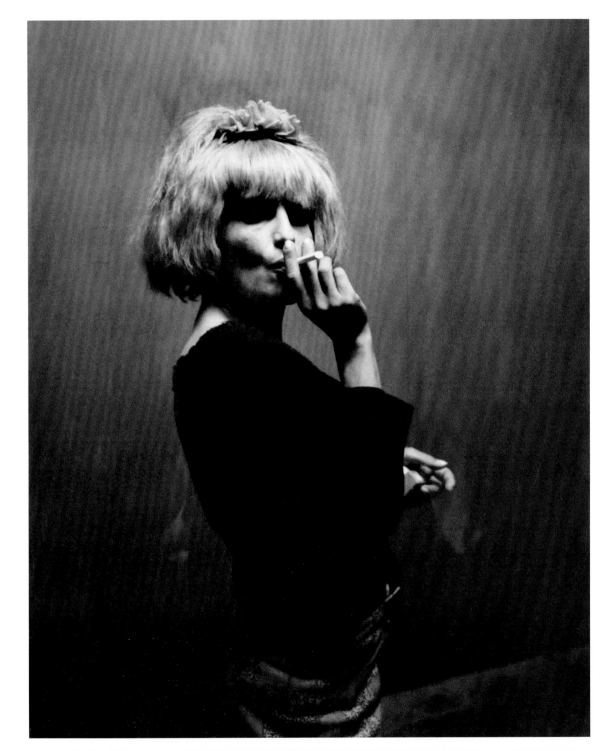

SINAI DESERT, ISRAEL
Father Neophitus, Saint Catherine's Monastery. The
Greek Orthodox priest had just finished baking bread,
which would be given to the Bedouin in the area in
accordance with an agreement made centuries ago
which guaranteed them safety. 1967

Micha Bar Am

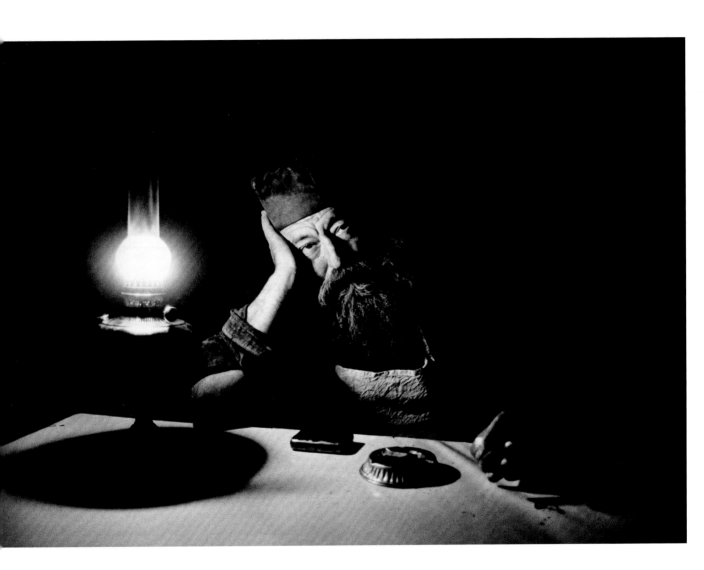

NABI SALEH, WEST BANK, PALESTINE
Palestinian protestors run from tear gas fired by
Israeli soldiers at a weekly protest against the
Israeli occupation. 2013

Peter van Agtmael

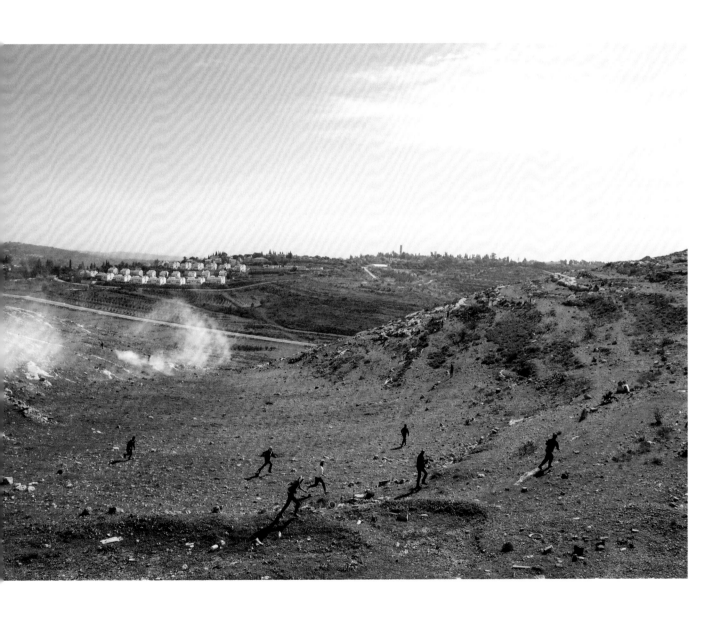

HEBRON, WEST BANK, PALESTINE
The rooftop of one of the last remaining Palestinian families living on Shuhada Street in Hebron. The family is frequently harassed by Israeli settlers who live just metres away. 2013

Peter van Agtmael

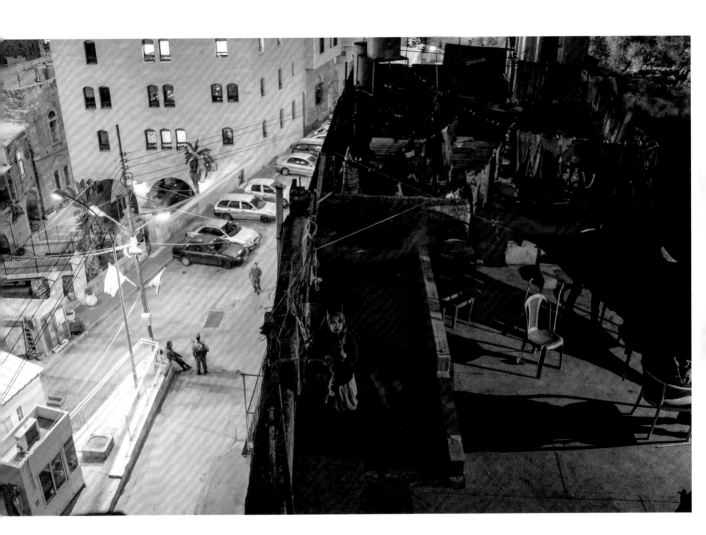

JERUSALEM, ISRAEL
Outside the Old City during Passover. 2015

Peter van Agtmael

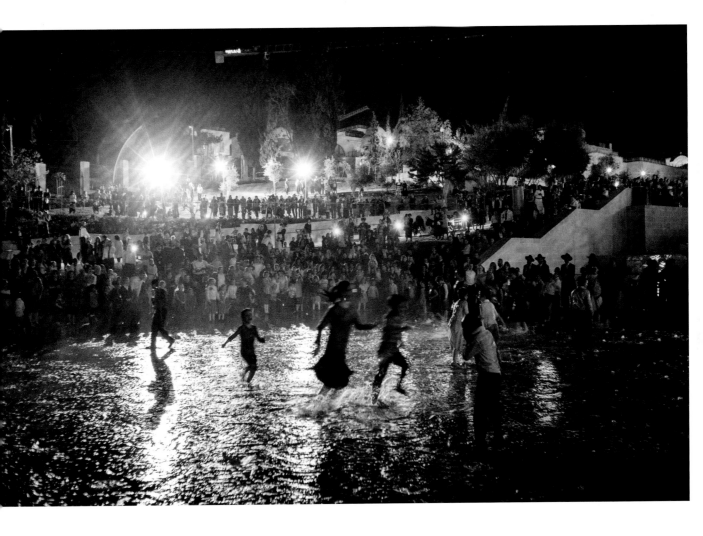

JERUSALEM, ISRAEL
Damascus Gate of Jerusalem's Old City. 2014

Peter van Agtmael

AUGUST 1 2 3 4 5 6 7 8 9 10 11 12 13 14 15 16 17 18 19 20 21 22 23 24 25 26 27 28 **29** 30 31

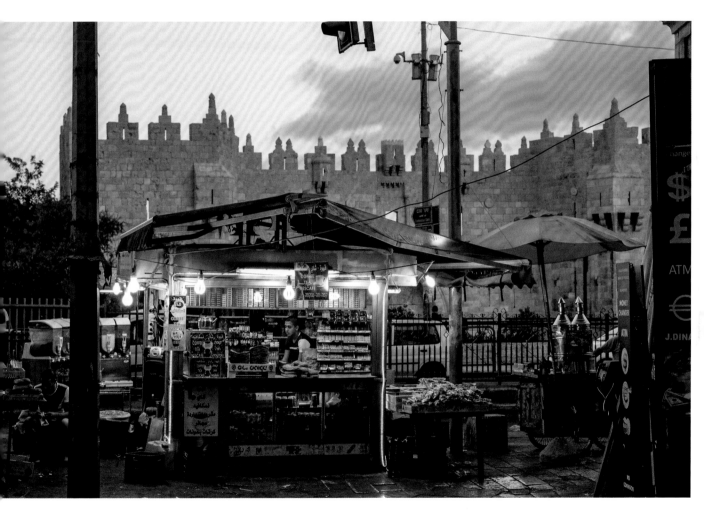

KEREM SHALOM, ISRAEL
The Kerem Shalom border crossing separating
Israel from Gaza. Humanitarian aid is transferred
from this crossing. 2014

Peter van Agtmael

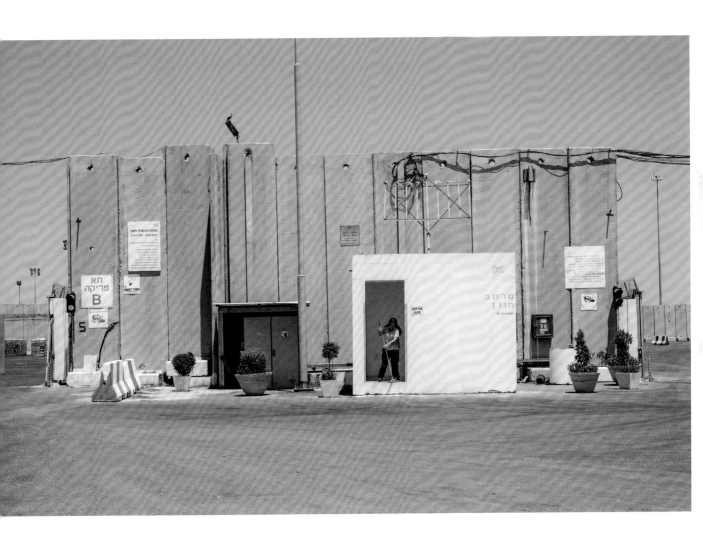

CAIRO, EGYPT
A young labourer inside a small aluminium pot
factory in the El-Magweern neighbourhood, one
of the poorest districts in the city. 2011

Moises Saman

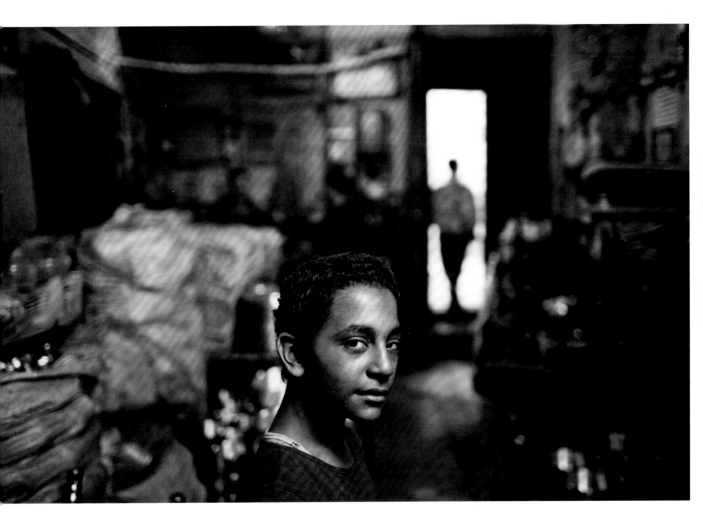

CAIRO, EGYPT
The Pyramids of Giza. 2013

Moises Saman

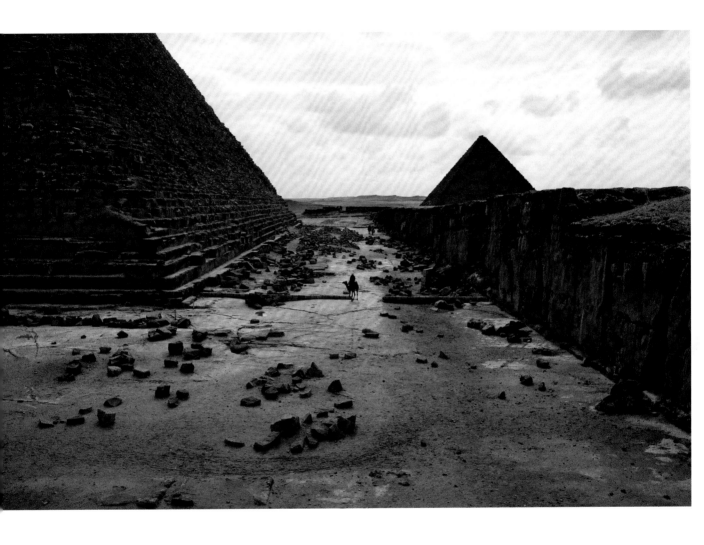

GONDAR, ETHIOPIA
Orthodox Christians celebrate Saint Mary's Day at
the church which bears her name. Priests sing and
dance to the beat of drums in her honour. 2015

Abbas

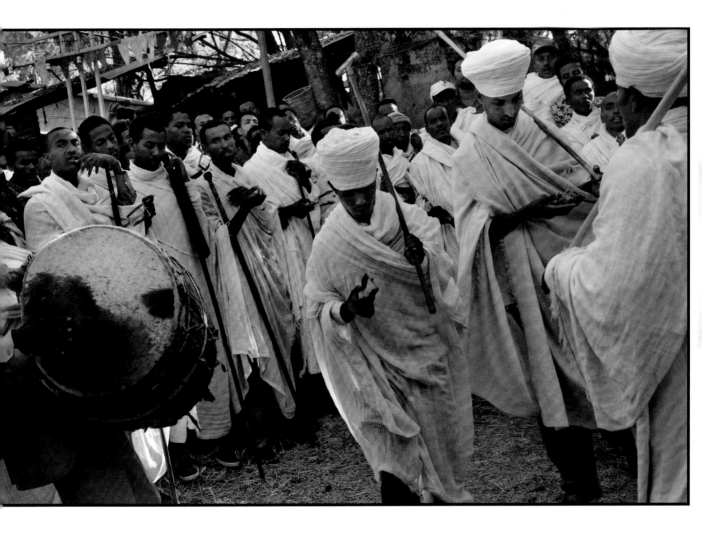

GONDAR, ETHIOPIA
Early morning street life in a popular
neighbourhood inhabited mostly by Orthodox
Christians. A woman burns teff-millet pancakes
to be fermented into a local beer. 2015

Abbas

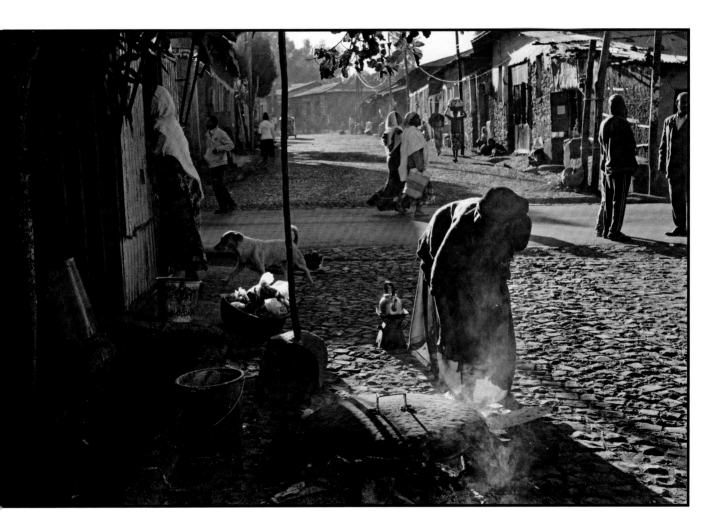

GONDAR, ETHIOPIA
A Jewish family which, having abandoned its good
village life, is still hoping to emigrate to Israel.
They are called Falash Mura. 2015

Abbas

SEPTEMBER 1 2 3 **4** 5 6 7 8 9 10 11 12 13 14 15 16 17 18 19 20 21 22 23 24 25 26 27 28 29 30

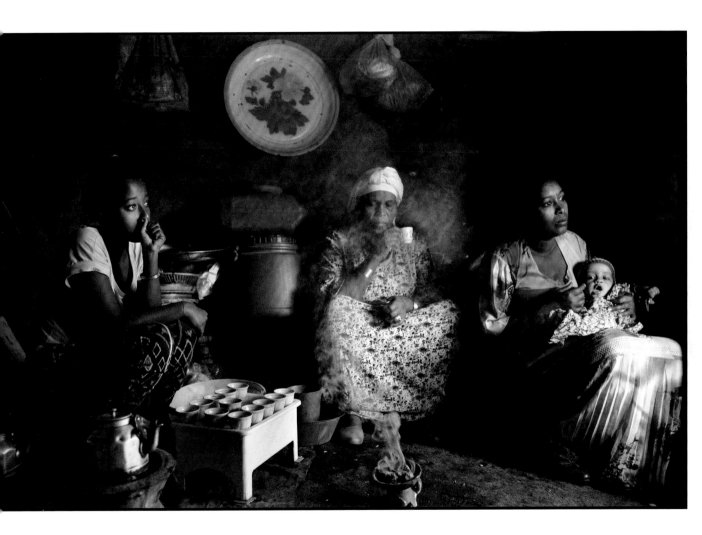

OROMIA REGION, ETHIOPIA
Magnete coffee cooperative. A woman performs
the coffee ceremony. Water is added to the coffee
in a kettle and put on the fire. Her sister attends
the ceremony. 2015

Abbas

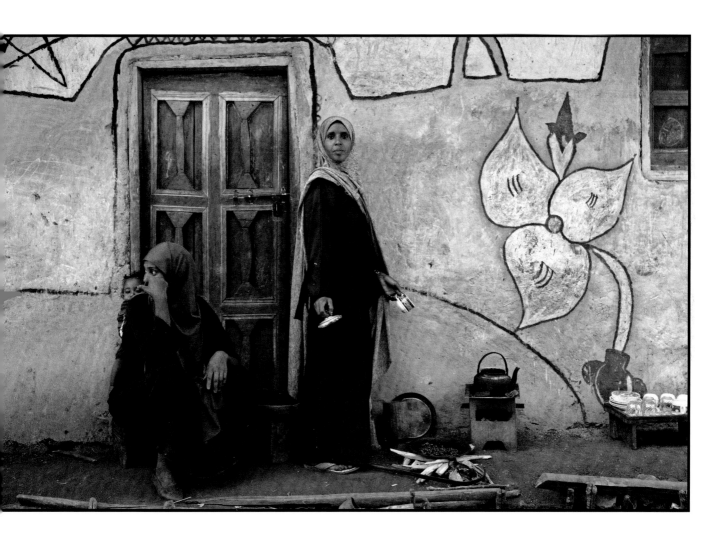

NEAR DODOLA, ETHIOPIA
Traditional farmer's compound in the shade
of acacia trees. 2015

Abbas

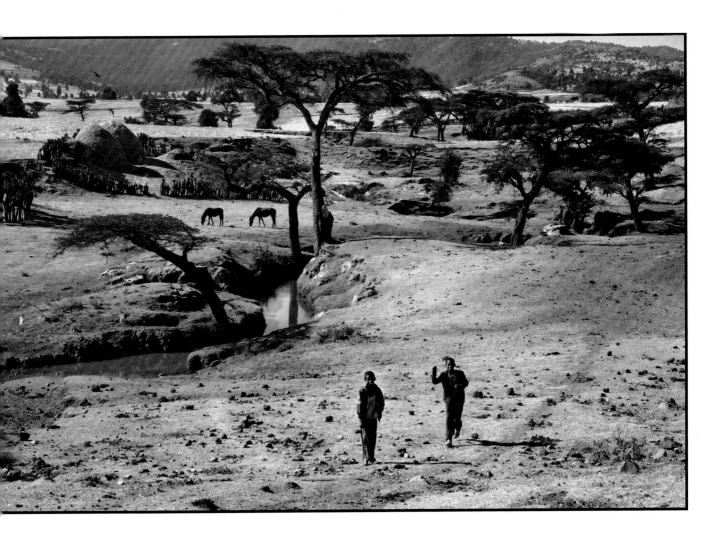

BEIRA, MOZAMBIQUE

Families living in the Grand Hotel in Beira. The Grand is an abandoned hotel that was popular before the revolution. It is now home to over 2,000 people. They live with no electricity or running water. 2012

Eli Reed

SEPTEMBER 1 2 3 4 5 6 **7** 8 9 10 11 12 13 14 15 16 17 18 19 20 21 22 23 24 25 26 27 28 29 30

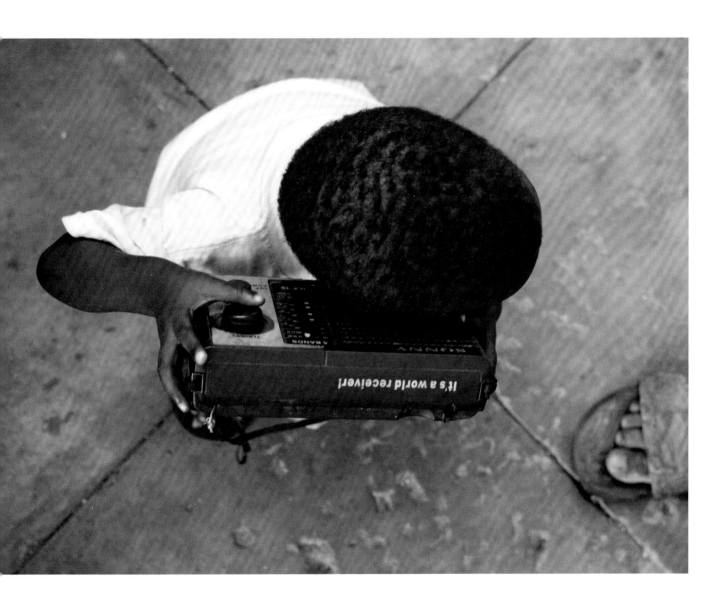

BEIRA, MOZAMBIQUE
Afua and her family. Afua volunteers with the
Kuplumusanna Women's Support Group
in Beira. 2012

Eli Reed

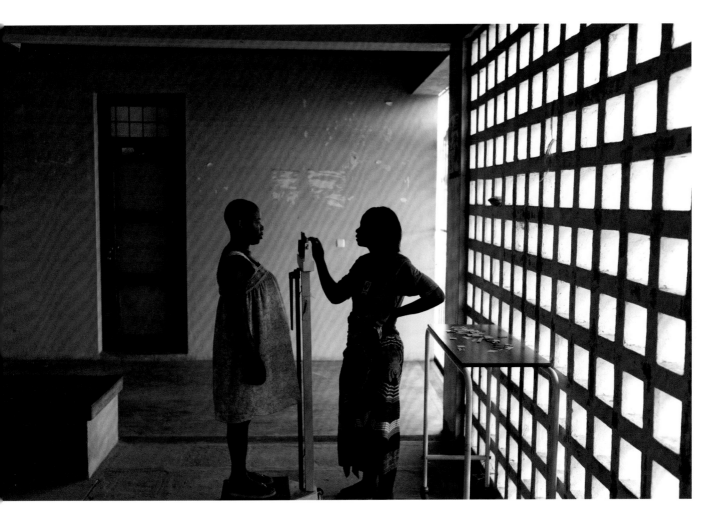

NHAMATANDA, MOZAMBIQUE
Nhamatanda Clinic. 2012

Eli Reed

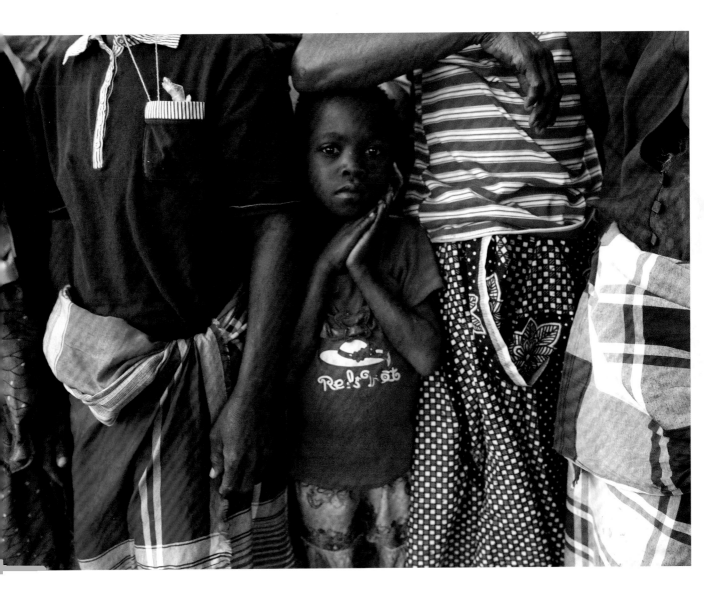

NHAMATANDA, MOZAMBIQUE
The Nhamatanda Clinic is a district-level clinic
located two hours' drive out of Beira in the village
of Nhamatanda. 2012

Eli Reed

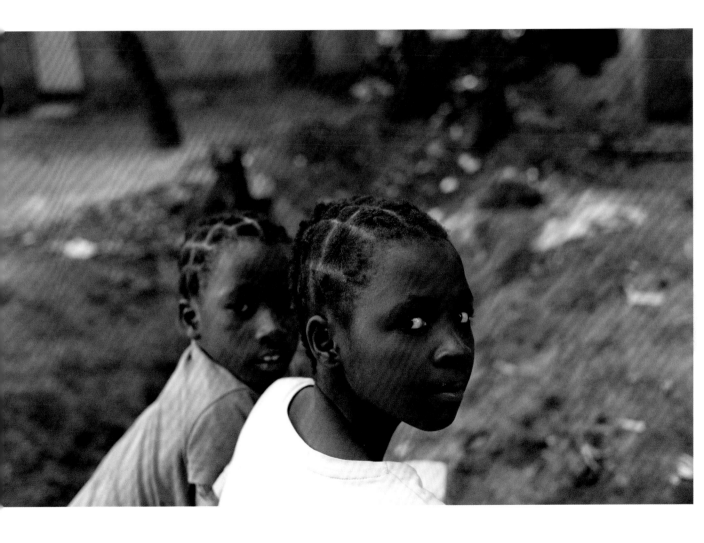

MAPUTO, MOZAMBIQUE
2012

Eli Reed

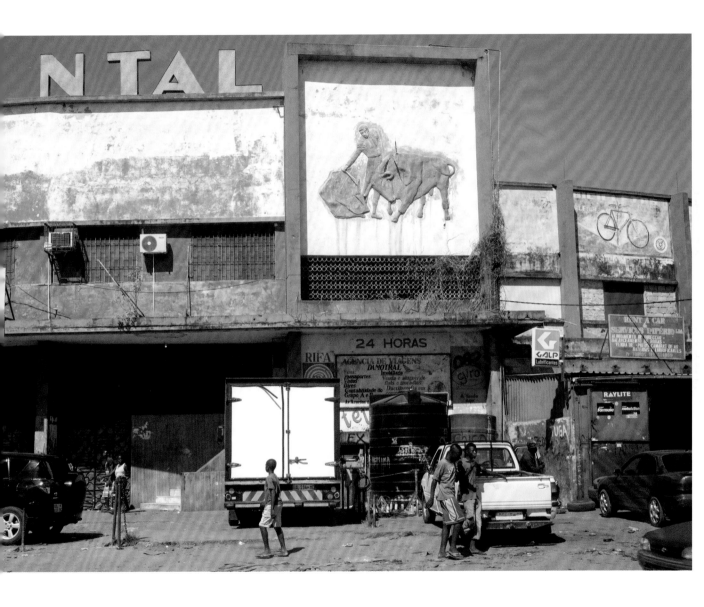

JOHANNESBURG, SOUTH AFRICA
2006

Raymond Depardon

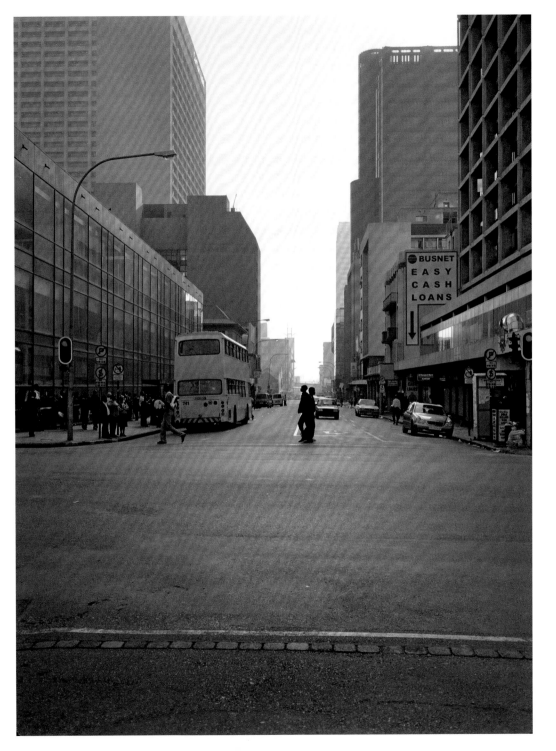

JOHANNESBURG, SOUTH AFRICA
2006

Raymond Depardon

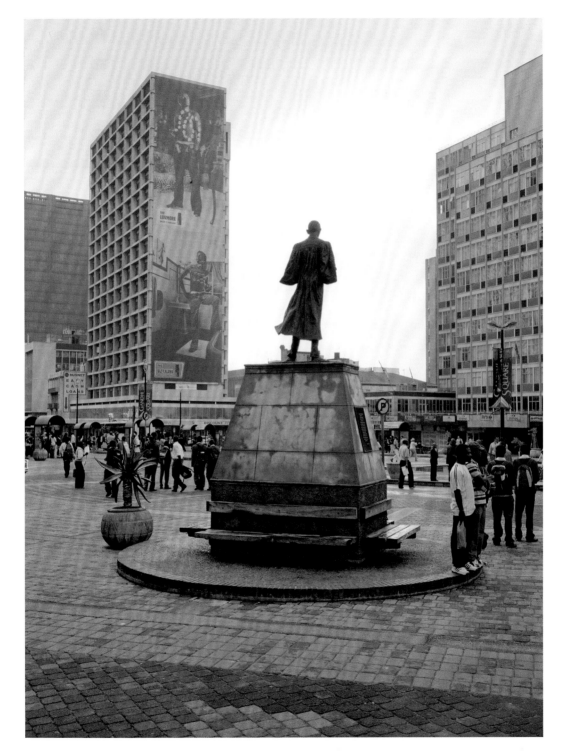

JOHANNESBURG, SOUTH AFRICA
2006

Raymond Depardon

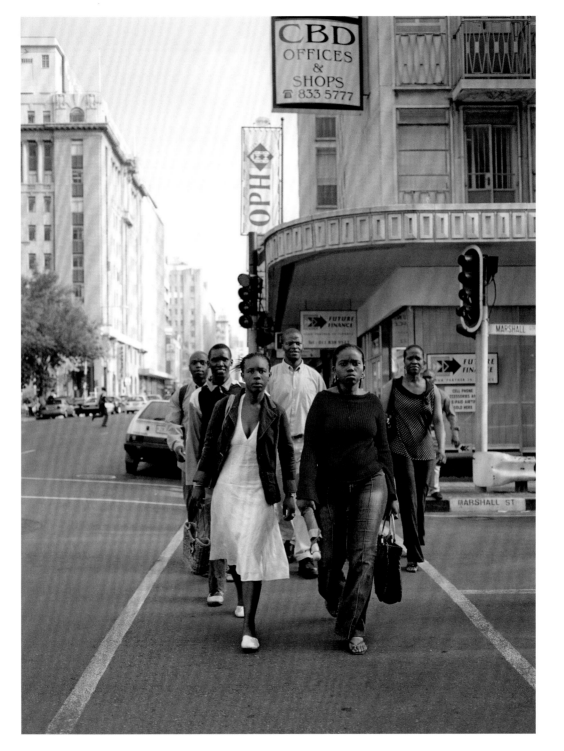

KIGALI, RWANDA
Rayon Sports FC, Stade Régional
de Nyamirambo. 2014

Carl De Keyzer

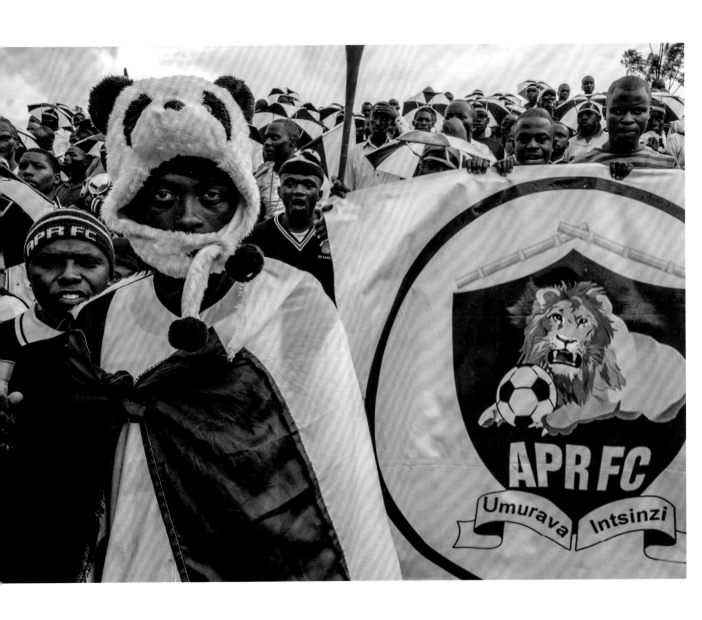

KIGALI, RWANDA
Presidential Palace Museum. Located four
kilometres from Kanombe Airport and the
residence of the formal President Juvénal
Habyarimana from 1973 to 1994. Mostly known
for its flight debris that are the remains of the
flight that went down on 6 April 1994. 2014

Carl De Keyzer

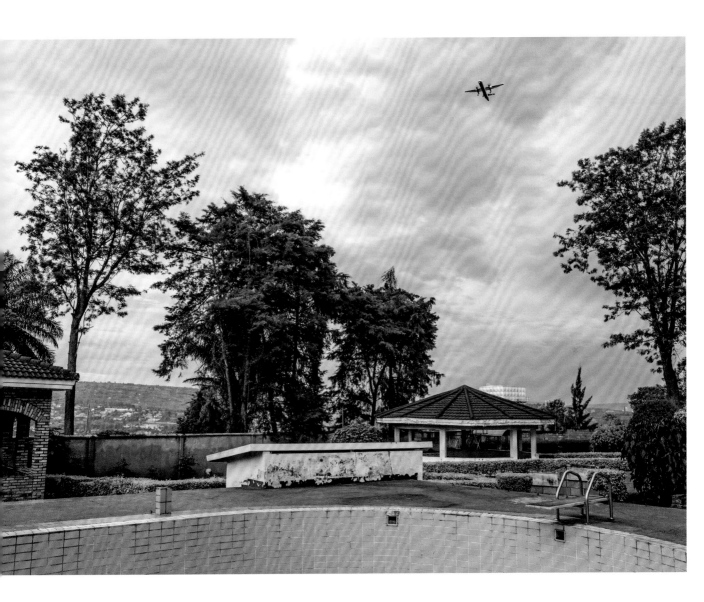

KIGALI, RWANDA
Blind musician, Salax Awards
for young musicians. 2014

Carl De Keyzer

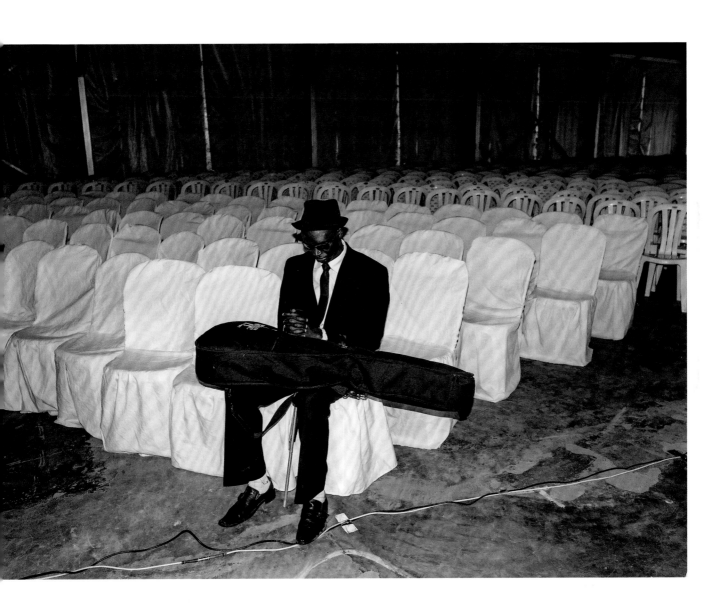

GISENYI, RWANDA
Beach. 2014

Carl De Keyzer

SEPTEMBER 1 2 3 4 5 6 7 8 9 10 11 12 13 14 15 16 17 **18** 19 20 21 22 23 24 25 26 27 28 29 30

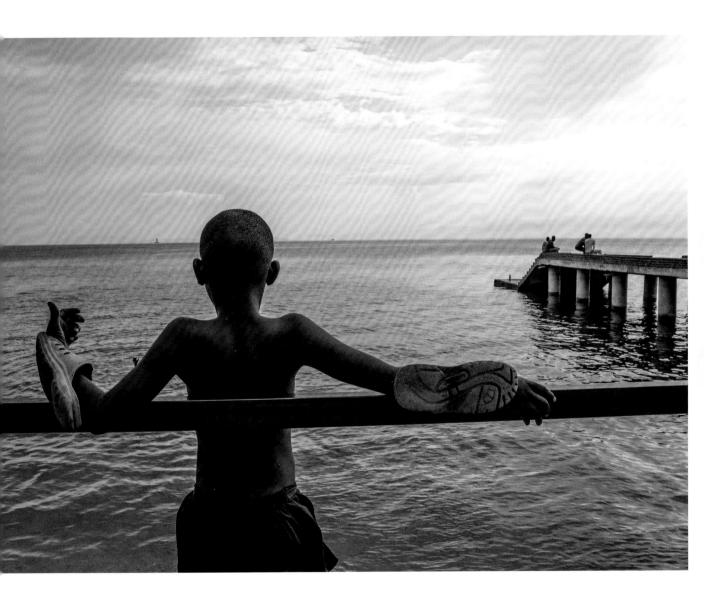

BUTARE, RWANDA
Karubanda Prison. 2014

Carl De Keyzer

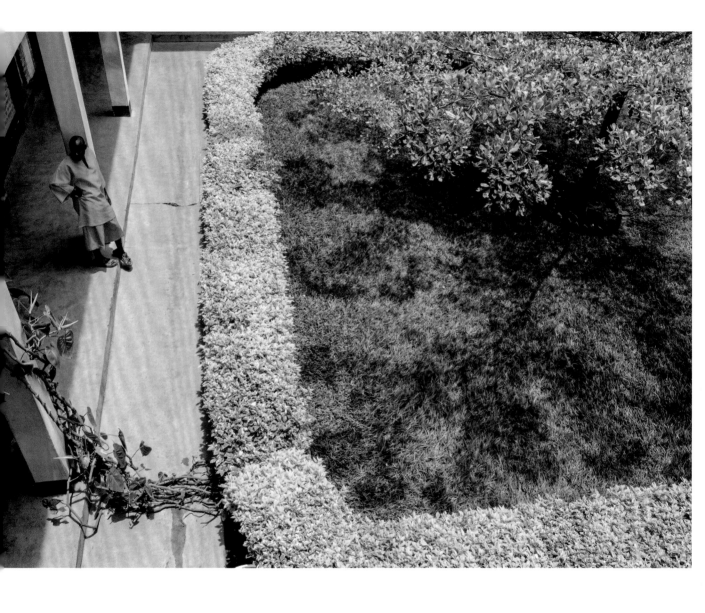

GOMA, DEMOCRATIC REPUBLIC OF THE CONGO
At Goma Airport, planes left due to wars and volcanic eruptions over the past two decades have become a playground for street children, some of whom sell the parts. 2012

Michael Christopher Brown

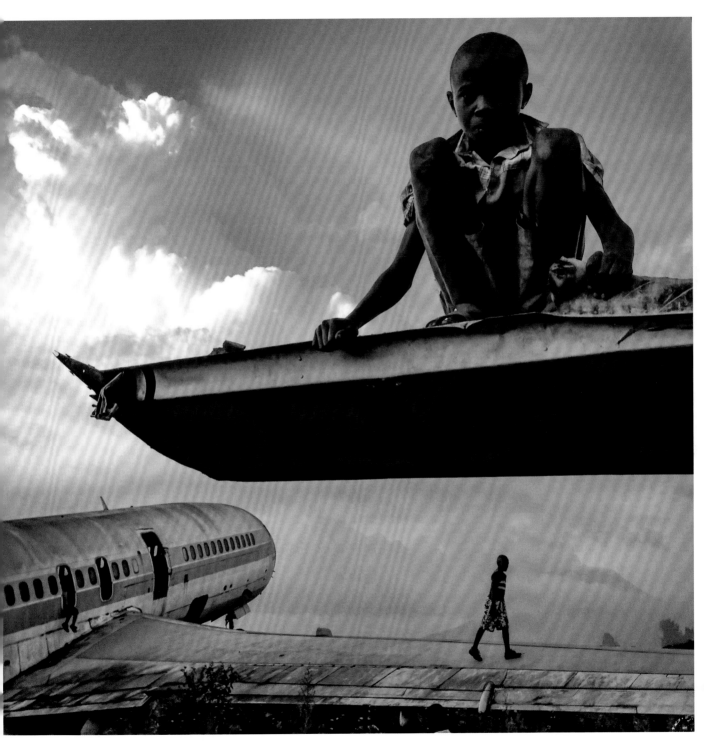

GOMA, DEMOCRATIC REPUBLIC OF THE CONGO
A famous thief, known as Ninja,
walks the streets of Goma. 2013

Michael Christopher Brown

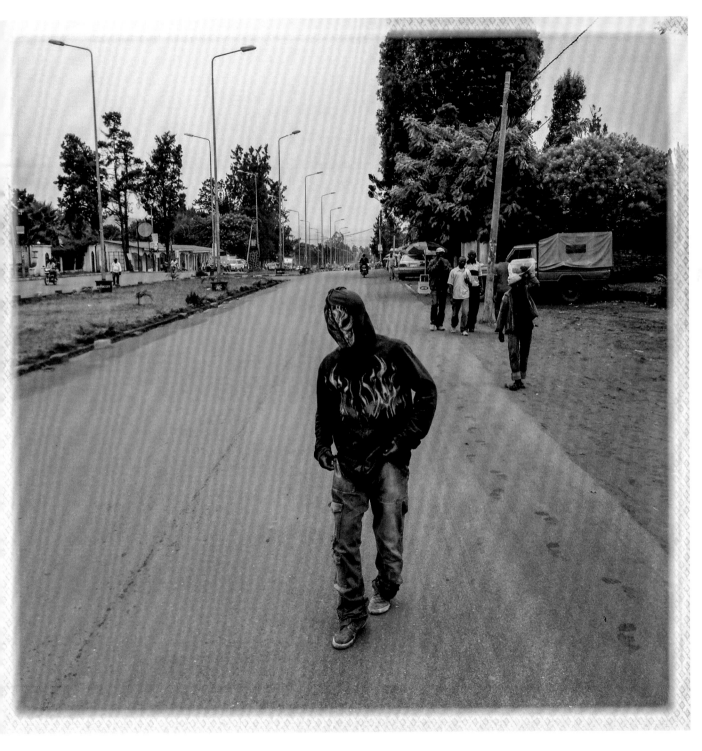

GOMA/GISENYI, DEMOCRATIC REPUBLIC OF THE CONGO
On the shores of Lake Kivu,
on the border with Rwanda. 2012

Michael Christopher Brown

SEPTEMBER 1 2 3 4 5 6 7 8 9 10 11 12 13 14 15 16 17 18 19 20 21 **22** 23 24 25 26 27 28 29 30

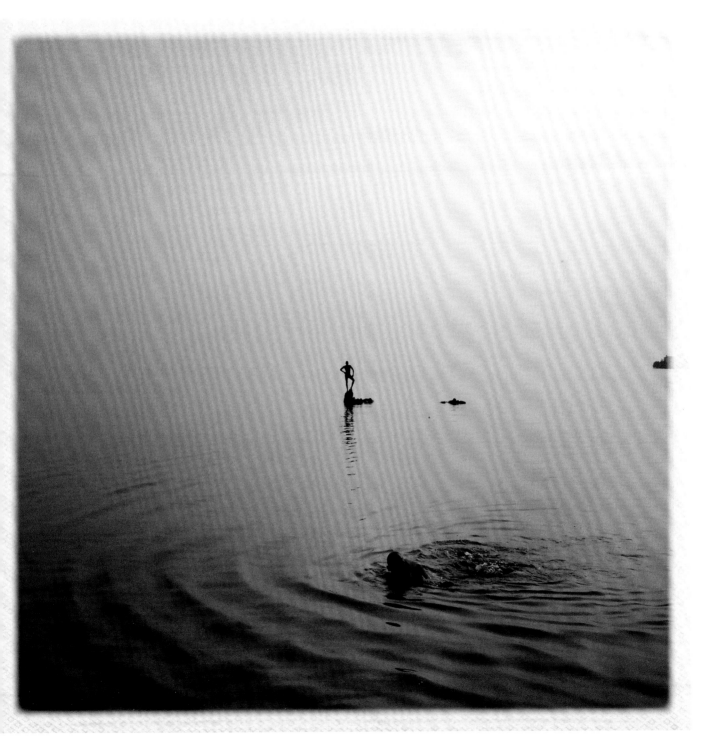

VIRUNGA NATIONAL PARK, DEMOCRATIC REPUBLIC OF THE CONGO
Climbing and camping on Mount Nyiragongo, a volcano. 2016

Michael Christopher Brown

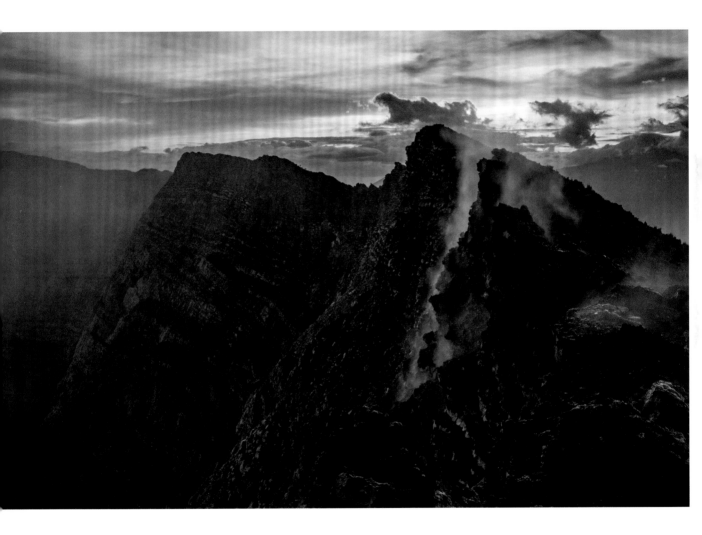

DEMOCRATIC REPUBLIC OF THE CONGO
On the road between Goma and Sake are a series of three internally
displaced persons camps, in an area called Magunga. 2012

Michael Christopher Brown

SEPTEMBER 1 2 3 4 5 6 7 8 9 10 11 12 13 14 15 16 17 18 19 20 21 22 23 **24** 25 26 27 28 29 30

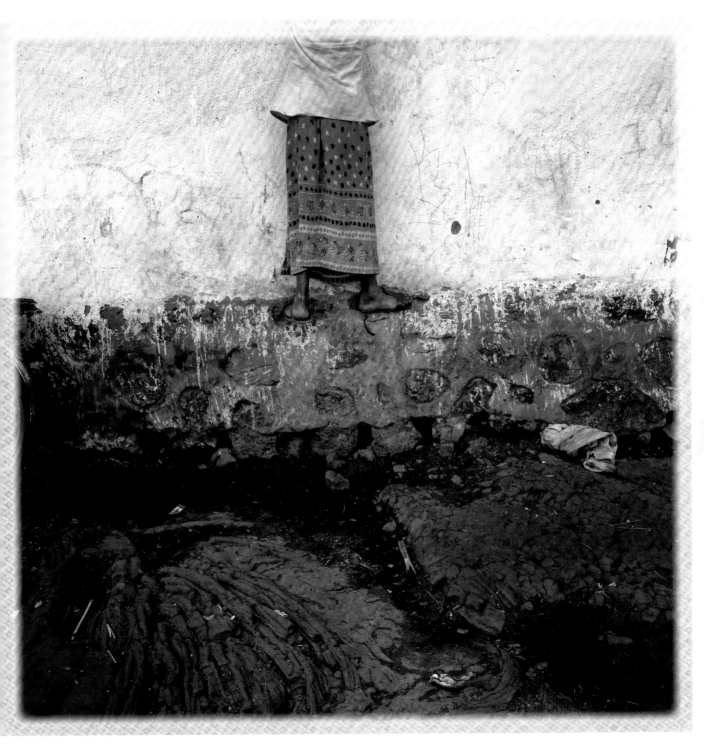

LAMBARÉNÉ, GABON, FRENCH EQUATORIAL AFRICA
Tropical rainstorm over Dr Albert Schweitzer's
missionary station. 1954

W. Eugene Smith

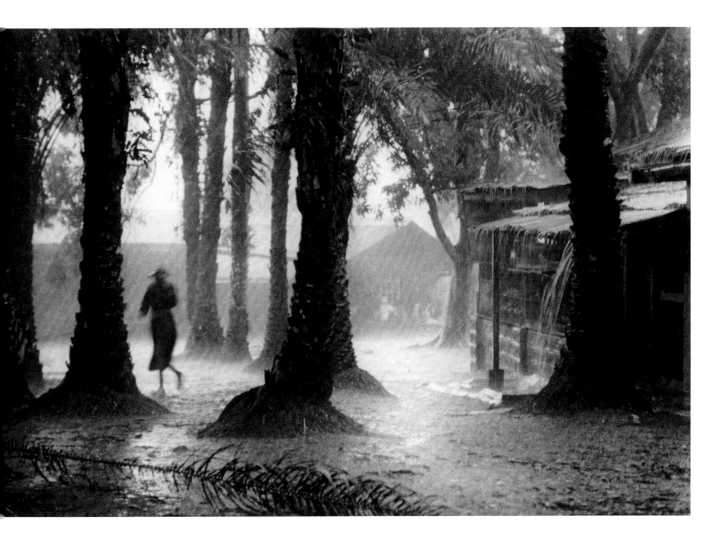

LAMBARÉNÉ, GABON, FRENCH EQUATORIAL AFRICA
On the grounds of Dr Albert Schweitzer's Mission Hospital. 1954

W. Eugene Smith

SEPTEMBER 1 2 3 4 5 6 7 8 9 10 11 12 13 14 15 16 17 18 19 20 21 22 23 24 25 **26** 27 28 29 30

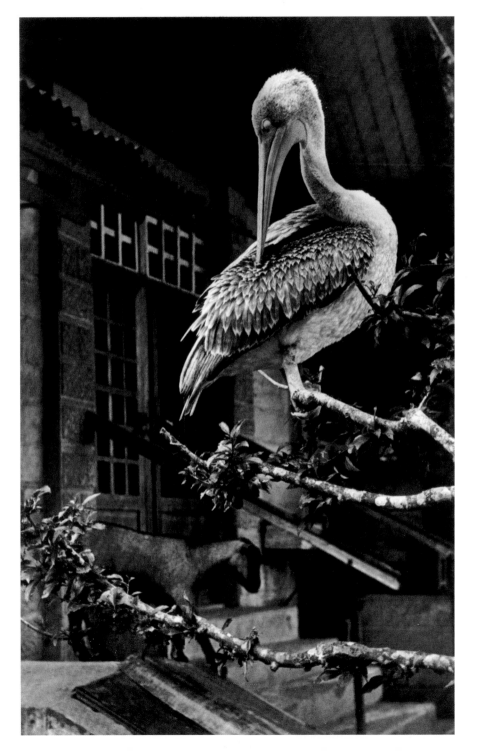

LAMBARÉNÉ, GABON, FRENCH EQUATORIAL AFRICA
Dr Albert Schweitzer's Mission Hospital. A patients'
hands can be seen through the wooden gates. 1954

W. Eugene Smith

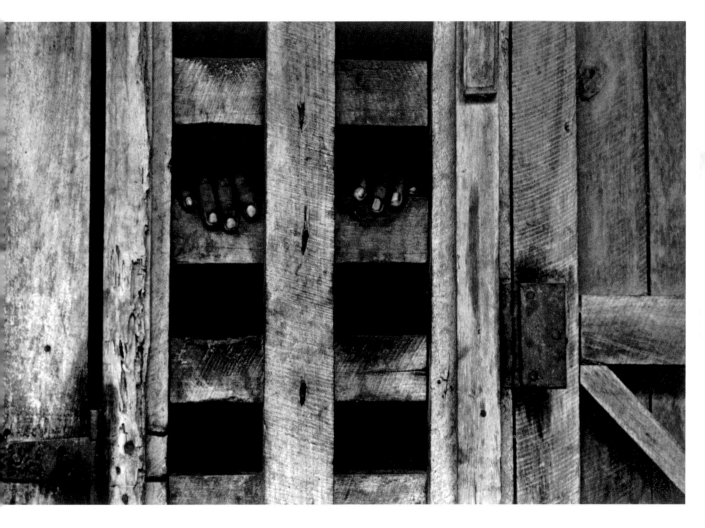

LAGOS, NIGERIA
Oshodi bus station. 2013

Alex Majoli

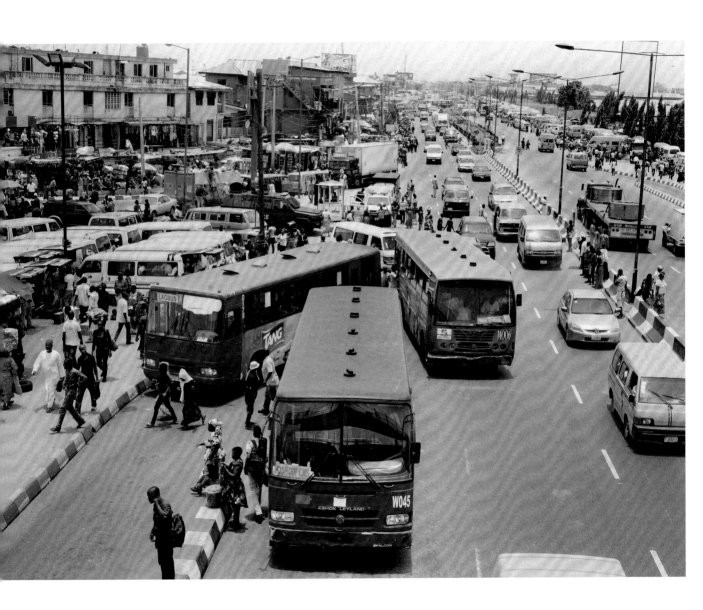

LAGOS, NIGERIA
A fisherman under the Third Mainland Bridge. 2013

Alex Majoli

SEPTEMBER 1 2 3 4 5 6 7 8 9 10 11 12 13 14 15 16 17 18 19 20 21 22 23 24 25 26 27 28 **29** 30

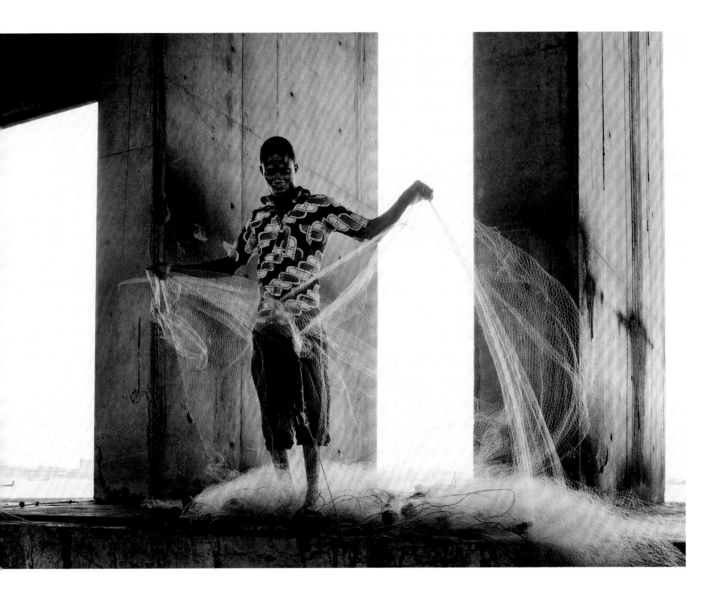

LAGOS, NIGERIA
During the Easter Carnival parade. 2013

Alex Majoli

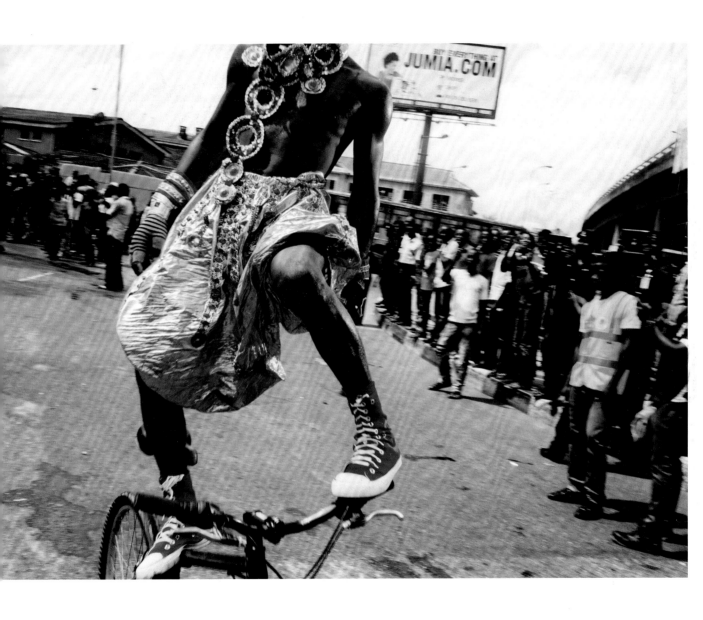

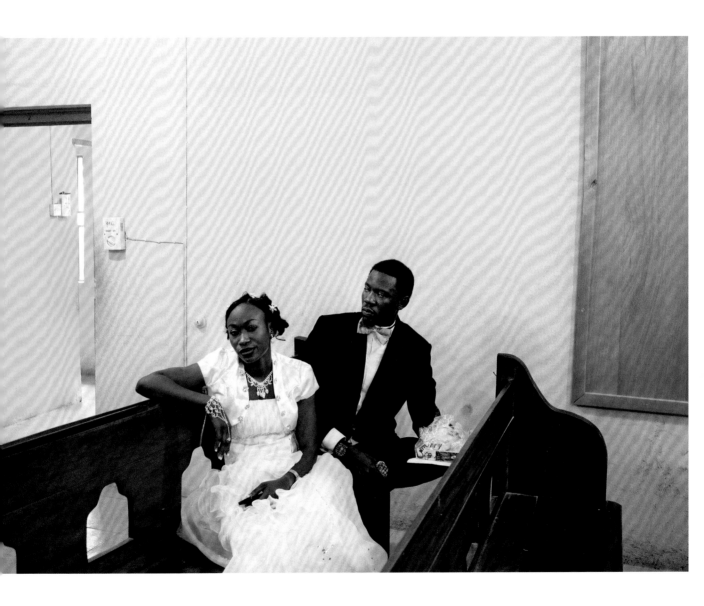

LAGOS, NIGERIA
During a match at the Lagos Polo Club. 2013

Alex Majoli

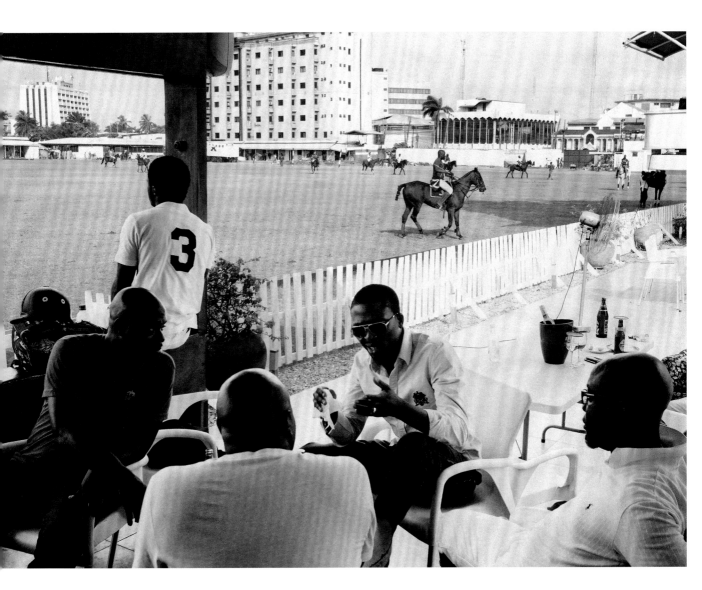

BURKINA FASO
Bus on the Nationale 1 road between Sabou and
Ouagadougou. 1993

Guy Le Querrec

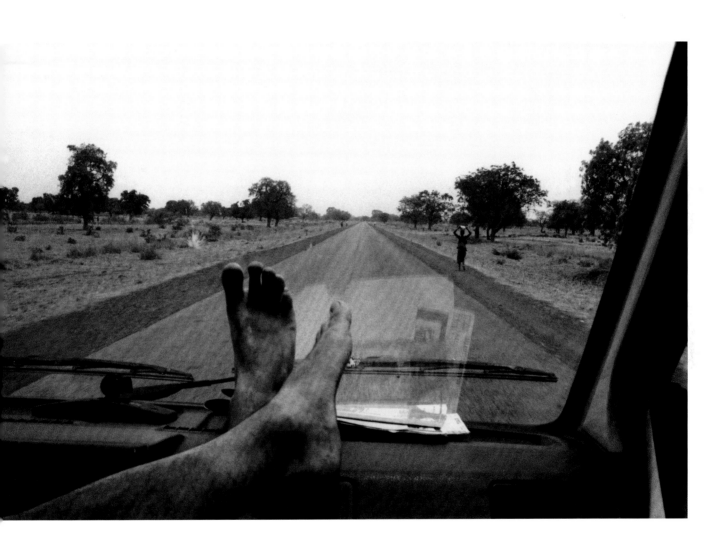

OLKOPOUO, PONI PROVINCE, BURKINA FASO
At Dapouné Da's. Third day of the last funeral, "Kodan",
of Tediremana Palenfo, stepmother of Dapouné Da,
deceased in December 1997. 1998

Guy Le Querrec

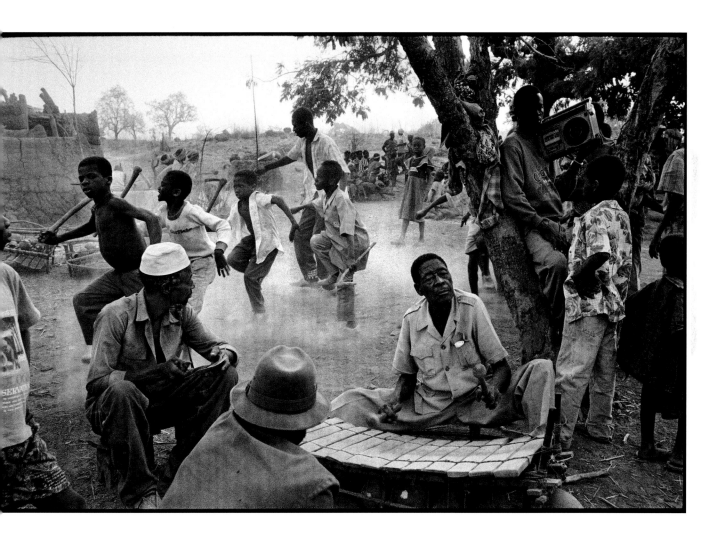

BAKONO, PONI PROVINCE, BURKINA FASO
At Tiofité Oussé's. Second day of the last funeral,
"Bobour", of Tiofité Oussé, chief of the village,
born around 1918, deceased on 8 August 1997.
Preparation of the millet beer *taan*. 1998

Guy Le Querrec

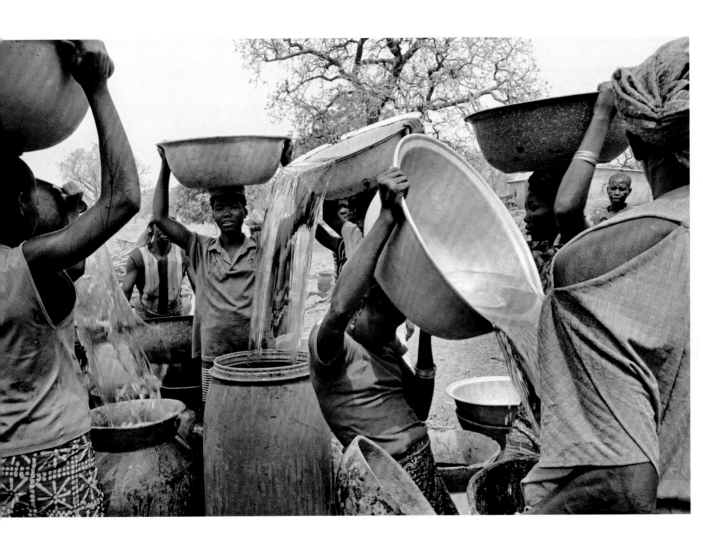

BAKONO, PONI PROVINCE, BURKINA FASO
At Tiofité Oussé's. Second day of the last funeral,
"Bobour", of Tiofité Oussé, chief of the village,
born around 1918, deceased on 8 August 1997.
Preparation of the hairdos. 1998

Guy Le Querrec

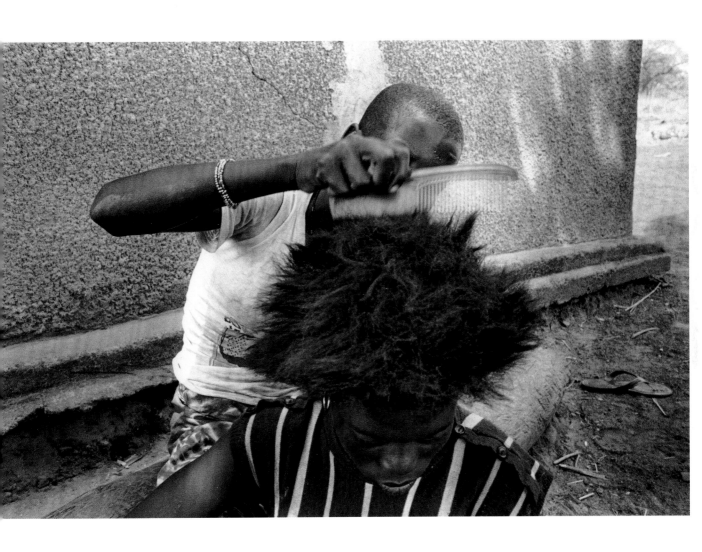

ACCRA, GHANA
Dockers, Port of Accra. 1960

Marc Riboud

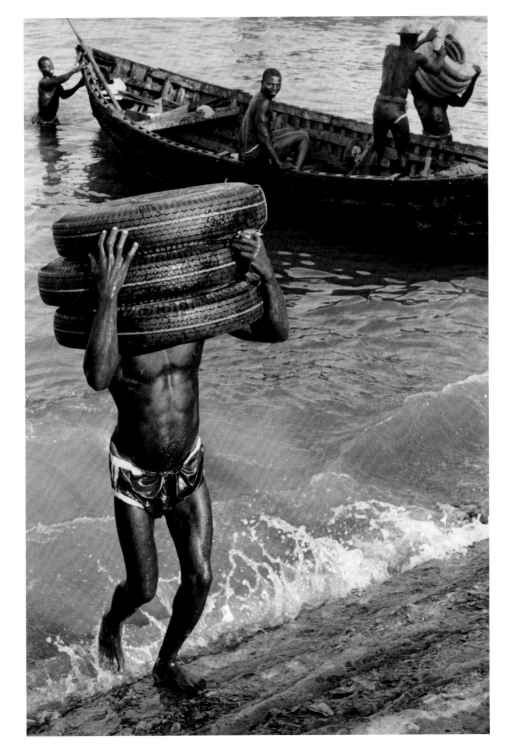

ACCRA, GHANA
1960

Marc Riboud

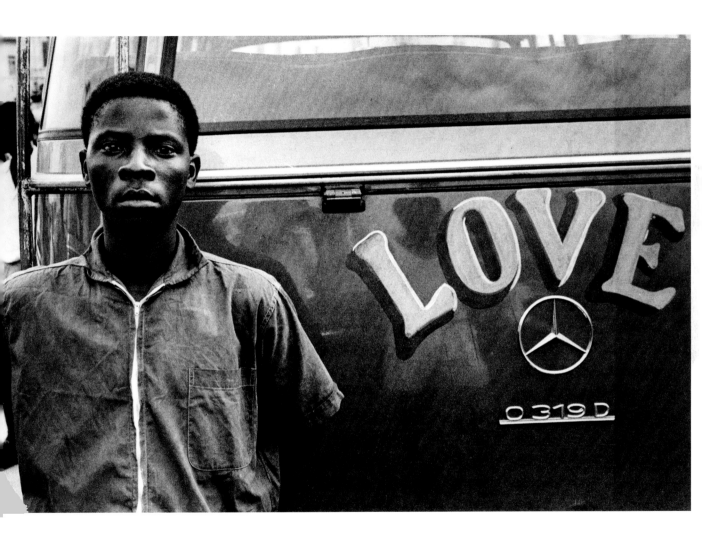

ABURI, GHANA
Festival. 1980

Marc Riboud

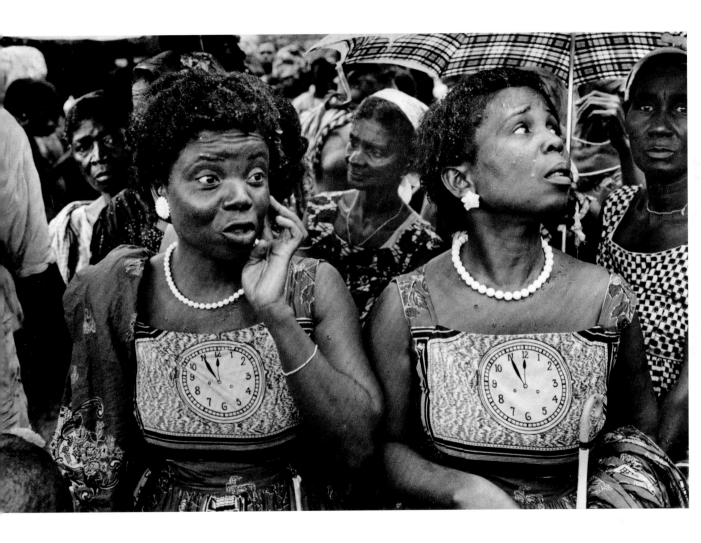

ABURI, GHANA
Festival. 1980

Marc Riboud

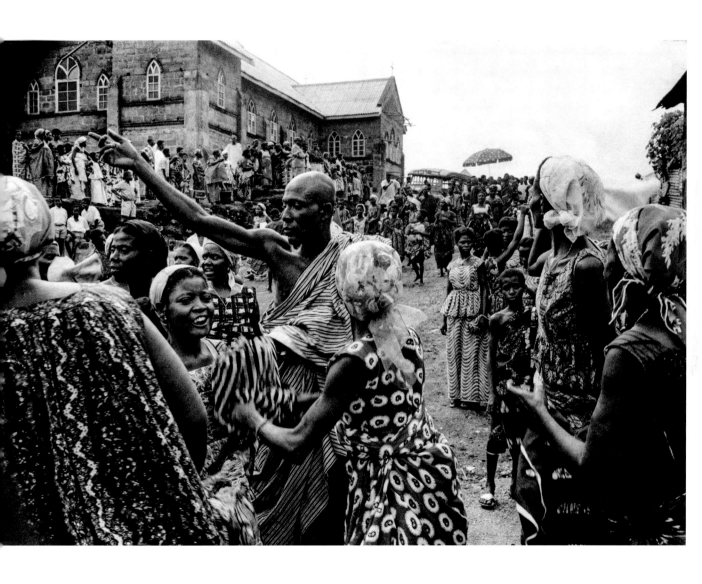

NGOR ISLAND, SENEGAL
Children playing near the garbage
incineration on Ngor Island. 2013

Bieke Depoorter

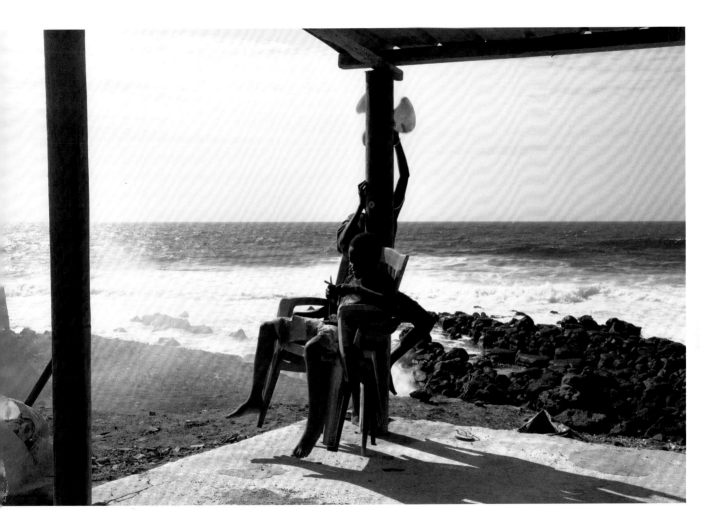

SÉBIKOTANE, SENEGAL
Hairdresser in Sébikotane. 2013

Bieke Depoorter

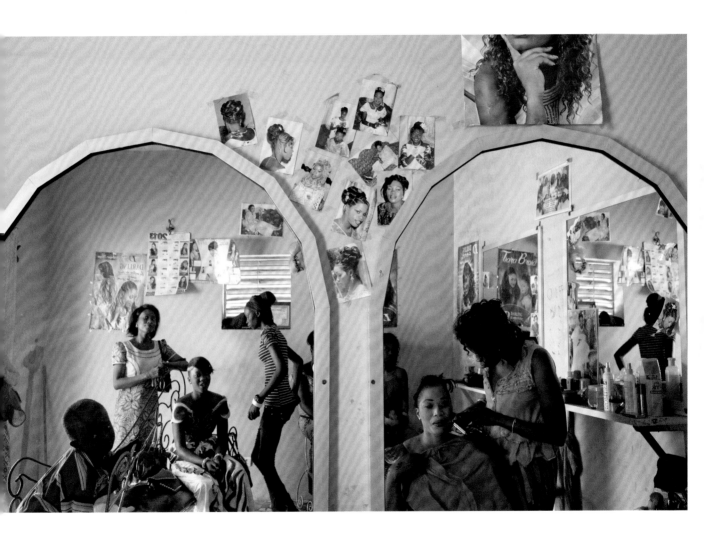

SENEGAL
Bed of Aminata Diallo Dieye. 2013

Bieke Depoorter

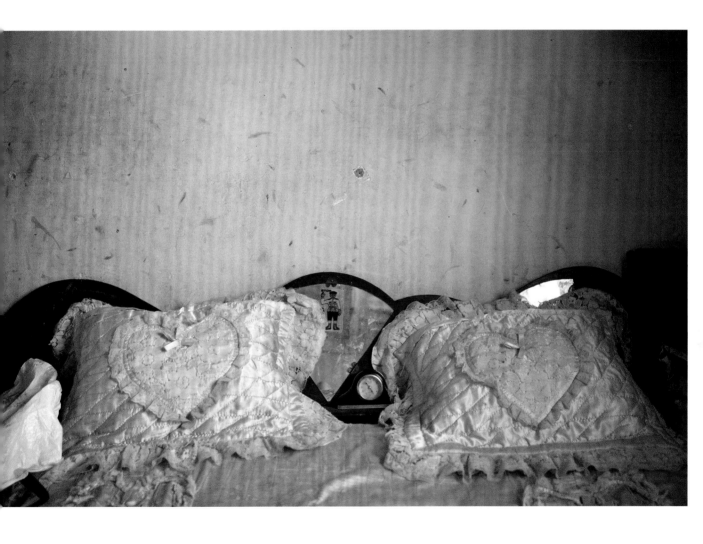

SENEGAL
Ouleye Dia, Bineta Sow and her little
brother in the bedroom. 2013

Bieke Depoorter

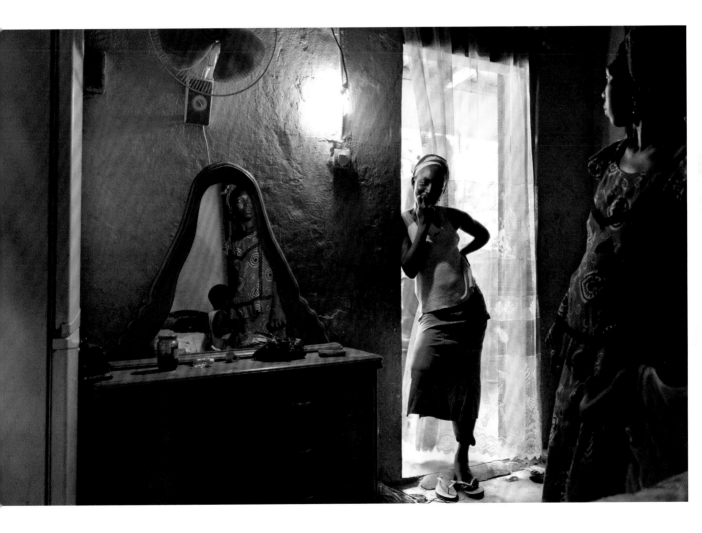

OCTOBER 1 2 3 4 5 6 7 8 9 10 11 12 13 14 **15** 16 17 18 19 20 21 22 23 24 25 26 27 28 29 30 31

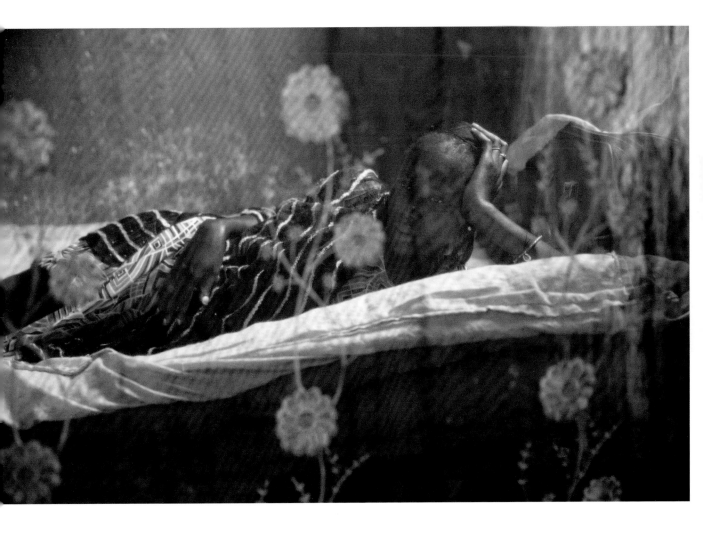

ERFOUD, MOROCCO
1986

Harry Gruyaert

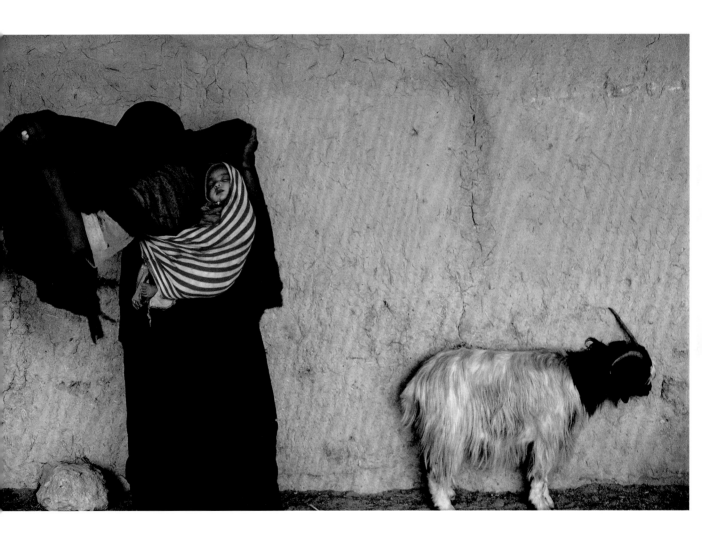

ESSAOUIRA, MOROCCO
Amusement stands near the beachfront. 1988

Harry Gruyaert

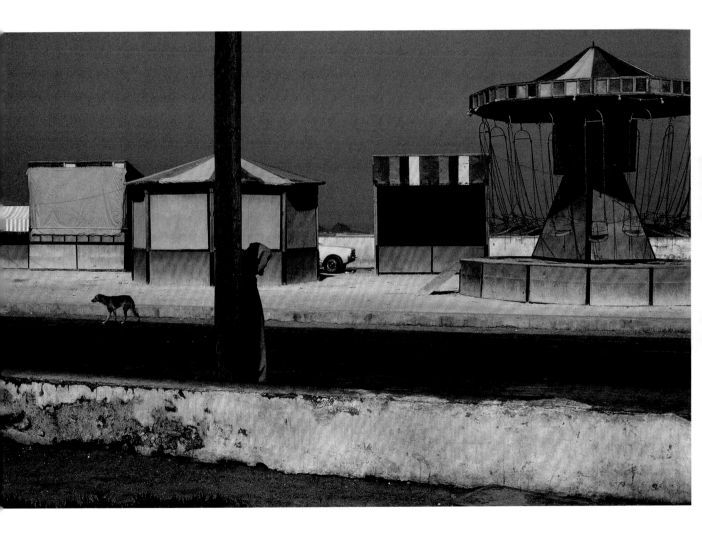

ESSAOUIRA, MOROCCO
Ramparts and fortified walls of the city. 1988

Harry Gruyaert

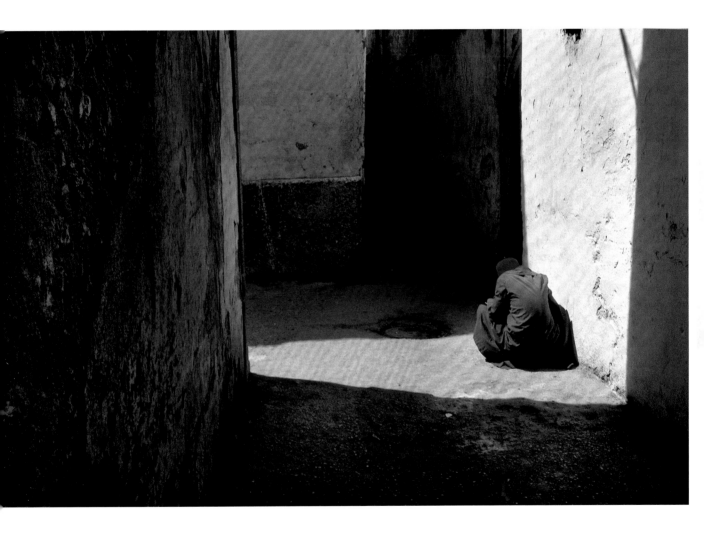

TANGIERS, MOROCCO
Beach and harbour. 1994

Harry Gruyaert

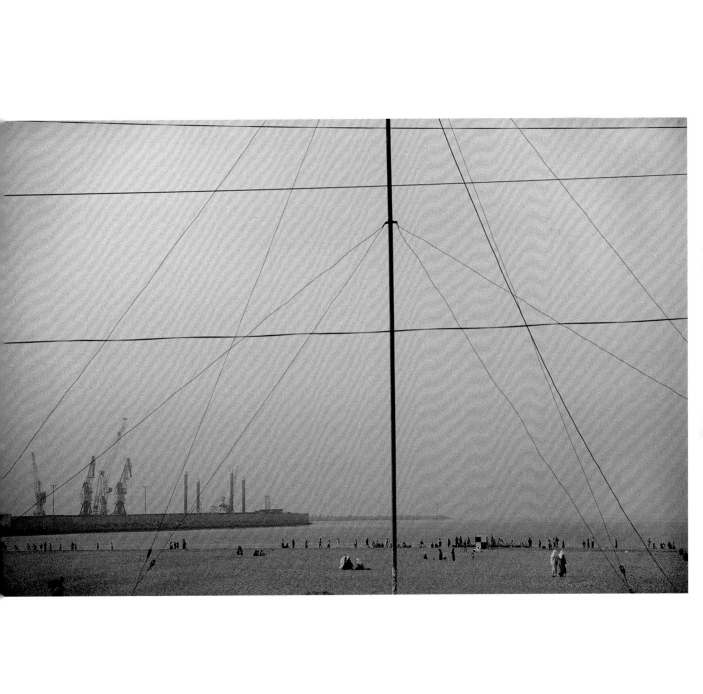

MARRAKESH, MOROCCO
Restaurant in industrial area. 1996

Harry Gruyaert

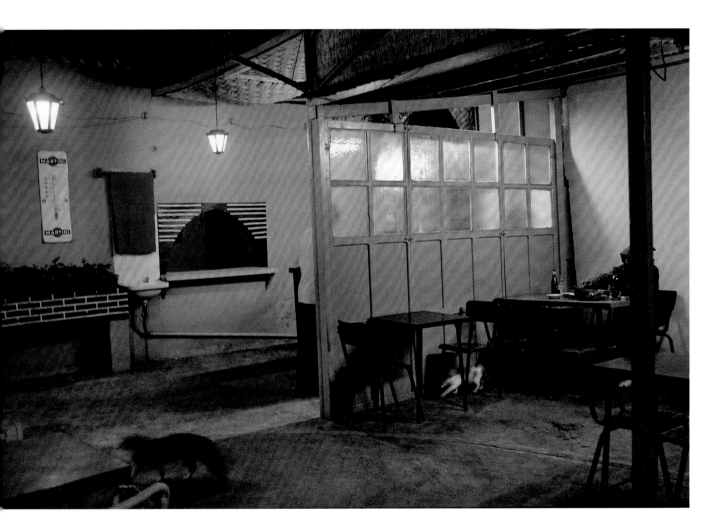

ALGERIA
Old man in what remained of his village
after French bombing. 1962

Philip Jones Griffiths

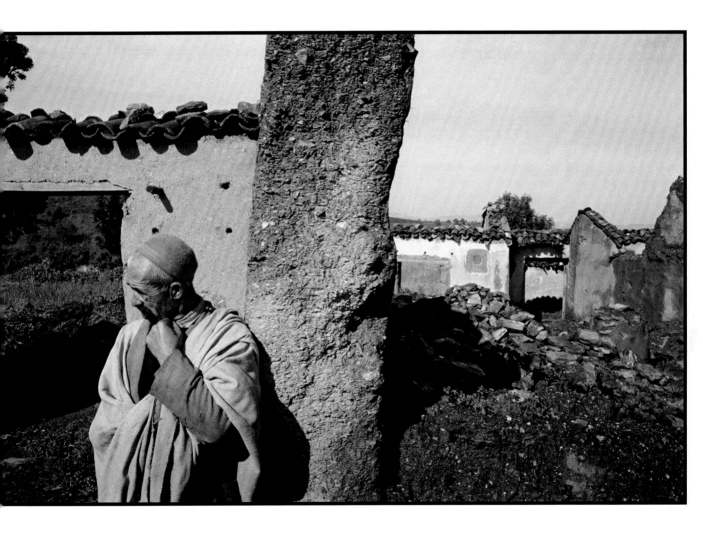

KABYLIE REGION, ALGERIA
Children in a village. 1962

Philip Jones Griffiths

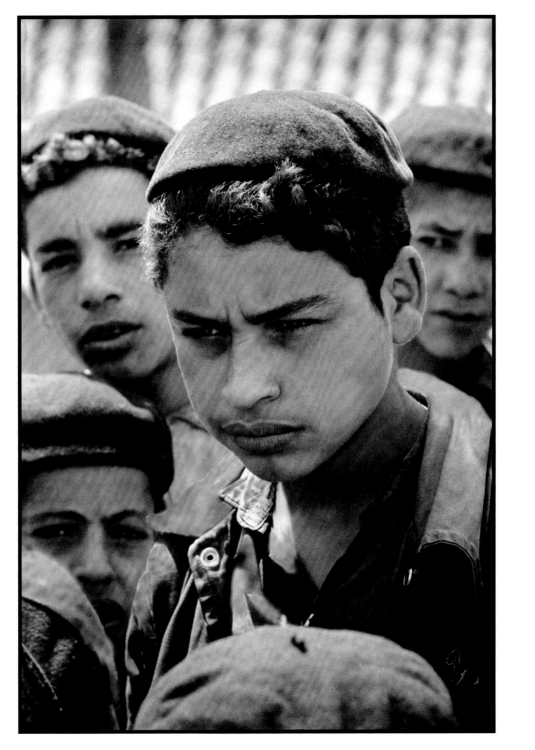

ALGIERS, ALGERIA
The Casbah. 1962

Philip Jones Griffiths

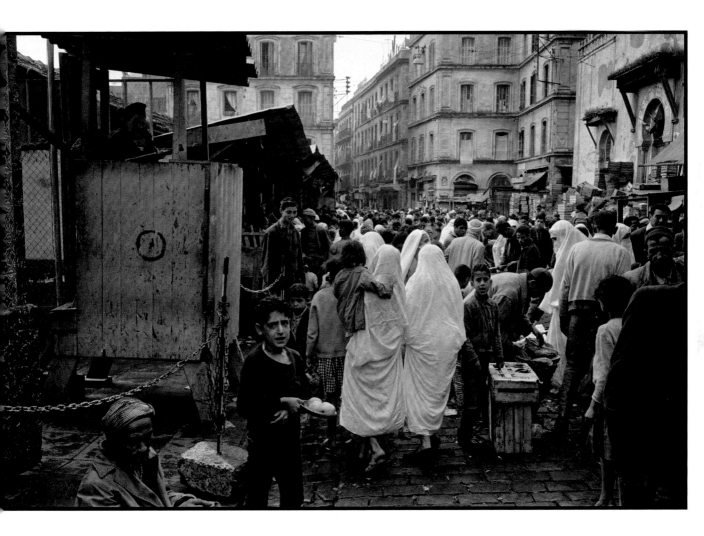

HAÏDRA, TUNISIA
2011

Josef Koudelka

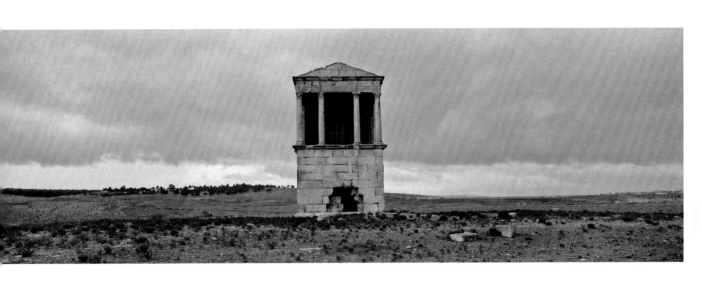

MAKTAR, SILIANA GOVERNORATE, TUNISIA
2012

Josef Koudelka

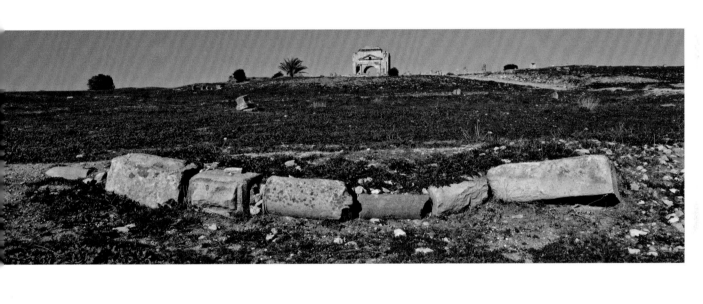

NEAR OUDNA (UTHINA), TUNISIA
Roman aqueduct. 2012

Josef Koudelka

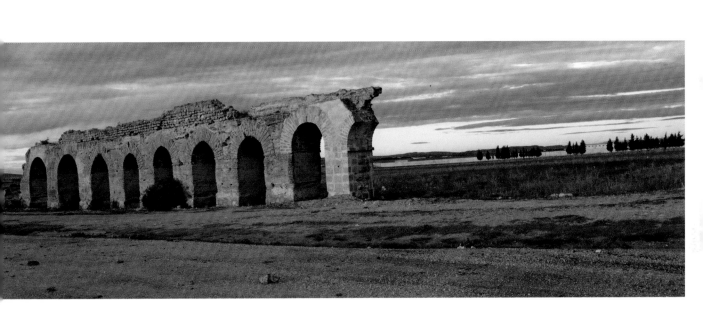

LIBYA
2011

Tim Hetherington

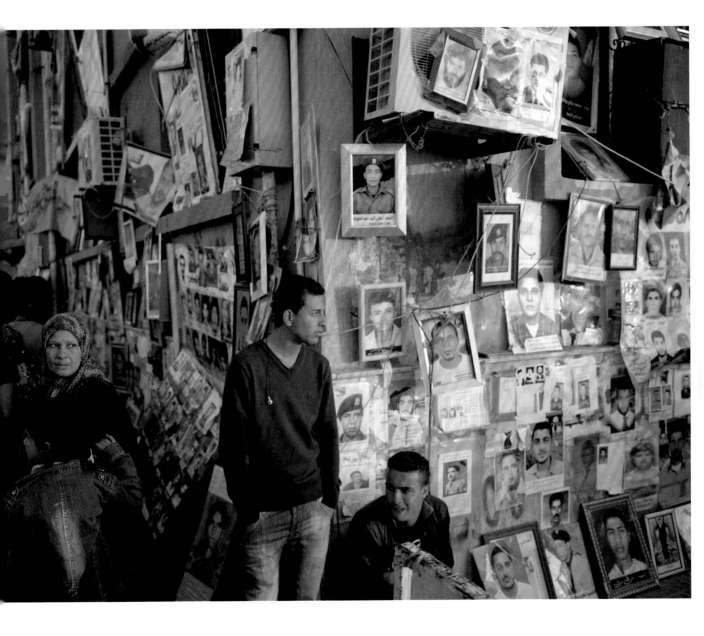

NEAR AJDABIYA, LIBYA
Men from Benghazi watch and film rebel
forces launch rockets at Gaddafi loyalist
positions in eastern Libya. 2011

Tim Hetherington

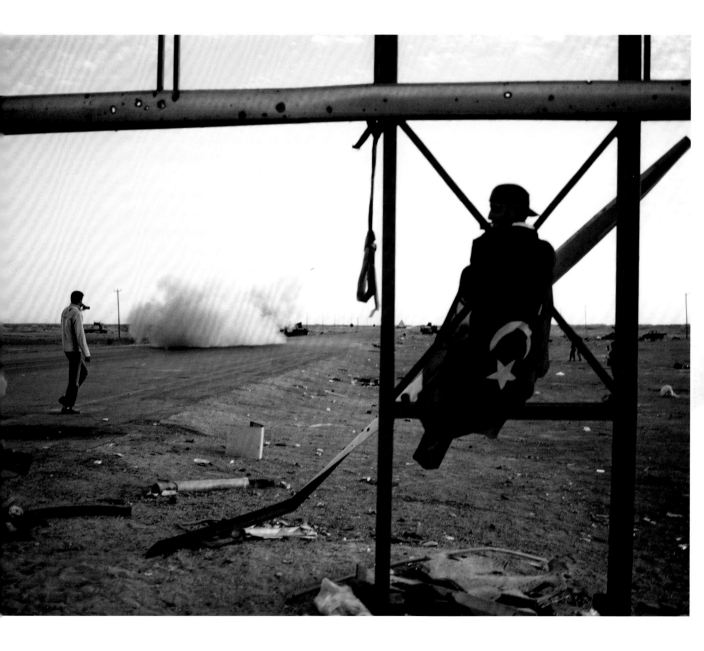

LIBYA
2011

Tim Hetherington

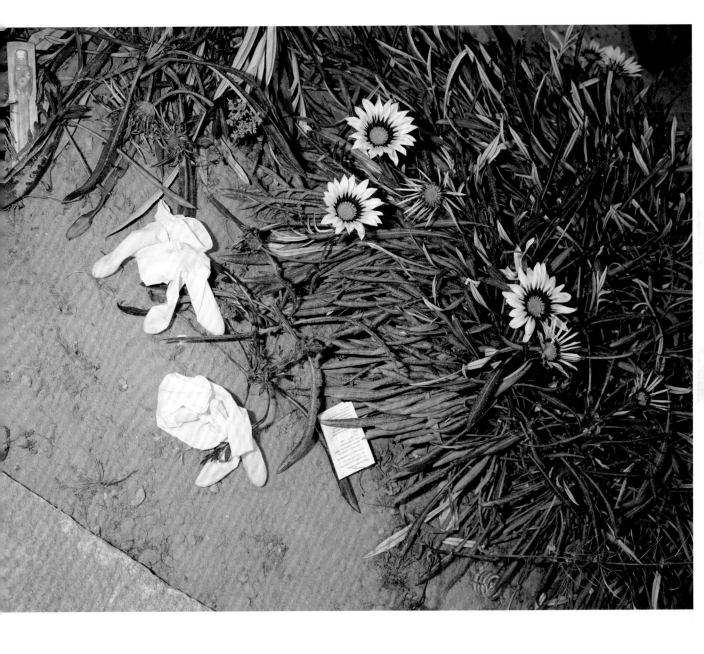

MISURATA, LIBYA
A rebel fighter takes cover behind a tree on the
strategically important Tripoli Street before
engaging with Gaddafi loyalists during a fierce
battle for control of the road on the morning
of 20 April 2011

Tim Hetherington

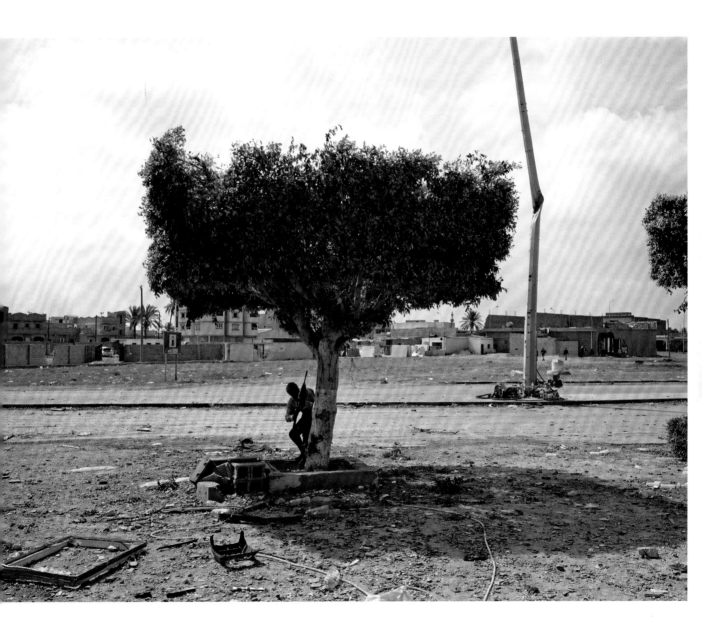

MISURATA, LIBYA
The backstreets of Misurata. 18 April 2011

Tim Hetherington

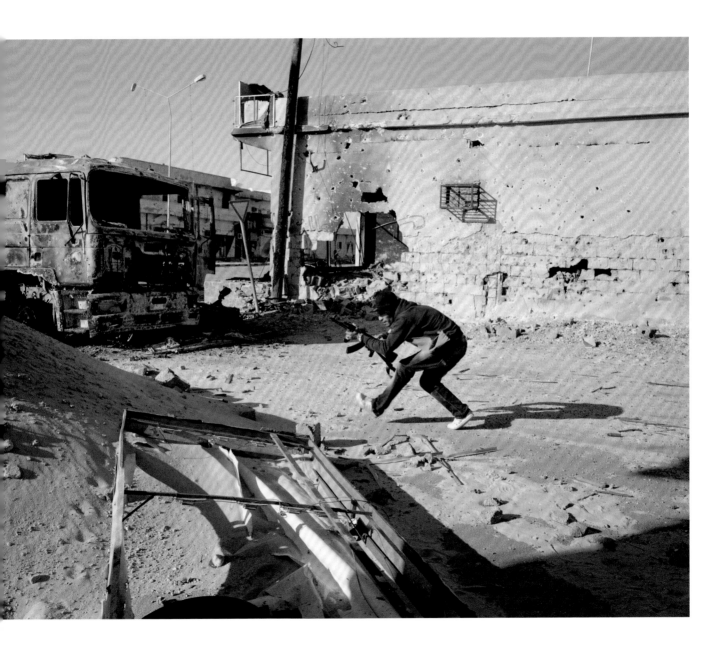

LAMPEDUSA, ITALY

In the cemetery of the island, some crosses are devoted to bodies of migrants found in the sea, as unidentified persons. Whatever is their religion – most of them are Muslim – they are buried according to Christian rites. 2011

Patrick Zachmann

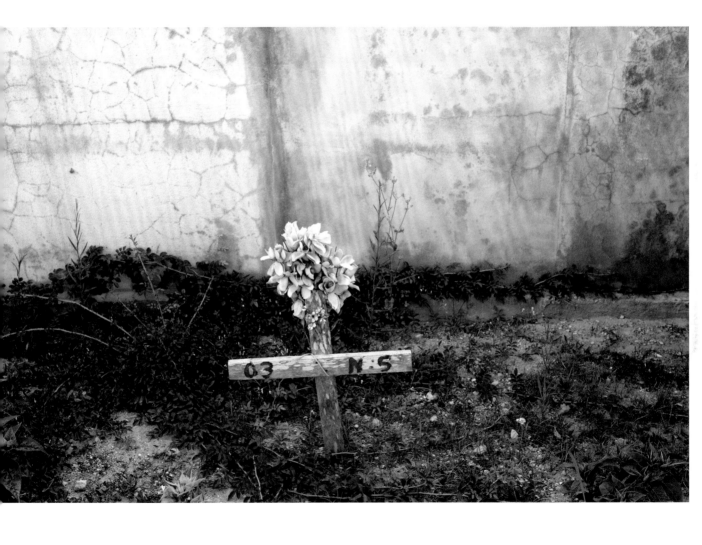

LAMPEDUSA, ITALY
2011

Patrick Zachmann

LAMPEDUSA, ITALY
The association Askavusa, created during the
emergency in March 2009, helps migrants as
they can and collects some belongings, including
photos they found in the abandoned boat. 2011

Patrick Zachmann

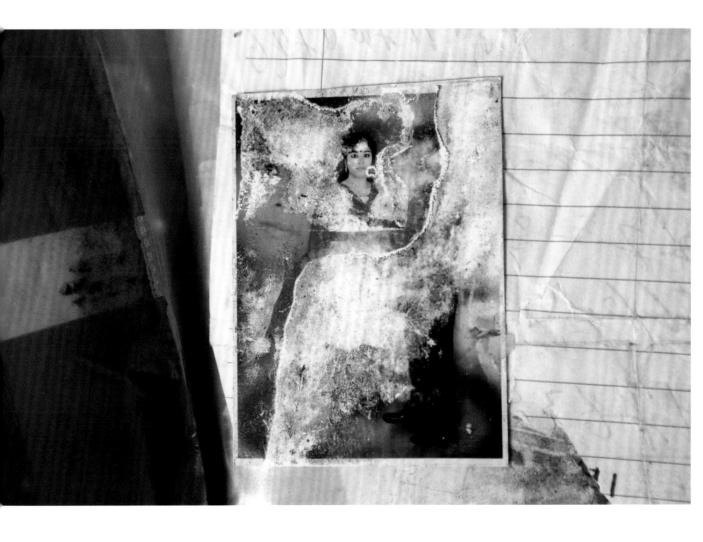

LAMPEDUSA, ITALY
A boat coming from Libya has been spotted and
caught by the Guardia Costiera thirty-five miles
away from Lampedusa. 2011

Patrick Zachmann

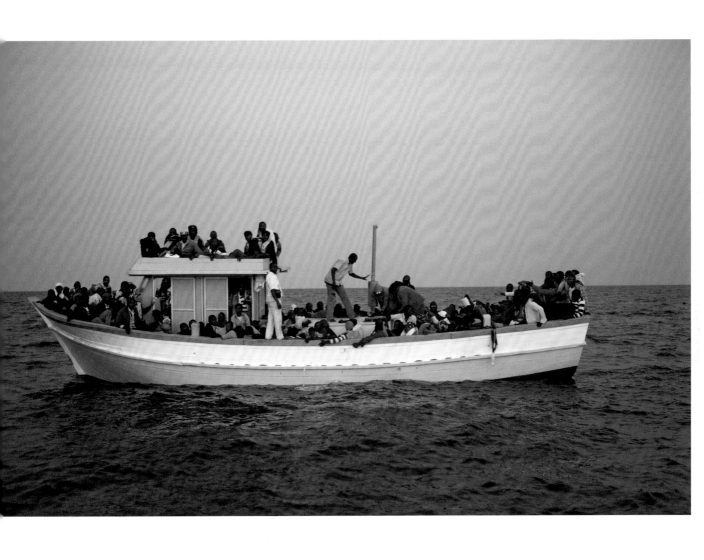

LAMPEDUSA, ITALY
A boat coming from Libya has been spotted and
caught by the Guardia Costiera thirty-five miles
away from Lampedusa. 2011

Patrick Zachmann

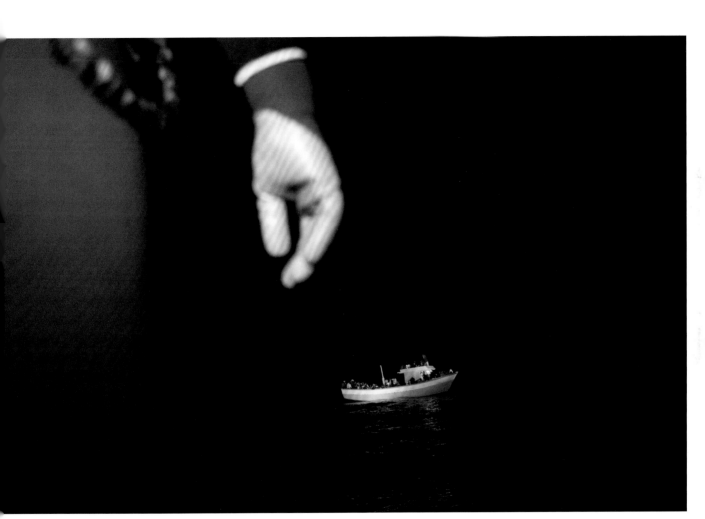

NOTO, ITALY
2011

Mark Power

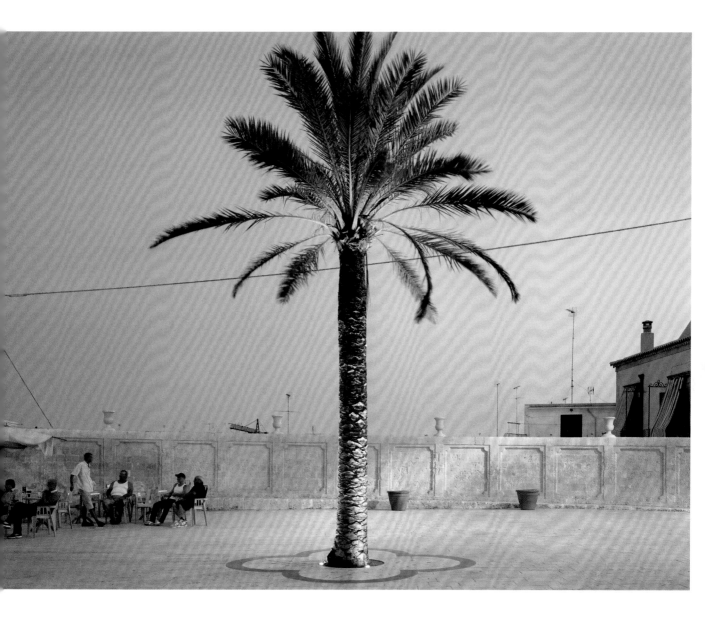

TURIN, ITALY
Palazzo Reale. 2011

Mark Power

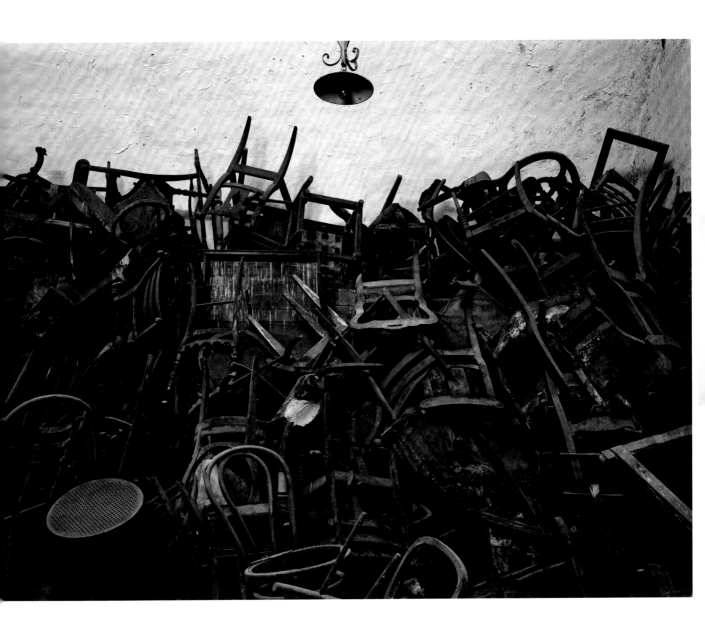

NAPLES, ITALY
Piazza del Gesù Nuovo. 2011

Mark Power

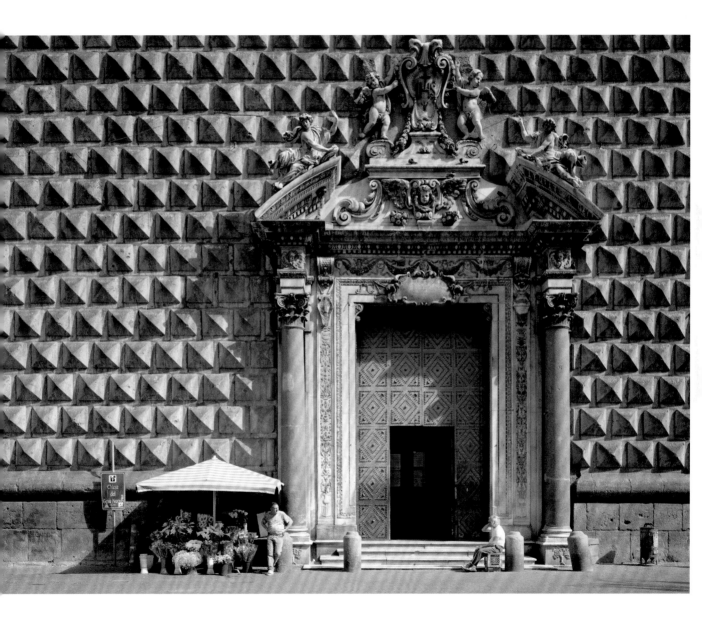

MILAN, ITALY
Duomo. 2011

Mark Power

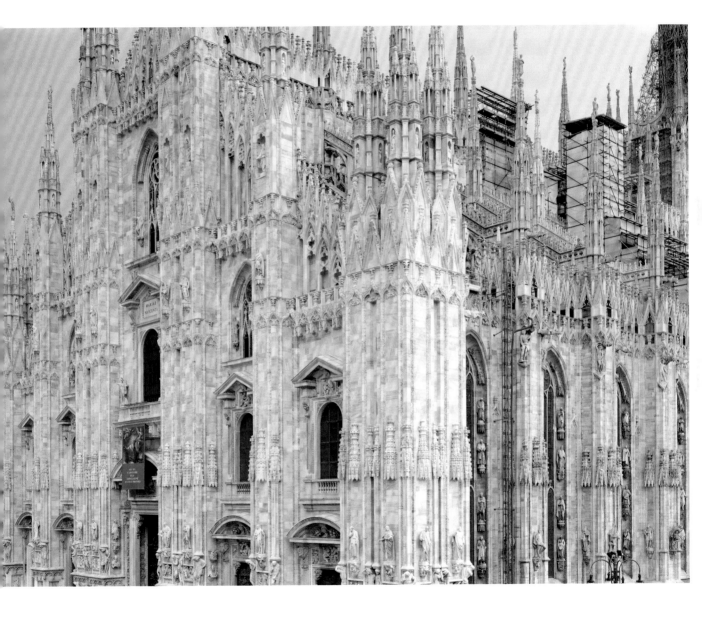

VENICE, ITALY
Piazza San Marco. 2011

Mark Power

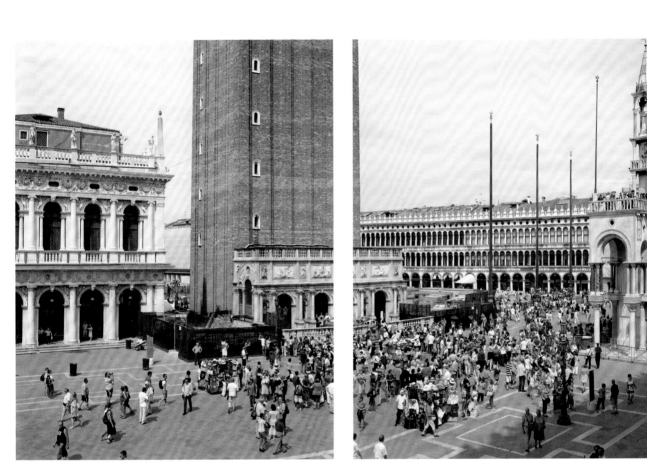

ST. MORITZ, SWITZERLAND
Piz Nair. 2003

Martin Parr

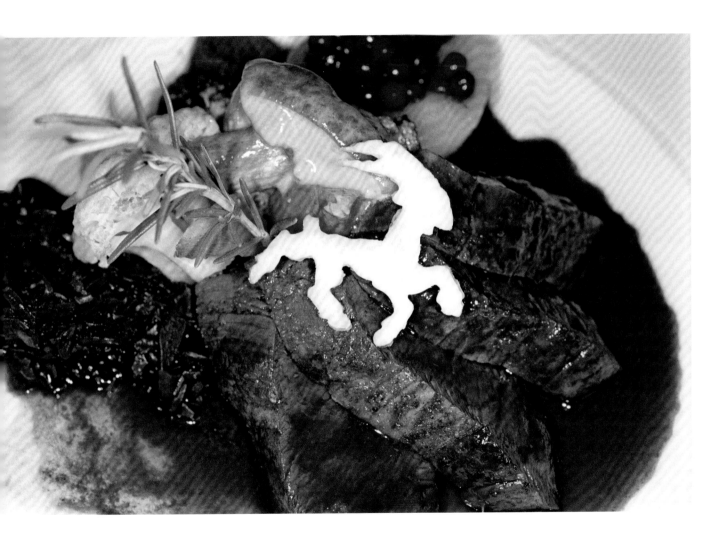

ST. MORITZ, SWITZERLAND
St. Moritz Polo World Cup on Snow. 2011

Martin Parr

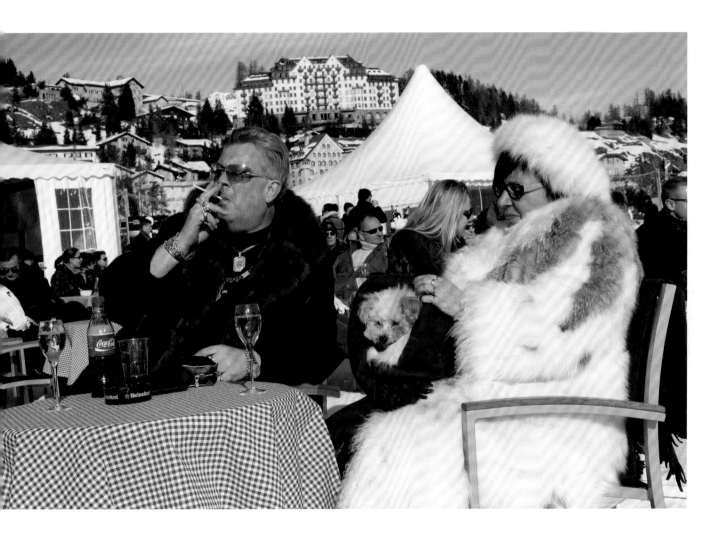

ZERMATT, SWITZERLAND
2012

Martin Parr

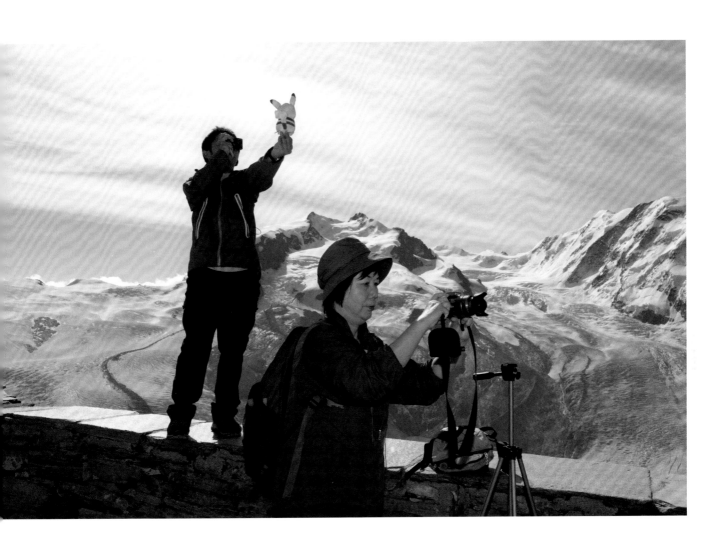

LUCERNE, SWITZERLAND
2012

Martin Parr

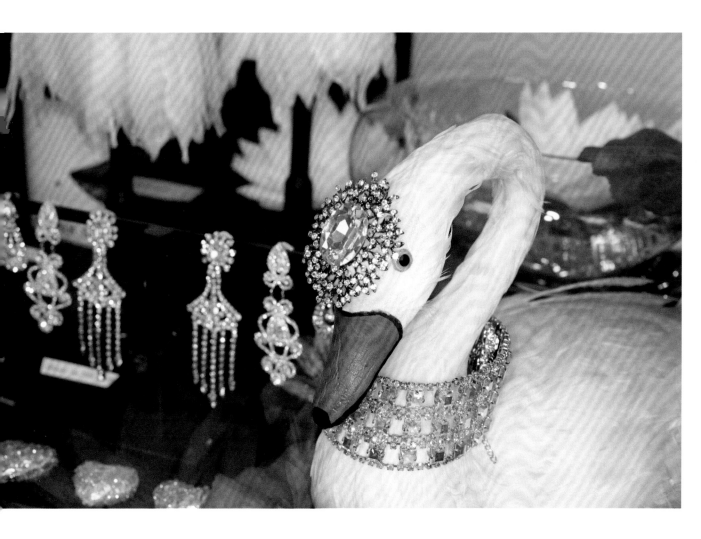

GENEVA, SWITZERLAND
2013

Martin Parr

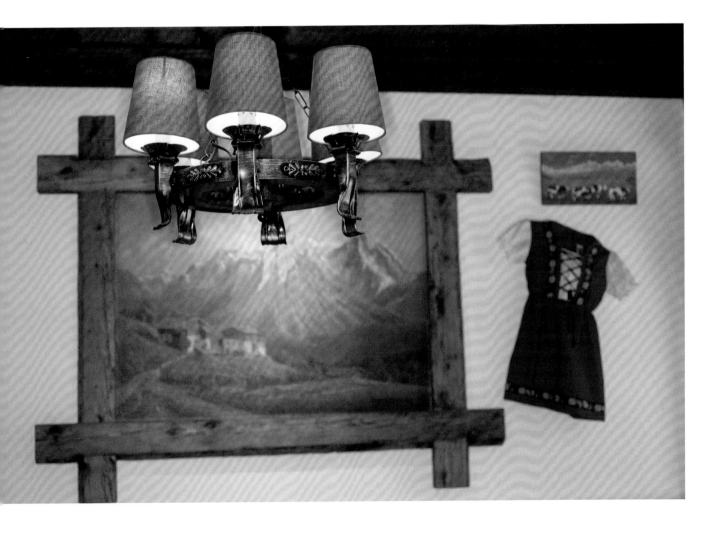

LIVRY, NORMANDY, FRANCE
A music break during the preparation of
dinner, New Year's Eve at a château. 2013

Richard Kalvar

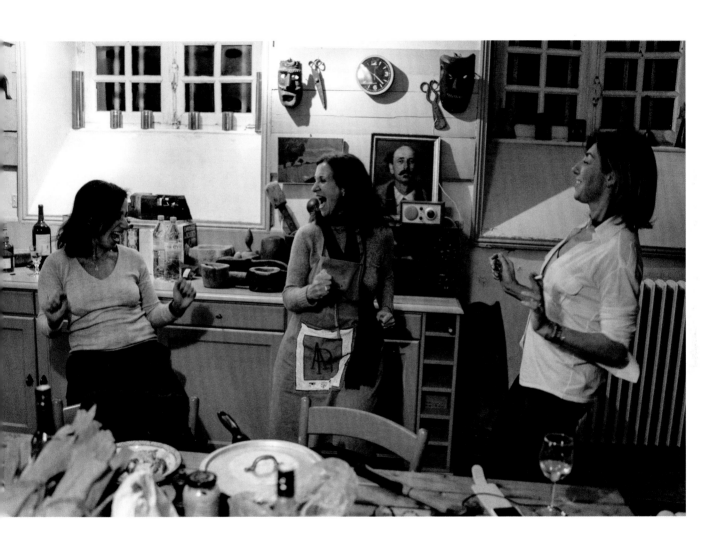

LIVRY, NORMANDY, FRANCE
After dinner, New Year's Eve at a château. 2013

Richard Kalvar

NOVEMBER 1 2 3 4 5 6 7 8 9 10 11 12 13 14 15 16 **17** 18 19 20 21 22 23 24 25 26 27 28 29 30

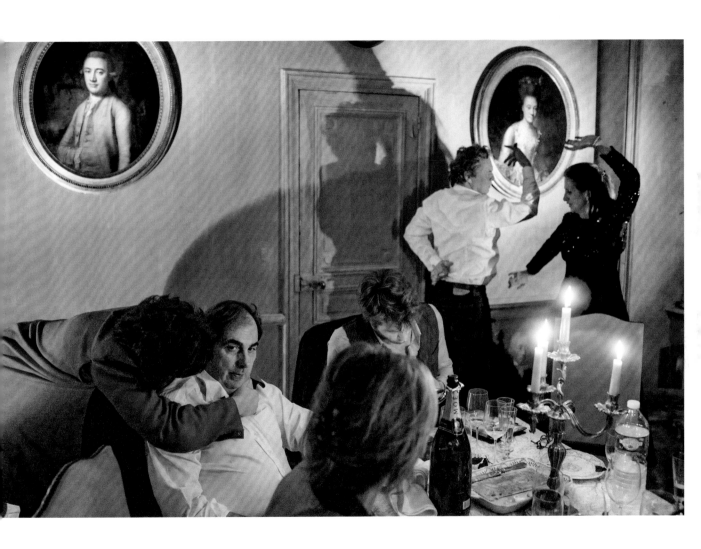

BAS-RHIN, ALSACE, FRANCE
Château du Haut-Kœnigsbourg. Antlers hung
during the restoration of the castle by Kaiser
Wilhelm II. 2014

Richard Kalvar

NOVEMBER 1 2 3 4 5 6 7 8 9 10 11 12 13 14 15 16 17 **18** 19 20 21 22 23 24 25 26 27 28 29 30

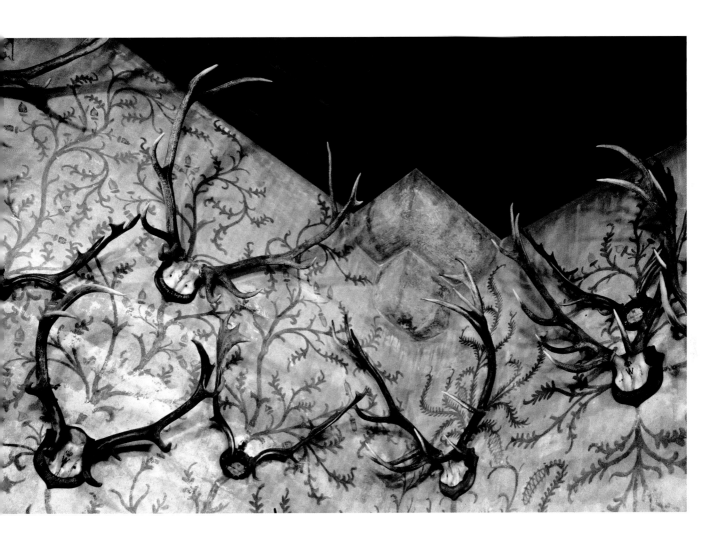

PARIS, FRANCE
Tattoo Salon (Le Mondial du Tatouage). 2016

Richard Kalvar

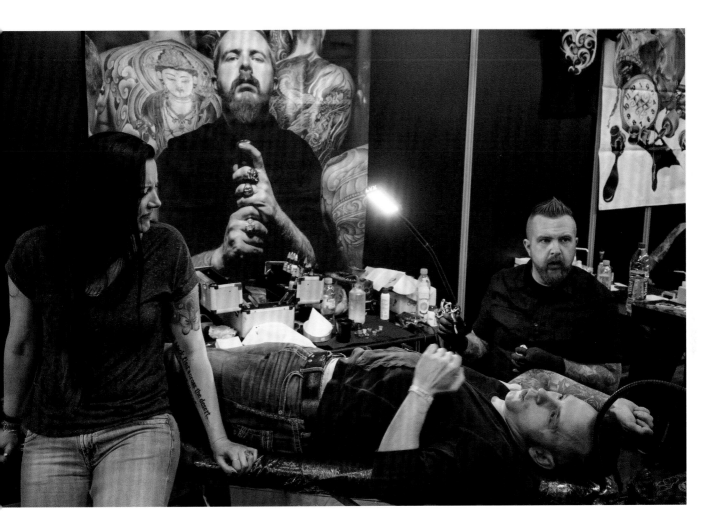

BRAY-DUNES, NORD, FRANCE
Summer. 2015

Christopher Anderson

PARIS, FRANCE
Established in 1886 as Cercle Saint-André-
des-Arts, the hall known for the last century as
Salle d'Armes Coudurier is the oldest fencing
school in Paris. 2015

Christopher Anderson

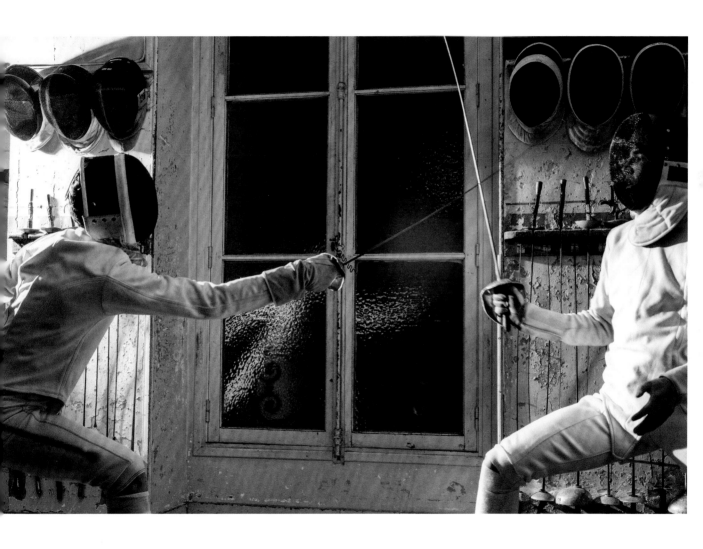

SÈTE, FRANCE
Joute sétoise (jousting of Sète). A traditional sport in
the port town of Sète, where participants joust from
boats. The sport's biggest competition comes every
year in August during the Saint-Louis Festival. 2011

Christopher Anderson

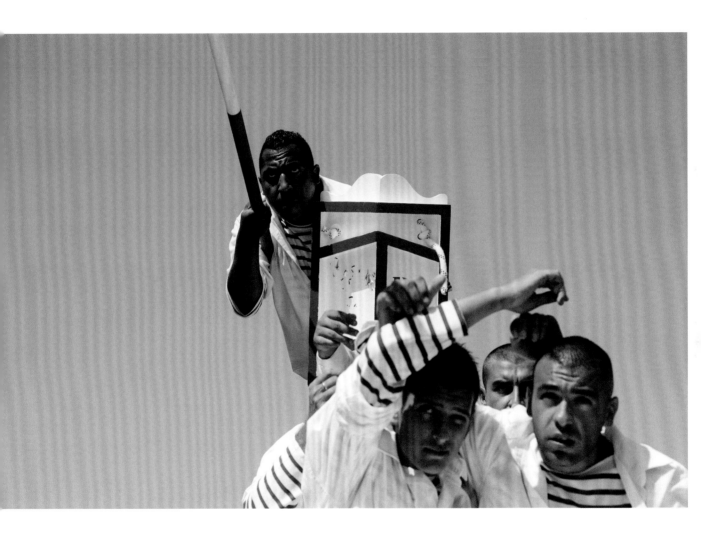

SÈTE, FRANCE
A pigeon inside a home. 2011

Christopher Anderson

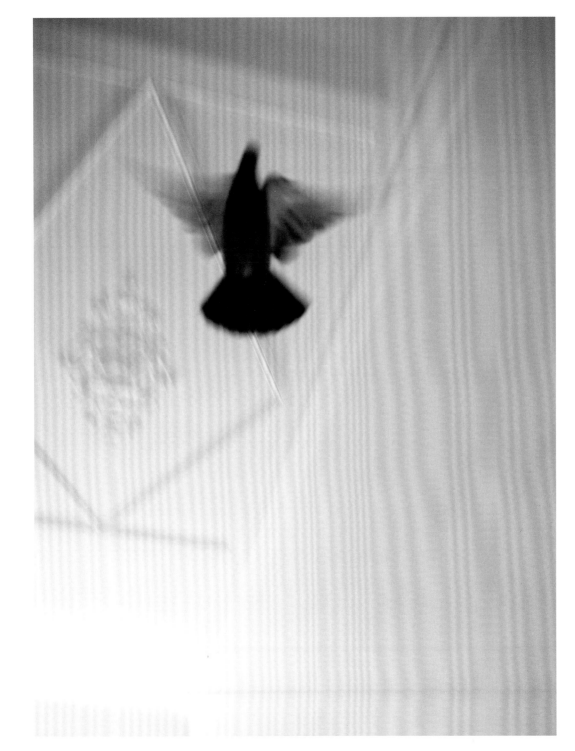

SPAIN
George C. Scott's sons playing war in
the Spanish desert where their father
is playing the role of Patton. 1969

Eve Arnold

NOVEMBER 1 2 3 4 5 6 7 8 9 10 11 12 13 14 15 16 17 18 19 20 21 22 23 **24** 25 26 27 28 29 30

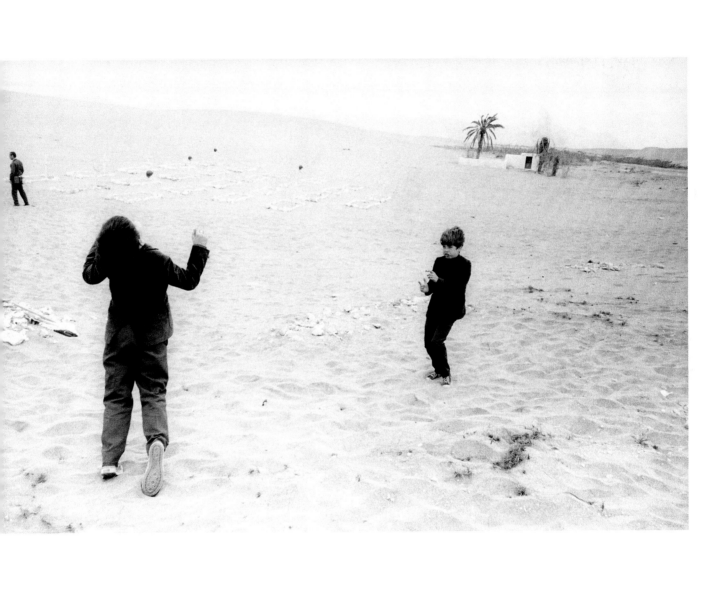

VALENCIA, SPAIN
1966

Eve Arnold

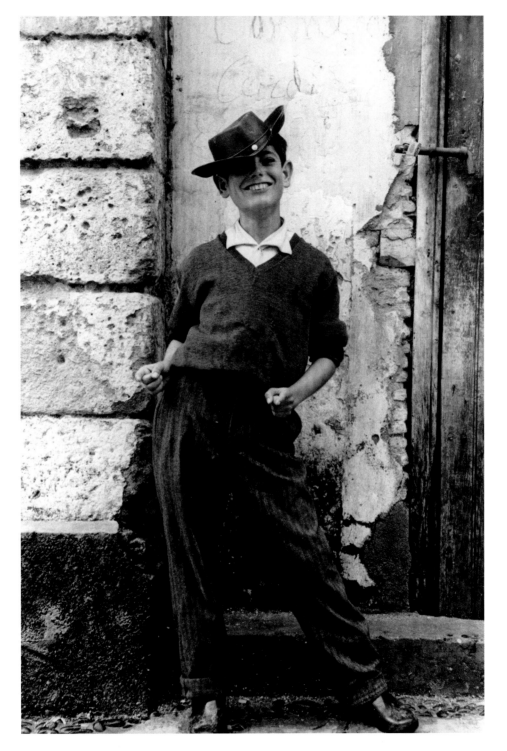

ANDALUSIA, SPAIN
The head of the hunters at a boar hunt
with his dogs. 1966

Eve Arnold

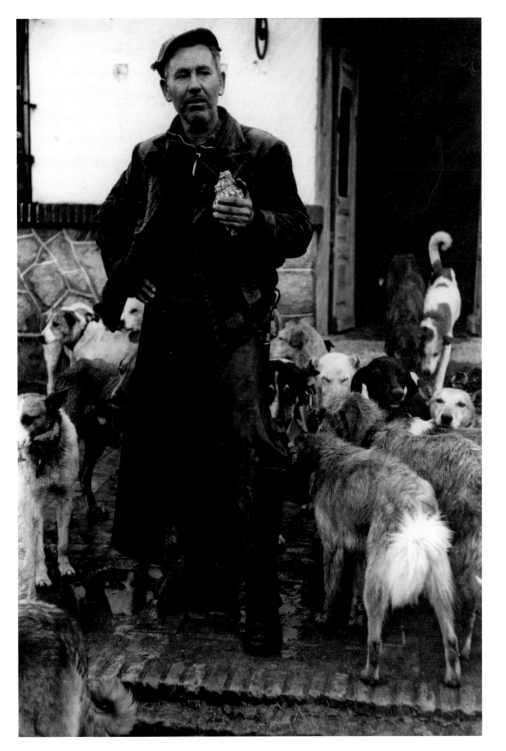

AMADORA, LISBON, PORTUGAL
Cova da Moura. 2004

Susan Meiselas

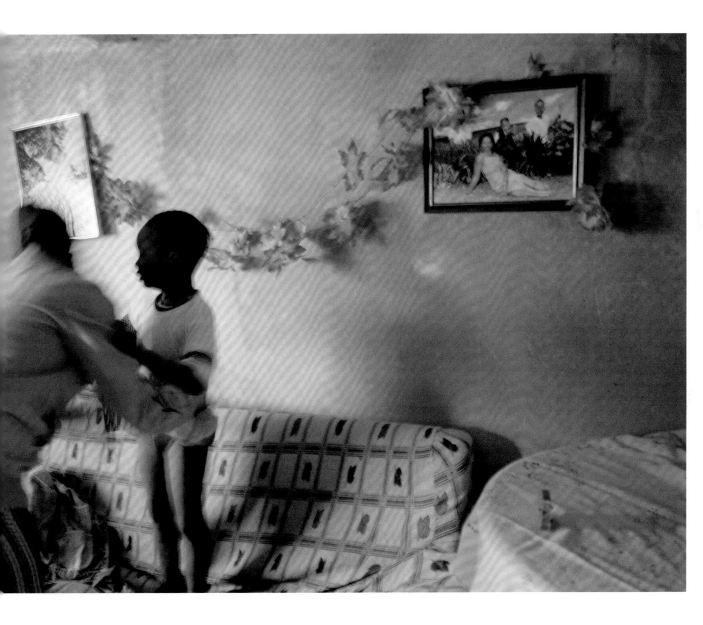

AMADORA, LISBON, PORTUGAL
Cova da Moura. 2004

Susan Meiselas

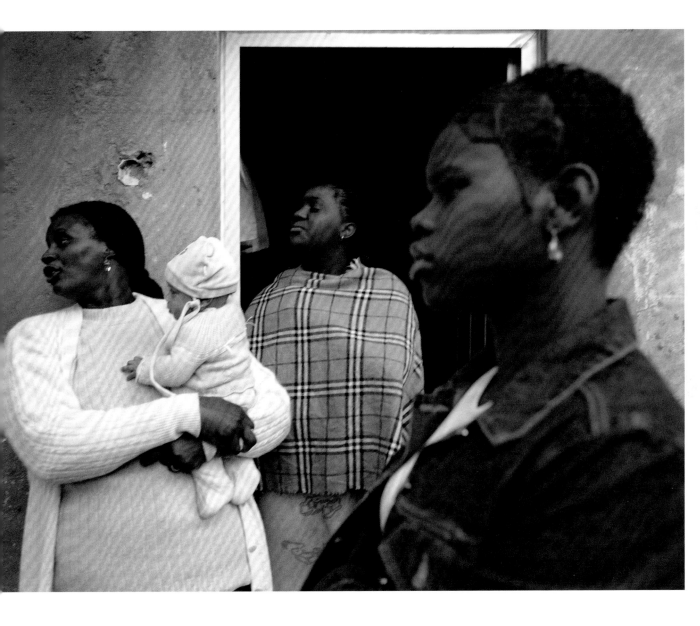

AMADORA, LISBON, PORTUGAL
Cova da Moura. 2004

Susan Meiselas

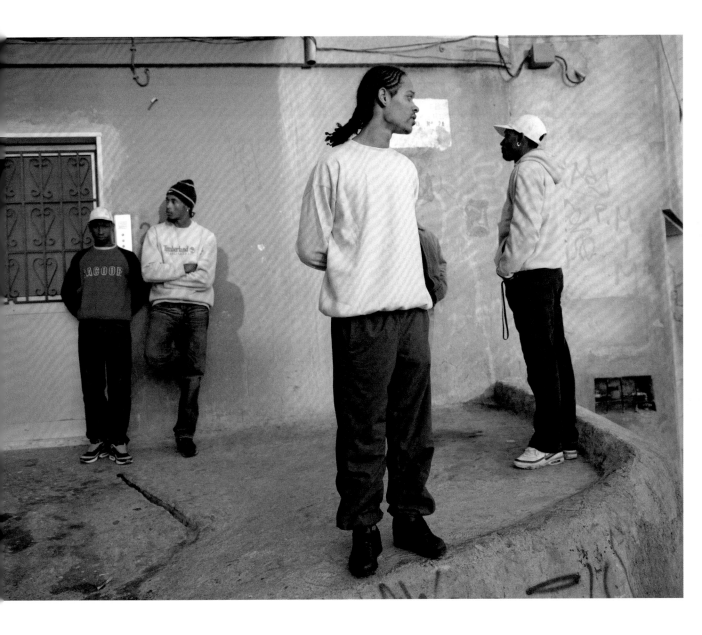

AMADORA, LISBON, PORTUGAL
Cova da Moura. 2004

Susan Meiselas

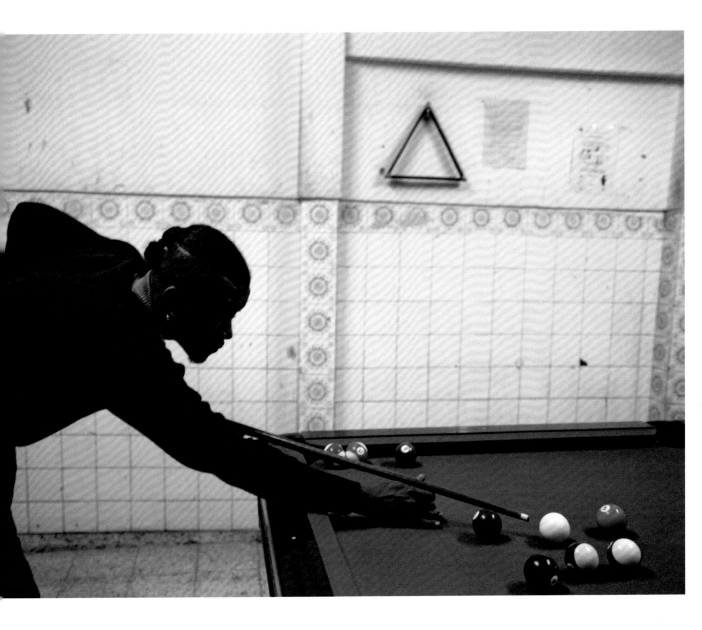

AMADORA, LISBON, PORTUGAL
Cova da Moura. 2004

Susan Meiselas

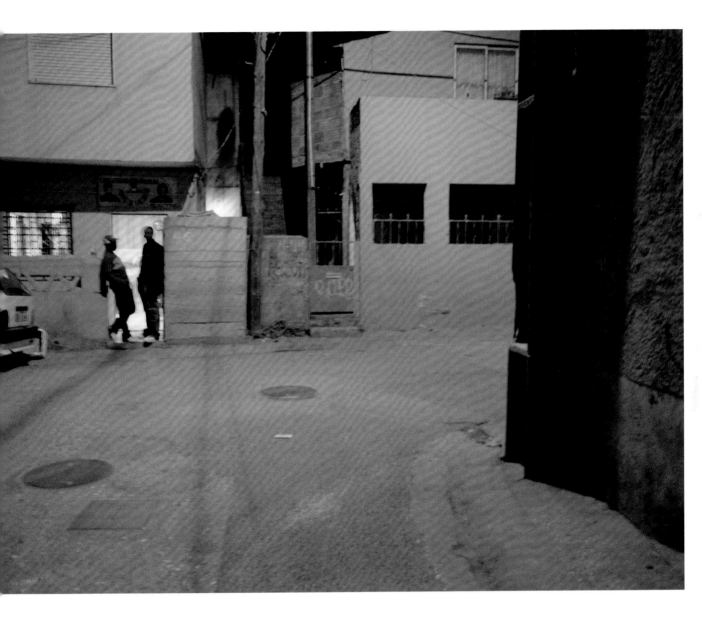

DUBLIN, IRELAND
Along Essex and Wellington Quays
by the River Liffey. 1964

Erich Hartmann

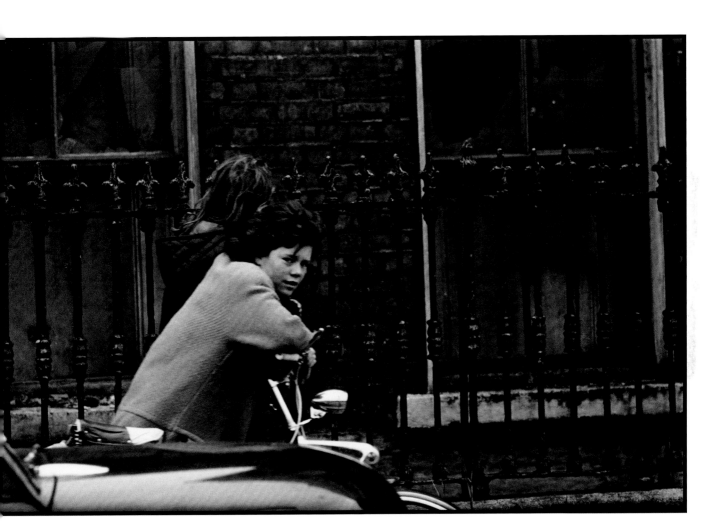

DUBLIN, IRELAND
Tenement Room. 1964

Erich Hartmann

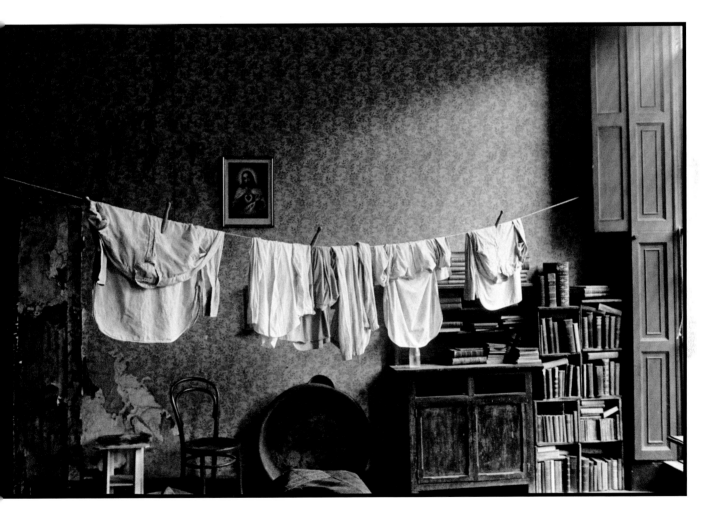

DUBLIN, IRELAND
Hurling match, Croke Park. 1964

Erich Hartmann

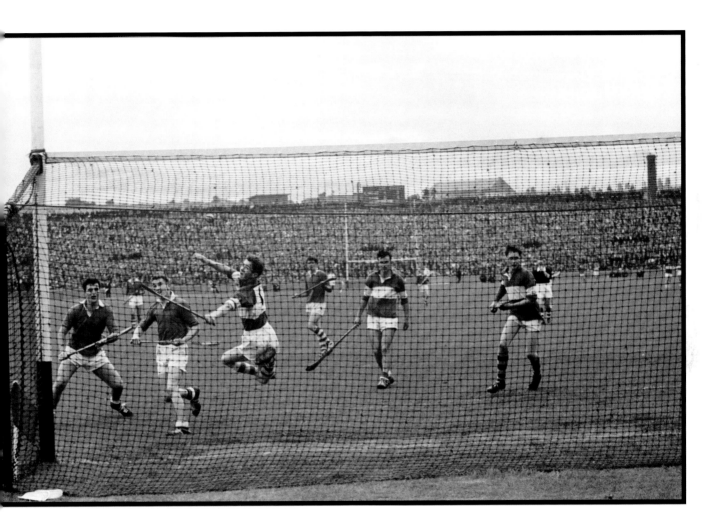

DUBLIN, IRELAND
View of the crowd at a hurling
match in Croke Park. 1964

Erich Hartmann

DECEMBER 1 2 3 4 **5** 6 7 8 9 10 11 12 13 14 15 16 17 18 19 20 21 22 23 24 25 26 27 28 29 30 31

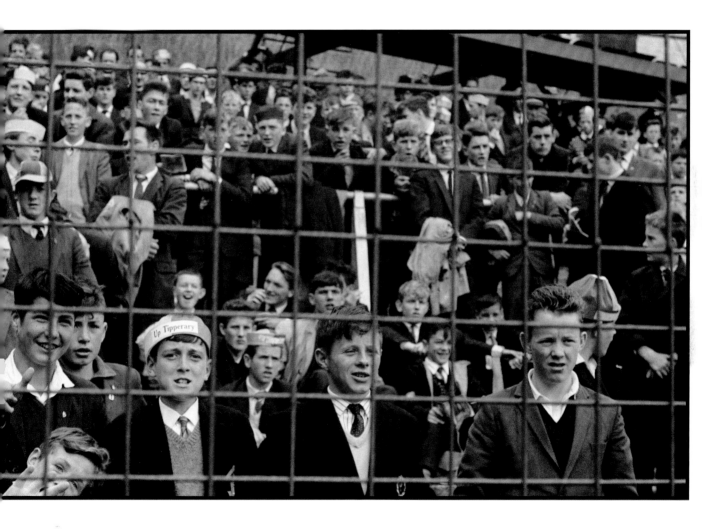

LONDON, ENGLAND
Fifties cultural meeting place. Nucleus coffee-
bar basement. The political left meeting place.
A student repairs her make-up. 1957

David Hurn

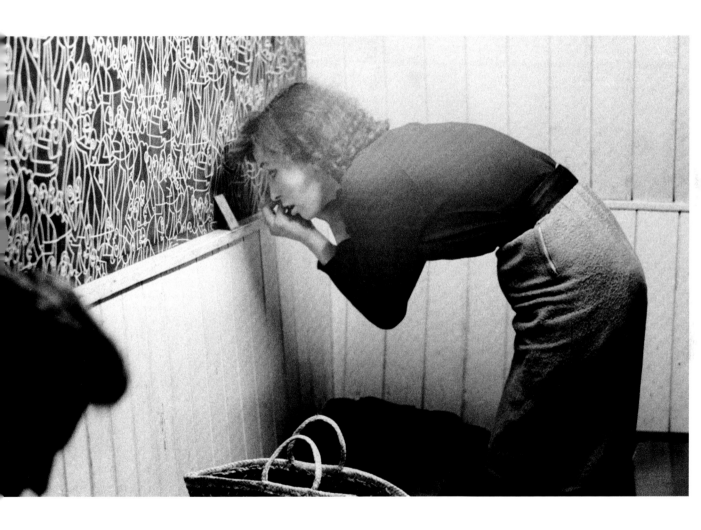

DECEMBER 1 2 3 4 5 6 **7** 8 9 10 11 12 13 14 15 16 17 18 19 20 21 22 23 24 25 26 27 28 29 30 01

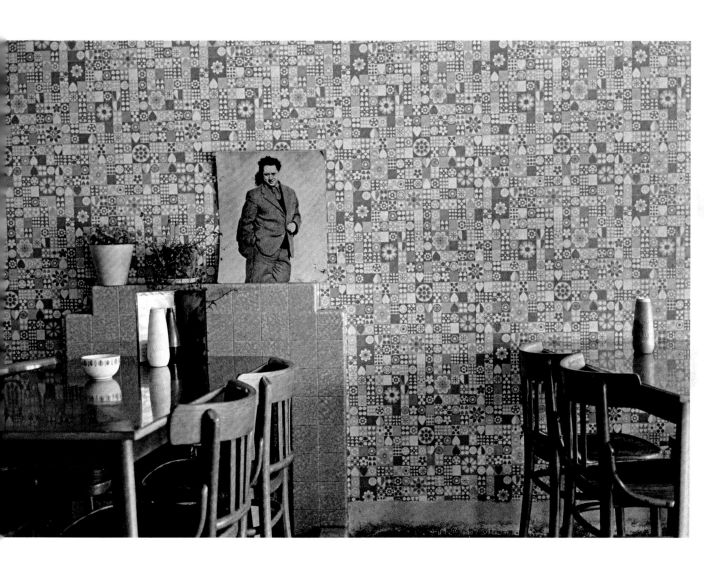

BRECON BEACONS, WALES
Wild pony colt. Cold tourists in the rain
in the background. 1974

David Hurn

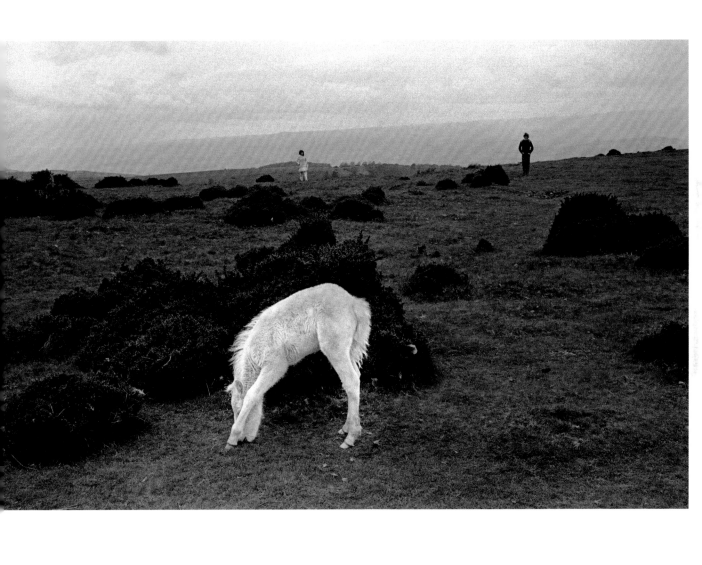

TINTERN, WALES
Train carriage, Old Station. 2013

David Hurn

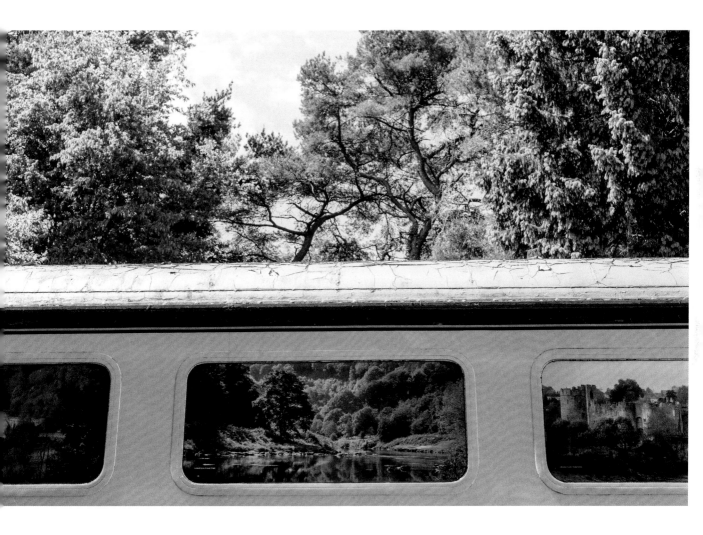

NORFOLK, ENGLAND
Aerial view of the River Ant, which
leads onto Barton Road. 1997

Peter Marlow

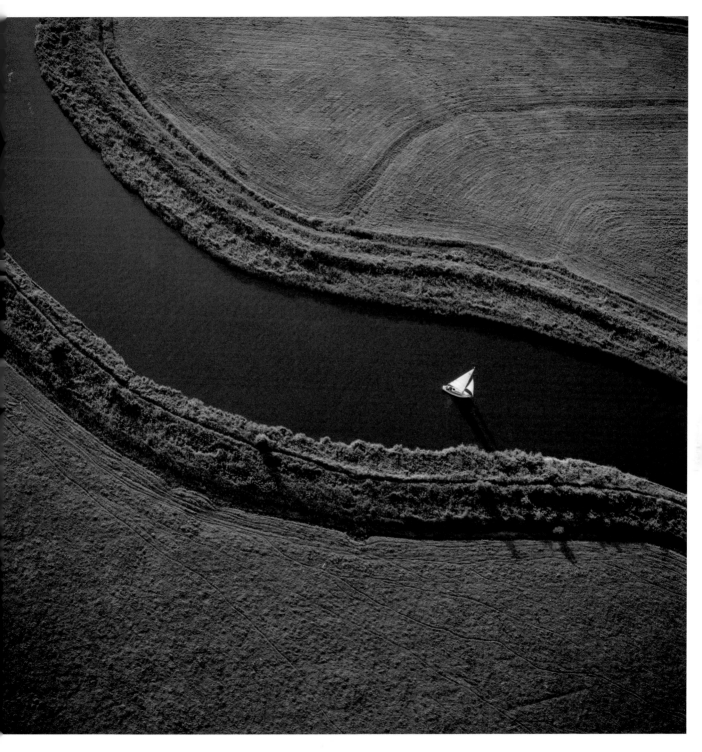

RICHMOND, NORTH YORKSHIRE, ENGLAND
A family Christmas at the Landmark Trust property
Culloden Tower, built in 1746 to commemorate
the Hanoverian victory over the Jacobite Scots at
Culloden Moor. 2005

Peter Marlow

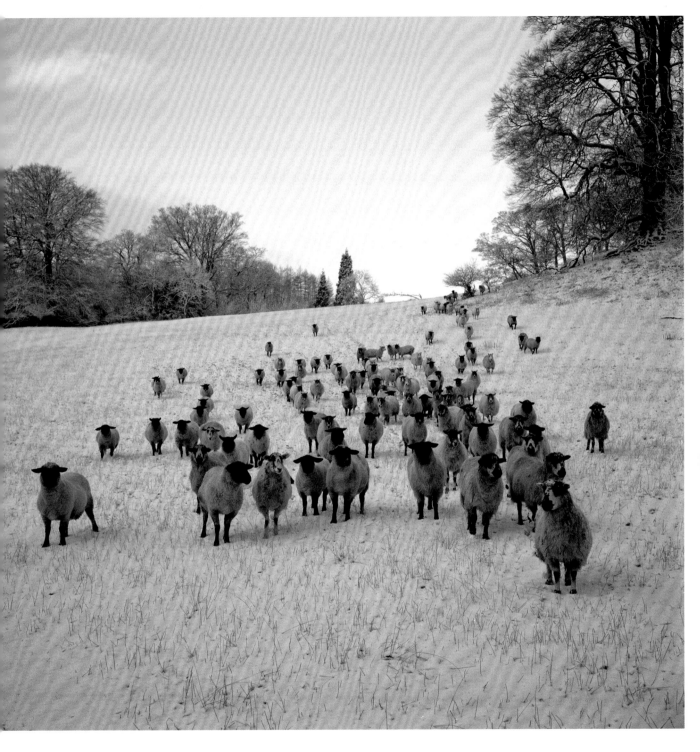

NEAR SAXTON, YORKSHIRE, ENGLAND
A fox hunting meet. 2003

Peter Marlow

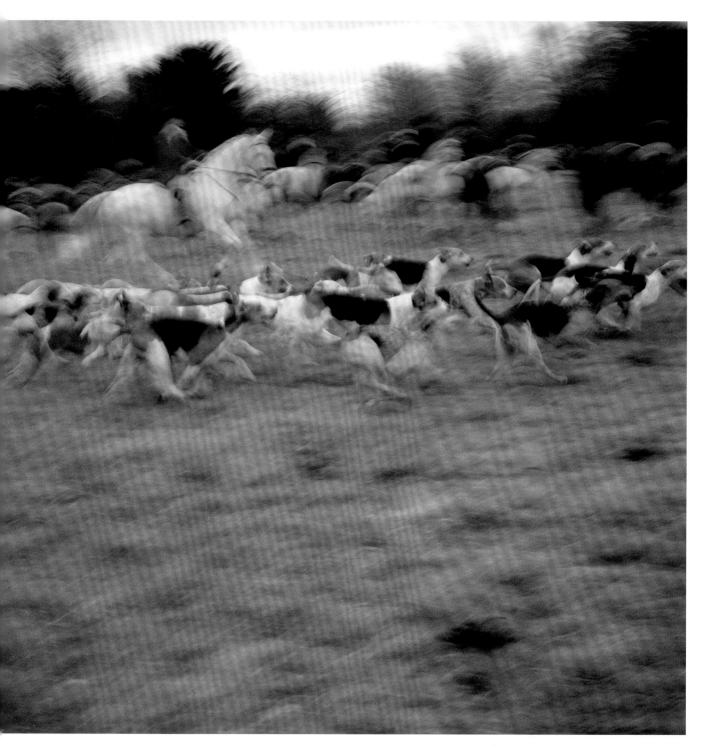

MARGATE, ENGLAND
A portrayal of a traditional English seaside
resort, Dreamland amusement park. 2002

Peter Marlow

DECEMBER 1 2 3 4 5 6 7 8 9 10 11 12 **13** 14 15 16 17 18 19 20 21 22 23 24 25 26 27 28 29 30 31

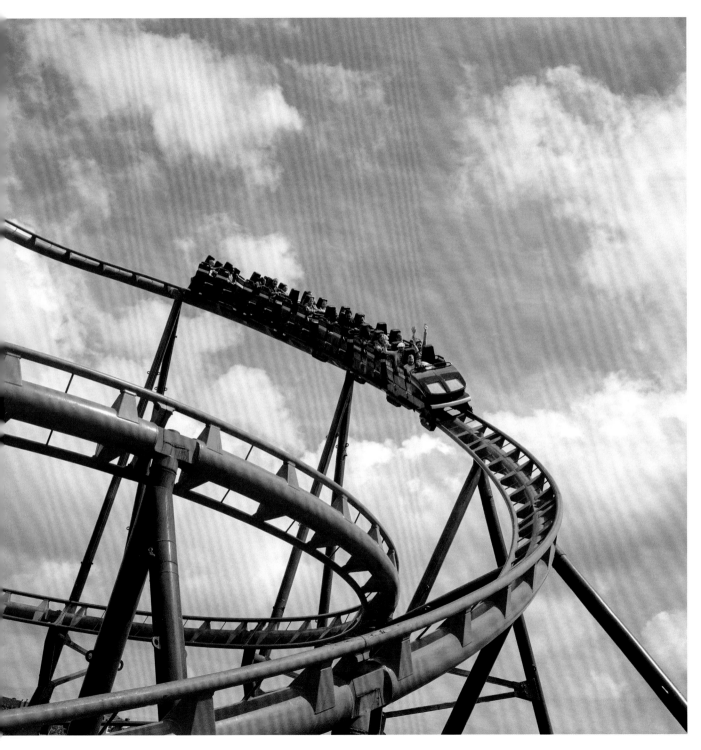

COWES, ENGLAND
America's Cup Jubilee Regatta. 2001

Peter Marlow

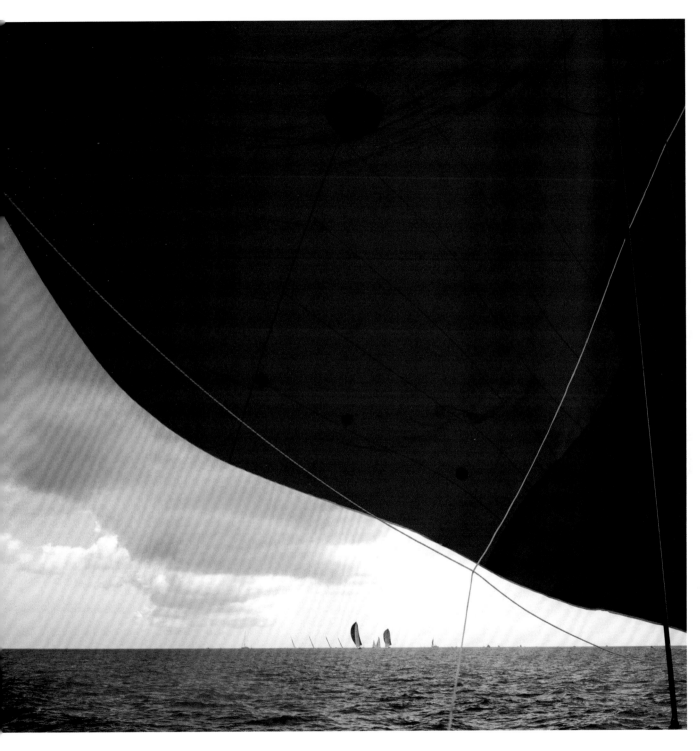

AMSTERDAM, NETHERLANDS
Winter scene. 1964

Leonard Freed

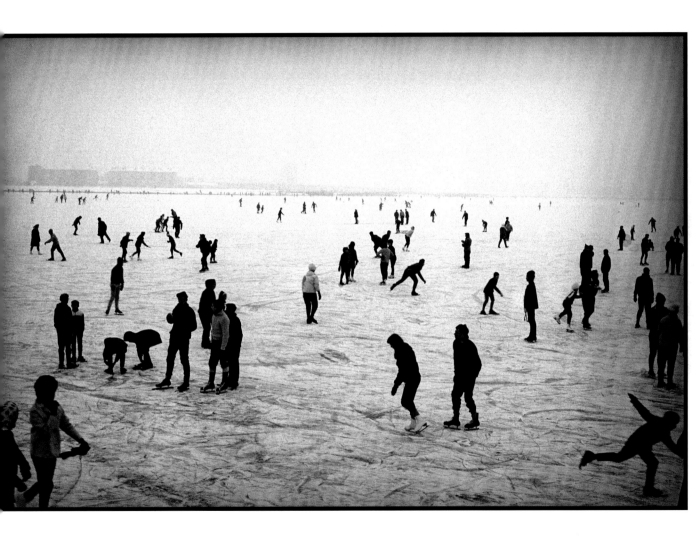

AMSTERDAM, NETHERLANDS
Narrow sidewalks near the
Rembrandt House. 1964

Leonard Freed

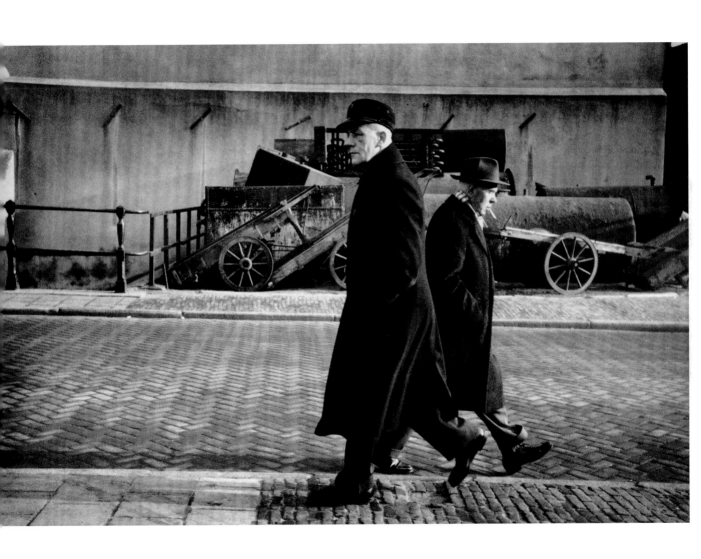

AMSTERDAM, NETHERLANDS
Businessman's Club. 1964

Leonard Freed

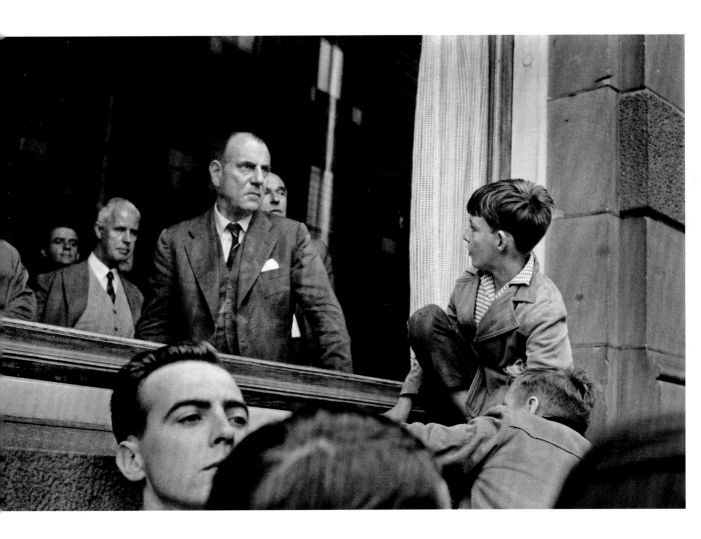

ZEELAND, NETHERLANDS
An Indonesian refugee family stand with Zeeland
women dressed in traditional costume. 1964

Leonard Freed

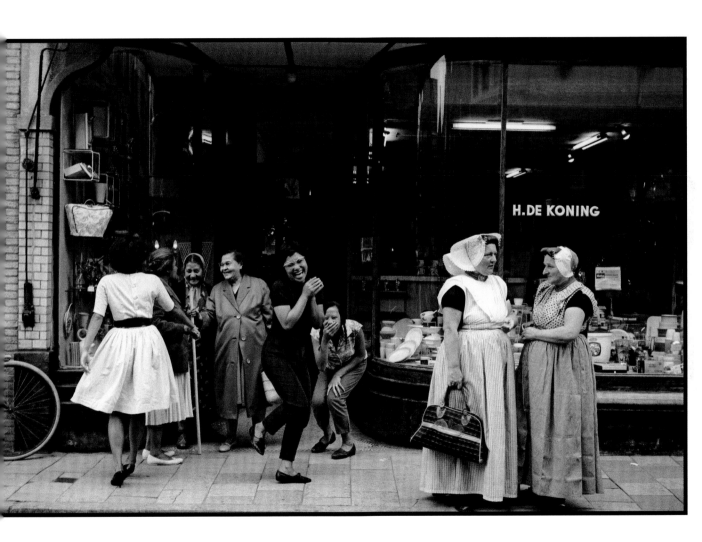

HAMBURG, GERMANY
A man fishing near the commercial
port of Hamburg. 2013

Moises Saman

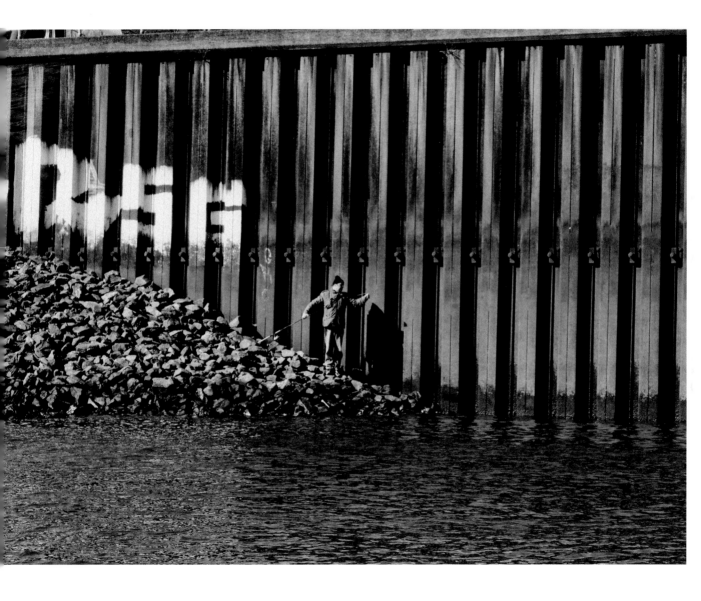

BREMERHAVEN, GERMANY
The commercial port of Bremerhaven. 2013

Moises Saman

PRORA, RÜGEN ISLAND, GERMANY
Inside the abandoned Prora beach resort
on the island of Rügen, Germany, a resort
favoured by Nazi party officers. 2013

Moises Saman

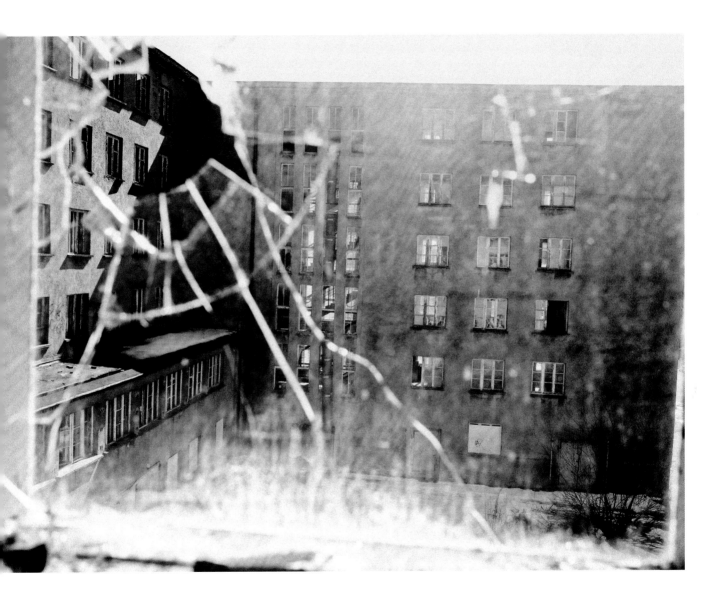

BAVARIA, GERMANY
2015

Thomas Dworzak

DECEMBER 1 2 3 4 5 6 7 8 9 10 11 12 13 14 15 16 17 18 19 20 21 **22** 23 24 25 26 27 28 29 30 31

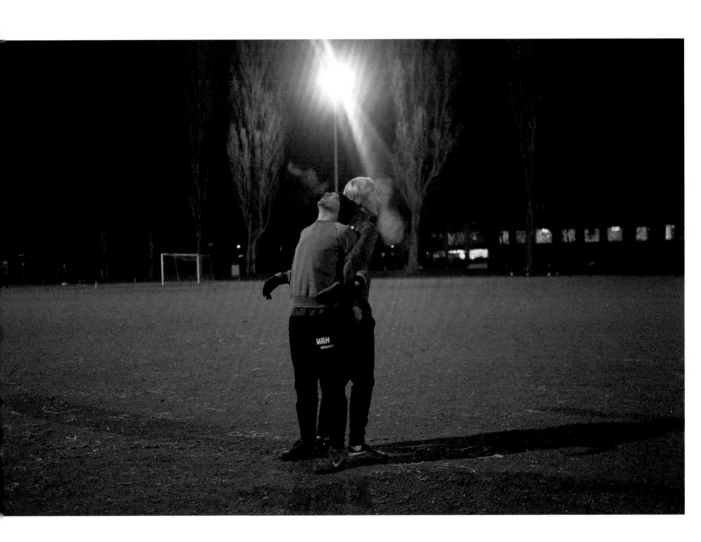

BAVARIAN-AUSTRIAN BORDER, GERMANY
Perchtenlauf/Krampuslauf: In Alpine tradition these
devils accompany Saint Nicholas. In early December
in many cities and villages local youth dress up as
"Krampus" and run through the village scaring and
hitting people. 2015

Thomas Dworzak

DECEMBER 1 2 3 4 5 6 7 8 9 10 11 12 13 14 15 16 17 18 19 20 21 22 **23** 24 25 26 27 28 29 30 31

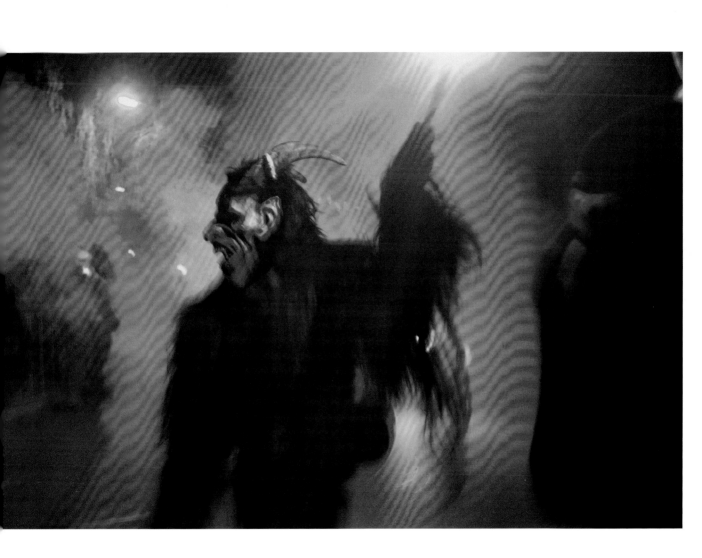

NAARVA, FINLAND
Students of a country school
during their recreation. 1948

Werner Bischof

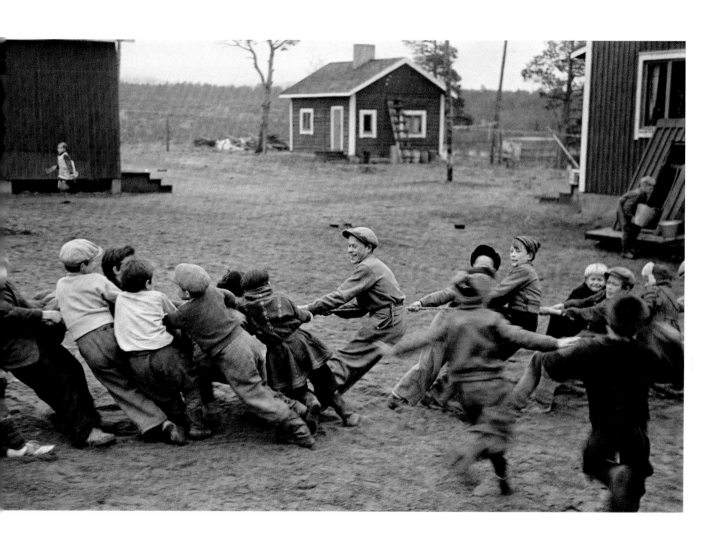

NAARVA, FINLAND
Spinning wheel. 1948

Werner Bischof

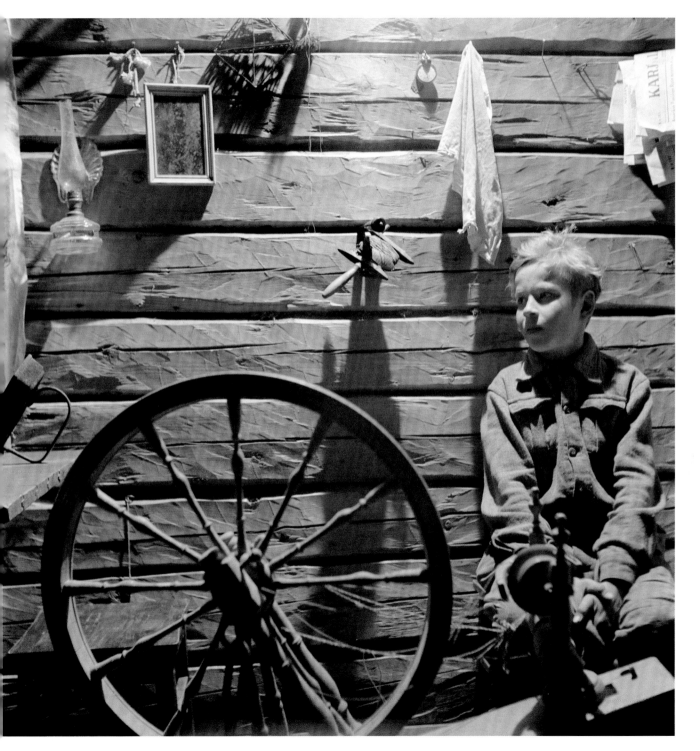

FINLAND
Rounding up reindeers. 1948

Werner Bischof

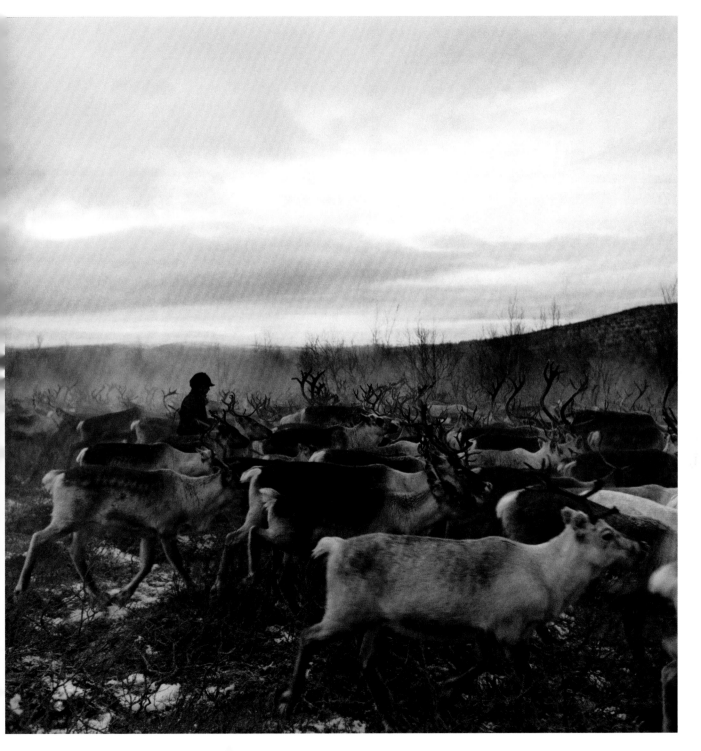

TROMSØ, NORWAY
East of the city of Tromsø. 2007

Jean Gaumy

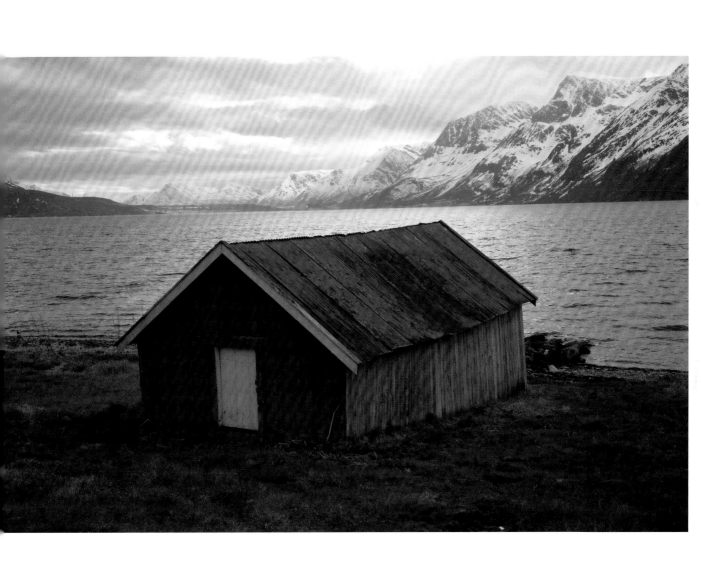

ELLESMERE ISLAND, CANADIAN ARTIC ARCHIPELAGO
Le Vagabond, during a blizzard. 2012

Jean Gaumy

DECEMBER 1 2 3 4 5 6 7 8 9 10 11 12 13 14 15 16 17 18 19 20 21 22 23 24 25 26 27 **28** 29 30 31

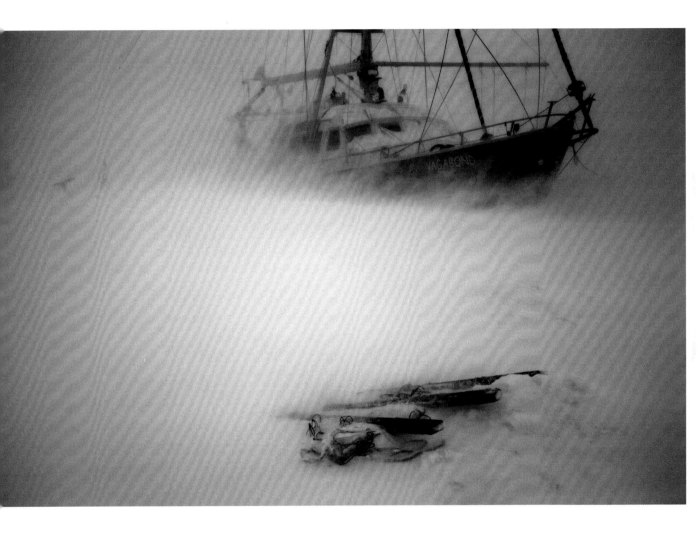

ELLESMERE ISLAND, CANADIAN ARTIC ARCHIPELAGO
In the middle of the day, when the sun is at the highest,
a walk outside is organized for a few hours with the dogs,
even if the temperature is very low. 2012

Jean Gaumy

DECEMBER 1 2 3 4 5 6 7 8 9 10 11 12 13 14 15 16 17 18 19 20 21 22 23 24 25 26 27 28 **29** 30 31

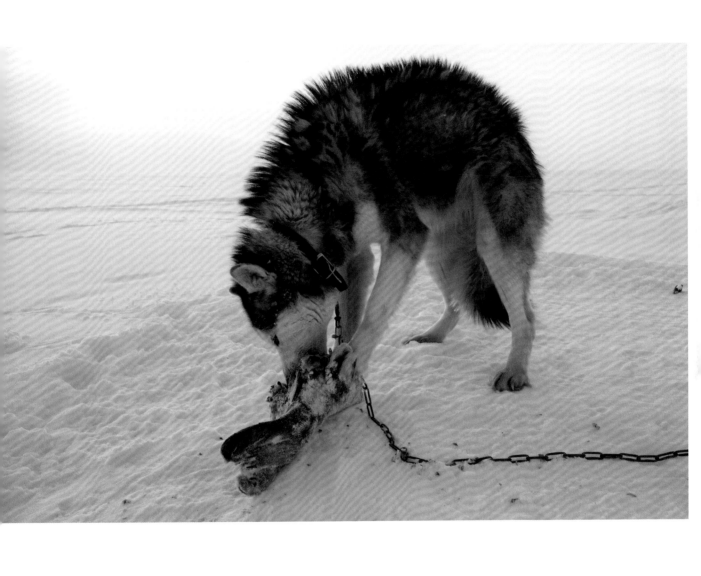

ELLESMERE ISLAND, CANADIAN ARTIC ARCHIPELAGO
Preparation for a departure towards remote zones. 2012

Jean Gaumy

DECEMBER 1 2 3 4 5 6 7 8 9 10 11 12 13 14 15 16 17 18 19 20 21 22 23 24 25 26 27 20 29 **30** 31

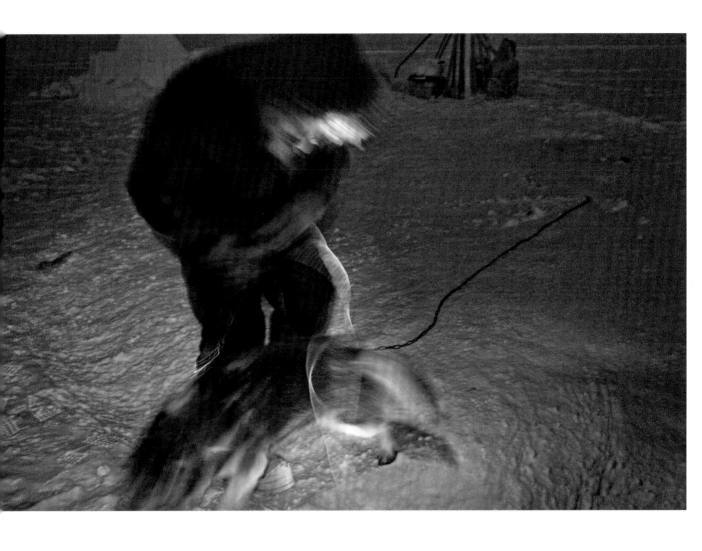

ELLESMERE ISLAND, CANADIAN ARTIC ARCHIPELAGO
On the neighbouring heights of *Le Vagabond* it is possible
to observe the extent of the fjord, of which the other bank
is eight kilometres away. 2012

Jean Gaumy

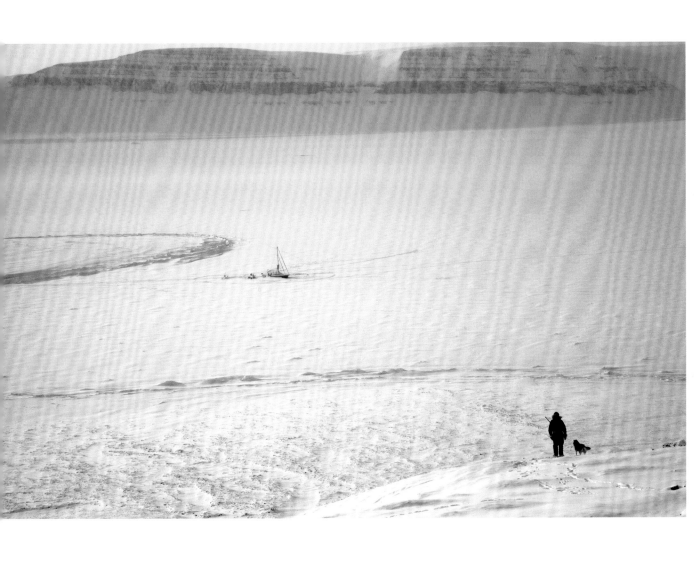

APPENDIX

APRIL 29–MAY 3
Stuart Franklin
Thailand, 2002
© Stuart Franklin/Magnum Photos

MAY 4–8
John Vink
Cambodia, 2014, 2016
© John Vink/Magnum Photos

MAY 9–12
Robert Capa
Indochina (Vietnam), 1954
Robert Capa © International Center of
Photography/Magnum Photos

MAY 13–15
Nicolas Tikhomiroff
Laos, South Vietnam, 1961
© Nicolas Tikhomiroff/Magnum Photos

MAY 16–20
Chris Steele-Perkins
Burma, 2014,2015
© Chris Steele-Perkins/Magnum Photos

MAY 21–23
Ara Güler
Bangladesh, India, 1987, 1988
© Ara Güler/Magnum Photos

MAY 24–27
Raghu Rai
India, 2015
© Raghu Rai/Magnum Photos

MAY 28–30
Marilyn Silverstone
Nepal, 1961, 1962
© Marilyn Silverstone/Magnum Photos

MAY 31–JUNE 4
Bruno Barbey
China, 2015, 2016
© Bruno Barbey/Magnum Photos

JUNE 5–9
Jacob Aue Sobol
Mongolia, 2012
© Jacob Aue Sobol/Magnum Photos

JUNE 10–13
Martine Franck
Russia, Kyrgyzstan, Uzbekistan, 1972
© Martine Franck/Magnum Photos

JUNE 14–17
Paul Fusco
Belarus, 1997, 1999, 2000
© Paul Fusco/Magnum Photos

JUNE 18–22
Jim Goldberg
Ukraine, 2006
© Jim Goldberg/Magnum Photos

JUNE 23–25
Erich Lessing
Poland, 1956
© Erich Lessing/Magnum Photos

JUNE 26–28
David Seymour
Hungary, 1948
© David Seymour/Magnum Photos

JUNE 29–JULY 2
Gilles Peress
Bosnia, 1993
© Gilles Peress/Magnum Photos

JULY 3–6
Nikos Economopoulos
Romania, 2012
© Nikos Economopoulos/Magnum Photos

JULY 7–10
Constantine Manos
Greece, 1964, 1967
© Constantine Manos/Magnum Photos

JULY 11–15
Jonas Bendiksen
Turkey, 2013
© Jonas Bendiksen/Magnum Photos

JULY 16–20
Antoine d'Agata
Georgia, 2016
© Antoine d'Agata/Magnum Photos

JULY 21–25
Cristina García Rodero
Armenia, 2013
© Cristina Garcia Rodero/Magnum Photos

JULY 26–29
Inge Morath
Iran, 1956
Inge Morath © The Inge Morath Foundation/
Magnum Photos

JULY 30–AUGUST 3
Steve McCurry
Afghanistan, 2002, 2003, 2007, 2016
© Steve McCurry/Magnum Photos

AUGUST 4–7
Elliott Erwitt
Pakistan
1954, 1960, 1980
© Elliott Erwitt/Magnum Photos

AUGUST 8–13
Olivia Arthur
Saudi Arabia, UAE, 2009, 2010, 2013, 2014
© Olivia Arthur/Magnum Photos

AUGUST 14–17
George Rodger
Kuwait, 1952
© George Rodger/Magnum Photos

AUGUST 18–22
Paolo Pellegrin
Iraq, 2016
© Paolo Pellegrin/Magnum Photos with support
from the Pulitzer Center

AUGUST 23–25
Micha Bar Am
Israel, 1966, 1967, 1969
© Micha Bar Am/Magnum Photos

AUGUST 26–30
Peter van Agtmael
Palestine, Israel, 2013, 2014, 2015
© Peter van Agtmael/Magnum Photos

AUGUST 31–SEPTEMBER 1
Moises Saman
Egypt, 2011, 2013
© Moises Saman/Magnum Photos

ABOUT MAGNUM

Magnum Photos is the world's premier photo agency. It was founded in 1947 in the wake of the Second World War by some of the biggest names in photographic history: Henri Cartier-Bresson, Robert Capa, George Rodger and David "Chim" Seymour.

Established as a collective, Magnum is owned and operated by a group of over sixty active photographer members. Individually, Magnum photographers are the best in their respective genres. They work independently as artists, documenting the world through their unique perspectives. Magnum reportage has evolved to include storytelling that embraces diverse media formats. All attributes of authorship are controlled by the collective: editing, negative and file ownership, distribution, and syndication.

Today, the agency continues to produce feature stories, books, exhibitions as well as maintaining an active assignment business producing content for the world's most influential media, NGOs, brands and cultural institutions. The Magnum Archive, updated daily and accessed by media clients, students, photographers and fans, has amassed over a million images, many of which have become iconic and are part of our collective visual memory.

As Magnum approaches its seventieth anniversary year in 2017, a new operating model sees the agency become a self-commissioning, self-publishing media platform and marks a significant investment in its digital future with further e-commerce and social media engagement for Magnum's international following. From the outset, Magnum Photos pioneered an experimental approach in the creation of an entrepreneurial, commercial platform for photography. Today, the agency is uniquely positioned to redefine the concept of visual documentary through a wide range of personal, artistic and agency-led projects and create a more sustainable model through the launch of its direct-to-audience strategy.

Cover: Trent Parke, Australia, 2006
Back cover: Clockwise from top left: Mark Power,
Italy, 2011; Herbert List, Mexico, 1958; Steve
McCurry, Afghanistan, 2016; Peter Marlow,
England, 2002; Bruce Davidson, USA, 1992
Frontispiece: Chris Steele-Perkins, Japan, 1999
World map: © Shutterstock, 2017

© Prestel Verlag,
Munich · London · New York, 2017
A member of Verlagsgruppe Random House
GmbH, Neumarkter Strasse, 81673 Munich,
Germany

Prestel Publishing Ltd. (London)
4, Bloomsbury Place
London WC1A 2QA
UK

Prestel Publishing (New York)
900 Broadway, Suite 603
New York, NY, 10003
USA

www.prestel.com

© for all images: Magnum Photos,
London, New York, Paris, Tokyo, 2017

Magnum Photos (London)
63 Gee Street
London, EC1V 3RS
UK

Magnum Photos (New York)
12 West 31st Street
New York, NY, 10001
USA

Magnum Photos (Paris)
19 rue Hegesippe Moreau
75018 Paris
France

Magnum Photos (Tokyo)
Tokyodo Jimbocho
N° 3 Building 7th Floor
1-1-17 Kanda Jimbocho,
Chiyoda-ku, Tokyo
101-0051
Japan

www.magnumphotos.com

The Publisher would expressly like to thank
Hamish Crooks and Elisa Mazza for their
invaluable assistance in curating these images
and their immense support in putting together
this publication. The Publisher is also very grateful
for the editorial guidance within Magnum Photos
of the photographers Chris Steele-Perkins and
Stuart Franklin.

Elisa Mazza would like to thank Ayperi Karabuda
for her constant and reassuring presence, Hamish
Crooks and Curt Holtz, working with whom has
been a real pleasure.

Hamish Crooks would like to thank Elisa Mazza,
Curt Holtz, the Magnum editors, Eva Bodinet
and Matthew Murphy, the Books team of Naima
Kaddour, Michael Shulman and Ruth Hoffmann,
and the Production team of Paul Hayward,
Enrico Mochi and Margot Becka. Thank you also
to Magnum Photos CEO, David Kogan along with
CFO Daniel Costantini and, of course, a big thank
you to all the photographers, with special mention
to Chris Steele-Perkins and Stuart Franklin for
their advice and support.

Library of Congress Control Number is available
British Library Cataloguing-in-Publication Data.
A catalogue record for this book is available from
the British Library.

The Deutsche Bibliothek holds a record for this
publication in the Deutsche Nationalbibliografie;
detailed biographical data can be found under:
http://dnb.ddb.de

Editorial direction: Curt Holtz
Copy-editing: Jonathan Fox
Typesetting & production: Corinna Pickart
Origination: Reproline Mediateam, Munich
Printing and binding: C&C Joint Printing Co., Ltd.
Paper: Chinese Matt Art

Verlagsgruppe Random House FSC® N001967

Printed in China

ISBN: 978-3-7913-8376-7